DICTIONARY

·OF·

CHRISTIAN
ART

DICTIONARY

·OF·

CHRISTIAN ART

Diane Apostolos-Cappadona

The Lutterworth Press
Cambridge

The Lutterworth Press
PO Box 60
Cambridge
CB1 2NT

British Library Cataloguing-in-Publication Data:
A catalogue record is available for this book from the British Library

Copyright © Diane Apostolos-Cappadona 1994

First published in the USA by
the Continuum Publishing Company, 1994

First published in Great Britain by
the Lutterworth Press, 1995

ISBN 0-7188-2932-8

Printed in the United States of America

In Memory of
Laurence Pereira Leite

Contents

Introduction

The Baptism of Christ (fig. 1) by the Master of the Saint Bartholomew Altarpiece serves as a visual guide in the use of this *Dictionary of Christian Art*. From its beginnings, debates have raged within Christianity for *and* against the use of the visual arts. As both a pedagogical and an inspirational mode of expressing Christian faith, art employs signs and symbols to fascinate and engage the viewer's attention. The vitality of Christian symbolism supports Christian art as a crucial form of the narration of the tenets and narratives of the faith. Narratives—whether visual or verbal—define human presence in the world in accordance with religious beliefs. Traditionally Christian art is categorized by two types of representations—historical or mystical. Historical representations include depictions of those personages who could have been present at an actual event, such as John the Baptist at the Baptism of Jesus Christ, whereas mystical images include representations of individuals who could have been pres-

ent as well as those who could not have been present, such as Teresa of Avila and Francis of Assisi at the Nativity of Jesus Christ.

This particular rendering of *The Baptism of Christ* (fig. 1) is a mystical image combining the reality of the historical event with the devotional spirituality of medieval Christianity. In the center of the painting is a representation of the scriptural event of the Baptism, in which a thoughtful Jesus of Nazareth is "washed clean" of his "sins" by John the Baptist, who is identified by his garment of animal skins. As this topos is placed in the center of the canvas, the viewer recognizes its immediate importance. A turn to the entry for this particular scriptural narrative provides the reader with both a description of the scriptural event itself and its place in the history of Christian art; for major events in the life of both Jesus Christ and the Virgin Mary, an abbreviated survey of the symbolism of the event in Christian art is included. The figure of Jesus is represented in a state

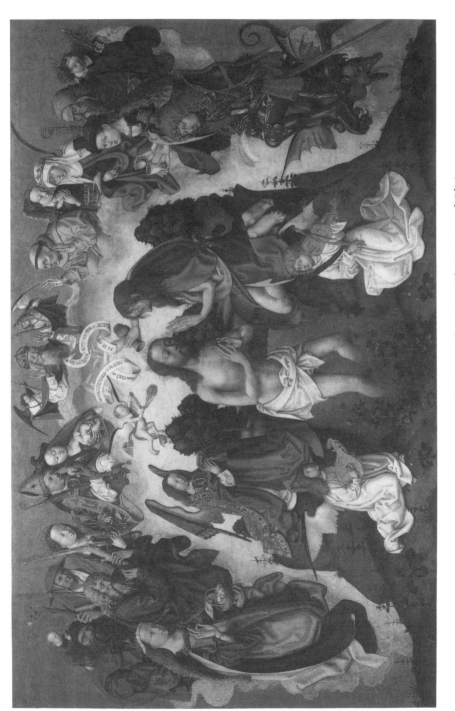

1. Master of the Saint Bartholomew Altarpiece, *The Baptism of Christ*.

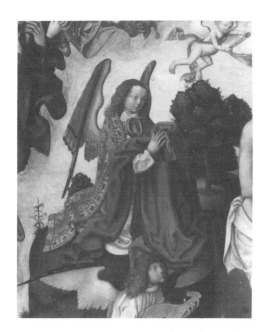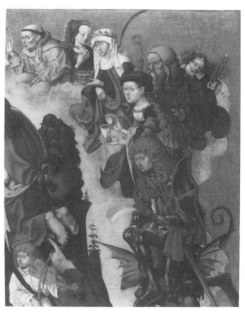

2. Detail: Archangel in Left Center from Master of the
Saint Bartholomew Altarpiece, *The Baptism of Christ* (fig. #1).
3. Detail: Saints in Upper Right from Master of the
Saint Bartholomew Altarpiece, *The Baptism of Christ* (fig. #1).

4. Detail: Flowers in Lower Center from Master of the
Saint Bartholomew Altarpiece, *The Baptism of Christ* (fig. #1).

of almost total nudity, signifying both the fullness of his humanity and his willingness to participate in human experience. The Master of the Saint Bartholomew Altarpiece was a northern European artist, as illustrated by John's employment of a flask (or bottle) for the baptism ritual (a southern European artist would have employed a seashell for this same purpose), the inclusion of an inscribed banner, and the direct influence of manuscript illuminations. The less-than-knee-deep waters indicate that the sacrament of baptism as practiced in the time of the Master of the Saint Bartholomew Altarpiece was no longer a ritual of total immersion but a "sprinkling of water" on the head of the baptismal candidate.

The four angels that surround the central figures of Jesus and John belong to a variety of angelic orders as signified by their bodily formations, wings, garments, and activities. The music-making angels kneeling on the earth imply the fusion of the celestial with the earthly as a sign of the Incarnation at this scriptural event. Their individual instruments—viola and lute—have symbolic significance. The kneeling archangel (fig. 2) is garbed in an archbishop's elaborate cope covered with symbolic flowers and jewels, and held together by a morse incised with an representation of the Madonna and Child. He participates in the liturgical action of the baptism while his music-making companions signify the celebration of this event on earth and in heaven. The floating cherubic putti swings a censer and captures the banner which descends from God the Father and upon which is written the scriptural passages related to this event. Individual entries on the topics of angels, liturgical garments and objects, and musical instruments enhance the viewing of this painting.

Although Jesus and John were historically present at the Baptism, the extraordinary assortment of fourteen saints in a semicircle within the heavenly realm implied by the upper half of the canvas were not. Each of these saints is identifiable to the artist's original audiences by their physiognomy and their attribute or identifying symbol. From the viewer's perspective, the saints on the left-hand side of the canvas include Dorothea of Cappadocia, identified by her basket of flowers; Andrew the Apostle, by his X-shaped cross; Christopher, by the young Christ Child resting on his shoulder; Jerome, by his cardinal's robes and hat; Catherine of Alexandria, by a sword and wheel, the instruments of her martyrdom; Augustine, by both his bishop's garments (cope with morse, staff, and miter) and his heart pierced by an arrow; and Agnes, by her lamb. On the right-hand side of the composition (fig. 3), this saintly semicircle continues with Francis of Assisi, displaying the stigmata; Lucy, the sword in her throat; Elizabeth of Thuringia (or Hungary), her three crowns; Anthony the Abbot, his monk's habit; Apollonia, her pincers with a tooth; Mary Magdalene, her unguent jar; and George of Cappadocia, with his sword and the dragon. A turn to the individual entries for these particular saints provides biographical and iconographic information about the saint, whereas the entries on individual attributes identifies individual saints or holy persons.

The natural order played a significant role in Christian art, and thereby a careful scrutiny of the flowers, plants, and trees in this painting would support both the medieval devotions of this scriptural event and the liturgical rite of baptism. At Jesus's feet, a medieval or renaissance viewer would recognize violets, columbine, hyssop, and plantains (fig. 4). Each of these flowers and plants has a direct relation to the humility of Jesus or the ritual of baptism. Individual entries on flowers, plants, and trees explain their Christian readings.

A careful review of the varied human, animal, and natural symbols brought together by the Master of the Saint Bartholomew Altarpiece not only enhance the scriptural, devotional, and liturgical interrelationships within this image, but illuminate the pedagogical and spiritual meaning of Christian art. By using this *Dictionary of Christian Art,* the reader can access the pictorial tradition that was once the common visual vocabulary of Christianity. Although the cultural ethos that supported the production of Christian art no longer exists and the fundamental method of learning how to "read" Christian art (from parent to child) functions with rarity, works of art with Christian themes and symbolism continue to intrigue and fascinate museumgoers, tourists, and religious believers. This *Dictionary of Christian Art,* therefore, is an attempt to explain and thereby to teach the process of interpreting the signs and symbols once so accessible to the average Christian.

As should be obvious from the title of this volume, this is not a comprehensive or exhaustive examination of either the history of or the relationship between Christianity and art. Such a work would be a multivolume project, and it would still be found wanting by readers with particularized interests or training. Rather, this present volume has been designed as a basic reference for both students interested in Christian art from the varied disciplines of art history, biblical studies, church history, history of Christianity, and Christian theology, as well as the museum visitors who have found the wall text descriptions or catalogue entries of a work of art insufficient to satisfy their curiosity about why certain flowers or animals are included in a particular painting.

In many ways, it is always easier to say what a book is not as opposed to what it is—beyond the author's hoped-for intentions. This present text is not a dictionary of Christian artists or of Christian theologians. There are, however, entries for those Christian artists and theologians whose works changed or influenced the course of the signs and symbols in Christian art. Individual works of art that are either cited or illustrated in this volume were selected both as an example of a particular symbolic motif and for their easy accessibility through museums and publications in the United States and Europe. Every effort has been made to place the illustrations as close as possible to the appropriate entry throughout the main body of this dictionary. In a similar fashion, this is neither a dictionary of liturgical arts or of Christian architecture, although once again the reader will find entries for liturgical vesture and objects, and also for specific architectural terms. These

have been selected for their obvious and regular presence in works of Christian art; the reader should note that especially in terms of liturgical vesture, the entries do not reflect the present-day usage of these same garments or objects, but rather their role or function within the historical framework of Christian art.

A similar caveat must be voiced about the entries on saints and classical mythological figures. Again, the entries have been narrowed down from a much larger listing of *all* the saints of Christian history, *all* the individuals of the Old Testament, and *all* the gods, goddesses, heroes, heroines, and minor players of classical mythology. Every attempt has been made to include those saintly, biblical, and mythological individuals who have been either the subject of a large array of works of art throughout the almost two-thousand-year history of Christian art, or who were popular topics during a specific period of Christian art and thereby merit mention. Also included are those mythological and Old Testament figures who influenced the symbolism of Christian art, most especially with reference to Jesus Christ or the Virgin Mary. Readers interested in a specific topic, artist, liturgical vesture, architecture, saint, mythological figure, or biblical personage should use this book as a starting point for their study. The selected bibliography suggests a series of common reference works and basic texts in the study of Christian art.

Symbols and subjects in Christian art are subject to multiple readings or interpretations, and for the most accurate presentation a particular topic, symbol, sign, or figure must often be placed within the context of the time period in which both the work of art was created and the artist lived. Legendary and devotional texts, lay spirituality, popular recitations of the stories of Christian saints and biblical figures, and personalized artistic iconography and style played a more important role in the history of Christian art than theological doctrines, ecclesiastical documents, and canonized scripture. The careful observer of Christian art will note regional as well as historical and artistic variations of the inclusion or interpretation of the same symbol, topic, sign, or figure, even within a clearly identified period of time. For example, saintly biographies have been layered with historical and popular devotional transformations from the time the saint either died or was canonized. Further variations or rereadings of these same saintly biographies have been influenced or in some instances even altered by shifting theological perspectives, such as the divisions between Eastern Orthodoxy, Roman Catholicism, Lutheranism, Anglicanism, and the Protestant traditions. For exactly this reason, I have omitted any reference to the feast dates of all saints and liturgical feasts which vary from Christian tradition to Christian tradition, and from historical time period to historical time period. Readers interested in either a particular saint or the interpretation of that saint in a specified period of Christian history should turn to those available reference works on the saints from the appropriate Christian tradition or historical period.

I have attempted to provide the

reader with a middle-of-the-road reading of the topics, symbols, signs, or figures listed herein. That is, the entries are based as much on popular and devotional texts as on theological treatises, on the vernacular use as opposed to the esoteric doctrine, and on the repeated usage of an individual figure, sign, symbol, or topic. These entries, then, reflect a reading that is perhaps more appropriate to what a particular saint or biblical heroine meant to the artist and his contemporary viewers than to postmodern biblical and theological scholarship. Such specialists will no doubt, find the present volume wanting in the style of critical precision and revisionisms of scholarly inquiries. Such readers are advised to proceed with caution and to delve more deeply into the books listed in the selected bibliography, and the bibliographies of those other books. Such readers, for example, would find Leo Steinberg's now classic book, *The Sexuality of Christ in Renaissance Art and in Modern Oblivion,* more to their purposes in its critical and scholarly analyses of this specific iconographic motif and its artistic and theological milieu.

I have made one concession to postmodern scholarship in the use of the New Revised Standard Version of the Bible for the scriptural citations and quotations within this book. However, readers are advised that should they find a particular symbol or topic of interest, they may find the NRSV (as it is commonly referred to by biblical scholars) lacking. Those readers are advised to turn either to a translation of Jerome's Vulgate or of the Douay-Rheims Bible. In my own study of Christian iconography, I prefer to use the Douay-Rheims Bible for both the richness of its language and its contemporary appropriateness to the times many of the works of Christian art were created. An artist like Michelangelo Buonarroti or Rogier van der Weyden read the version(s) of the Bible available in his own time, and his work and its symbolism may be more accessible or understandable, then, with a reading of that rendering of the scriptural texts. For example, I have used the titles and spellings of persons, topics, and events employed in the NRSV; however, I suspect that few readers, and I know of no medieval or renaissance artist, who would immediately connect the parable of the "ten bridesmaids" to that of the "wise and foolish virgins." Therefore, I have placed an index of subjects at the end of this text. Readers are advised to look for specific biblical figures, topics, and titles in the index should an initial alphabetical search for an entry prove fruitless. On occasion, the reader may find a scriptural citation with the letters DR; this indicates that the Douay-Rheims Bible is the source, not the NRSV. Certain "outdated" terms such as adder or basilisk are not used in the NRSV, and so the scriptural citation would appear to be either erroneous or useless, or both, in clarifying the iconography.

An explanatory note is necessary for the use of the word "foretype" throughout this volume. Traditionally, the study of Christian Iconography has depended upon the process of analogy known as typology, in which the individual or motif from the New Testament or Christian history was identified as the "antitype,"

that is, both the model and the fulfillment of that which was prophesied or promised in the Old Testament "type." From my training as a historian of religions, I am committed to the historical reality that no one religious tradition or belief system is superior to any other and that the integrity of what was the classical mythological tradition of the Mediterranean and the still living tradition of Judaism are appropriate modes of religious belief. Therefore, in an effort both to broaden what I believe to be the original readings of the many symbols and images of Christian art, and also to respect the integrity of these other religious traditions, I am employing the term "foretype" throughout this present study to denote that these varied classical and Hebraic figures, topics, signs, and symbols had an identity and integrity of their own before their assimilation into Christian art.

The preparation of any book is not the achievement of one individual. As with all authors, I am endebted to those colleagues and friends who have supported me throughout the drafts and rewrites of this study, and to those research librarians who assisted my searches in a myriad of untold ways. Although these individuals and libraries are too numerous to mention, several must be thanked for their efforts "above and beyond the call of duty." I am grateful for the research services of the Dumbarton Oaks Library; Graduate Library, University of California, Berkeley; Lauringer Library, Georgetown University; and National Gallery of Art Library, Washington, D.C. I am indebted to Ira Bartfield, Coordinator of Visual

Services, and his staff at the National Gallery of Art, Washington, D.C.; and to Joanne Greenbaum, Permissions Director, and her staff at Art Resource for their generous assistance in the process of illustrating this book. Several individuals at the Continuum Publishing Company deserve recognition, most notably Frank Oveis for his editorial counsel, Ulla Schnell for her unceasing support during the production process, and Werner Mark Linz for his belief in this project from the very beginning.

Of the many individuals who kindly supported me throughout the preparation of this book, I would like especially to thank John E. Perkins and Lucinda Ebersole for their unflagging friendship. Leo Steinberg offered critical admonitions, art historical and linguistic precision, insightful conversations, and intelligent advice that has had as much to do with the formulation of both this dictionary as with my continuing study of religion and the arts. I am most obliged to Robley E. Whitson, whose conscientious reading of this manuscript kept me from countless theological and anthropological errors, but at whose feet none of my present sins (of omission or interpretation) can possibly be laid. Throughout the process of revising this manuscript, Dr. Whitson offered me that style of patient guidance and willingness to share erudition that initially encouraged me to enter into the world of scholarship.

My deepest personal and scholarly indebtedness continues, however, to remain with Laurence Pereira Leite, whose compelling lectures on Christian Iconography afforded me my first glimpse into the vitality of reli-

gious art when seen within its original context. As my first mentor, he put the tools of art history and Christian iconography into my hands, and wisely guided my initial ventures into the crossroads, roadblocks, and extraordinary discoveries of the interdisciplinary scholarship of religion and the arts. I now trust celestial messengers to deliver both the news of this publication and my continuing appreciation for the vast learning and pedagogical model Dr. Leite so generously shared.

<div align="right">
Diane Apostolos-Cappadona
Georgetown University
Washington, D.C.
</div>

Aaron. Elder brother of *Moses, co-leader during the Exodus, and first head of the Hebrew priesthood. Aaron is a foretype for *Jesus Christ as priest. *Aaron's Staff* (Nm 17:5–11): Following God's command, Moses ordered that each of the twelve tribes of Israel place an identifying *staff before the *Ark of the Covenant. Only Aaron's staff flowered as a sign of his divine selection to exercise priestly office. This motif was a foretype of the flowering of Joseph's staff as a sign of his divine selection as Mary's earthly bridegroom. *The Exodus from Egypt* (Ex 4:1–5): Aaron's staff effected the plagues in Egypt and the parting of the *Red Sea, enabling the Hebrews to cross in safety. When the Pharaoh refused Moses's request of the release of the Hebrews from Egypt, Aaron dropped his staff on the ground where it transformed into a *serpent. Pharaoh's magicians changed their staffs into serpents which were devoured by Aaron's serpent. *The Golden Calf* (Ex 32:1–35): While Moses conversed with God on Mount Sinai, Aaron pressured by the impatient Hebrews, fashioned from their jewelry a golden calf as a false god of deliverance. As he descended from Sinai, Moses discovered the Hebrews worshiping the Golden Calf. Enraged, he smashed the tablets of the Ten Commandments and burned the Golden Calf, which was then ground to powder, mixed with water, and drunk by the worshipers. In Christian art, Aaron was depicted as a bearded elderly man dressed in priestly vestments (Ex 28) and holding a staff.

Abel. The second son of *Adam and *Eve, who was slain by his jealous brother *Cain (Gn 4:2–8). *Abel's Sacrifice to God* (Gn 4:4): The offering of a perfect *lamb by Abel as the first *shepherd was a foretype of the eucharistic gifts. *The First Murder* (Gn 4:8): Abel's gift of *blood, a symbol of the essence of life, may have been deemed more appropriate by God, or was offered with more sincerity. In anger and jealousy at God's favor of

Abel's gift, Cain struck his younger brother dead. This first murder signified the struggle between the farmer and the shepherd in early western society. In Christian art, Abel was depicted as a youthful shepherd within the context of the scriptural narrative of either his sacrifice or the first murder.

Abraham. Descendant of *Noah and a founder of the Hebrew people. Abraham was the paradigm for the biblical patriarch and as the symbol for unconditional, obedient faith. God revealed to Abraham the religious concept that established monotheism. *Abraham and Melchizedek* (Gn 14:18–21): Triumphant in his rescue of his nephew, Lot, during the war with the Sodomite chieftains, Abraham was greeted by *Melchizedek, king of Salem and High Priest, with bread and wine. This episode was a foretype of the sacrifice of *Jesus Christ, the *Eucharist, and of the priesthood of Christ. *Abraham and Hagar* (Gn 16:1–16): Abraham's barren wife, *Sarah, followed the custom of her time by offering her husband her Egyptian maid, *Hagar, in the hope that the slave woman would conceive a child. Hagar bore Abraham a son, Ishmael, who became a source of jealousy between the two women. *Philoxeny* (or *Hospitality*) *of Abraham* or *Angels at Mamre* (Gn 18:1–15): Three men identical in stature and visage paid an unexpected visit to Abraham and Sarah. Following their hosts' more than the customary hospitality, the visitors disclosed the eminent pregnancy of the previously barren Sarah. Beyond the age of child-bearing, Sarah laughed at this prophecy, which was later fulfilled in the birth of her son, *Isaac (the supposed etymology meaning "and Sarah laughed"). The three visitors as God's messengers were a foretype of the *Trinity, and this episode a foretype of the *Annunciation (to Mary). *Expulsion of Hagar* (Gn 21:9–21): With Isaac's birth, the jealousy between Sarah and Hagar was renewed. Desirous that her natural son be her husband's heir, Sarah pressured Abraham to banish Hagar and Ishmael to the desert and eventual death. Reassured by God's promise of greatness to all his descendants, Abraham acceded to Sarah's demands, and expelled Hagar and Ishmael into the desert. *Sacrifice of Isaac* (Gn 22:1–14): In this test of faith, Abraham sought to fulfill God's command of the sacrificial offering of Isaac. Abraham set out with Isaac for the place of sacrifice despite his son's poignant question, "Where is the lamb for the burnt offering?" At the last possible moment, an angel, usually identified as the *Archangel *Michael, appeared and stopped the sacrifice of the child by substituting a *ram which was caught in a nearby thicket. Isaac's carrying the wood for his own funeral pyre was a foretype of Jesus carrying his own *cross on the *Road to Calvary. The theme of the Sacrifice of Isaac was a foretype for the *Passion of Jesus Christ. In Christian art, Abraham was depicted as a patriarchal figure with a full *white or graying, *beard. His *attribute was a *knife, an allusion to the Sacrifice of Isaac.

Absalom. Third son of King *David who was noted for his physical beauty, particularly his abundant

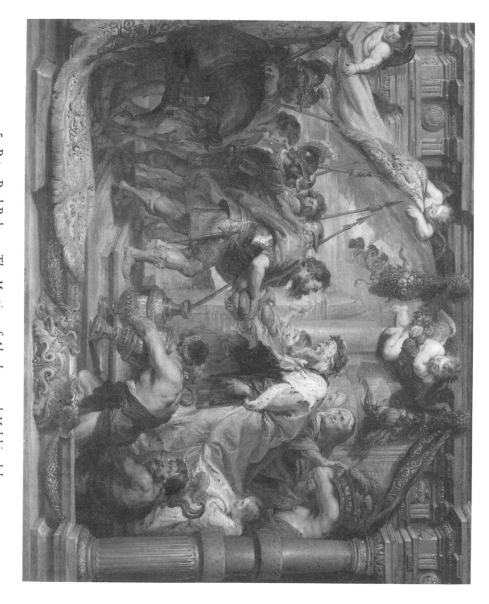

5. Peter Paul Rubens, *The Meeting of Abraham and Melchizedek.*

*hair. After murdering his half-brother Amnon for the rape of their sister Tamar, Absalom fled *Jerusalem, but was welcomed back by his father three years later. Absalom then attempted a rebellion which led to his own death. His long hair became entangled in a *tree branch, and he was killed by Joab, commander in chief of David's army. David lamented his son's death with one of the most poignant lines in the Bible, "Would I had died for you, O Absalom, my son, my son!" (2 Sm 18:33) In Christian art, Absalom was depicted as a muscular young man with long flowing hair.

Acacia. A botanical symbol of friendship, the moral life, and the immortality of the soul. The *red and *white *flowers of the acacia represented life, death, and rebirth. As the sacred wood of the Hebrew Tabernacle, acacia wood was reputed to have been used for the crown of thorns.

Acanthus. A botanical symbol whose *thorns signified pain and the punishment for sin in Christian art.

Acheiropaeic image. A singular category of works in Christian art which were deemed "not made by hands." The *Veil of Veronica and *Mandylion of Edessa were two of the more famous acheiropaeic images in Christian art.

Acheiropoitos. From the Greek for "not made by hand(s)." Works of art such as the *Veil of Veronica, the *Mandylion of Edessa, or portraits of *Mary with the Christ Child by *Luke the Evangelist were deemed to be miraculously made by divine intervention.

Adam. The first man, created in the image of God, who lived initially in the *Garden of Eden. Adam's story was central to the development of Christian art as the early church fathers interpreted his role as that of the first foretype of *Jesus Christ. *Creation of Adam* (Gn 2:7): God formed Adam from the mud of the *earth and breathed life into him. In Christian art, the breath of life was depicted as transmitted like an electric spark from God's fingertips into Adam. *Adam's Taxonomy* or *Adam Naming the Animals* (Gn 2:20): As one of his responsibilities, Adam was authorized to name (and identify) all the *animals of the earth. This activity implied human dominance over the animal kingdom, and prefigured Christ as the Ruler of Animal Kingdom. *Creation of Eve* (Gn 2:21–23): Adam noted his need for a "helper" to God, who removed one of the sleeping Adam's ribs to create the first woman. After the Fall, Adam named this woman *Eve (supposed etymology meaning "Mother of All Living," Gn 5:20). The Creation of Eve prefigured the Birth of the *Church, for Eve emerged from Adam's side just as the Church would emerge from the wounded side of the crucified Jesus. *Temptation and Fall* (Gn 3:1–7): The *serpent tempted Eve to eat of the forbidden *fruit, which offered the divine power of knowing Good and Evil. Allegedly, Eve persuaded Adam to eat also of this forbidden fruit. Instantly, the primal couple recognized their nakedness. These events implied the reason for the birth and sacrificial

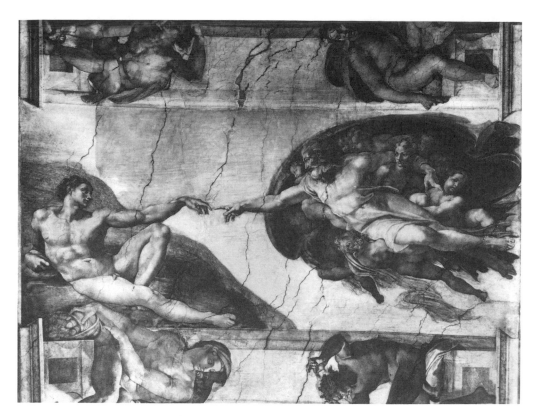

6. Michelangelo Buonarroti, *Creation of Adam*.

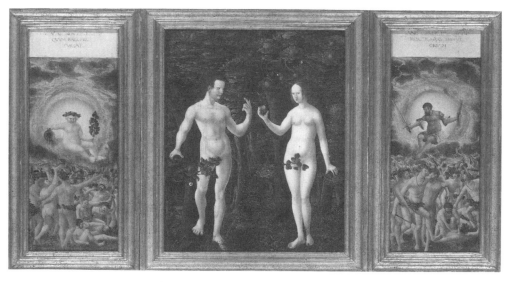

7. Workshop of Albrecht Altdorfer, *The Fall of Man*.

death of Jesus Christ. As Adam was the first foretype of Jesus Christ and Jesus Christ was the Second Adam, so Eve was the first foretype of Mary and Mary was the Second Eve. *Expulsion from the Garden* (Gn 3:8–24): Confronted by God about their act of disobedience, Adam blamed Eve, who in turn blamed the serpent. As a result of the Fall, men were eternally condemned to work in the fields and women to bear children in pain. Adam and Eve were expelled from the Garden by the *Archangel *Michael, who guarded its entrance gate. Theologically, this theme implied the tragedies of the human condition, while psychologically and artistically it was a birth symbol. *Adam's Labors* (Gn 3:23): Popular in medieval Christian art, this final image of Adam working the ground as a pregnant Eve sat nearby signified human inferiority and submission to God's authority, which was represented on earth by the Church.

Adder. An animal symbol for human treachery (Gn 42:17, Ps 58:4, Ps 91:3, Prv 23:32). Following the writings of *Augustine, the adder signified the presence of the *Devil or of evil in Christian art.

Adoration of the Child. A popular theme in medieval Christian art and devotions. Without any scriptural basis, the image of the Christ Child being adored by both his earthly parents and the animals evolved from the devotional piety and mystical writings of the twelfth and thirteenth centuries, especially those of *Bernard of Clairvaux and *Francis of Assisi. The specific image of *Mary kneeling in adoration before her newly born son was influenced by the visions and writings of *Bridget of Sweden. This visual motif was first popularized in northern art, and eventually became conflated with the Nativity.

Adoration of the Kings. *See* Adoration of the Magi.

Adoration of the Magi (Mt 2:1–12). Scriptural event that signified the homage of human *kings to *Jesus Christ and to the ecclesiastical authority of the *Church. Having followed the Star of Bethlehem, the *Magi found the newborn child in the manger and offered him gifts. According to tradition, the Magi were identified as Melchior ("king of light"), who presented gold in recognition of the child's royalty; Caspar ("the white one"), who offered frankincense in accordance with the child's divinity; and Balthazar ("the lord of treasures"), who presented myrrh as a sign of the child's future suffering and death. The Magi, a Persian sacred caste who were skilled in astrology and the occult, followed a singular star to Bethlehem in search of its source—Mary and the Christ Child. Identified as the *Epiphany, this event signified the first manifestation of Jesus Christ to the Gentile world. Until the fifth century, the feast of Epiphany celebrated the Adoration of the Magi, the *Baptism of Jesus Christ, and the *Marriage at Cana. By the seventh century, the Adoration of the Magi underwent narrative and visual transformations as the three Magi (representing the number of gifts, the three ages of humanity, and the *trinity) were identified as

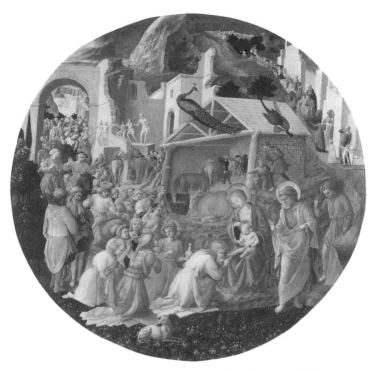

8. Fra Angelico and Filippo Lippi, *The Adoration of the Magi.*

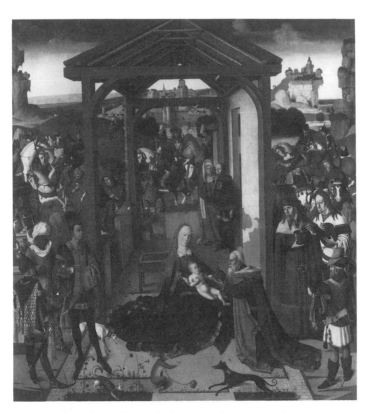

9. North Netherlandish, *The Adoration of the Magi.*

Caspar, Melchior, and Balthazar. By the twelfth century, the Magi became kings whose relics were interred in the cathedral in Cologne. An older celebration than Christmas, the feast of Epiphany was identified in the medieval church as Twelfth Night. In the Eastern Orthodox tradition, "little Christmas" was the day gifts were exchanged. The Adoration of the Magi was a popular theme throughout the history of Christian art. In earliest Christian images, the depiction of this motif featured three similarly sized and garbed male figures approaching Mary and the Child. Each of these male figures carried a *box. The Magi's Phrygian caps (signifying they were from the East) distinguished them from the three *shepherds. By the medieval period, the magi were represented by a young man, a middle-aged man, and an elderly man. The elder Magus was positioned closest to Mary and the Christ Child. The three gifts took the shapes of different containers which implied their contents. Elegantly garbed, each Magus was accompanied by a retinue of servants and animals. In the fourteenth-century, the eldest Magus knelt before the Christ Child as a sign of both humility and a recognition of the manifestation of the infant's singular unity of humanity and divinity. Following medieval legend, one of the Magi was depicted as black. During the great age of explorations, at least one of the Magi began to take on the facial characteristics, skin color, and dress of the varied lands "Christianized" by Europe, including the Americas, Africa, China, and Japan. In *renaissance art, the Adoration of the Magi and the *Adoration of the Shepherds (Lk 2:8–20) become fused into one adoration scene.

Adoration of the Shepherds (Lk 2:8–20). Scriptural event which implied the recognition of *Jesus Christ by the lowliest of the *Hebrews and signified his domain over the products of the earth and over the animals. Having heard the *Archangel *Gabriel's proclamation of the birth of this special child, the shepherds journeyed to the stable where they found the newborn infant and offered him gifts of animals and foods. A popular theme throughout the history of Christian art, the Adoration of the Shepherds was initially a simple depiction of two or three shepherds with gifts (*lambs, sheaves of *wheat, and an occasional basket of *eggs) for the newborn Christ Child. By the medieval period, this motif became complicated both in the number of the shepherds and the kind of gifts they offered, until its conflation with the *Annunciation to the Shepherds in the High Middle Ages. In *renaissance art, the *iconography of the Adoration of the Shepherds fused with that of the *Adoration of the Magi resulting in a massive "adoration scene." As the role of the shepherd and of agrarian society waxed and waned in western history so did the theme and the presentation of the Adoration of the Shepherds.

Advent. The Christian liturgical period of repentance and mourning in preparation for the joy of *Christmas and the *Last Judgment. During the four Sundays of Advent, no weddings or joyous music were permitted, and the liturgical *color of *purple was

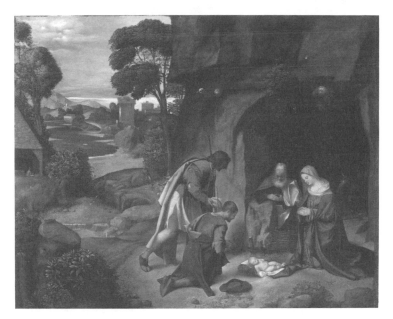

10. Giorgione, *The Adoration of the Shepherds.*

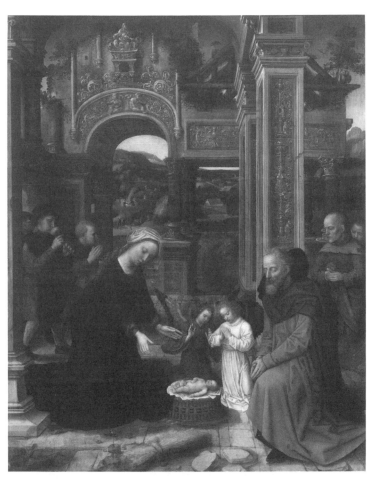

11. Adriaen Isenbrandt, *The Adoration of the Shepherds.*

used for *vestments and altar cloths as decreed by the sixteenth-century Papal Court of Rome.

Agatha, Saint (third century). Early virgin martyr. This young Christian from Catania (or Palermo) rejected the advances of the lecherous Roman governor, Quintianus. He attempted to corrupt her by forcing her to live in a house of prostitution for thirty days. When this failed, Quintianus had Agatha racked and further tortured by cutting off her *breasts. According to legend, *Peter appeared to heal her *wounds. Agatha was rolled in hot coals until she died. A year after her martyrdom, Mount Etna erupted and the citizens of Catania halted the lava flow with Agatha's *veil carried on a *spear. Agatha was the patroness of nurses, wet nurses, and jewelers, and her name was invoked as protection against *fire, earthquakes, volcanic eruptions, and natural disasters. In Christian art, Agatha was depicted as a beautiful young woman holding her *attributes of a palm branch and a *dish with breasts. The visual resemblance of the shape of female breasts to loaves of *bread led to the practice of blessing bread on Agatha's feast day.

Agnes, Saint (d. 304). Early virgin martyr. According to tradition, this youthful Christian refused to marry the son of the Roman prefect, having dedicated herself to God. Her suitor's father had the naked Agnes pulled by her *hair through the streets to a brothel. As she prayed, her hair grew to cover her naked body. Her virginity was protected in the brothel by an *angel. When the spurned suitor

sought to ravish Agnes, he was struck dead, but her prayers restored his life. After a failed attempt to burn her to death, Agnes was decapitated with a *sword. According to pious legend and devotion, the martyred virgin— radiant with heavenly glory and accompanied by a *lamb—appeared at her grave, initiating it as a sacred site. Agnes was the patroness of young maidens and was invoked for chastity. In Christian art, she was depicted as a beautiful young woman who held her main *attribute, a lamb (which was both a pun on her name in Latin and a sign of her legendary claim to have been a bride of Christ). Her other attributes included long flowing hair, a palm branch, an olive branch, a crown of olives, a sword or *dagger, and a flaming pyre.

Agony in the Garden (or **Garden of Gethsemane**) (Mt 26:36–46; Mk 14:32–43; Lk 22:39–46). Scriptural event signifying the physical and spiritual sufferings of Jesus before the Crucifixion. Following the events of the *Last Supper, Jesus, accompanied by the intimate triumvirate of *Peter, *James, and John, withdrew to pray in the *Garden of Gethsemane. Jesus meditated in solitude and affirmed his obedience to God's will. His devotion was so deep that he sweated *blood (according to tradition at his brow), which was captured by an *angel in a *chalice. The Christian *iconography of the *Man of Sorrows was inspired by this passage, which was prefigured by the Suffering Servant of Isaiah 53:3. The Agony in the Garden was rarely depicted in Christian art. The earliest representations of this theme were found on fourth-century sar-

cophagi with occasional presentations in sixth- to tenth-century manuscripts. In these early images, there were direct relationships (if not confusion) with the *iconography of the *Transfiguration of Jesus Christ, in which the same three disciples were seen praying or asleep on a lower plane than the central figure of Jesus. Even with the advent of the medieval liturgical dramas, the motif of the Agony in the Garden was rarely illustrated. In *medieval art, Jesus began to wear blood-stained clothing as a sign that he had "sweated blood" and undergone physical suffering as a visual manifestation of his spiritual suffering. The motif of the Agony in the Garden attained some artistic attention in the nineteenth-century revival of Christian art.

Alb. A liturgical white linen *robe symbolizing *chastity, purity, and the eternal joy of those who were redeemed by the *Blood of *Christ. This represented the purple robe Herod's soldiers placed on Jesus when they mocked him (Mk 15:16–17). Following a medieval tradition, the five *wounds of the crucified Jesus were embroidered on the sleeves, chest, and hem of this garment.

Alban, Saint (d. 304). The first martyr of Britain. This Roman-Briton sheltered a fleeing Christian priest during the Diocletian persecutions. Alban was impressed by this Christian's courage that he converted and then exchanged clothes with the persecuted priest. Mistakenly arrested by the Roman soldiers, Alban refused to worship the pagan gods. He was tortured and beheaded at the site of what

became the Abbey of St. Alban. According to pious legend, he performed miracles on the way to his execution. In Christian art, Alban was identified by his *attributes: a *sword, a *crown, a *cross, and his severed *head, which he carried in his *hands as a sign of his martyrdom.

Alexis, Saint (fifth century). A hermit called "the man of God." Alexis was the son of a wealthy Roman senator renowned for his *charity. Choosing to be a nameless man, Alexis lived by begging and sharing alms with the poor. According to tradition, he lived in a shack adjoining the *church dedicated to Mary in Edessa. Another legend reported that after seventeen years Alexis returned to his father's house where he worked as an unrecognized servant. After his death, Alexis's identity was revealed when his autobiography was found among his meager possessions. Popular in medieval legend and spirituality, he was the patron of hermits, beggars, and the nursing society identified as the Alexian Brothers. In Christian art, Alexis was identified by either his pilgrim's *staff or the stiff posture of a dead body on a mat with a *letter in his extended hand(s).

Almond. A symbol of virginity, purity, and divine approval in Christian art. A sweet *fruit with a hard shell, the almond implied the essential spiritual and hidden internal reality of the Incarnation of Christ. The almond symbolized divine approval, recalling to the flowering almond *staffs of *Aaron (Nm 17:1–8) and *Joseph (of Nazareth) (*Protoevangelium of James* 8:1). An *attribute of *Mary, the

sweetness and delicacy of both the almond blossoms and the nuts themselves resulted in their ritual use at joyous feasts such as weddings and *baptisms. The almond-shaped frame that encased the *head and body of a holy person is a *mandorla (from the Italian for "almond").

Almond Tree. A botanical symbol for the *Resurrection of Jesus Christ. In the Mediterranean climate, the almond tree produced blossoms as early as January and thus became an omen of spring.

Aloe. A botanical symbol for Jesus' death and *Entombment. The aloe was a tall *tree with fragrant but bitter oil that when mixed with *myrrh was used to anoint the bodies of the dead.

Alpha and Omega. The first and the last *letters of the Greek alphabet which signified the immortality of *Christ (Rv 1:8). These letters often appeared in depictions of *Jesus Christ, and were incorporated into his monogram.

Alphabetical symbolism. *Letters were a purely decorative compositional component in Christian art. Specific letters and/or combinations of letters, such as *initials or *monograms, had symbolic meanings. *See also* Alpha and Omega, Chi-Rho, IC XC, IHS/IHC, INRI, IR, IS, M with a Crown, MA, T, and XP.

Altar. From the Latin for "high." A table of stone or wood, usually carved, which was the central focus of the sanctuary. In pre-Christian re-

ligious practice, the altar was a raised platform for sacrificial offerings. In early Christianity, the altar symbolized the *Last Supper. By the fourth century, the altar implied a place of sanctuary and refuge. It was the site of the liturgical offerings and symbolized the presence of *Christ in the *Eucharist. The altar faced *east towards *Jerusalem and the rising *sun (Ez 43:4) in preparation for the Second Coming of Christ.

Altar cloth. A pure white linen covering for the top of the *altar and extending down the sides. This liturgical vesture symbolized the shroud of Jesus.

Altarpiece. A decorated or painted panel or panels attached to or placed behind the *altar and which visually narrated the central teachings of the Christian faith. An altarpiece took several forms: a large, single panel; a *triptych, or three-paneled form; or a *polyptych, a many-paneled form. The single or central panel depicted *Mary and the Child or a great event in the life of *Jesus Christ. On the wings or hinged panels were images related to the liturgical feasts. There was an analogous relationship to the liturgical services in the growing complexity of the size, number of panels, and visual symbols of the altarpieces.

Ambrose, Saint (c. 340–397). One of the four Fathers of the Western Church, an early church father, and bishop of Milan. Trained in Rome, Ambrose became a lawyer and governor ruling two imperial provinces. Divided by religious feuds, Milan tried unsuccessfully to elect a new

bishop. A capable and popular administrator, Ambrose was acclaimed bishop in 374, even though he was not yet baptized. Although a novice in ecclesiastical matters, he became one of Christianity's greatest scholars, theologians, and poets. Instrumental in eradicating *Arianism from Italy, he was also influential in the conversion of *Augustine. The first western teacher favoring extensive use of hymns as a popular means of prayer and praise, Ambrose elevated the dignity of the liturgy and is credited with the Ambrosian chant. He was the patron of beekeepers and domestic animals. In Christian art, Ambrose was depicted as a bishop with a *crosier and *miter. His *attributes included a *beehive as an allusion to the legend that a swarm of *bees settled on his mouth when he was an infant in his cradle, signifying his future eloquence; a *scourge or *lash with which he expelled the Arians; and a *scroll of music.

Amice. The first liturgical garment a priest donned when vesting for a liturgical service. It was an oblong piece of white linen upon which a *cross was sewn or embroidered alluding to the cloth that covered Jesus's face during the mocking by the Roman soldiers.

Ampula. The liturgical vessel which contained the holy oil used in the Christian sacraments of *baptism, confirmation, extreme unction, and holy orders, and also for coronation services.

Anchor. A symbol of the soul, and of hope, adherence, and steadfastness;

an *attribute of the virtue hope (Heb 6:19). An anchor with a *cross, looking like an F, combined with the Greek letter P (rho), symbolized hope and was found in early Christian *catacombs or on jewelry. The anchor with a *dolphin signified Christ on the cross. The anchor was an *attribute of *Clement and *Nicholas (of Myra or Bari).

Andrew, Saint and Apostle (first century). A brother of *Peter, a follower of *John the Baptist, and one of the first "called" of the disciples of *Jesus Christ (Jn 1:35–41). According to later traditions, Andrew became a missionary to Asia Minor, Macedonia, and southern Russia, and was martyred in Patras, Greece, in 70. Having made many converts, he was feared by the governor who had him crucified by being tied to an X-shaped (saltire) *cross. He was the patron saint of fisherman, sailors, Greece, Russia, and Scotland; and was invoked against gout and a stiff neck. In Christian art, Andrew was depicted as an elderly man with long white *hair and *beard, holding a *book in his right *hand and leaning on his X-shaped cross.

Androcles. A legendary foretype for *Jerome. Androcles was a runaway Christian slave who sought refuge in a cave. An enraged *lion entered the cave and lifted up a paw so that a vicious *thorn could be removed. Subsequently captured and condemned to fight a lion in the Roman arena, Androcles found himself before the lion he had rescued. The lion recognized his benefactor, greeted him with affection, and spared his life.

Anemone. A botanical symbol of death and mourning which also implied illness and decline. A classical Greco-Roman symbol for sorrow and death, the anemone was reputed to have sprung from the *blood of Adonis. This floral *attribute of *Mary signified her sorrow over the *Passion and Death of *Jesus Christ. The red-spotted petals of this flower symbolized the blood of Christ. According to legends, the anemone sprung up on *Calvary on the eve of the Crucifixion and was therefore found in depictions of this scriptural event. The triple-leafed anemone signified the *Trinity in early Christian art.

Angelico, Fra, or Fra Giovanni da Fiesola (c. 1387 or 1400–1455). A Dominican Friar whose simple and direct style of painting was used for didactic, not mystical, purposes. Also known as Beato Angelico, his first attributed painting, *Linaccioli Madonna*, dated from 1433. When the Dominican Order took over the Convent of Saint Mark in Florence, Fra Angelico created over fifty *frescoes in the monastic cells as aids to contemplation. The *altarpieces he painted for this and two other convents led to the development of the format known as the *sacra conversazione* ("sacred conversation"). At the request of Pope Eugenius IV, Fra Angelico painted frescoes for the Vatican Chapel between 1446 and 1449. He began two frescoes as part of the *Last Judgment cycle for the Cathedral in Orvieto (which were completed by Luca Signorelli). In 1449, Fra Angelico was elected Prior of the Dominicans in Fiesole. He returned to Rome in 1452 to paint the Chapel of the Sacrament in Saint Peter's Basilica Church (since destroyed). He died in Rome in 1455.

Angels. From the Greek for "messenger." Spiritual attendants and messengers of God. The initial Christian *iconography of angels was derived from the winged beasts guarding the royal palaces of Assyria and Babylonia. In the fifth century, the classification of angels was defined by Pseudo-Dionysus the Areopagite according to the political structure of the Byzantine Empire. The first hierarchy of angels consisted of the seraphim, cherubim, and thrones. The seraphim as representatives of divine love were red-colored, bodiless creatures with six wings and flaming *candles. As the signifiers of divine wisdom, the golden-yellow or *blue cherubim carried *books. Thrones, garbed in judicial *green *robes, symbolized divine justice. The second hierarchy of angels were the dominations (dominions), virtues, and powers. As the representatives of the power of God, dominations were depicted as crowned angels who carried the *scepter and *orb as symbols of authority. The *virtues had as their *attribute either the *white *lilies of purity, the *red *roses of Jesus' *Passion, or the *censer as the symbol of pleas and prayers. Signifying God's eventual triumph over the *Devil and evil, the powers were fully armored, victorious warriors. The third, and lowest, hierarchy of angels was composed of the princedoms (principalities), archangels, and angels. Princedoms (principalities) were the dispensers of the fates of nations; archangels were the warriors of

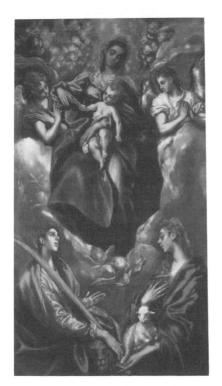
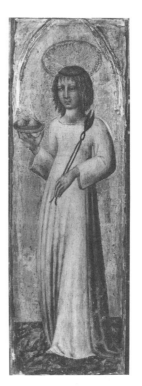

12. El Greco, *Madonna and Child with Saint Martina and Saint Agnes.*
13. Giovanni di Paolo, *Saint Agatha.*

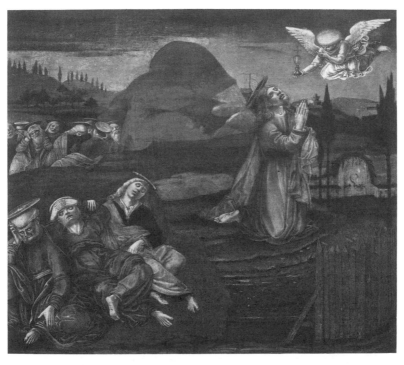

14. Benvenuto di Giovanni, *The Agony in the Garden.*

heaven; and angels were the guardians of the innocent and the just, and messengers of God's presence. In the *Old Testament, the angels composed God's heavenly court and were his servants guarding the entrance to the *Garden of Eden, protecting the faithful while punishing the guilty, and conveying divine messages to humanity. The cherubim and the seraphim guarded God's *throne, decorated Solomon's temple, and protected the *Ark of the Covenant. In the *New Testament, the angels were present at all the major events in the life of Jesus, either to assist him or to announce God's will. In Christian art, the figuration of the angels related to both contemporary artistic style and the angelology. For example, in the fourth century, angels appeared as male figures (usually without *feet) dressed in long *white *robes with *wings. By the High Middle Ages, these personages were more elegantly garbed (depending on their station in the hierarchies) and appeared to be androgynous. In the Renaissance, angels were depicted as being either female figures dressed in the latest fashions (making them more approachable) or plump little children with wings (as influenced by classical Greco-Roman art). The archangels— *Michael, *Gabriel, and *Raphael— were the most frequently depicted angels in Christian art.

Animals, symbolism of. Animals were a purely decorative compositional component in Christian art. Specific animals and/or combinations of animals, such as the *lion and the *lamb, may have conveyed symbolic meanings. *See also* Adder, Ant, Apes, Asp, Ass, Basilisk, Bat, Bears, Beaver, Bee, Bestiary, Boar, Bull, Calf, Camel, Cat, Centaur, Chameleon, Chimera, Crab, Crocodile, Deer, Dog, Donkey, Dragon, Elephant, Ermine, Fabulous Beasts, Fish, Fly, Fox, Frog, Gazelle, Giraffe, Goat, Grasshopper, Griffin, Gryphon, Hare, Hart, Hedgehog, Hind, Hippopotamus, *Historia Animalium,* Horse, Hyena, Lamb, Lion, Lizard, Locusts, Lynx, Mole, Monkeys, Mouse, Mythical Beasts, Ox, Ox and Ass, Panther, *Physiologus,* Pig, Rabbit, Ram, Rat, Salamander, Scapegoat, Scorpion, Serpent, Sheep, Snail, Snake, Spider, Squirrel, Stag, Starfish, Toads, Tortoise, Unicorn, Weasel, Whale, Wild Beast, Wolf, and Worms.

Anne, Saint (first century). The mother of *Mary and the wife of *Joachim. Anne's story and her place in Christian art and spirituality were derived from the apocryphal *Gospel of Mary* and the *Protoevangelium of James.* Although of the House of *David, Anne and Joachim were childless, thereby causing his sacrifice to be rejected by the High Priests. Joachim ventured into the desert to offer his sacrifice directly to God. After his offering was completed, Joachim had a vision that his wife would bear a child as an *angel simultaneously announced this special birth to Anne. On his return to *Jerusalem, Joachim met Anne at the Golden Gate and they rejoiced in this news. Anne was the patroness of pregnant women and was invoked during childbirth. In Christian art, Anne was depicted in the extrascriptural narrative scenes of the Marian

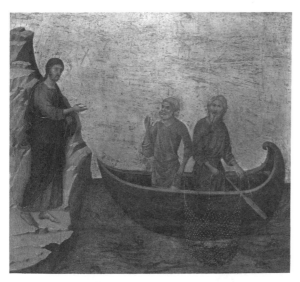

15. Duccio di Buoninsegna, *The Calling of the Apostles Peter and Andrew.*
16. Workshop of Fra Angelico, *The Madonna of Humility.*

17. Gerard David, *The Saint Anne Altarpiece.*

narrative of the Annunciation of the Birth of Mary (*Protoevangelium of James* 4:1), the *Meeting at the Golden Gate (*Protoevangelium of James* 4:4), the *Nativity of the Virgin Mary (*Protoevangelium of James* 5:2), and the *Presentation of the Virgin Mary in the Temple (*Protoevangelium of James* 7:2). In single paintings, Anne taught Mary to read or embroider, and was represented seated with Mary on her lap. In Christian art, Anne was depicted in a red dress with a green mantle signifying divine love and immortality.

Annunciation (of the Death of Mary) (*The Golden Legend* 119). Rarely depicted in Christian art, the Annunciation of the Death of Mary was the first scene in the narrative of her dormition. Having completed a full life, Mary prayed for the release offered by death. The *Archangel *Michael, the carrier of *souls, appeared and presented her with a *palm branch. He told Mary that in three days she would join her son. The symbol of the oasis, and therefore of heaven, the palm branch was later carried by John in Mary's burial procession. Presented in a similar manner to the *Annunciation to Mary, the Annunciation of the Death of Mary was comprised of the kneeling or praying figure of Mary who was offered the palm branch by the Archangel Michael.

Annunciation (to Mary) (Lk 1:26–38). Scriptural event signifying the announcement of the miraculous conception of the Son of God. The *Archangel *Gabriel appeared to *Mary to tell her that she would bear

God's special child. One of the most popular themes in the history of Christian art, rivaled only by images of the Crucifixion and the *Madonna and Child, the Annunciation was described in both canonical and apocryphal texts. In the earliest Christian renderings of this theme, Mary was placed to the viewer's left and Gabriel to the right. She was initially depicted as a simple maiden who held a spindle or a piece of embroidered cloth signifying her weaving the *veil of the Temple, according to the *Protoevangelium of James* (10:1). A visual metaphor for gestation, weaving was a reminder of the parallels between Marian imagery and that of *Athena. Gabriel was originally represented as a youthful erect male figure who raised his right hand in a gesture of greeting. By the medieval period, the *iconography of the Annunciation became more complex, from the elaborate garments of Mary and Gabriel (including his rainbow-colored *wings) to the inclusion of such botanical symbols as the *lily and the rose without thorns (influenced by the Song of Songs), and several signs of cleanliness such as the *water *jar, *white *towels, and the *washbasin. Mary was characterized as the enthroned queen of *heaven who received the kneeling messenger of God. Her garments, throne, and bodily gestures, along with the posture of the archangel, indicated the esteem with which Mary was revered. In the twelfth century, the Virgin Annunciate held a *book either in her *hands or open before her on her lap or prie-dieu. This new iconographic motif related directly to the concept of Mary as *Sophia (*Wisdom) and

18. Giovanni di Paolo di Grazia, *The Annunciation.*
19. Jan van Eyck, *The Annunciation.*

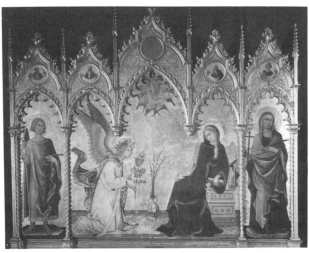

21. Juan de Flandes, *The Annunciation.*
20. Simone Martini, *The Annunciation.*

to the economic position of women book-owners. Theologically, this image of the Virgin Annunciate reading a book denoted Mary's foreknowledge that her child was born to die in her own lifetime, thereby making her acceptance of God's request that much greater and her sacrifice more meaningful. The *dove, the symbol of the *Holy Spirit, became more prominent as it either hovered over Mary's womb or descended towards her from a clear glass window. This new motif developed in northern *medieval art as a visual defense of Mary's perpetual virginity: for just as light descended through the window without destroying the clean glass, so Mary conceived and bore this special child while her physical virginity remained intact. The setting for this scene was defined in the medieval period; southern artists painted this scene in gardens or palazzo porches, while northern artists favored interior domestic or ecclesiastical settings. One unique variation of Annunciation iconography in late medieval art was Simone Martini's *Annunciation.* In his version, Gabriel wore a *wreath of olive leaves and carried an olive branch to present to Mary, while the more typical vase of lilies rested in the background. As a Siennese artist, Martini could not have allowed Gabriel to present Mary with the symbol of the rival city of Florence! Beginning with the Renaissance, Mary was represented as a simple young maiden whose reading of her *Book of Hours was interrupted by the unexpected visitor. With the revival of Mariology in *baroque art, the topic of the Annunciation to Mary was revived as the initial moment of Mary's glorification.

Annunciation (to the Shepherds)
(Lk 2:8–14.) Scriptural event signifying the announcement of the birth of Jesus to the lowliest—peasants and shepherds—thereby denoting that salvation was intended for *all* humanity. During the night, the *Archangel *Gabriel appeared to the shepherds to announce the glad tidings of the birth of this special child. Amazed at both the angelic vision and the news, the shepherds fell to their knees and gave thanks to God. In the earliest Christian art, this theme was distinguished by the presence of one *angel pointing to an enormous *star as the sign of the birth of the child to the shepherds. They were identifiable from both their simple peasant garb and their *crooks, and the surrounding *sheep. Immediately following the *Nativity of Jesus Christ, the night was denoted by the sleeping sheep, and/or an occasional sleeping shepherd. In *medieval art, the *angel or chorus of angels who celebrated this event usually held a *banner or *scroll inscribed with the scriptural passage of the "good tidings" of this birth. The theme of the Annunciation to the Shepherds became easily confused (and fused) with the *Adoration of the Shepherds (Lk 2:15–20), and by the Renaissance, these became elements of the massive "adoration scenes."

Anointing at Bethany
(Jn 12:1–8; Lk 7:36–50). Differing scriptural accounts exist of the anointing of Jesus by a woman who recognized his uniqueness. According to John, Jesus

went to the home of *Lazarus and his two sisters, *Martha and Mary of Bethany, for the evening meal on the sixth day before Passover. After Martha served the meal, Mary anointed Jesus' *head and *feet with precious ointments. Then she dried his feet with her hair. *Judas rebuked her for this extravagance which could have benefited the poor, while Jesus defended her as he knew his time was short. *Luke, however, related that Jesus was dining in the house of Simon the Pharisee when an anonymous, sinful woman entered and anointed his feet. Both the anonymous anointer of Luke and Mary the sister of Martha became conflated with *Mary Magdalene.

Ansanus, Saint (third century). This "Apostle of Siena" was born into a noble Roman family, secretly baptized by his nurse, and raised as a Christian. Persecuted under the Roman emperor Diocletian, Ansanus recovered from the tortures of scourging. He was later imprisoned in Siena, he continued to preach and convert the multitudes until he was martyred by decapitation. Ansanus was the patron of Siena. He was depicted in Christian art as a young man holding either a baptismal *cup or a *fountain, and a *banner inscribed with a *cross.

Anselm, Saint (c. 1034–1109). The "Father of Scholasticism" and one of the *Doctors of the Church, who as the archbishop of Milan became embroiled in church-state conflicts. A philosopher and a theologian, Anselm wrote *Cur Deus Homo* (*Why God Became Man*), the outstanding medieval

treatise on the *Incarnation, in which he fused the legal and political language of the feudal system with Christian theology. In Christian art, Anselm was identified by his archbishop's *robes. His *attribute was a *ship, which signified both the church and the ship he took to Rome during a dispute with William II over the election of bishops.

Ant. Symbol of diligence, organized communal life, and foresight in Christian art.

Anthony the Abbot, Saint (c. 251–356). The "Father of Christian Monasticism." Born of wealthy Egyptian parents, Anthony lived a life of comfort and ease. After his parents' deaths, he distributed all their wealth to the poor, placed his sisters in a convent, and retired to the *desert for a life of contemplation and prayer. He struggled successfully against many temptations of the flesh which were orchestrated by the *Devil. At the age of ninety, Anthony went in search of *Paul the Hermit. On this journey he resisted several temptations—including a *centaur, a satyr, and a nugget of *gold—with the sign of the *cross. Finding Paul the Hermit, Anthony learned that a *raven brought half-a-loaf of *bread each day to the hermit saint. With Anthony's arrival, the raven began to bring a whole loaf. Following Paul's death, Anthony buried him with the assistance of a *lion, and later returned to his own desert retreat until he died at the age of 105. The patron of all domestic animals, swineherds, and the Hospitalers of France, he was invoked against nervous disorders, venereal

22. Juan de Flandes, *The Nativity* (with *Annunciation to the Shepherds* in background).

23. Jacopo Bassano, *The Annunciation to the Shepherds*.

disease, and erysipelas or ergotism, (Saint Anthony's fire). A popular figure in *medieval and *renaissance art, Anthony was identified by his *monk's *habit, which had a *blue *T (signifying both *theos* and a tau-cross) on the left shoulder. An elderly and bearded man, he walked with a crutch, from which a bell was suspended to ward off *demons and evil spirits. He was often accompanied by a *pig, which was a dual symbol of the Hospitalers of France and of his personal triumph over gluttony. He was also depicted with a raven, or with flames under his *feet in reference to his triumph over lust. The theme of the "Temptations of Saint Anthony" was popular with fifteenth- and sixteenth-century northern artists.

Anthony of Padua, Saint (1195–1231). *Doctor of the Church famed for his eloquence and his commitment to the educational work of the *Franciscans. An *Augustinian monk, Anthony became interested in the social work and humble piety of *Francis of Assisi. He became a Franciscan, and a close friend to Francis. During a spiritual vision, Anthony received the Christ Child to hold in his arms. According to legend, Anthony converted an Albigensian to the true meaning of the *Eucharist when the heretic's *donkey knelt before Anthony as he walked in procession with the Eucharist. The patron of the poor, the oppressed, and the city of Padua, Anthony was invoked for lost items. In Christian art, he was depicted as a young man in Franciscan robes and was identified by one of his *attributes—the *lily, the flowered *cross, the *fish, a *book, *fire, or a flaming *heart. He was also represented carrying the Christ Child or accompanied by a donkey.

Apes. Signifying the baser forces of human and animal existence such as lust, envy, cunning, and malice, apes represented the *Devil. An ape eating an *apple denoted the *Fall of Adam and Eve. Depictions of enchained apes in scenes of the *Adoration of the Magi were personifications of sin conquered by *Jesus Christ.

Aphrodite. Greek goddess of love, beauty, and the generative powers of nature who was born of seafoam and carried to land on a seashell. With her earthly lover, Anchises, she conceived Aeneas, the Trojan ancestor of Rome, and was identified as "the Mother of Rome and the Romans." As a fertility goddess, she was connected visually and literally with the oriental goddess Astarte (Ishtar). The goddess to whom Paris awarded the Golden Apple, Aphrodite was integral to the Trojan War and the downfall of Troy. *Incense and *flowers were sacrificed to her; the apple, *rose, *poppy, and *myrtle were her botanical *attributes. She was also seen with the *ram, *goat, *hare, *dove, *sparrow, *swan, and *swallow. In classical Greco-Roman and *renaissance art, Aphrodite was depicted as a beautiful young woman who was either nude or lightly clad, and was identified by any of her attributes. Pearls, the tears of the oyster (a sea creature), were sacred to her. As the "Mother of Rome," a fertility goddess, the temptress who won the Golden Apple, and from her associations with

the *sea, love, and certain flower and animal symbols, Aphrodite prefigured *Mary.

Apocalypse. From the Greek for "uncovering" or "revelation." A form of visionary literature found in the *Old and *New Testaments. Exemplified by the prophecies of *Ezekiel and *Daniel, apocalyptic literature predicted the end of the world. In the New Testament, the Book of Revelation attributed to John (not to be identified with John the Apostle) was influential on Christian art, especially the medieval depictions of the last days. The allegorical Four Horsemen of the Apocalypse (Rv 6:1–17) was a popular theme in late *medieval and northern *baroque art. Other iconographic motifs developed from the Book of Revelation include *Christ enthroned on a *rainbow while surrounded by four living creatures (popular in *Last Judgment scenes); Christ standing or seated above seven *lambs and surrounded by the twenty-four elders; the fall of Babylon; the Seventh Seal being opened and the seven *angels with the seven trumpets; the New *Jerusalem; and the lamb atop Mount Zion from which flowed the four *rivers of *paradise. These images were popular in medieval manuscript *illuminations, tapestries, and woodcuts, especially during the times of the Black Plague.

Apocrypha. From the Greek for "obscure" or "hidden." These fifteen books were written after the fifth to fourth century B.C. and not included in the Hebrew canon of Scripture, but were part of the Septuagint Greek canon. Though often regarded as extracanonical, these texts were removed from the formal canon but were nonetheless influential upon Christian art and in the consciousness of Christian believers. The *Old Testament apocryphal texts were composed twelve inspired books including Tobit, *Judith, *Susanna, Bel and the Dragon, Wisdom of Solomon, and I and II Maccabees. All the texts of the Old Testament Apocrypha, except for I and II Esdras and the Prayer of Manasseh, formed an accepted part of the derivative versions of the Roman Catholic *Bible. The Protestant traditions identified all fifteen books as apocryphal and have excerpted them into an appendix to the Bible. The *Council of Trent declared these books to be "deuterocanonical"; that is, inspired texts equal in rank but later in date to the other books of the bible.

Apocryphal Gospels. A series of legendary and devotional narrative texts written after the second century A.D. which relate extraordinary and strange tales about scriptural figures. An important source for writers and artists, these texts were identified as untrue or false stories. Among the Apocryphal Gospels were the *Protoevangelium of James, Gospel of Pseudo-Matthew, Gospel of Thomas, Infancy Gospel of Mary, Acts of Saint Andrew, Acts of Saint Peter, Epistles of Abgar and Lentulus*, and *Apocalypse of Saint Paul.*

Apollo. Greek god of light, the arts, medicine, pastoral activity, and culture. Identified with *Helius, the sun god, Apollo was the brother of *Ar-

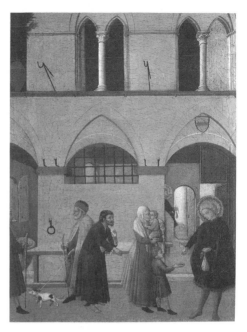

24. Sassetta and Workshop of Sasseta, *The Meeting
of Saint Anthony and Saint Paul.*
25. Sassetta and Workshop of Sassetta, *Saint Anthony
Distributing His Wealth to the Poor.*

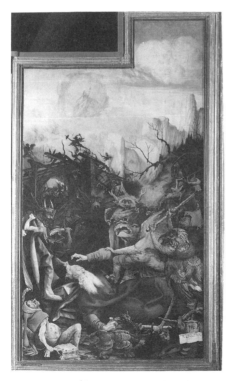

26. Mathias Grünewald, *The Temptation of Saint Anthony*
detail from *Isenheim Altarpiece.*
27. Vincenzo Foppa, *Saint Anthony of Padua.*

temis. He had many loves, including the nymph Daphne, who resisted his advances and was turned into a *laurel tree by her river-god father to escape Apollo's clutches. The laurel became sacred to Apollo and the *laurel wreath became the sign of the champion of the Pythian Games which were dedicated to Apollo. The unfaithfulness of another love, Coronis, caused him to turn the *white *feathers of the messenger raven *black. In classical Greco-Roman and *renaissance art, Apollo was depicted as a handsome young man, usually nude or lightly draped, and accompanied by one of his many *attributes—the *lyre, *serpent, *dolphin, bow and arrows, or shepherd's crook. The laurel and *palm trees, along with the *grasshopper, *mouse, *raven, *hawk, *snake, *swan, *deer, and *wolf, were sacred to Apollo. As both the patron of the arts and pastoral pursuits, he prefigured *David, and as a healer and the god of light *Jesus Christ.

Apollonia, Saint (d. 249). Alexandrian Christian noted for her *charity, piety, and purity. A *deaconess of the *church, she refused to worship pagan idols, which broke into a thousand pieces as she made the sign of the *cross. According to early Christian accounts, Apollonia was tortured by having her jaws broken. Medieval legend, however, described the painful removal of her *teeth with flaming *pincers. In any event, following these tortures, Apollonia dedicated her *body to Christ and fell upon a burning pyre. The patron of dentists, she was invoked against toothaches. In Christian art, Apollonia was depicted as a beautiful young woman who held either a pincer with teeth or a *dish with pincers and teeth and a palm branch.

Apostles. From the Greek for "one who is sent out." Title given to the original twelve followers of Jesus. The number twelve signified completion and was related to the twelve tribes of Israel. According to the *New Testament, the apostles were those called by Jesus to follow him, and who saw the Risen *Christ and confirmed the Resurrection. *Paul was counted as an apostle because he had a vision of the Risen Christ on the Road to Damascus. In Christian art, the apostles were depicted as a group in the appropriate narrative scenes of the life of Jesus, or individually in presentations of their individual missions. They were also signified by twelve *doves, twelve *sheep, or twelve men each holding a sheep; or by a procession of twelve men who were juxtaposed with the twelve *prophets of the *Old Testament; or by their individual symbols or *attributes which related to their traditional martyrdoms. The symbols of the apostles were: the X-shaped cross for *Andrew; the flaying knife and skin for *Bartholomew; the *scallop shell, *pilgrim's *staff, and *gourd for *James Major; the fuller's *pole and *saw of *James Minor; the *chalice with the *serpent of *John; a *bag of money and a *rope for *Judas Iscariot; a *club and a *ship for *Jude; a *hatchet or *ax, and a purse for *Matthew; an ax and an open *book for *Matthias; a *sword for Paul; *keys or crossed keys and a *rooster for *Peter; a staff surmounted by a

cross and loaves of *bread incised with *fish for *Philip; a saw and a book with a fish for *Simon; and a *lance and a *carpenter's square for *Thomas.

Appearance to His Mother. Without any scriptural or apocryphal foundation, and first advocated by *Ambrose, this post-resurrection event was described in detail in *The *Meditations on the Life of Christ.* This motif was popular in northern *medieval art and legend, and was a special devotion of the *Jesuits. *Mary prayed for solace following the death and burial of her son, while the Risen *Christ, who was holding the victorious *banner and displaying his *wounds, interrupted her prayers. This motif was alternatively identified as Christ Appearing Before His Mother or Christ Taking Leave of His Mother.

Appearance to Mary Magdalene (*Noli me tangere*) (Jn 20:1–18). Scriptural event signifying both the *Resurrection of Jesus Christ and denoting *Mary Magdalene as the first witness to the Resurrection. Having found the tomb of Jesus empty, the other Marys went to tell *Peter and the other *apostles, while Mary Magdalene remained at the tomb crying over the loss of the body of Jesus. The two *angels in the sepulcher inquired why she wept, and when she turned to respond she encountered a man she thought was a gardener. However, when he called her name she recognized him as the Resurrected Christ. Reaching out to touch him, he warned her he had not yet ascended to his Father. He then sent her to af-

firm his resurrection to the apostles. This dramatic scene was originally included within the context of the Passion and Resurrection narratives, but by the medieval period became an independent topic influenced in part by the development of the passion plays. *See also* Noli me tangere.

Apple. A classical Greco-Roman *attribute for *Aphrodite, who was awarded the Golden Apple by Paris, an action which led to the Trojan War. The apple bough signified both the minor Greek goddess Nemesis and the price of entry into the Elysian Fields. In Christian art, the apple was an ambivalent symbol for sin and salvation. The primary botanical symbol for sin, especially *Original Sin, the apple was depicted in the *hands of either *Adam, *Eve, or the *serpent, or in the mouth of an *ape to signify the Fall. The apple nonetheless became the *fruit of the Tree of Good and Evil because the Latin word for apple, *malum*, had derived from the same root as the word for evil, *malus*. When held by either the infant or young Jesus, or by his mother, *Mary, the apple became a fruit of salvation, as they bore the burden of human sinfulness and restored humanity to God (Song 2:3). Three apples, usually in a *basket, were an *attribute of *Dorothea.

Apse. The vaulted semicircular *east end of the *church just behind the high *altar. This architectural area was usually covered with *mosaics or *frescoes glorifying the Risen Christ or *Mary either through a symbolic or narrative representation.

Archangels. The seven warrior and attendant *angels of God. In the *Old Testament, the archangels supported the throne of God, while in the *New Testament they were in attendance at almost every major event in the life of Jesus, from the *Annunciation to Mary to the Resurrection. As the heavenly messengers, guides, and protectors of the church militant on *earth, the archangels were symbolic of the Christian tradition, especially in the medieval period. The seven archangels were *Michael, *Gabriel, *Raphael, *Uriel, Chamuel, Jophiel, and Zadkiel. In Christian art, archangels were depicted as handsome, strong young men with elaborate *wings who carried *swords and *orbs as warriors of *heaven. They were individually identified by their *attributes. Gabriel, the Angel of Mercy who ruled over the *Garden of Paradise, announced the birth of *John the Baptist to *Zacharias and the birth of Jesus to Mary, and appeared twice to the *prophet *Daniel, was identified by the *scepter or *lily which he carried. Michael, the commander of the heavenly hosts, the protector of soldiers, announcer of the death of Mary, and protector of *souls, was identified by his elaborate *armor and the sword and scales. Raphael, the *guardian angel of *Tobias, was recognized by his *pilgrim's *staff and his *fish or *dish. Uriel was distinguished by the *book or *scroll he carried; Chamuel who wrestled with *Jacob, by a *cup and staff; Jokiel, who guarded the Gates of Eden, by his flaming sword; and Zadkiel, who rescued *Isaac, by his sacrificial *knife.

Ares. Greek god of war characterized by courage, endurance, and military cleverness. In classical Greco-Roman and *renaissance art, he was depicted as a muscular, handsome, bearded man who wore *armor. His companions included his *dog, a *boar, or a vulture, and the goddess *Aphrodite and their son Eros. He was the classical Greco-Roman foretype for *Samson and Christian military saints such as *George of Cappadocia and William of Aquitaine.

Arianism. Fourth-century heresy premised on the belief that Jesus as the Christ was neither eternal or equal with God. Coeternality and equality of God and *Christ was affirmed in the Nicene Creed, which was promulgated by the same Council of Nicaea that condemned Arianism in 325.

Ark of the Covenant (Ex 25:16). The sacred gold-encrusted chest containing the two stone *tablets given by God to *Moses. The Ark of the Covenant was stored in the holiest and safest area of the Hebrew tabernacle, and later in the Temple. In Christian art, the Ark of the Covenant was represented by two male figures dressed in rabbinical and/or priestly garments who carried a large gold-colored chest inscribed with Hebrew letters.

Ark of Noah (Gn 6–9). Scriptural event signifying the salvation from the great flood by which God destroyed the wickedness of humanity. The righteous *Noah, the grandson of *Adam and *Eve, and the son of Seth, was a good and just man. To

save humanity from total destruction, God ordered Noah to build the ark for his family and pairs of all living creatures. A symbol of salvation, Noah's Ark was a popular motif in early Christian and *medieval art, and a foretype of both the sacrament of *baptism and the imagery of the *church as a *ship.

Armor. A sign of chivalry and defense against evil. Armor was a metaphor for Christian faith as a protection against the *Devil or evil (Eph 6:11–18). Most of the Christian military saints, like *George of Cappadocia, William of Aquitaine, and *Joan of Arc, were depicted in their armor and carried a *sword. The *Archangel *Michael was distinguished by his armor, which was covered with the sign of the *cross.

Arrow. A spiritual weapon signifying the dedication of one's life to God. As an instrument of torture, the arrow was an *attribute of *Sebastian and *Ursula. A symbol of war and death, the arrow was an attribute of most military saints, including *George of Cappadocia and *Joan of Arc. The flaming arrow was an attribute of *Teresa of Avila, and three arrows identified *Bartholomew and Edmund. Arrows piercing the heart signified *Augustine, and an arrow piercing both the *stag and his *hand represented *Giles.

Ars Moriendi (*The Art of Dying*). One of the most celebrated *blockbooks in late fifteenth-century Germany, and intended for clergy attending the dying. A devotional illustrated text like the *Biblia Pau-* perum, the *Ars Moriendi* was based either on a set of moralizing engravings by the Master E.S. (an anonymous German master engraver identified solely by his initials in the borders of his works) or an earlier Netherlandish blockbook published c. 1450. The *Ars Moriendi* featured images of death and dying both as proper and improper modes of Christian action. They were influential upon late *medieval and *renaissance art in northern Europe.

Artemis. Greek virgin goddess of the *moon, the night, and the hunt. Artemis was the guardian and huntress of wild *animals and the protectress of youth, particularly maidens. The sister of *Apollo, she was associated with other virgin goddesses including Diana of Ephesus and Astarte. She was attended by virgins who were severely punished if they strayed from their vows of chastity. In classical Greco-Roman and *renaissance art, she was depicted as a beautiful young woman dressed in a short chiton, wearing *sandals, carrying a bow and quiver, and with the crescent moon in her *hair. Her companions were does and *dogs. She was a classical Greco-Roman foretype of *Mary, especially through her connection to Diana of Ephesus, and most of her *attributes were assimilated into Marian *iconography.

Ascension, Feast of. Celebrated forty days after *Easter as the joyous commemoration of the Risen Christ's ascension into *heaven and reunion with God the Father. The liturgical colors for the Feast of the Ascension were *white and *gold.

Ascension of Elijah (2 Kgs 2:1–12). Scriptural event signifying the sudden and dramatic departure of this *Old Testament *prophet in a *chariot of *fire drawn by *horses of fire. The Ascension of Elijah into heaven was interpreted as a foretype of the *Ascension of Jesus Christ. In Christian art, the prophet was depicted as an elderly male figure dressed in simple woolen garments who stood in the middle of a golden chariot pulled by two *white horses that ascended upwards towards *heaven.

Ascension of Jesus Christ (Lk 24:50–53; Acts 1:1–11). Final scriptural appearance of the Resurrected *Christ, signifying the end of his earthly life according to the Lucan tradition. After Jesus and his *apostles met in *Jerusalem, they journeyed to Bethany. There, the apostles watched in awe when, after blessing them, Jesus ascended into *heaven. In the Johannine tradition, the Ascension was part of the *Easter event as the glorification and revelation of the divinity of Jesus as the Christ. Having blessed his apostles, the Risen Christ ascended into heaven on the fortieth day after Easter. According to the Acts of the Apostles, the Resurrected Christ remained with his disciples for forty days and then gathered them together on the *Mount of Olives as he ascended into heaven.

Only the Risen Christ could ascend into heaven, while *Mary and other saintly persons must be assumed. The term, ascension, indicated no additional support, while assumption implied the assistance of others, such as *angels or *clouds. In Christian art, the Ascension depicted the Risen Christ garbed in glowing *white *robes, encased in a golden *mandorla, and displaying his *wounds. As he moved upwards, he was greeted by music-making and/or singing angels and God the Father, who either sat or stood as he awaited his son. The apostles were presented in a state of amazement. Images of the Ascension were most popular in the narrative tradition of medieval Christian art, and were replaced, if not conflated with, the *Resurrection of Jesus Christ.

Ashes. Sign of the transitory nature of human existence and penance. In early Christian and medieval times, repentant sinners rubbed ashes over their bodies and wore sackcloth as signs of the denial of material goods. Ashes from the *palms of the previous year's Palm Sunday were blessed and then placed on the forehead of Christian believers as a sign of the penance of Lent.

Asp. A reptilian symbol for evil and venom, and thereby death, in Christian art.

Aspen. A symbol of the *Crucifixion. According to legend, the wood of the aspen was chosen for the *cross of Jesus, and the leaves of the *tree trembled with shame. According to another legend, when Jesus died on the cross, all the other trees bowed their heads in sorrow and respect, except for the aspen. As a punishment for its hubris, the aspen's leaves were condemned to eternal trembling.

Asperges. From the Latin for "thou shalt sprinkle." As both a preparation

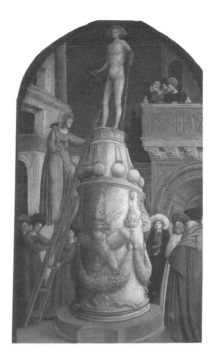

28. Attributed to Sassetta, *Saint Apollonia.*
29. Antonio Vivarini, *Saint Apollonia Destroys a Pagan Idol.*

30. Johann Koerbecke, *The Ascension.*

for the *Eucharist and a reminder of *baptism, this ritual sprinkling of the congregation with holy water was performed prior to the liturgy.

Aspergillum. From the Latin for "to sprinkle." This brush, or sponge on a handle, was used to sprinkle holy *water on the *altar and the congregation. Based on Psalm 51:7, this liturgical action represented the expulsion of evil. The aspergillum was an *attribute of those *saints known for exorcising *demons, including *Benedict of Nursia, *Anthony the Abbot, and *Martha of Bethany.

Ass. Symbol of the simplest and most humble of all created beings. Known for its docility, humility, patience, and stubbornness, the ass was a common presence in Christian art, and was included in narrative presentations of the Sacrifice of *Isaac, *Nativity of Jesus Christ, *Flight into Egypt, *Rest on the Flight into Egypt, *Return from Egypt, and *Entry into Jerusalem. Both *Mary and Jesus rode an ass to signify their humility. The presence of the ass in Nativity scenes fulfilled the prophecy of Isaiah 1:3 and signified that even the lowest of the animals recognized the *Messiah. In this same context was the folk tradition that it would be easier to have an ass kneel before the *Eucharist than to convert a *Jew to Christianity. As a domestic animal, the ass was depicted with Old Testament figures, such as Abigail, or Christian *saints, including *Jerome and *Anthony of Padua.

Assumption of the Virgin Mary (*The Assumption of the Virgin* and

The Golden Legend 119). Event signifying *Mary's entry into *heaven following her *dormition and burial. Without scriptural foundation, this event was described in legendary and devotional materials, and was accepted as common belief. The word assumption implied assistance or help, so that Mary was depicted surrounded by *clouds and *angels who carried her upwards to her heavenly reward. Originally, the representation of the assumption of Mary's soul was a motif in the byzantine *iconography of the *Koimesis. Once a part of the narrative and iconography of the Dormition, the Assumption of the Virgin Mary became an independent topic in Christian art during the late medieval period. This theme flourished in the art of southern baroque artists who visually defended Mary's uniqueness against the outcries of the Reformers. The Assumption of the Virgin Mary was interpreted as central to her position as intercessor or mediator for human beings who hoped for salvation and protection within the Christian faith. This common belief was declared an article of faith for all Roman Catholics by Pope Pius XII in 1950. In depictions of this theme, Mary was surrounded by music-making or singing *angels, wispy *clouds, and many *attributes from the Song of Songs and the Book of Revelation, including a *crown of twelve *stars and roses of sharon. The *apostles stood below in total amazement, while God the Father and the Risen Christ awaited her arrival. In byzantine and late medieval renderings of this theme, Mary dropped her girdle, the last symbol of her earthly chastity and her perpetual

31. Paolo di Giovanni Fei, *The Assumption of the Virgin.*
32. Michel Sittow, *The Assumption of the Virgin.*

33. Anthony van Dyck, *The Assumption of the Virgin.*
34. Nicolas Poussin, *The Assumption of the Virgin.*

virginity according to legend and apocryphal texts, upon the *head of *Thomas, who doubted both her dormition and assumption.

Athanasius, Saint (c. 296–373). A *Doctor of the Church, the "Father of Orthodoxy," Patriarch of Alexandria, and a defender of the Christian tradition against *Arianism. His teachings were the foundation for the condemnation of Arianism at the Council of Nicaea in 325 and for the development of the Nicene Creed. His biography of Anthony the Abbot supported the establishment and development of Christian *monasticism. In Christian art, Athanasius was depicted as an elderly but physically strong man who was dressed in patriarchal regalia and read an open *Bible which rested on two doric columns.

Athena. Greek virgin goddess of *wisdom, war, and weaving. The protectress of eternal virginity who ruled over the moral and intellectual life of the Greeks, Athena was responsible for inventions and innovations in the arts and sciences. The protectress and defender of Athens, her greatest temple was the Parthenon on the Acropolis. In classical Greco-Roman and *renaissance art, she was depicted as a physically strong woman dressed in a long chiton and a breastplate, her *head covered with a *helmet, and carrying *shield emblazoned with the head of the *Medusa. She was accompanied by an *owl, the symbol of wisdom, who sat on her arm. She held either a spear as the goddess of war or a distaff as the goddess of weaving and the domestic arts. The olive tree, the

sea eagle, *serpent, and *rooster were sacred to Athena. An imposing physical figure, she was the classical Greco-Roman foretype of the heroines and female warrior *saints of the Hebraic and Christian traditions. As the embodiment of chastity and the personification of wisdom, she prefigured *Mary.

Athletes of God. An early Christian visual and verbal metaphor derived from the writings of *Paul and the early church fathers who saw an analogy between the disciplined physical and spiritual training of the Olympian and Pythian athletes and the sufferings of the early Christian martyrs. In their fatal competition against the gladiators or the *lions in the Roman arenas, these Christian "Athletes of God" were depicted receiving the *laurel wreath of victory, which represented the victory over death, from *angels. This image was revived and reinterpreted by renaissance artists, including *Michelangelo Buonarroti.

Atlas. One of the Titan leaders of Greek mythology and condemned to support the *heavens on his shoulders by *Zeus. In Ovid's *Metamorphoses*, Atlas's refusal of hospitality to Perseus caused the young hero to show Atlas the *Medusa's *head, which turned him into stone thus creating the Atlas Mountains in North Africa. The depiction of Atlas as a bent-over muscular male figure with the world on his back was a common sign in *medieval and *renaissance art for the *earth.

Atonement. Medieval Christian doctrine espoused by Anselm in *Cur*

35. Sandro Botticelli, *Saint Augustine in His Study.*

Deus Homo (*Why God Became Man*). Following the feudal system's code of honor and justice, the honor of God—which had been damaged by *Adam and *Eve's disobedience—could only be satisfied by a person of God's own rank. Thus, the suffering and death of *Jesus Christ on the *cross atoned for *original sin and allowed humanity to be reunited (at one) with God. This theological understanding of the meaning of the suffering and sacrificial death of Jesus influenced the medieval *iconography of the *Passion and the *Crucifixion of Jesus Christ, and led to an exacerbation of the physical signs of torment and pain as well as visual motifs such as the *blood of Jesus dripping into *chalices carried by *angels in support of the theme of the eucharistic sacrifice of the liturgy.

Attribute. An emblem or an object which identified a biblical or historic figure in Christian art. In most cases, the attribute was connected to either the style of martyrdom, e.g., a *sword for *Paul; the central legend or moral the person represented, e.g., the *dragon for *George of Cappadocia; or the prophecy foretold by the person, e.g., a *scroll with the inscription of verse 7:14 for *Isaiah or a shut *gate for *Ezekiel.

Augustine of Canterbury, Saint (d. c. 605). An Italian missionary and the Apostle of the English. He was a Roman Benedictine monk who was sent at the head of forty *monks to England in 596 by Pope *Gregory the Great to preach to the heathen. He was to become the first archbishop of Canterbury.

Augustine of Hippo, Saint (354–430). A *Doctor of the Church and one of the four great fathers of the Western Church. Born to a pagan father and a Christian mother, *Monica, the story of his lengthy journey to the Christian faith was reported in the first autobiography in western literature, *Confessions*, which was also a classic work of Christian mysticism. One of the most influential theologians of the early *church, Augustine wrote the first Christian philosophy of history, *The City of God*, which had a great influence on *Charlemagne and the establishment of the medieval feudal system. He was famed for his treatises against the Manichaean and the Pelagian controversies, and he established or codified the church's official position on almost every aspect of the Christian life, including the teachings on *Original Sin. Augustine was the patron of theologians and scholars. In Christian art, he was depicted in Christian art as a middle-aged man, either beardless or with a short beard, dressed as a bishop and holding a *book or a *pen signifying his many influential texts. Symbolic of his mystical and pious devotion, he was represented with a whole, broken, flaming, or arrow-pierced *heart. Augustine was pictured with a small boy at his *feet who held a seashell as a visual reference to the story that he met such a child on the beach who was trying to empty the sea into a hole he had dug into the sand. When Augustine advised the *child this was impossible, the child retorted that it was no more difficult than the theologian's own attempts to understand and explain the *Trinity.

Augustinians. A religious order of male monastics named after Augustine and who followed his rule for communities of clerics. Primarily mendicants and teachers, Augustinians were identified by their *habit, which consisted of a *black *robe with a black leather *belt.

Aureole. From the Latin for "golden." A circle or orbit of light signifying the radiance of divinity. Transported to western art from Oriental art by the armies of Alexander the Great, the origin of the aureole was similar to that of the *mandorla, which signified the radiance of the holy person. In Christian art, the mandorla came to be reserved for representations of *Jesus Christ and *Mary as a signifier of their unique bodily glory, and the aureole or halo came to encase only the head of a holy person. *See also* Glory.

Ax. A symbol of destruction, an instrument for animal sacrifice, a symbol of power, and an emblem of rank. The ax was an *attribute of *Joseph (of Nazareth) as a carpenter, and of *Matthew, *Matthias, and *John the Baptist, who were beheaded. An ax in a *tree or a tree stump signified the destruction of a sick or evil tree, that is, one which did not bear fruit blessed by God. An ax at the base of a tree denoted the *Last Judgment.

B

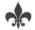

Babel, Tower of (Gn 11:1–9). Biblical symbol for proud, unrestrained humanity. This *ziggurat*, or seven-stepped pyramid temple of Marduk, was built near the ancient city of Babylon. This *Old Testament story related how ancient peoples were warned of the folly of competition with God. Living in a world of one universal language, these ancients sought to build a *tower to reach to *heaven. To prevent this from happening, God confounded human language so that no one nation understood another nation's speech. This confusion of languages or of speech was synonymous with the word babel (from the Hebrew for "Babylon"). The Tower of Babel was a popular motif in northern *medieval art.

Bacchus. Roman god of wine, personifying the cultivation, and preparation, and bad qualities of wine. In Roman art, Bacchus was depicted as a beautiful youth with flowing curls interwoven with *ivy, who wore a panther skin and held *grapes in an outstretched *hand. As the god of wine, Bacchus and his *attributes are classical Greco-Roman foretypes for eucharistic symbolism. Along with other classical mythological figures, he reappeared in renaissance Christian art.

Bag of Money. An *attribute of *Judas Iscariot who managed the disciples' money.

Baldachino or Baldachin. From the Italian for "Baghdad." The silken canopy, identified with Baghdad, the source of the finest silk brocades, was placed above the *altar and derived from the *Old Testament symbolism of the Temple of *Solomon. In Christian architecture, the baldachino was positioned over altars, chancels, *tombs, and statues, thereby implying the spiritual significance or power of whatever or whoever was beneath it. In the Roman Catholic tradition, the baldachino was the canopy under which the Blessed Sacrament was carried in liturgical processions.

36. Gian Lorenzo Bernini, *Baldachino*.

Balls. Three balls denoted the dowries that *Nicholas (of Myra or Bari) donated to the three marriageable daughters of an impoverished count.

Banner. Sign of victory, the nature of which was characterized by the *colors or design of the banner. A white-ground banner with a *red *cross symbolizing victory represented *Constantine's conversion to Christianity, or the victory of George of Cappadocia and Ursula over evil. When carried by the *Lamb of God, a banner indicated victory over death. The Resurrected *Christ carried the Banner of Victory in postresurrection narrative depictions. *John the Baptist held a banner inscribed with either a cross or the words *Ecce Agnus Dei ("Behold the Lamb of God"). All military saints including *George of Cappadocia, *Ansanus, *James Major, *Ursula, *Reparata, and *Joan of Arc, carried banners. The use of the banner as a symbol of military victory was adapted by the fourth-century *church, and became a common symbol in Christian art.

Baptism. From the Greek for "to dip" or "to dip under." Act of ritual purification and regeneration by which one became a Christian. It was the first of the Seven Sacraments and was symbolized by three *fish. Along with the *Eucharist, baptism was one of the two central sacraments shared by virtually all the Christian traditions.

Baptism of Jesus Christ (Mt 3:13–17; Mk 1:9–11; Lk 3:21–22). Scriptural event signifying the initiation of Jesus' public ministry. Jesus presented himself for the ritual cleansing administered by his cousin, *John the Baptist. Although John recognized Jesus as the *Christ, he assented to perform this otherwise unnecessary rite. At the moment of the cleansing with the *waters of the River Jordan, the *heavens opened and God acknowledged Jesus as his son—the interpretative question here was whether only Jesus, or Jesus and John, or all those present heard God's voice. This action established the foundation for the Christian sacrament of baptism. This event was the paradigm for the Christian ritual of spiritual cleansing and purification signifying initiation as a Christian. Adapted from the practice of some Jewish sects, the Christian rite of baptism evolved from a similar practice of purification by immersion in the Eleusian mysteries, Mithraism, and Near Eastern cults. Celebrated as a feast of *Epiphany, it was originally celebrated on January 6 along with the other epiphany of the *Adoration of the Magi. The distinguishing characteristic of baptism as practiced by John was the repentance from sin and preparation for the Messianic Kingdom. A popular motif throughout the history of Christian art, the Baptism of Jesus Christ became a more and more elaborate composition as the theology of baptism and of penance developed. Eastern Orthodox *icons of the Baptism of Jesus Christ represented this as a ritual of total immersion, whereas Western Christian images emphasized the pouring (or sprinkling) of water on the *head of the person being baptized. Those images in which John employed a *ewer or *pitcher to perform the rite of baptism were by

northern European artists, whereas the use of a seashell indicated southern European influence. The liturgical and theological history of the sacrament of baptism can be studied by noting the bodily positions, ritual gestures, and styles of immersion in the images of the Baptism of Jesus Christ.

Barbara, Saint (late third century). Popular medieval *saint and one of the *Fourteen Holy Helpers. Converted to Christianity by an emissary of the Christian theologian Origen, this beautiful young woman was imprisoned in a *tower by her father to separate her from possible suitors. She spent her time reading philosophical texts and became interested in Christianity. Feigning an illness, she was visited by a Christian missionary in the guise of a physician. He proceeded to baptize her into the Christian faith. Barbara's father learned about her conversion when she asked that a third *window be put into her tower. In response to her father's query as to why she needed another window, Barbara proclaimed for the Holy *Trinity. Angered at her conversion, her father tried to kill her, but she was miraculously delivered from him. Civil authorities subjected her to torture until her father decapitated her. He was immediately struck dead by lightning. Barbara was the patron of artillery soldiers, gunsmiths, architects, builders, and miners, and was invoked against lightning, thunderstorms, and sudden death. A popular topic in northern *medieval art, she was depicted as a richly dressed and beautiful young woman seated before a tower and

reading a *book. She was the only female saint who was accorded the *attribute of a *wafer and a sacramental *cup in honor of her dying request that those who honored her martyrdom would receive the sacrament. In some depictions, she held a *peacock *feather as a reference to Heliopolis, her native city, where the *phoenix rejuvenated itself. Since the phoenix was an unknown entity to northern artists, the phoenix feather of Heliopolis became a peacock feather in Barbara's *hand.

Barnabas, Saint (first century). A Cypriot *Jew who became a Christian missionary and teacher. A companion of *Mark, Barnabas urged the church in Jerusalem to accept *Paul as an *apostle. According to tradition, Barnabas traveled throughout the Mediterranean to preach the Christian message, and founded the Cypriot Church. He was credited with writing the apocryphal *Epistle of Barnabas, Gospel of Barnabas,* and *Acts of Barnabas,* as well as several miraculous healings. He was stoned to death in Salamis in 61. According to legend, Barnabas was the founder and first bishop of the church in Milan. In Christian art, he was identified by his *attributes: a *book, a *Gospel, a stone, and a *pilgrim's *staff.

Baroque art. From the Portuguese for "irregularly-shaped pearl." Style of architecture, painting, and sculpture that succeeded *Mannerism and lasted into the eighteenth century. The purest presentation was identified as the High Baroque (1630–1680), which corresponded with the artistic maturity of *Gian Lorenzo

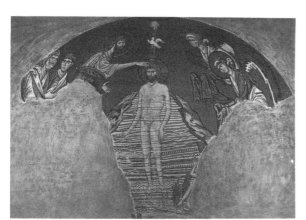

37. *The Baptism of Christ.*
38. Master of the Life of Saint John, *The Baptism of Christ.*

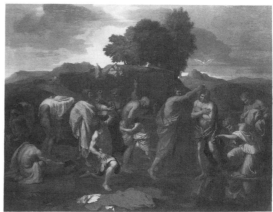

39. Paris Bordone, *The Baptism of Christ.*
40. Nicolas Poussin, *The Baptism of Christ.*

Bernini in Rome. The premise of the baroque tradition was the union of architecture, painting, and sculpture, which worked together to allow the spectator's participation in the spiritual dramas being depicted before them. Emphasizing an asymmetrical composition, simple subject matter, unidealized naturalism, complex *iconography, and *chiaroscuro* (theatrical dark-light identified as tenebrism in northern European art), baroque art sought to overwhelm the viewers's emotional sensibilities. Northern baroque art, contemporary to the establishment of *Lutheranism and the Protestant traditions, no longer favored religious themes; instead, northern baroque artists turned their attention to the topics of history painting, portraiture, *landscape, *still life, and genre scenes. Leading northern baroque artists included *Rembrandt van Rijn, Pieter de Hooch, and Jacob van Ruisdael. Southern baroque art and artists defended the teachings and traditions of the Roman Catholic Church affirmed by the *Council of Trent; as a result, a new series of iconographic motifs were developed which defended the teachings and the *saints of the Roman Catholic Church against the Reformers' critiques. Leading southern baroque artists included *Michelangelo Merisi da Caravaggio, the Carracci Brothers, *Bartolomé Esteban Murillo, Diego Vélasquez, Guido Reni, and *El Greco. Although northern by birth, *Peter Paul Rubens was a devout Roman Catholic; in theme and symbolism his art was southern baroque, but it was northern baroque in terms of his use of color.

Barren Fig Tree. *See* Parables.

Bartholomew, Saint and Apostle (first century). Linguist, extraordinary preacher, and reputed author of the apocryphal *Gospel of Saint Barnabas.* According to *The *Golden Legend,* Bartholomew evangelized India and Armenia, and tradition further identified him as the founder of the Armenian Church and the restorer of life to the Armenian king's son. Also known as Nathaniel, Bartholomew was martyred by first being flayed alive and then crucified. He was the patron of butchers and leather traders, and was invoked against skin and nervous diseases. In Christian art, he was depicted as a middle-aged man with dark *hair and *beard, with his flayed skin hanging over his arm. His *attributes included a flaying *knife and a *book.

Bartolommeo della Porta, Fra (c. 1474–1517). *Dominican friar and artist influential on the young *Raphael Sanzio. Fra Bartolommeo was in residence at San Marco when Savonarola was captured in 1498, and he vowed to become a Dominican monk. In 1504, he became the head of the monastery workshop, a position held earlier by *Fra Angelico. His paintings featured a sober and generalized setting, an idealized simplicity and balance in the composition, emotive gestures and facial expressions, and the use of nondescript drapery on religious personalities to indicate the distance between humanity and divinity, as found in his *Lamentation over the Body of Christ.*

Basil the Great, Saint (c. 330–379). A *Doctor of the Church and one of the four fathers of the Eastern Chris-

tian Church, and a vigorous defender of Christian orthodoxy against *Arianism. Basil was the bishop of Caesarea and the brother of Gregory of Nyssa. As the "Father of Eastern Monasticism," Basil developed the monastic rule for the Eastern Christian tradition. The author of many doctrinal texts, he also composed the liturgy named for him and celebrated on New Year's Day. In Christian art, Basil was depicted as an elderly man dressed as a bishop holding his *attribute of a *dove perched upon an outstretched arm or *hand.

Basilisk. A fabulous *animal composed of the three-crested *head of a *cock, the body of a lizardlike *serpent, and a three-pointed tail. Medieval *bestiaries described the basilisk as born of a yokeless *egg laid by a *cock and hatched by a *toad on a bed of dung. According to legend, the basilisk killed merely by glancing at an animal or a person. A popular symbol in early Christian, *byzantine, and *medieval art, the basilisk was a symbol of the *Devil and of the Antichrist (Ps 90:13 DR).

Basket. An open container with a handle used to carry items, especially foods and flowers. A basket with *roses and *apples was an *attribute of *Dorothea. A basket containing an infant denoted *Moses. An empty basket or one filled with *bread and *fish signified the Multiplication of *Loaves and Fishes. A basket filled with *scrolls signified both the classical philosopher and *Jesus Christ as the *Philosopher-Teacher in early Christian art.

Bat. An impure animal signifying duplicity, hypocrisy, sexuality, melancholia, evil, and the *Devil. This night creature haunted *ruins and lonely places. The bat was understood to be an incarnation of the Prince of Darkness.

Bath(ing). Ritual of purification and cleansing. In some contexts, such as those of the *Old Testament heroines *Bathsheba or *Susanna, the ritual bath depicted in Christian art was a *mikveh*, the ritual cleansing required by Judaic law of women after childbirth, sexual intercourse, or the menstrual cycle. In other contexts, the bath(ing) signified *baptism.

Bathsheba (2 Sm 11–12). The wife of Uriah the Hittite and later of *David, and mother of *Solomon. Overcome by her beauty as he watched her bathe, the *king sent for Bathsheba and they became lovers. Wishing to marry his now pregnant mistress, David arranged for Uriah to be killed in battle. Reproached by the *prophet Nathan, the king repented of his sin of adultery, but the child born of Bathsheba sickened and died. Later she bore David a second son, Solomon. In *medieval art, Bathsheba was represented either in the act of adultery with David or bathing as he espied her. Since David was interpreted as a foretype of Jesus, Bathsheba as his beloved bride was understood to represent the *church undergoing purification by cleansing, while Uriah signified the Devil. Late northern medieval, renaissance, and baroque artists turned their attention to depictions of Bathsheba at the bath, so that by the seventeenth century this motif

41. Anonymous Portuguese, *Saint Barbara.*

42. Giovanni Bellini and
Workshop of Giovanni Bellini,
Madonna and Child in a Landscape.

became a scriptural excuse for painting the female nude.

Bears. An *Old Testament sign for cruelty and evil associated with Persia according to the prophecies of *Daniel (7:5). The story of *David and the bear was interpreted as a foretype of *Christ battling the *Devil (1 Sm 17:32–37), and was popular in medieval carvings and psalters. According to the *Physiologus, bears were born shapeless and were formed by their mothers licking them, symbolizing the conversion of the infidels and barbarians to Christianity. The bear was an *attribute of *Euphemia.

Beaver. An animal symbol for chastity, asceticism, and vigilance.

Bee. Symbol for creativity, diligence, resourcefulness, and the industrious Christian. Reputed never to sleep, the bee was a sign of Christian vigilance in practicing the *Virtues. The bee's production of honey denoted sweetness and religious eloquence, and was a sign of *Jesus Christ and of the virtue of *Mary. According to ancient legends, the female bee reproduced without the assistance of the male bee, thereby symbolizing the *Virgin Birth and the *Incarnation. The bee was an *attribute of *Ambrose, *Bernard of Clairvaux, and *John Chrysostom.

Beehive. A symbol for the Christian *church as a unified community where all worked with diligence and harmony to spread the "honeyed" words of the *gospel. The beehive was an *attribute of *Ambrose, *Bernard of Clairvaux, and *John Chry-

sostom, and a symbol for *Mary as *Mater Ecclesia* (Mother Church).

Bell. A symbol for the Word of God. An *attribute of lepers, the bell warned of their approach. Bells were also carried by *saints like *Anthony the Abbot who were reputed to be exorcisers of *demons. The ringing of church tower bells to summon the faithful to prayer was an announcement of the Word of God. The ringing of the sanctus bell during the preparation of the *Eucharist announced the presence of *Christ. Bells were an *attribute of *Aaron, *David, and *Agatha. A bell tied to a crutch was an attribute of *Anthony the Abbot.

Bellini, Jacopo (c. 1400–1470), **Gentile** (c. 1429/30–1507), **Giovanni** (c. 1430–1516). A family of Venetian artists who had great influence on the development of Venetian art during the Renaissance. The father, Jacopo Bellini (who was also the father-in-law of *Andrea Mantegna), was an important teacher to aspiring young Venetian artists, including his sons. The most famous of the Bellinis was Giovanni, who was influenced by Mantegna and was the teacher of Giorgione and Titian. An acute observer of nature, Giovanni filled his canvases with poetic but naturalistic details which never overwhelmed the human figures in his compositions. He was at his best in fulfilling official commissions, such as the votive offerings of the Doges, the large altarpieces offered by the varied Venetian guilds, and small devotional works. Iconographically, he was the most innovative painter of northern Italy, and was

especially concerned with the *iconography of *Mary.

Belt. A sign of virginity and chastity when worn by a woman. At puberty, a young girl would be given her "girdle" by her family as a sign of womanhood. The legend of the Virgin's girdle being dropped from heaven on *Thomas's head after her Assumption related to this cultural custom, and was interpreted as a sign of her perpetual virginity. On a male figure, the belt signified preparation for service, as this was the last item one put on when dressing. *Old Testament *prophets wore belts as a sign of humility.

Benedict of Nursia, Saint (c. 480–c. 547). The traditional founder of Benedictine monasticism, the Father of Western Monasticism, and the author of the Benedictine Rule. Revered as an eloquent speaker, he was reputed to have earned his name, which comes from the Latin for "well spoken." His sister, *Scholastica, founded an order of *nuns devoted to her brother's rule and ideals. They were often depicted together in stories, legends, and art. Benedict was the Patron Protector of Europe, and the patron of coppersmiths, and was invoked against witchcraft and demons. In Christian art, Benedict was depicted as a male figure with flowing *beard, usually *white, and dressed in a black-and-white *habit, which combined the *black of the original Benedictine habit and the *white of the habit of the Reformed Order. He had many *attributes, including a white *dove as the sign of his sister, Scholastica; a *raven; a

*blackbird; a crystal glass with a *snake or a broken glass with wine dripping through it; a *cup; a thorned bush; an *aspergillum; a broken sieve; a luminous *ladder; two male youths; and a naked male youth.

Benedictines. The "black monks" were an order of monastics established by *Benedict at Monte Cassino. As the model for western monasticism, this close community of men religious was led by a spiritual father, the abbot, and adhered to the rule of a common life predicated upon a division of each man's time to contemplation, prayer, and manual labor. Benedictines emphasized the importance of education, liturgy, and the arts, and had a long and fruitful missionary history. In Christian art, these monks were identified by their original *black *habit. Reforms led to the establishment of new orders, including the *Carthusians, *Cistercians, and Trappists, from the original Benedictine tradition.

Bernard of Clairvaux, Saint (1090–1153). A *Doctor of the Church known as the "Mellifluous Doctor," and the "last of the Fathers" (prescholastic theology). He was considered the second founder of the *Cistercian Order. An outstanding medieval mystic, Bernard held a deep devotion to *Mary and the Infant Jesus, and his writings had a profound effect upon medieval spirituality. A powerful religious leader, Bernard supported the Second Crusade, obtained the condemnation of Abélard, and defended the legitimacy of Pope Innocent II. A popular figure in Christian art, Bernard was depicted as a beardless

43. Filippo Lippi, *Saint Benedict Orders Saint Maurus to the Rescue of Saint Placidus.*

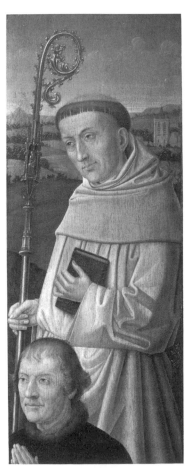

44. Imitator of Flemish 15th Century, *Saint Bernard with Donor.*

young man with a tonsured *head and dressed in the *white *habit of the Cistercian Order. He was sometimes accompanied by a black-and-white *dog, a reference to his mother's dream of a black-and-white dog following the birth of her son; this dream was interpreted as Bernard's destiny as a member of the reformed Benedictine order. His *attributes included a *book and a *pen as a Doctor of the Church, a *beehive for his eloquence, a *demon in chains symbolizing his attacks on heresy, and three *miters representing the three bishoprics he refused. The *cross and other *Instruments of the Passion represented *Bernard's mystical writings on *Christ. He may be depicted with the *Madonna and Child since as a sign of special favor, Bernard received several drops of Mary's milk directly in his expectant mouth.

Bernini, Gian Lorenzo (1598–1680). The greatest exponent of High Baroque architecture and sculpture. Influenced by classical Greco-Roman sculpture, *Michelangelo Buonarroti, and the *baroque art of *Michelangelo Merisi da Caravaggio, the Carracci, and Guido Reni, Bernini developed the sculptural concept of a single frontal viewpoint which incorporated a clear expression of energy and psychological insight. As Architect of Saint Peter's Basilica Church, Bernini was responsible for the design and execution of the Baldachino, the Cathedra Pietri, and the Piazza. A devout Roman Catholic, Bernini sought to express and defend the teachings of the *Council of Trent through his innovative *iconography. He was particularly noted for his attempts to

visually express mystical experience as in his great single sculptures of the *Ecstasy of Saint Teresa* and the *Death of the Blessed Ludovica Albertoni.*

Bestiary. A moralizing natural history of ancient origins based on the Greek *Physiologus,* and rivaling the Bible, in popularity in the Middle Ages. There were three categories of animals described in the medieval bestiaries: beasts, *birds, and reptiles and *fish. On average, each bestiary described the history, legend, natural characteristics, and symbolism of one hundred animals as opposed to the original forty-nine animals studied in the *Physiologus.* The bestiaries became standard books used by medieval artists in the development of their complex iconographies, as moralizing parallels were regularly drawn between the animals and their human counterparts.

Betrayal by Judas (Mt 26:47–56; Mk 14:43–52; Lk 22:47–53; Jn 18:1–10). Scriptural event signifying the dramatic moment when *Judas Iscariot identified Jesus to the Roman soldiers with a *kiss. Judas's transformation of the kiss from a sign of physical and spiritual intimacy into the despicable mark of betrayal became an important theme in Christian art and literature. The tension was heightened when *Peter cut off the ear of Malchus, the servant of the High Priest, which was restored by Jesus. Common symbols in the scene of the betrayal included the Kiss of Judas, *bags of money or thirty pieces of *silver, a *rope, and Malchus's ear. Depictions of the Betrayal by Judas were regularly represented in Christian art from the

fourth century up to the present day. As the medieval liturgical dramas developed, so too did the crowds and complex *iconography of the scene of the Betrayal. In *renaissance and *baroque art, the realism of the brute, physical strength of the Roman soldiers was juxtaposed with the passive resistance of Jesus.

Betrothal and Marriage of the Virgin Mary (*Protoevangelium of James* 8:2–9:2 and *The Golden Legend* 131). Legendary events signifying the initiation of *Mary into womanhood and her role as the mother of *Jesus Christ. As she approached the age of puberty, the High Priests began to make the arrangements for her marriage. Mary refused initially to marry, declaring that she had dedicated herself to God, but she eventually acceded to God's will. An *angel (or an oracle) ordered the High Priests to call for the assembly of all eligible bachelors (or aged widowers) from the House of *David. Each man brought his *staff and left it overnight in the Temple so that God could select the future husband of his special handmaiden. When the High Priests arrived the following morning, they found that the staff of *Joseph (of Nazareth), a widowed carpenter, had flowered (fulfilling the prophecy of Aaron's Staff). The Marriage Ceremony, presided over by the High Priest, was depicted outside of the Temple as Mary and Joseph exchanged *rings and formed the ceremonial handclasp. In the background, the rejected suitors broke their staffs in a gesture. A narrative element in the Marian cycle, the individualized scenes of the Betrothal and Marriage

became conflated into one theme by the mid-fourteenth century as the suitors's staffs were either placed on the high *altar or broken by the rejected suitors while the sacrament of marriage took place with Joseph distinguished by his flowering staff and the *dove hovering over his *head. In *baroque art, the wedding guests (and rejected suitors) were either greatly reduced in number or omitted completely as was Joseph's flowering staff; the visual emphasis became the solemn sacrament of marriage as Joseph placed a ring on Mary's finger and the High Priest gestured a blessing.

Bible. From the Latin for the Greek for "books." The composite collection of the sacred writings of the *Old and *New Testaments. Described as one *book in this unitary view, the Bible presented God's plan of salvation history, beginning with the creation of the world and ending with the Day of Judgment. Originally written in Hebrew, the Old Testament was translated into Greek (the *Septuagint*), for the Greek-speaking Jews of Alexandria (the version cited throughout the New Testament). The New Testament was originally written in Greek, and was translated into Latin by *Jerome; a revision of his Vulgate was declared the authoritative version of the Roman Catholic Church at the *Council of Trent. *Martin Luther translated the Bible into German, and several English translations followed during the Reformation until the King James' Bible was accepted as the authorized version.

Biblia Pauperum. From the Latin for "Bible of the poor." An illustrated *blockbook of forty images designed in a typological, or "moralizing," fashion, consisting of three columns in which the center illustration was from the *New Testament and to either side was the *Old Testament or classical foretype. For example, a depiction of the *Baptism of Jesus Christ was paralleled with images of Noah's Ark and of Moses Striking Water from the Rock in the Desert. Probably invented by Anschar of Bremen (801–865), this popular medieval book originally published in 1466 was inspired by Gregory the Great's defense of Christian art as the "biblia pauperum" or the bible of the poor (meaning "the illiterate"). Gregory advocated the idea that simultaneously seeing the image and reading (or hearing) the appropriate scriptural lessons sealed these Christian teachings in the heart of the believer.

Birds, symbolism of. Avian symbol for both the *soul and the mediator between *heaven and *earth. Following ancient Egyptian practice, the bird represented the soul. As such, birds symbolized the spiritual life, and in early Christian art, signified saved souls. When held by either *Mary or the Christ Child or tied to him by a string, individual birds had specific meanings. One of the most popular images in late *medieval art was that of *Francis of Assisi preaching to the birds which denoted both his concern for all the creatures of the creator God and for the Christian faithful. *See also* Blackbird, Cock, Dove, Eagle, Falcon, Goose, Hawk, Hen (with Chicks), Kingfisher, Lark, Magpie, Nightingale, Ostrich, Partridge, Peacock, Pheasant, Phoenix, Quail, Raven, Sparrow, Stork, Swallow, Swan, Turtledove, and Woodpecker.

Biretta. An ecclesiastical hat which was square in shape with three or four ridges on top, and a central pompom. The different colors of the biretta signified the different orders of the ecclesiastical hierarchy: *black for priests, *purple for bishops, and *red for cardinals.

Black. A dual symbol simultaneously denoting sacrifice, deprivation, sickness, mourning, and death; or the fertility of the earth and the nourishment of the night (sleep). As it was the practice of pagan religions to sacrifice black animals to the gods and goddesses of the underworld, the color became associated with death and the underworld. In Christian art, the color black was identified with the *Devil—the color of the "Prince of Darkness." In medieval times, black was associated with witchcraft and magic. As a symbol of abstinence, penance, and humility, the color black was used for the *habits of several monastic orders including the *Augustinians, *Benedictines, and *Dominicans. Women dressed in black in Christian art were understood to be either widows or *nuns.

Black Madonna. Images of *Mary and the child Jesus which either turned *black from some natural cause (such as candle smoke or tarnish), or a chemical imbalance of the paints, or were naturally black. These images were predominantly found in

medieval France, and had a series of interconnections with worship sites previously dedicated to fertility goddesses and with pilgrimage sites related to the *Holy Grail, and also with Albigensianism, the Knights Templar, and the Merovingian dynasty. Devotional images of the highest order, Black Madonnas were found all over Europe with the most famous ones being at Chartres, Czestoschowa, Einsiedeln, Montserrat, and Oropa. A fourth group of Black Madonnas were of a more recent (post-renaissance) vintage and their coloration was more directly related to the racial and ethnic types appropriate to their geographic location, such as Our Lady of Guadalupe.

Blackbird. The beautiful *black *feathers and melodious song denoted the temptations of the flesh and human sinfulness. According to legend, *Benedict of Nursia was tempted by a blackbird during his prayers. This blackbird was interpreted as a sign of the *Devil it could be vanquished when the *saint made the sign of the *cross.

Blaise, Saint (d. c. 316). This Armenian physician and bishop was divinely inspired to retire to a life of contemplation in a wilderness cave. There he was surrounded by many wild animals whom he befriended by healing their *wounds. Seized by the emperor's huntsmen, Blaise was tortured with burning iron *combs and thrown into a lake. He survived to walk across the water to preach and convert the multitudes. He was later decapitated. The patron of wild animals and wood-carvers, Blaise was in-voked for throat afflictions as legend recounted his rescue of a choking child. The "Blessing of the Throats" occurred on his feast day. In Christian art, he was depicted as an elderly man with a *white *beard who was dressed as a bishop. His *attributes included an iron comb, a lighted *candle, and a wild animal.

Blessing the Little Children (Mt 19:13–15; Mk 10:13–16; Lk 18:15–17). Scriptural event signifying the innocence of the *child. Although the *apostles sought to save Jesus from the strain of blessing the multitude, he asked that the children be brought to him for blessing as they were "the kingdom of God." Rarely depicted in Christian art, this theme became a popular topic among northern artists following its representations by *Lucas Cranach as a visual defense for *Martin Luther's controversy with the Anabaptists over the validity of infant *baptism.

Blind, Healing of the. See Man Born Blind.

Blind Beggar of Jericho (Mk 10:46–52; Lk 18:35–43). Scriptural event signifying the metaphor between physical and spiritual blindness. A voice cried out in the crowd to be healed. Although the crowd tried to quiet the voice, Jesus called the blind beggar to come forth. When the man faced Jesus, his sight was restored. In a variation of this story, there were two blind beggars whose sight Jesus restored (Mt 20:29–34). This miraculous healing was very rare in Christian art, and was eventually fused

with other "healings" into one visual episode.

Blockbook. A fifteenth-century form of illustrated book in which the text and pictures were cut from the same block, and were printed on the movable-type printing press. Most blockbooks had devotional topics; notable examples include the *Biblia Pauperum* (1465), *Song of Songs* (1466), and *Ars Moriendi* (1466).

Blood. This dual symbol denoted both life and death, as well as the sacrament of the *Eucharist. The *red *color of blood permitted association both with life-giving symbols such as the red *rose (for true love), and with sacrificial symbols such as the red martyrdom (the sacrifice of life as opposed to the white martyrdom of the sacrifice of sexuality). The blood which spurted from the wounded side of the crucified Jesus was interpreted as a sign of both his sacrifice of life and of the new life available in the *church through the Eucharist. In byzantine *iconography, two streams of fluid flowed from Jesus's wounded side—one white and the other red. These denoted water and blood as color symbols for the two central *sacraments of the Christian traditions—*baptism and Eucharist. In medieval art, these red and white streams signified the life of the spirit and the life of the body.

Blue. This color denoted the *heavens, spiritual love, constancy, truth, and fidelity. Blue garments were worn by *Jesus Christ and *Mary to signify their personification of these characteristics. The deep blue color

favored for depictions of Mary was a very expensive color made from ground lapis lazuli; its use was interpreted as a form of adoration for both its monetary value and its symbolic properties (the deeper the color the truer the characteristics exemplified by the individual).

Bluebell. A floral symbol for luck and good fortune. Given its physical resemblance to a bell, a bluebell suspended over a doorway warded off or exorcised evil and the *Devil.

Boar. An animal symbol for brutality, evil, lust, and the sins of the flesh.

Boat. *See* Ship.

Bonaventure, Saint (1221–1274). A *Doctor of the Church, Minister General of the Franciscan Order, and official biographer of *Francis of Assisi. A learned theologian, Bonaventure's *Constitution on the Rule* (1260) had a profound influence on the Franciscan Order. Known as the "Seraphic Doctor," his personal humility was demonstrated by stories such as his rejection of a cardinal's hat while he was washing his own dinner plates as a sign of humility and could not be disturbed, and his continued restraint from going to the *altar to receive the Holy Sacrament. In Christian art, Bonaventure was depicted as an elderly beardless man in a *Franciscan *habit who wore a cardinal's hat or was accompanied by an *angel with sacramental *wafer or *chalice. His *attributes included the *cross, chalice, *pen, and *book.

Book. A symbol for learning, teaching, and writing. The book was an

*attribute of authorship or of erudition. An open book signified the dissemination of *wisdom and truth, and a closed book a hidden secret or mystery. A book with *pen and ink symbolized an author. In Christian art, the usual convention was that a book signified the *New Testament and a *scroll either classical Greco-Roman philosophy or the *Old Testament. The Hebrew *prophets were identified by a scroll which might have been inscribed with an appropriate verse. Classical Greco-Roman philosophers, like Aristotle or Plato, were represented by a basket of scrolls, a symbol which also identified Jesus as the *Philosopher-Teacher. In *medieval art, the size and shape of the book became significant as the small, thick, hardbacked book held by or on the lap of a lady was a *Book of Hours, the oversized book with encrusted covers in the *hands of the *Evangelists were the *gospels, sacramentaries, or *psalters. A simply covered book held by any one of the *Evangelists signifies their individual gospel. *Doctors of the Church each held a book to signify their theological erudition. In the hands of missionary *saints such as *Francis Xavier, the book signified evangelization. A monastic with an open book was identified as the founder of an order, while a monastic with a book and pen or inkhorn was an individual author. The Archangel *Uriel held a book as the interpreter of judgments. Stephen the First Martyr held a book signifying the Old Testament. The symbolism of *Mary with a book at the Annunciation related both to her role as the *sedes sapientiae* ("seat of wisdom") and her foreknowledge of fu-

ture events. *Anne held a book when she taught Mary or Jesus to read, thereby symbolically imparting *wisdom. A book with the *Alpha and Omega symbolized Jesus as the *Christ; with a *fish, *Simon; pierced by a *sword, *Anthony of Padua. A book was an *attribute of *Barbara, *Catherine of Alexandria, *Jerome, and *Mary Magdalene.

Book of Hours. Popular prayer book of medieval Christians. Based on the "Little Hours of the Virgin" (a tenth-century addition to the Divine Office), these small, thick, hardbacked books contained the hours of the Divine Office, prayers, scriptural and devotional texts, and *illustrations or *illuminations. Commissioned individually, Books of Hours entered into the *iconography of the Virgin Annunciate and female saints in the twelfth century.

Bosch, Hieronymus (c. 1450–1516). Greatest master of fantasy and fantastic imagery in late medieval art, and famed for his allegorical religious works such as the *Ship of Fools* and the *Garden of Earthly Delights*. He employed an intricate and idiosyncratic symbolism in his paintings of both secular and sacred subjects. Bosch's works were favored by orthodox Roman Catholics such as Philip II of Spain, especially during the *Counter-Reformation.

Botticelli, Sandro (c. 1445–1510). This leading painter of late fifteenth-century Florence, influenced by the development of renaissance ideas, sought to represent emotional (and later spiritual) expression in his art.

45. Sandro Botticelli,
Madonna of the Magnificat.

46. Sandro Botticelli,
The Mystic Nativity.

Botticelli's early works reflected mythological themes but he progressed to inspired religious themes. Deeply effected, if not converted, by the preaching of Savonarola, the artist destroyed several important early works after hearing sermons on the "vanities" of the arts. Botticelli had a workshop dedicated to the production of devotional images of the *Madonna from 1480 until the early 1500s. His greatest legacy to Christian art were his innovations in the gentility and devotionalism of his depictions of the *Madonna, such as his *Madonna of the Magnificat.*

Bow. A symbol for war, hostility, and worldly power (Jer 49:35). In classical Greco-Roman and *renaissance art, the bow was an attribute of *Artemis (or Diana) as a huntress and of Eros (or Cupid) as an agent of love. The bow and arrows signified the hunt. In Christian art, the bow and arrow signified torture and martyrdom.

Box. A simple square or rectangular container for the storage of varied items. In Christian art, the box represented the containment or concealment of an important item, such as a relic(s) or the severed *head of one's enemy. It also signified worldly possessions, as in a jewelry box or box for the storage of money.

Box of Ointment. The major *attribute of *Mary Magdalene, who reputedly anointed Jesus at the *Feast in the House of Simon (Jn 12:3), and who sought to anoint the crucified body of Jesus at the by-then-empty *tomb. A box of ointments was an

attribute of *Cosmas and Damian who were physicians.

Bramble. A sign of the Burning Bush (Ex 3:2). The bramble symbolized the purity of *Mary, who never experienced physical lust, since she was immaculately conceived, but did know divine love. The *Burning Bush was also a sign of the perpetual virginity of Mary for just as the bush burned but was not consumed, so Mary conceived and bore a child but was still virginal.

Bread. Symbol of the sustenance of life. In the *Old Testament, bread in the form of *manna was a sign of God's nurture (Ex 16:15). In the *New Testament, it denoted the body of Jesus (Lk 22:19) and the staff of life (Jn 6:35). Loaves of bread were an *attribute of several *saints, including *Dominic, who was signified by one loaf of bread; *Mary of Egypt, by three loaves; *Philip, by a loaf of bread incised with a *cross or *fish; and *Paul the Hermit, by a loaf of bread in the mouth of a *raven.

Breast. A symbol of love, nurture, nourishment, and protection, and thereby of maternity and motherhood. In Christian art, several women were depicted expressing breast milk, including *Charity, who was distinguished by the presence of more than one *child, and *Mary, who allowed *Bernard of Clairvaux the singular gift of three drops of her milk directly expressed into his mouth. The *iconography of the Maria Lactans (Mary as the Nursing Mother) was derived from the byzantine icon of the *Galakotrophusa* ("Mother of

God as milk-giver"). As it would have been indecorous to display Mary's actual breast, a third unusually placed and distortedly large breast signified the nourishment of the Christian faithful by Mother Church. This Marian motif appeared and disappeared throughout the history of *medieval and *renaissance art. The Maria Lactans was popular during periods of famine and plague. Breasts on a platter were an *attribute of *Agatha as a sign of her martyrdom.

Bridget of Sweden, Saint (1303–1373). Founder of the Order of the Holy Savior ("Bridgettines") and famed medieval female mystic. Bridget recounted her mystical visions in the *Revelations of Saint Bridget of Sweden*. The vivid descriptions of her spiritual visions of the major events in the life of *Jesus Christ, especially of the Nativity and the Crucifixion, profoundly affected northern *medieval art and later Christian art. Bridget was the patron of Sweden. In Christian art, she was depicted dressed in a nun's black habit with a white wimple and veil banded in red. Her *attributes included the *candle, *crosier (as foundress of her order), *pilgrim's *staff with *wallet, *book, *pen, and *crown at her feet.

Brown. Color symbol for mortification, mourning, humility, and abstinence. As the sign of spiritual death (*ashes were brown) and physical degradation, this color became symbolic of renunciation of the world. This "lifeless" color, then, was used for the *habits of the *Franciscans, Carmelites, and *Capuchins.

Bull. A symbol for brute force, strength, and fertility. The bull was an *attribute of *Thecla, *Sylvester, and *Eustace. A winged bull (or ox) was the sign of *Luke the Evangelist.

Bulrush. A common plant or weed, grew low to the ground, was thickly clustered, and flourished near *water. The bulrush became a sign of the Christian faithful, especially those from the "low walks of life," who followed the path of Christian humility and ecclesiastical laws. The story of the infant *Moses found in the bulrushes was interpreted as a symbol of salvation and as a foretype of *Jesus Christ (Ex 2:5–6).

Burning Bush (Ex 3:2). Sign of God's presence when he spoke to Moses in the wilderness. Miraculously, the bush which burned was not consumed. The Burning Bush was a foretype for the perpetual virginity of *Mary.

Butterfly. A dual symbol whose short life and transcendent beauty signified vanity and futility, but whose three-stage cycle as caterpillar, chrysalis, and butterfly denoted resurrection or new life. The chrysalis was interpreted as a symbol of sleep or death, and the butterfly as the new life which arises out of sleep or death. When either the Christ Child or his mother held the butterfly, it connoted the Resurrection.

Byzantine art. A style of painting associated with the *icons of the Eastern Orthodox Church. Whether created by artists in the eastern or western Mediterranean, byzantine art

was generally characterized by a golden background signifying no particular geographic or historic site, a flatness of form, static figures, elongated proportions in the human forms, an emphasis upon frontality, and a code of *color symbolism, and was without a normal sense of perspective or spatial relationship. In Eastern Christianity, the rubrics and style of byzantine art begun in the fourth century continues into the present day. In Western Christian art, the byzantine influence lasted into the twelfth and thirteenth centuries with the development known as Italo-Byzantine art, which merged many characteristics of byzantine art with the growing Italian interest in the expression of emotion and human relationships.

Cain (Gn 4:1–16). Elder son of *Adam and *Eve, the brother of *Abel, and a farmer. Cain killed his brother in a jealous rage after God favored Abel's sacrificial offering. Initially denying any knowledge of his brother's death, Cain was cursed by God with a mark which identified him as his brother's murderer. Cain became a fugitive and perpetual wanderer. The story of the sacrifice of Cain and Abel was popular in early Christian art as a foretype of the *Eucharist. *Mark of Cain* (Gn 4:15) was the source for the medieval and renaissance *iconography that became essential to anti-Semitic symbols and images in Christian art.

Calf. An unblemished sacrificial animal was a foretype of *Jesus Christ.

Calf, Golden (Ex 32). Formed by *Aaron at the repeated requests of the *Hebrews, who had despaired of God's promise during Moses's absence on Mount Sinai. When *Moses returned with the Tablets of the Law, he was outraged to find the Hebrews dancing and acting lasciviously around the Golden Calf. Smashing the tablets, Moses condemned the Hebrews who had abandoned God and ordered the Levites to punish three thousand guilty Hebrews with death. In Christian art, the theme of the Adoration of the Golden Calf or Dance Around the Golden Calf was a sign of the lascivious and immoral nature of *dance, and was a popular image during those periods in which liturgical dance was questioned and/or condemned by ecclesiastical officials.

Calling of the Apostles (Mt 4:18–22; Mk 1:16–20; Lk 5:1–11). Scriptural event signifying the beginning of Jesus's public ministry. In order to fulfill his mission, Jesus needed a group of supportive and faithful followers to whom he could bequeath that mission after his death. The first "called" of the apostles, *Peter and his brother *Andrew, were mending their *nets when Jesus told them to

abandon their fishing and become "fishers of men." Later he called *James and John in a similar fashion. This episode was usually depicted as part of the life cycle of Jesus Christ; it was rarely depicted as a separate topic. The traditional format was established by the fourth century, with two fishermen seated on the side of the *boat, holding or mending fishing nets. Jesus stood in the center of the composition and beckoned to them with an appropriate gesture of his right hand. The *apostles' expressions of amazement were the outward sign of their vocation. The most dramatic rendering of this theme, the *Vocation of Saint Matthew*, was painted by *Michelangelo Merisi da Caravaggio.

Calvary. Latin for the Hebrew "golgotha" for "skull." The location of the Crucifixion of Jesus Christ. According to the fourth-century tradition, during her quest for the True Cross, *Helena identified the site of the Crucifixion and ordered the building of the Basilica Church of the Holy Sepulcher. Following the legendary and devotional texts, the linguistic connection between the names *Calvary and *Golgotha and the word *skull led to a common belief that the *cross was erected upon the site of Adam's grave. Medieval artists depicted either a skull and crossbones, a *skeleton (oftentimes in a casket), or male and female corpses (*Adam and *Eve) seated upright in one casket beneath the foot of the cross.

Calvinism. The tradition of Reformed Protestantism established under the guidance of John Calvin (1509–1564). Calvin's theology was based upon four central concepts: the Absolute Sovereign Will of God, Christocentricism, Scripture as the sole Supreme Rule of Faith and Life, and the Church. Calvin advocated a pessimistic view of humanity as totally corrupted by sin, a doctrine of election and predestination, and a vigorous morality. More thoroughgoing in his reform of ecclesiastical organization and liturgical worship than *Martin Luther, Calvin stripped away the nonessentials (that is, everything not expressly mandated in the biblical texts) from the worship environment to focus the congregation's attention upon the pulpit with the open Bible. In his proclamation against violent iconoclasm, Calvin formulated a median position on Christian art in his *Institutes of the Christian Religion* I.11. He allowed for the possibility of historical images for the sake of religious pedagogy, which gave rise to a select group of biblical themes such as the Sacrifice of Isaac, and *Blessing the Little Children, which were rendered by sixteenth- to eighteenth-century artists in Calvinist countries. Calvinism spread from Switzerland into southern Germany, the Netherlands, Scotland, England, France, and eventually the American colonies.

Camel. An animal symbol for temperance and humility. Since the camel sustained itself for several days without water, it was interpreted as a sign of physical control and abstinence. When it knelt down to receive its burden of either a human passenger or material objects, the camel was described as a humble creature and was a sign of *Jesus Christ. Since the

camel traveled through the *desert (to or from the Orient), it was both a beast of burden and a royal sign. In Christian art, the camel was placed in depictions of the *Adoration of the Magi. *John the Baptist wore camel skins as a sign of his life in the desert. According to several legends, the camel symbolized nymphomania and female lust, because the female camel was uncontrollable during her time of heat and copulated all day long with her mate.

Canaanite Woman's Daughter (Mt 15:21–28; Mk 7:24–30). A mother whose daughter was possessed by the *devil asked *Christ for a cure. After some conversation, he rewarded this mother's faith by cleansing her daughter. When the woman went home, she found her daughter healed and resting upon her bed. This miraculous healing was rarely depicted in Christian art, and was fused with other healings.

Candle. A symbol of light and of *Jesus Christ as "the light of the world." The number or type of candles used in liturgical services had a symbolic value: six candles represented the church's constant prayers during liturgy or mass, twelve candles the exposition of the Blessed Sacrament, three candles the *Trinity, seven candles the *sacraments, eucharistic candles the coming of Christ in the Eucharist, and the paschal candle the Resurrection. In Christian art, a lit, unlit, or extinguished candle signified Christ. In the *hands of *Joseph (of Nazareth) at the Nativity, the lighted candle denoted the light given to the world by the birth of this special *child.

Candlemas. Liturgical feast celebrating the Purification of the Virgin Mary and the *Presentation of Jesus of Nazareth in the Temple. As the conclusion to the Christmas cycle, the name "candlemas" was derived from the liturgical procession of *candles that symbolized the coming of "the light of the world" into the Temple.

Candlestick. A symbol of spiritual light and salvation in Christian art. The seven-armed candlestick, or menorah, signified *Judaism.

Capernaum Man Possessed of the Devil (Lk 4:31–35). Scriptural event signifying Jesus's constant struggle with the *Devil. Inside the synagogue of Capernaum, Jesus was confronted by a man possessed of the Devil. He healed the man by ordering the Devil to come forth. Depictions of this miraculous healing were very rare in Christian art. It was fused with other healings of Jesus.

Capuchins. From the Italian for "pointed cowl." An order of *Franciscan friars established by Matteo di Bassi, which sought to adhere to the original, austere rule of *Francis of Assisi.

Caravaggio, Michelangelo Merisi da (1571–1610). First major painter of the Italian *Baroque and a major innovator in the *iconography of the *Counter-Reformation. Working directly on the canvas from a model, Caravaggio shunned the traditional

practice of preparatory sketches for his works. Known best for his vivid realism and the intensity of the dramatic emotions his paintings conveyed, Caravaggio employed contemporary costumes and settings, an immediate simplicity of forms, and chiaroscuro (theatrical dark-light identified as tenebrism in northern European art) to highlight specific details. More than a technical innovator, Caravaggio sought to redefine traditional symbols and images, thereby invigorating his presentations of biblical and devotional figures. Among his best-known works were *Vocation of Saint Matthew*, *The Entombment*, and *The Death of the Virgin*.

Carbuncle. A deep-red colored stone symbolizing blood and physical suffering. In Christian art, a carbuncle signified the passion and death of Jesus. The implementation of five carbuncles on a liturgical book cover, liturgical vessel, *altarpiece, or reliquary box symbolized the five *wounds of the crucified Jesus.

Cardinal's Hat. A broad brimmed, low-crowned red hat decorated with two cords, each with fifteen tassels. The cardinal's hat was an *attribute of *Jerome and *Bonaventure.

Carmelites. A mendicant order legendarily founded by the *Old Testament *prophet, *Elijah, at Mount Carmel. Known as the "white friars" because of the white cloak of their habits, the Carmelites were dedicated to teaching and were among the prominent educators at Oxford, Cambridge, Paris, and Bologna. The original Carmelite Rule was accepted in 1206, mitigated in 1432, and reformed by *Teresa of Avila in the sixteenth century. In Christian art, Carmelites were identified by their brown habit with a white cloak.

Carnation. A floral symbol for commitment, betrothal, and love. As with other flowers, the color of the carnation characterized the nature of love; thus, *red carnations signified true love, marriage, and passion; pink carnations young love, fidelity, and maternal love (especially that of *Mary); white carnations pure (platonic) or spiritual love; and yellow carnations rejection. According to legend, the carnation originated from the Virgin's tears on the *Road to Calvary, and was therefore a sign of maternal love and eventually, of Mother's Day. The carnation's clove-scented aroma enhanced its association with the *Crucifixion of Jesus Christ because the clove was shaped like a *nail. As sign of fidelity, it was a Flemish custom for a bride to hide a "pink" on her gown and to allow her bridegroom to search for it. The pink carnation became a symbol of fidelity in marriage, and newlyweds were depicted in portraits holding a pink.

Carpenter's Plane. An attribute of *Joseph (of Nazareth), who was a carpenter.

Carpenter's Square or **Rule**. An *attribute of *Thomas and of *Joseph (of Nazareth).

Carthusians. A contemplative and austere Order of Reformed Benedictines established by Bruno in 1084. In

Christian art, Carthusians were identified by their totally white habits.

Cassock. From the Italian for "overcoat." A close-fitting, long-sleeved classical Greco-Roman garment that reached to the ankles. This form of daily clerical dress had thirty-three buttons, signifying the number of years in the life of *Jesus Christ. The color of the cassock identified the ecclesiastical rank of the wearer: *black for priests, *purple for bishops, *red for cardinals, and *white for the pope.

Cat. A sign of passivity and lust. In classical Mediterranean culture, Isis, a goddess of the underworld and fertility, was accompanied by a cat. As Isis was black in coloration, the cat became associated with the *Devil and with *witches in Christian art. In particular, the black cat denoted death and evil. According to medieval legend, the cat of the Madonna (*gatta della Madonna*) was the exception to this symbolic rule. She had her litter in the stable as *Mary gave birth to Jesus. As a sign of her unique nature, the *gatta della Madonna* had a cross-shaped marking on her back.

Catacombs. From the Latin for "to the hollows." The underground burial chambers of *Jews and early Christians in Rome. These underground passageways and burial chambers were decorated with *frescoes and carvings representing scriptural stories and Jewish and Christian symbols. The catacombs were reputedly the original sites for communal worship until Christianity was declared a legal religion by the Emperor *Constantine in the fourth century.

Cathedra. From the Latin for "chair or seat of authority." The chair of the bishop. As a symbol of ecclesiastical and teaching authority, the cathedra was originally placed within the apse behind the high *altar. With liturgical revisions and in response to architectural changes brought about by the *Counter-Reformation, the bishop's chair was located in the sanctuary by the side of the altar.

Cathedral. From the Latin for "chair or seat of authority." An ecclesiastical building which housed the cathedra or chair of the bishop. The cathedral was developed in the medieval period as an expansion of the basilica church plan. It featured an elongated *nave and transept arms that were extended beyond the octagonal floor plan of the basilica to create a Latin or Roman *cross. This elongation allowed for the additional space required by the medieval *pilgrimages, and by both liturgical innovations and the growth of the adjacent monasteries.

Catherine of Alexandria, Saint (d. 310). Virgin martyr and model for the bride of Christ. According to historical and legendary texts, Catherine devoted herself as a young girl to a life of study and prayer after the death of her mother. A convert to the Christian faith, she pleaded with her legendary suitor, Emperor Maximus (Maxentius), to cease the persecution of Christians and the worship of idols. He challenged her to an intellectual confrontation with his greatest philosophers. According to tradition,

her erudition was so great that she not only demolished their arguments, but all fifty philosophers converted to Christianity. Enraged at both her victory and her refusal to marry him, Maximus had Catherine tortured and imprisoned. She was visited daily by *angels and *doves who fed her and nursed her *wounds. She also was visited by *Christ in her cell. Maximus ordered that she be tortured with a spiked *wheel, but she remained faithful to Christ, and her strength brought two hundred Roman soldiers to conversion. When she was beheaded, Catherine's veins flowed with *milk instead of *blood. There are many legends associated with Saint Catherine, including the vision that her *head glowed with an *aureole at her birth. The most famous legend associated with Catherine was that of her Mystical Marriage to the Christ Child. In one version of the story, *Mary appeared to a desert hermit and ordered him to show the young Catherine an image of the Virgin and Child, and to tell her that this would be her husband. Catherine became so enraptured with the Christ Child that she dedicated herself to him as his bride. In another legend, while awaiting *baptism the young Catherine had a dream in which Mary asked her son to take Catherine as his servant; he declined by turning his head away and saying she was not beautiful. After studying the dream, Catherine proceeded to be baptized and was found beautiful by the Christ Child, who placed a celestial *ring on her finger. One of the *Fourteen Holy Helpers, Catherine of Alexandria was the patroness of young girls, spinsters, scholars, schools, universities, preachers, millers, and wheelwrights. Hers was one of the voices heard by Joan of Arc. A popular topic in Christian art, Catherine was depicted as a beautiful young woman dressed as a princess in an elegant costume and wearing a *crown. She was identified by her *attributes: the Catherine Wheel, crown, *palm, *sword, wedding ring, and *book.

Catherine of Siena, Saint (1347–1380). Christian mystic and *Doctor of the Church. Catherine dedicated herself at the age of seven to *Christ, with whom she believed she had entered into a mystical marriage. A member of the Third Order of *Dominicans, she was reputedly protected during her prayers by a *white *dove on her *head. Catherine became an influential figure in fourteenth-century ecclesiastical and secular politics. Her intense periods of prayer and mystical unions ultimately led to her receipt of the *stigmata. She was the patroness of all Italy, and especially of Siena. In Christian art, Catherine was depicted as a young woman dressed in the *habit of a Dominican Tertiary *nun; she was identified by her *attributes of a white dove, *lily, *cross surmounted by a lily or a *heart, *rosary beads, *book, crown of thorns, pierced heart, and an amanuensis writing her letters.

Cauldron of Oil. A symbol for both a means of torture and death, and a receptacle for evil. The cauldron of oil was an *attribute of *John the Evangelist and *Vitus.

Cecilia, Saint (third century). Virgin martyr and saint. Converted as a

47. Lodovico Carracci, *The Dream of Saint Catherine of Alexandria*.
48. Giovanni di Paolo di Grazia, *The Miraculous Communion
of Saint Catherine of Siena*.

49. Orazio Gentileschi and Giovanni Lanfranco, *Saint Cecilia and an Angel*.
50. Master of Saint Heiligenkreuz, *The Death of Saint Clare*.

child to Christianity, Cecilia married at her father's request but was unable to consummate her marriage, having vowed perpetual virginity. Her bridegroom, Valerian, respected her vow on the condition that he be allowed to see the *angel Cecilia claimed protected her. She sent him to her mentor, Urban, who was instructing catechumens in the *catacombs. Urban told the young husband to respect his bride's vow and he would see an angel upon his return home. When he entered his home, Valerian found the house filled with sweet smells and beautiful music. An angel presented him with a *wreath of *lilies for Cecilia, and a wreath of *roses for himself. He and his brother were converted to Christianity by Urban. They began to preach, were imprisoned, and executed. Seeking to obtain Valerian's property, the Roman governor ordered Cecilia to perform an act of idolatry, but she refused. Locked in a bathroom filled with hot steam, Cecilia survived her ordeal, only to have herself subjected to three attempts at decapitation. On the third day following the last execution attempt, Cecilia died after counseling Urban as to the distribution of her wealth to the poor in the Christian community. According to tradition, Cecilia was buried in the catacomb of Callistus, and her tomb was opened in 817 after Pope Paschal I had a vision of it. He ordered her body to be reburied alongside the remains of Urban, her husband, and her brother-in-law, in the crypt of Saint Cecilia-in-Trastevere. During renovations to the crypt in 1599, her sarcophagus was discovered and her body was miraculously found to be in perfect con-

dition. This event—the incorruptible body of the saint—was documented by the sculptor Stefano Maderno. The patroness of music and musicians, Cecilia became the patroness of the Academy of Music in 1584. In Christian art, she was depicted as a beautiful young woman with three wounds in her neck, and was represented playing a musical instrument and singing. Among her *attributes were the *harp, *organ, and a *crown of lilies and roses.

Cedar. A stately and majestic *tree signifying Christian incorruptibility. The Cedars of Lebanon, treasured as sources of wealth and the timber used to build the Temple of *Solomon, were symbols of both *Mary (Song 5:15) and *Jesus Christ (Ez 17:22).

Censer. A metal vessel in which incense was burned during rituals and liturgical services, the censer signified prayers and petitions to God. It was a symbol for *Aaron as the High Priest of Israel, and an *attribute of *Laurence and *Stephen.

Centaur. A mythical creature which was half-man and half-horse, symbolizing brute force, savage passions, adultery, heresy, and vengeance. According to legend, a centaur led *Anthony the Abbot to *Paul the Hermit.

Ceres. An Italian goddess of grain and the harvest. The Romans fused Ceres with the Greek goddess *Demeter.

Chains. Symbol of the Passion of Jesus Christ, especially the *Flagella-

tion. Chains were also an *attribute of *Leonard.

Chalice. An ambiguous symbol for nourishment, containment, tribulation, and protection. The chalice was the liturgical vessel used for the consecration and distribution of the wine of the *Eucharist. In Christian art, the chalice signified the *Last Supper, the Sacrifice of Jesus, and Christian faith. A chalice with a *serpent was an *attribute of *John the Evangelist, a chalice with a *wafer of Barbara, and a broken chalice of Donatus. A chalice with a *cross was an attribute of *Thomas Aquinas and also signified the *Agony in the Garden. A simple chalice was an attribute of *Bonaventure. The quest for the *Holy Grail, the chalice used at the Last Supper, became a central theme in medieval art and legends.

Chameleon. A animal symbol for the many guises of *Satan, which he used to beguile humanity.

Chariot. A symbol for the *church as the vehicle that transported the faithful to *heaven. A fiery chariot was an *attribute of the *Old Testament *prophet *Elijah.

Charity. One of the Seven Virtues, and foremost among the theological virtues. In classical Greco-Roman and Christian art, charity was typified by a mother who nursed and protected her children. A characteristic of *Mary whose charity was evident in those depictions in which she held her son in one arm while the little *John the Baptist played at her *feet.

Charity, Saint (second century). The personification of the cult of Divine *Wisdom (Sophia) in the eastern Mediterranean. According to this tradition, the Roman widow, *Sophia, had three daughters—*Faith, *Hope, and Charity. The mother and her daughters were tortured and beheaded under the Emperor Hadrian.

Charlemagne (c. 742–814). King of the Franks, ideal Christian King, and first Holy Roman Emperor (800–814). Part of his story was told in the medieval epic poem, *The Song of Roland,* and in many medieval legends. Charlemagne was canonized by Pope Paschal III, the twelfth-century antipope, but a popular devotion to Charlemagne survived throughout the medieval period. In Christian art, he was depicted as an elderly man dressed either in his *armor or a royal *robe, and wearing an imperial *crown. His *attributes included an *orb, a *shield decorated with the *fleur-de-lis, a *book, or the model of his *cathedral at Aix-la-Chapelle.

Charles Borromeo, Saint (1538–1584). Cardinal Archbishop of Milan during the *Counter-Reformation. He sought to reform the clergy and to fulfill the goals of the *Council of Trent, including the preparation of a new catechism, breviary, and missal; and the establishment of a Confraternity of Christian Doctrine for religious education of children. When Milan was gripped by the plague between 1575 and 1578, Charles Borromeo walked the streets administering the last rites and offering spiritual solace to the sick. He was the patron of Palestrina and founder of the Or-

der of Oblates. In Christian art, Charles Borromeo was depicted as a distinguished-looking middle-aged man with dark skin and high forehead. He was often represented as a barefoot cardinal with a *rope around his neck, and wearing a *crown inscribed with the word *humilitas* and a processional *crucifix. His *attributes included the crucifix, *skull, rope of the penitent, and *chalice.

Chasuble. From the Latin for "little house." The final liturgical garment worn by the eucharistic celebrant (priest, bishop, or archbishop). An allusion to the purple robe *Pontius Pilate ordered worn by Jesus as a sign of his being "king of the Jews," the chasuble also referred to the *seamless robe for which the Roman soldiers cast lots at the Crucifixion. Embroidered on the back with a *cross in memory of the *Passion of Jesus Christ, chasubles conformed to the colors of the liturgical seasons. As the outside cover of a celebrant's liturgical garments, the chasuble represented both protection and charity, the virtue that preceded all others.

Cherry. A sweet red fruit symbolizing the pleasant character resulting from good deeds. One of the "Fruits of Paradise," the cherry represented eternal life. When held by the Christ Child, the cherry signified the delights of the blessed or, on occasion, the "forbidden fruit" of the *Garden of Eden.

Cherubim. The second order of the first hierarchy of *angels. Led by the *archangel Jophiel, they guarded the Tree of Knowledge and the *Garden of Eden, and protected the *Ark of the Covenant in the Temple of *Solomon. In Christian art, cherubim were depicted as either *blue or *yellow in *color, and as bodiless creatures who rode on winged *wheels. As symbols of God's *wisdom, cherubim held or read *books. In *baroque art, the cherubim became chubby, smiling, winged little babes, and were depicted most often as winged *heads or torsos.

Chestnut. A symbol of chastity and triumph over the temptations of the flesh, as the meat of this *nut laid in its husk, unharmed by its surrounding *thorns.

Child/children. A human symbol for innocence and trust, spontaneity, new beginnings, and abundant possibilities. Child or children were *attributes of *Anthony of Padua, *Charity, *Christopher, and *Vincent de Paul. *See also* Blessing the Little Children.

Child Jesus on a Book or **Carried in the Arms of a Saint**. An *attribute of *Anthony of Padua, while a *child or young man carried as a dead corpse identified *Zenobius.

Chimera. A mythological beast composed of the *head of a *lion, the body of a *goat, and tail and *feet of a *dragon. Alleged to breathe *fire, the chimera was an invisible monster which regularly threatened Christian martyrs and, later, medieval princesses. It was a popular element in *medieval art, especially in the decorative carvings of *cathedrals and designs for tapestries.

Chi-Rho. The first two letters of the Greek word for "Christ." They became the monogram of *Jesus Christ.

Christ. From the Greek for "the anointed one." The title or name signifying the *Messiah, the promised and long-awaited deliverer of the people of Israel. The initial affirmation of faith in the Christian tradition was the proclamation that "Jesus is the Christ."

Christ Among the Doctors (Lk 2:41–50). Scriptural event signifying the initiation of Jesus into manhood in the Jewish tradition. *Mary and Joseph (of Nazareth) took their twelve-year-old son to Jerusalem for the Passover. Jesus disappeared for three days, but was finally located by his parents in conversation with the doctors (theologians or elders of the synagogue). Rarely depicted as a separate theme in Christian art, Christ Among the Doctors was included in the narrative cycles of the life of Jesus Christ.

Christ Appearing Before His Mother. *See* Appearance to His Mother.

Christian Iconography. The study and system of the signs, symbols, and images used in Christian art. Premised on the allegorical and metaphorical teachings of the early church fathers, Christian artists developed a typological reading of both classical Greco-Roman heroes and heroines and the *Bible. The image of *Mary or *Jesus Christ, or some *New Testament element, was the fulfillment of the "foretype" from either classical

Greco-Roman legend, literature, and mythology or the Bible.

Christian Scriptures. *See* New Testament.

Christina, Saint (third century). Virgin martyr. According to legend, this daughter of wealthy Romans smashed the family idols, distributed *gold and *silver pieces to the poor, and was imprisoned for filial infidelity and impiety. After burning, attempted drowning, and torture with a *knife and tongs failed to kill her or force her to recant, Christina died after being shot with three arrows. She was popular in *medieval art and legend, and northern Italian *renaissance art and spirituality. In Christian art, Christina was depicted as a beautiful young woman with three arrows in her neck. Her other *attribute was the millstone as a sign of her attempted martyrdom by drowning. Christina was a companion to *Ursula.

Christmas. From the Middle English for "the festival mass of Christ." The liturgical feast celebrating the *Nativity of Jesus Christ. A central date in the liturgical or church year calendar, Christmas was celebrated initially at the Spring Equinox near *Easter. Later it became identified with the winter solstice and Mithras festivals, and by the fourth century Christmas was established as December 25. The liturgical color for the celebration of the Christmas season was *white.

Christopher, Saint (third century). From the Greek for "Christ-bearer." According to pious tradition, this

giant of great strength sought to serve the greatest of kings. Having been converted to Christianity by a desert hermit, Christopher was sent to be a ferryman, whose job it was to carry travelers, ostensibly *pilgrims, across a wide, rushing river. During a stormy night, a young *child appeared and asked to be carried across the river. As the *waters rose, the weight of the child increased. Christopher knew fear for the first time, and was relieved to reach the other side of the river bank. Placing the child on the ground, the giant told him that he had been put to great risk and never carried such a burden. The child retorted that this was because he was the *Christ who bore the whole world and all of human sinfulness. According to pious legend, Christopher was decapitated. The patron of travelers and motorists, and one of the *Fourteen Holy Helpers, Christopher was invoked against fire, storms, and earthquakes. A popular topic in Christian art, he was depicted as a gigantic, muscular, bearded man with a *staff who was bent over from the burden of carrying the child on his shoulders across the river.

Church. From the Greek for "assembly" or "gathering." A term of dual meaning signifying either the social reality of the Christian community or an architectural edifice. As a social designation, church referred to the community of the people who had been called and gathered to follow *Christ. As the place of gathering, the church was the building used for the assembly of the Christian faithful. This "House of God" was referred to as the Body of Christ or the Ark of Salvation. In Christian art, the image of a church building in the *hands of a *saint, bishop, or male figure signified that this person had been either the patron, *donor, bishop, or architect of the building. In the hands of either *Jerome or *Gregory the Great, the image of the ecclesial building signified the larger sense of the church. The image of *Ecclesia, a crowned and wide-eyed female figure holding a *banner, *chalice, and/or a *book, represents the church, specifically the Church Triumphant, in opposition to *Synagoga.

Church Model on a Saint's Head or **in a Saint's Hand.** *Attribute identifying the *saint being portrayed as either the founder or patron of the building; for example, *Helena was shown with a model of the Basilica Church of the Holy Sepulchre.

Ciborium. Liturgical term with a double meaning as either the ceremonial canopy placed over the *altar as an allusion to the *Ark of the Covenant, or the liturgical receptacle used for the reserved Host of the *Eucharist. The ciborium signified the presence of *Christ, the *Last Supper, and the Sacrament of the Eucharist.

Cincture. *See* Girdle.

Circle. Round shape with no apparent beginning or end symbolizing eternity and God. Within a *triangle, the circle signified the *Trinity, as did the motif of three intertwined circles.

Circumcision of Jesus Christ (Lk 2:21–38). Scriptural event signifying that the infant Jesus was a member of

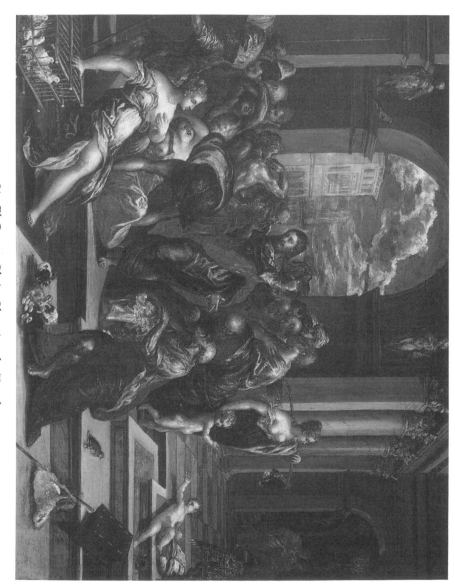

51. El Greco, *Christ Cleansing the Temple.*

the Jewish community. A form of initiation rite among primal peoples, circumcision was practiced by the Hebrews as a sign of their unique covenant with God and as a distinguishing mark from the neighboring Assyrians, Babylonians, and Philistines. A ritual of purification and acceptance as a member of the community, the circumcision of the male child on the eighth day after his birth was also the occasion of the naming ceremony; thus, the child was fully identified as an individual and a member of the community. In order to fulfill the Law and be a Jew, Jesus was circumcised and named on the eighth day after his birth. This ritual was replaced with the Christian rite of *baptism as the sign of initiation into the community. In medieval Christianity, the Circumcision of Jesus Christ as the first shedding of his blood was interpreted as the first event of the Passion. Ostensibly in accordance with Jewish practice, the infant Jesus would have been circumcised in his family home. Rarely depicted in *byzantine, *medieval, and *renaissance art, the Circumcision became conflated with the Purification of the Virgin Mary and the *Presentation of Jesus of Nazareth in the Temple (Luke 2:29–38). It became a popular theme in its conflated form in the fourteenth and fifteenth centuries as an integral part of devotionalism to *Mary, and was revived in the art of the *Counter-Reformation. Images of the Circumcision abound in pulpits, *altars, and fonts as the foretype of *baptism.

Cistercians. An order of Reformed Benedictines established by *Bernard of Clairvaux in 1112. They were known as "White Monks" because of their *white *habits, which identified them in Christian art.

Clare of Assisi, Saint (c. 1194–1253). Founder of the Order of the Poor Clares, dedicated to the cloistered contemplative life. A devoted follower of *Francis of Assisi, Clare was the greatest female *Franciscan. Her deep devotion legendarily allowed her to repel Moslem invaders by holding up a *monstrance before them. Miraculously, the *bread supply at her convent was replenished daily as a sign of her extraordinary holiness. The patroness of television, Clare was invoked against possession by the *Devil or evil. In Christian art, she was depicted as an elderly woman wearing the gray tunic with knotted *girdle and the *white coif and *black *veil of her order. Her *attributes included a monstrance, *lily, *cross, and *crosier (as the foundress of her order).

Cleansing of the Temple (or **Expulsion from the Temple**) (Mt 21:12–17; Mk 11:15–19; Lk 19:45–48; Jn 2:13–25). Jesus went to the Temple of *Jerusalem to pray, and found the Temple and its immediate vicinity overrun with merchants and money changers. In a display of physical and emotional anger, he turned over their booths and counters, and threw their money upon the ground. He then proceeded to chase the men and their animals from the Temple, accusing them of turning God's house of prayer into a "den of thieves." The drama of Jesus' anger was interpreted as a form of Heliodorus' being driven from the

Temple by Christian artists. The Reformers favored this theme as a foretype of *Luther's condemnation of the sale of papal indulgences.

Clement of Rome, Saint (first century). Apostolic father, disciple of *Peter and *Paul, and bishop of Rome. A celebrated Christian writer, Clement was the first to employ the allegory of the *phoenix for the *Resurrection of Jesus Christ. In the epistle credited to him, Clement bid the Corinthian Church to cease its internal quarreling. According to pious legends, he was condemned to hard labor in the Crimea by Emperor Trajan. Clement and his companions suffered greatly from the lack of food and *water. As he prayed a *lamb appeared to him, and Clement struck that spot with an *ax as *water gushed forward. Tied to an *anchor, he was thrown into the sea and drowned. Clement was the patron of tanners. In Christian art, he was depicted in papal robes and tiara. His *attributes included an anchor, lamb, and *fountain.

Cloak. A covering garment signifying protection or dignity and rank. Covering and protecting the *body, the cloak was also interpreted as a symbol of modesty. A cloak divided into halves by a *sword was an *attribute of *Martin of Tours.

Clouds. Meteorological symbol for the omnipresence of God. The Divine Omnipotence of God was signified by a right *hand emerging from the clouds.

Clover. Dual symbol of good and of evil. A four-leaf clover was a sign of good luck, while a five-leafed clover of bad luck. A three-leaf clover represented the *Trinity. The Irish clover, or shamrock, was an *attribute of *Patrick and of Ireland.

Club. Symbol for the *Betrayal by Judas. A sign of *fortitude in the *hands of the virtuous, the club was an *attribute of *James Minor and *Jude.

Coat. *See* Cloak.

Cock. An avian sign for vigilance and watchfulness. The loud crowing of the cock routed burglars, announced the dawn, and called the faithful to work and prayer. In Christian art, the cock as the announcer of the new day was a sign of the Resurrection. It was also an *attribute of *Peter and a symbol for the Passion.

Coins. Signs of wealth and worldly power. In Christian art, a *dish of *gold and *silver coins was an *attribute of *Laurence, while thirty pieces of silver represented *Judas Iscariot, the *Betrayal by Judas, and the Passion. Coins on a table at which several men were seated and Jesus was standing signified the Calling of *Matthew. A *fish with a coin in its mouth or a Pharisee holding a coin denoted the *Tribute Money.

Colors, symbolism of. Signifiers of the identity of individuals, rankings in society, and emotional or personal characteristics. In Christian art, colors were interpreted on the two levels of inherent characteristics and emotional connotations. For example, because the inherent characteristic of

*red was heat, the color red signified hot temperatures, hot tempers, and *fire; the emotional connotations of red were emotional and physical passion and suffering. The same color could have had opposite meanings which could only be clarified by the narrative or theological contexts; thus red signified both the divine love of *John the Evangelist and the sensual sinfulness of the *Devil.

Columbine. From the Latin for "dovelike" and "dove." A botanical symbol for the *Holy Spirit. However, the blue columbine was a symbol for sorrow, and so seven *blue columbines signified the *Seven Sorrows of the Virgin Mary. The seven *flowers on the stalk of the columbine denoted the Seven Gifts of the Holy Spirit.

Column. A sign of the Passion, specifically of the *Flagellation. A depiction of the *Madonna and Child with a column represented the foreknowledge that this child was born to suffer and die. Falling columns topped with idols were a sign of the *Flight into Egypt. The column was an *attribute of *Samson and Simon Stylites.

Comb. An iron comb was an *attribute of *Blaise.

Constantine the Great, Saint (c. 280–d. 337). Roman Emperor who proclaimed the toleration of Christianity in the Edict of Milan (313). Not yet a Christian, Constantine had a dream the night before the decisive Battle of the Milvian Bridge that his armies would triumph if they went into battle carrying a *white *banner

with a *red monogram, *Chi-Rho (for CHRist) on it. He abolished crucifixion as a form of punishment and declared Christianity the religion of Rome in 325. He moved the capital of the Roman Empire from Rome to Byzantium, renamed New Rome, although it was commonly called Constantinople in his honor. He supported the *pilgrimages, missionary zeal, and church building projects of his mother, *Helena. According to tradition, Constantine was baptized on his death bed. A rare figure in Christian art, Constantine was depicted as a young man dressed in *armor with an imperial *cloak. His *attributes were a white banner with the inscription, *In hoc signo vinces* ("By this sign conquer") and a *scepter.

Cope. This elaborate and richly decorated liturgical vestment with an elegant collar and embroidered back was worn by the liturgical celebrant. Fastened by a morse (a brooch), the cope was coordinated to the colors of the liturgical season. A cope was worn only in liturgical processions and at significant religious services. By both its decorative details and its placement as the last vestment, the cope signified innocence, purity, and dignity. In Christian art, the cope denoted a bishop.

Coral. A light-red stone used as an amulet or charm against evil, witchcraft, or possession by the *Devil. Worn by infants and small children, a piece of coral or a *rosary of *gold and coral beads as when held by the Christ Child was a sign of triumph over the Devil.

Cord. A length of linen or rope worn around the waist over the *habit of a monastic or the *alb of the liturgical celebrant. For the monastic, the cord served both as a *belt from which necessary objects like *keys were attached and as a sign of humility and penance. The length of the cord and the number of knots tied into it identified the different monastic orders. For the celebrant of the liturgy, the cord alluded to the *rope with which Jesus was tied to the *column at the Flagellation, thereby signifying temperance and self-restraint. The celebrant crossed the *stole across his chest and then tied the cord across his waist with three knots for the *Trinity.

Cornucopia. A symbol of fruitfulness and plenty, especially of the harvest. This "horn of plenty" signified the *Garden of Eden as the Paradise Garden.

Coronation of the Virgin Mary. Final legend in the narrative cycle of *Mary. When she was received by God the Father and her son into *heaven, Mary was enthroned and crowned as Queen of Heaven. This iconographic motif developed in thirteenth-century *cathedral *tympanums in which the seated Mary crowned by her son fulfilled the *Old Testament foretypes of *Solomon and the *Queen of Sheba (1 Kgs 10:1–13), and of *Bathsheba seated at the right *hand of her enthroned son, *Solomon (1 Kgs 2:19). A popular topic in *medieval, early *renaissance, and early southern *baroque art, the Coronation of the Virgin Mary illustrated the conflation of the temporal

with the eternal as Mary was the intermediary both to heaven and the power of the secular queen. As *Mater Ecclesia* ("Mother Church"), Mary became a visual image for the enhanced power and authority of the Church in the medieval, early renaissance, and southern baroque worlds. In Christian art, Mary was depicted dressed in elaborate royal *robes being assumed into heaven with the assistance of *angels and *clouds, or kneeling at the foot of her son's (and later jointly God's) throne, as a crown held jointly by Father and Son was placed upon her head. This image was replaced by the *iconography of the *Immaculate Conception in southern baroque art.

Corporal. From the Latin for "body." The *white linen cloth laid on the *altar for the consecration of the *bread and the wine of the *Eucharist. At other times, the corporal was the protective covering for these elements.

Corpus Christi. From the Latin for "Body of Christ." The liturgical feast of the Veneration of the Blessed Sacrament held on the Thursday after *Pentecost. Instituted by Pope Urban IV in 1246, Corpus Christi was celebrated with an extraordinary liturgical procession which included flowery floats and pageantry. The celebration of this feast supported the development of religious dramas which in turn influenced medieval *iconography.

Cosmas and Damian, Saints (fourth century). Christian healers who assessed no fee for their medical and

52. Paolo Veneziano, *The Coronation of the Virgin*.

53. Fra Angelico, *The Healing of Palladia by Saint Cosmas and Saint Damian*.

surgical practices. These twin Arabian physicians were raised by a Christian mother. According to one legend, Cosmas and Damian treated a male patient who was suffering from a canker which had eaten away his leg. Seeking a remedy for his patient's suffering flesh, Damian went to the cemetery and amputated the leg of a recently deceased Ethiopian man. The two brothers then replaced their patient's leg with that of the Ethiopian. When he awoke, the patient recognized his restored health and jumped out of bed only to discover that he had one white leg and one black leg. During the Diocletian persecutions and after refusing to sacrifice to idols, Cosmas and Damian were cast into the sea only to be rescued by *angels. They survived a fiery death and stoning, and were beheaded. Cosmas and Damian were the patrons of barbers, apothecaries, physicians, medicine, surgery, the city of Florence, and the Medici family. They were depicted in Christian art as being identical male figures dressed in the long red robes lined and trimmed with fur, and wearing the round red caps of physicians. Their attributes were the *mortar and pestle, a *box of ointments, and *surgical instruments.

Council of Trent. The ecumenical council convened in Trent from 1545 to 1565 to examine, study, and promulgate official ecclesiastical decrees defining the Roman Catholic Church's position on all aspects of Christian life, religious practice, liturgy, and canon law. Directly responding to the attacks and critiques of the Protestant Reformers, the Council of Trent carefully defined *Roman Catholic orthodoxy and codified the practice and meaning of Roman Catholicism until the Second Vatican Council (1962–1965). At its Twenty-fifth Session in December 1563, the Council of Trent issued a decree "On the Invocation, Veneration, and Relics of Saints, and on Sacred Images," in which the accepted rules and regulations for art in the church were defined. Works of art as visual images of moral and religious pedagogy were to be welcomed into the church as long as they were appropriate to scripture and church teachings, and were not of a lascivious nature. The ultimate judge of the appropriateness of a work of art for the church was the local bishop.

Counter-Reformation. The Roman Catholic Church's formal response to the theological and critical attacks of the Reformers. This response was shaped by the *Council of Trent, the establishment of new religious orders including the Society of Jesus, and the new spirituality as advocated by *Teresa of Avila, *John of the Cross, *Vincent de Paul, and others. It clearly defined Roman Catholic identity and spirituality and led to the reinvigoration of religious *iconography, especially the development of new motifs that visually defended the church against the Reformers's criticisms, such as the motif of the penitential saints in defense of the sacrament of penance, and those of the *Immaculate Conception and Assumption in defense of *Mary.

Crab. This crustacean which regularly shed its shell was a sign of the *Resurrection of Jesus Christ.

54. Lucas Cranach, *The Torgau Altarpiece*.

Cranach, Lucas (1472–1553). One of the leading sixteenth-century German artists and a close friend and supporter of *Martin Luther. The Court Painter to the Electors of Saxony, Cranach's artistic interests varied from portraiture to religious themes with *landscapes. A talented engraver, etcher, and printmaker, Cranach was important in the initial development of the *iconography of the Reformation. He painted *altarpieces and single panel paintings illustrating Luther's theology, and also produced a series of woodcuts to illustrate Luther's writings and his translation of the Bible into German in 1520. Along with his son, Lucas Cranach the Younger (1515–1586), Cranach the Elder developed a series of iconographic types, such as the theme of the *Law and the Gospel,* as well as the inclusion of portraits of the Reformers within the context of biblical events such as the *Last Supper.* His portraits of Luther created a visual biography of the great Reformer. Cranach the Elder was also important for his depictions of biblical heroines, and helping to popularize the themes of the *Holy Kindred* and *Blessing the Little Children.*

Crane. An avian symbol for loyalty, good works, vigilance, and order, especially in terms of the monastic life. According to legend, the cranes gathered every evening and formed a protective *circle around their *king. One crane was selected as the watch for the evening; to insure that it remained, this crane had to balance itself on one leg, so that if it fell asleep it would fall to the ground and awaken immediately .

Crescent. This symbol of the purity of *Mary was assimilated into Christian art and symbolism from her association with the classical Greco-Roman virginal goddesses of the moon, *Artemis and *Diana. In Spanish art, Mary was represented standing on an upside-down crescent *moon which signified the triumph of Spanish Christianity over Islam. When placed within a *circle, the crescent represented the Kingdom of *Heaven.

Crocodile. An animal symbol for hypocrisy. Insincere "crocodile tears" supposedly were shed by this animal after it had entrapped and eaten its human prey. Reputed to have uncontrollable sexual urges, the crocodile was also a symbol of lust. In Christian art, the crocodile—like the *whale—was associated with *Hell because it slid through the mud into the *waters, and had large teeth like the "maws of Hell."

Crosier. A staff symbolizing mercy, authority, and correction of vice. The pastoral staff of a bishop or abbot, the crosier was an ornate interpretation of what was once a simple and functional walking staff or shepherd's crook. The crosier was an *attribute of *Benedict of Nursia, *Bernard of Clairvaux, *Bridget of Sweden, and *Clare of Assisi as founders of their orders. A crosier with a fish typified *Zeno, while one with a two-barred cross represented *Gregory the Great and *Sylvester.

Cross. An ancient, universal symbol of the conjunction of opposites with the vertical bar representing the posi-

tive forces of life and spirituality and the horizontal bar the negative forces of death and materialism. The cross also symbolized the meeting of *heaven and *earth. As the instrument of the death of Jesus, the cross became the primary emblem of Christianity, signifying both the sacrifice of Jesus Christ and his victory over death through the Resurrection. In Christian legend and art, the cross became a sign of the *Tree of Life and the Tree of Paradise. There were over four hundred varieties of the cross possible in Christian art and symbolism. The most commonly represented form was the Latin cross, in which the upper vertical bar and two horizontal bars were equal in size while the lower vertical bar was elongated. According to Christian tradition, Jesus was believed to have been crucified on a Latin cross, and therefore the Latin cross was a symbol of the Passion. The Greek cross, which was identified by its four equal arms, came to symbolize the *church and represented the basic floor plan for ecclesiastical buildings. An archiepiscopal cross used by bishops and patriarchs was a Latin cross with an additional shortened upper crossbar for the placement of the inscription. An Eastern Christian variant of the archiepiscopal cross included a slanted crossbar towards the bottom of the cross to suggest the *suppadaneum* ("footrest"). A Latin cross on a pedestal of three-graded steps was the Calvary cross, while the Papal cross was a Latin cross with three graduated, ascending bars. In remembrance of his crucifixion, *Andrew was identified with the X-shaped or saltire cross. The Old Testament cross that

served as the sign of the Passover was also known as the *T, *tau,* or Egyptian cross, and was an attribute of *Philip and *Anthony the Abbot. The Maltese cross—the sign of the Crusaders, Hospitalers, and Knights of Malta—was a Latin cross whose arms ended in inward-pointed spearheads. A Celtic cross was elaborately carved with the stories of the Passion, Death, and Resurrection, and with a circle incised around its central crossing. A simple Latin cross was the sign of *Reparata and *Margaret, while one with loaves of *bread represented *Philip. A Latin cross with a chalice suggested the *Agony in the Garden, while with a *crown it denoted the reward of the faithful in *heaven. *Catherine of Siena was signified by a Latin cross surmounted by a *lily or a *heart, *John the Baptist by a Latin cross with a *reed, and *Helena by a Latin cross with a *hammer and *nails. The Church Triumphant was represented by a Latin cross surmounting an *orb or the *globe, while the Latin cross on an obelisk represented the Triumph of Christianity over Paganism. A *red Latin cross on a *white *banner typified *George of Cappadocia and *Ursula. When the Christ Child held a cross it meant a prophecy of his destiny.

Cross, Finding of the True. *See* Finding of the True Cross.

Crow. An avian symbol for solitude and the *Devil blinding sinners, the crow was an *attribute of *Vincent of Saragossa.

Crown. A sign of distinction, royalty, and victory. In Christian art,

crowns denoted the royal lineage of a particular *saint or of *Mary, who was from the Royal House of *David. When worn by a martyr, a crown implied victory over human sinfulness and death. *Catherine of Alexandria wore a royal crown, as did Mary as Queen of Heaven. *Elizabeth of Hungary was signified by the triple crown of her royal birth, royal marriage, and royal status in *heaven. *Cecilia wore a crown of *lilies and *roses; *Louis of France, *Catherine of Siena, *Veronica, and William of Norwich each a crown of thorns. *Louis of Toulouse was illustrated standing on a crown and scepter. The crown of thorns and *nails symbolized the Passion and Crucifixion. The crown of thorns was a symbolic reversal of the Roman Imperial Crown of Roses.

Crowning with Thorns (Mt 27:27–29; Mk 15:16–20; Jn 19:1–5). Having scourged Jesus, the Roman soldiers crowned him King of the Jews with a crown of thorns. They also placed a royal purple robe over his shoulders and bowed before him. They then took him to *Pontius Pilate, who presented him to the crowd. This episode was the foundation for the Christian image of the *Ecce Homo, Latin for "Behold the Man." During periods of Christian devotions to the sufferings of Christ, the crown of thorns was composed of large, thick thorns which drew *blood and further wounded the flagellated Jesus. A popular image for Christian devotionalism, the Ecce Homo also had liturgical use.

Crozier. See Crosier.

Cruciform nimbus. Symbol for the Resurrected *Christ. This special halo had three lines radiating from the sides and top of Christ's *head, implying that were his head transparent the fullness of the cross would be revealed. The cruciform nimbus signified that Jesus had passed through the Passion and Death, and had experienced the Resurrection.

Crucifix. A Latin *cross with a representation of the *body of the crucified Jesus, and an *attribute of Jesus Christ. A crucifix with *lilies was an attribute of *Nicholas of Tolentino, and a crucifix between a stag's antlers signified *Eustace and *Hubert. John Gualbert was identified as kneeling before a crucifix as the head of the Crucified Christ bent towards him. The crucifix with a skull denoted the penitential saints, including *Mary Magdalene, *Francis of Assisi, and *Charles Borromeo.

Crucifixion of Jesus Christ (Mt 27:33–50, Mk 15:22–32, Lk 23:33–43, Jn 19:16–30, Ps 22:1). Scriptural event signifying the final episode in the earthly life of Jesus. After nailing him to the *cross, the Roman soldiers placed a titulus over Jesus' *head with the inscription, "Jesus of Nazareth King of the Jews." Among the crowd of spectators were *Mary, *Mary Magdalene, other holy women, *John the Evangelist, *Nicodemus, and *Joseph of Arimathea. A soldier (later identified as *Longinus) speared the side of Jesus to hasten his death.

Beginning with the fourth century, the Crucifixion was one of the central images in the history of Christian art. In earliest Christianity, the daily

55. *Crucifixion.*

56. *Crucifixion.*

57. Master of Saint Veronica, *The Crucifixion.*
58. Mathias Grünewald, *Crucifixion* detail from *Isenheim Altarpiece.*

threat of crucifixion combined with a fear of idolatry to deter images of the Crucifixion. Following the Emperor *Constantine's decrees of toleration and political recognition of Christianity, images of the Crucifixion began to enter into Christian art as the *Cross, *Crucifix, and Crucifixion became the central identifying emblems of the Christian, replacing that of the *fish. The *iconography of the Crucifixion was directly related to developments in Christology. For the next few centuries, the Crucifixion was depicted as a scene of victory as the figure of Jesus took on the motif of the *Christus Victor* ("Victorious Christ"), who was rendered as a static, elegant figure garbed in royal *robes, standing firmly with two *feet spread apart on the *suppadaneum* ("footrest") and his two arms outstretched with regal grandeur. The *Christus Victor* wore a crown and was wide-eyed as the moment of the death was fused with the triumph of the Resurrection. In *byzantine art, the Crucifixion was transformed by the aspects of the *Christus Dolor* ("Sad Christ"), whose body was covered only by a loincloth thus exposing his humanity and his wounded side. His head tilted to the side, his arms drooped, and his eyes began to close. Two streams poured from his wounded side—a *white one signifying the *waters of *baptism and a *red one the *blood of the *Eucharist, the two central sacraments of all the Christian traditions. Jesus was now accompanied by his mother, who mourned his sufferings with her gestures of sorrow, and *John the Evangelist, who typified the Christian faithful. In the early medieval period,

the Crucifixion became more complex in *iconography and theological meaning. As *Anselm of Canterbury preached the Doctrine of Atonement, the figure of the Crucified Jesus displayed the characteristics of the *Christus Patiens* ("Patient Christ"), portrayed with his head sagged down on his chest, his arms hung heavily with pain, and his legs twisted together in agony as the previous four *nails were replaced by only three. The body was more exposed and the physical sufferings exacerbated by the dripping blood which was captured into little *chalices by the accompanying *angels and *Adam and *Eve, who were reputedly buried at the foot of the cross. Mary was now accompanied by the other holy women, including *Mary Magdalene, who mourned uncontrollably. John the Evangelist was joined by other *apostles and male figures including the Roman centurion who became identified as Longinus. As the medieval dramas emphasized more and more the agony of the death experience and the emotional sufferings of the followers, the composition of the Crucifixion became more and more crowded and complex. The final stage in the iconographic development of the Crucifixion was the *Christus Mortuus* ("Dead Christ") of the late fourteenth and early fifteenth century, which was favored by northern artists like Martin Schongauer and *Mathias Grünewald. In these depictions, the body of Jesus reflected all the aspects of physical death and tremendous suffering. His loincloth became smaller and smaller as a sign of the revelation of his full humanity and the totality of his physical pain. The crowd had

became a mob as the Magdalene clutched the foot of the cross, Mary swooned into the arms of John, and other identifiable and unidentifiable figures covered the lower register of the composition.

Cruet. Small pitcherlike vessel with a stopper that contained the wine or the water for the sacrament of the *Eucharist. In Christian art, a cruet signified the redemption of humanity by *Jesus Christ.

Crutch. A sign of great age, or the need of support to walk or to stand for an injured or ill person. A crutch with a *bell attached to it was an *attribute of *Anthony the Abbot.

Cup. A sign for the *Agony in the Garden (Mt 26:39). *See also* Chalice.

Cup and Wafer. Symbols of the *Eucharist and an *attribute of *Barbara in Christian art.

Cup with serpent(s). A symbol for *John the Evangelist as the poisoned wine he was about to drink miraculously turned into *serpent(s).

Cupid. Son of *Venus and *Mars, Roman god of love, and identified with the Greek Eros and the Latin Amor. An impish young male creature, Cupid was notorious for shooting *arrows of impassioned love into his unsuspecting victims, who could neither deny or forget the new "object of their affection." The famous legend of his love affair with Psyche was an allegory of the progress of the perfection of the *soul. A popular image in classical Greco-Roman and *renaissance art, Cupid with his *bow and arrows represented profane love.

Cyclamen. A floral symbol whose red center signified the bleeding heart and sorrow of *Mary at the death of her son.

Cypress. A classical Greco-Roman symbol for death. An evergreen *tree that was popular in cemeteries, the cypress took on its symbolic meaning because it never recovered from any pruning. Cypress branches were carried at funeral processions as a sign of death.

D

❧

Daffodil. An attribute of *David, the patron of Wales.

Dagger. An attribute of those martyrs who were stabbed to death, including Edmund the Martyr, *Lucy, and *Peter Martyr.

Daisy. A floral symbol for simplicity and innocence, particularly that of the Christ Child.

Dalmatic. The traditional long-sleeved, calf-length, outer tunic worn over the *alb of a *deacon, or formerly under the *chasuble of bishops and abbots during pontifical masses. Usually identified as the *liturgical vesture of a deacon, the dalmatic's *cross shape signified the *Passion of Jesus Christ, and was interpreted as a garment of salvation. From the fourth to the twelfth centuries, dalmatics were *white with two parallel, lengthwise colored stripes. After the twelfth century, dalmatics were coordinated to the colors of the liturgical season and had one central colored stripe. In *renaissance art, bishops and abbots were depicted wearing both chasubles and dalmatics. The white dalmatic was an *attribute of *Stephen, *Laurence, and *Vincent of Saragossa.

Damian. *See* Saints Cosmas and Damian.

Danae. Only daughter of Acrisius, King of Argos, in Greek mythology. According to an ancient prophesy, her son would bring about the death of Acrisius. In an effort to protect himself, the *king had his daughter imprisoned in a bronze *tower. Nonetheless, the god *Zeus came to her in the form of a shower of *gold, and she bore him a son, Perseus. Acrisius locked Danae and her son in a chest which was cast into the sea. After floating to the island of Seriphus, the chest was found by Dictys, a fisherman, who sheltered Danae and Perseus. Dictys' brother, Polydectes, was of Seriphus. He fell in love with Danae, who spurned his advances. In an attempt to garner her affection,

Polydectes sent Perseus to capture the *head of the *Medusa. When he returned, Perseus recognized that his mother was being harassed, so Perseus displayed the Medusa's head at a banquet and the king and his companions were immediately turned into stone. Danae was the Greco-Roman mythological foretype for several *Old Testament women including *Susanna and *Bathsheba. As a symbol of chastity and miraculous conception, Danae was a medieval foretype of the Virgin Annunciate.

Dance. Patterned movement of the body, signifying both joyous celebration and sexual seduction. Depictions of the celebratory dances of *David and of *Miriam were found in *medieval art, while the representations of the Dance Around the *Golden Calf signified licentious behavior and were modeled upon classical Greco-Roman images of the Dionysian reveleries and bacchanals. The Christian ambivalence towards dance as celebratory and seductive was evidenced in the history of the images of *Salome. In the apocryphal *Acts of the Saint John*, the twelve *apostles circled *Jesus Christ. The celebratory circle dances and processions practiced in the early and medieval Christian liturgies were the sources for the medieval and renaissance depictions of the Dance of the Angels and the Dance of the Blessed in paintings of the *Last Judgment.

Dance of Death. Medieval belief that the dead rose form their *tombs at midnight and danced before leaving the cemetery to claim "fresh" lives. The Dance of Death became confused (and conflated) with the *Danse Macabre. The most famous images of the Dance of Death were found in the series of woodcuts by *Albrecht Dürer and *Hans Holbein.

Dandelion. Bitter herb that the Israelites were ordered to eat at the *Passover meal (Ex 12: 8). A symbol of suffering and grief, the dandelion signified the *Passion of Jesus Christ and thereby placed in scenes of the Crucifixion, *Noli me tangere*, and *Veil of Veronica. In images of the *Madonna and Child, the dandelion implied his Passion, and their foreknowledge of the events to come. The medicinal qualities of this flower made it an *attribute of *Mary in *medieval art.

Daniel. Brilliant interpreter of dreams and visions, and one of the four major prophets of the *Old Testament, including *Ezekiel, *Isaiah, and *Jeremiah. Daniel served in the court of Babylonian rulers Nebuchadnezzar and Belshazzar, and his adventures and visions are recorded in the Book of Daniel. His four apocalyptic visions of the great beasts prophesied the future course of history and were popular motifs in *medieval art. The story of *Susanna rescued by the young Daniel from unjust accusation was believed to be an addition to the Book of Daniel (Dn 13 or the apocryphal Book of Susanna). In his rescue of the innocent Susanna, Daniel prefigured *Jesus Christ and the salvation of Christians. The Book of Daniel was interpreted by early and medieval Christians as a foretype for the Book of Revelation. He was an Old Testament foretype of Jesus Christ and the *Hebrew personifica-

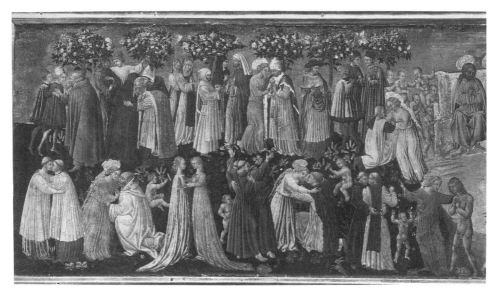

59. Giovanni di Paolo di Grazia, *Dance of the Blessed* detail from *Last Judgment*.

60. Hans Holbein, *End of Mankind* from the series *Dance of Death*.
61. Peter Paul Rubens, *Daniel in the Lions' Den*.

tion of *Justice. *Three Hebrews in the Fiery Furnace* (Dn 3:19–30): Daniel's three friends, Shadrach, Meshach, and Abednego, although placed in positions of authority in Babylon, would not worship the golden image of Nebuchadnezzar, and were caste into a fiery furnace. As they were miraculously not consumed by the flames, the Three Hebrews in the Fiery Furnace was a foretype of *Mary's perpetual virginity and of the salvation of Christians. *Belshazzar's Feast* (Dn 5): Daniel's ability to interpret the mysterious writing which appeared on the banquet hall wall during the reign of Belshazzar announced the downfall of the *king for his act of blasphemy—profaning the Jewish temple vessels by drinking wine from them. This theme was popular in Reformation and nineteenth-century American art as a prophecy of the downfall of religious tyranny. *Daniel in the Lions's Den* (Dn 6): As a *Jew, Daniel himself was unable to obey a decree of the Emperor Darius, and was condemned to death in the lion's den. God again intervened, and at the end of seven days Daniel was released unharmed from the lion's den. This event was a foretype of the *Passion, Death, and *Resurrection of Jesus Christ, and the salvation of Christians.

Danse Macabre. Visual allegory of death as a lively *skeleton or corpse who led all levels of humanity (popes, housewives, emperors, lords, knights, and children) in a processional *dance in which both the living and the dead participated. Originating from fourteenth-century German morality plays, the Danse Macabre

became very popular throughout the late Middle Ages, especially in those areas decimated by the Black Plague. The first depiction of the Danse Macabre was the stone relief in Holy Innocents Cemetery, Paris (1424/5). The Danse Macabre became confused (and conflated) with the *Dance of Death.

Dante, Alighieri (1265–1321). Author of *The Divine Comedy.* Divided into three parts, this narrative poem recounted the poet's journey through *Hell and Purgatory, accompanied by Virgil, and into *Paradise, accompanied by his ideal woman, Beatrice. Dante's vivid descriptions of both the settings and the persons he saw on his journey were influential upon depictions of heaven and hell in late *medieval and *renaissance art. His daily conversations with *Giotto in Padua influenced the latter's representation of the *Last Judgment*, in particular the image of the *Devil as *blue in *color and frozen in ice in the deepest pit of Hell.

Daphne. Mythological huntress who, like the virgin goddess *Artemis, rejected all suitors. *Apollo fell in love with her, but she sought refuge from his advances by praying to her father, the river god Peneus. Just as Apollo was about to embrace Daphne she was transformed into a *laurel tree. Binding his head with laurel leaves, Apollo promised that the laurel would always be green as a sign of his eternal love for Daphne. The *laurel wreath became the prize awarded to victors at the Pythian Games in Delphi, which were dedicated to Apollo. The laurel wreath became a symbol of

both the champion and of victory, and was assimilated into early Christian art through the writings of those church fathers who described the early Christian martyrs as the *Athletes of God.

Darkness. Sign for the absence of light and thereby of God. The absence of God manifested spiritual darkness and the presence of the *Devil, who was the prince of darkness.

David. Youngest son of Jesse, and second Hebrew king, traditionally the author of the Book of Psalms and an ancestor and foretype of *Jesus Christ. A national hero and great poet, David symbolized ideal kingship. *David and Saul* (1 Sm 16:14–23): As a young shepherd boy, David was chosen by God to succeed *Saul, and was so anointed by the *prophet Samuel. Soon after, David earned a position in Saul's court by soothing the king's headaches with the music from his *harp, prefiguring the healing power of Jesus. *David and Goliath* (1 Sm 17): The youthful David slew the Philistine giant, Goliath, with a single stone from his slingshot and then decapitated his enemy, prefiguring Jesus Christ as the savior. *David and Bathsheba* (2 Sm 11): Espying *Bathsheba at her bath, David invited her to the palace. They became lovers, and upon learning that Bathsheba was pregnant, David arranged for her husband to be killed in battle. David then married Bathsheba, but he was punished by God for adultery and murder as the child became ill and died. Later Bathsheba gave birth to *Solomon, David's suc-

cessor, and an ancestor of Jesus. In Christian art, his *attributes were a harp and a *crown.

David of Wales, Saint (sixth century). Founder of several monasteries dedicated to severe asceticism in Wales. His famous monastery at Saint David's retained contact with Irish monasteries, and became a *pilgrimage center in the twelfth century when two visits there equaled one visit to Rome. One of the Seven Champions of Christianity, he was the patron saint of Wales. In Christian art, David was depicted garbed as a bishop and standing on a mound, a reference to his position at the Synod of Brefi. A *dove rested on his shoulder as a sign of divine inspiration, especially for his eloquence against the Pelagian heresy. His *attributes included the *daffodil and the *leek.

Dawn. Sign of the coming of *Christ and eternal salvation. Jesus' act of shedding his *blood to redeem humanity was interpreted as a conquest of darkness and a triumph (or return) of the *light. Thus, rosy color was associated with dawn in art and poetry. The Risen Christ wore rose-colored garments in scenes of the Resurrection to imply the dawn of eternal salvation.

Deacon. From the Greek for "to serve" and "server." Originally an officer who offered services, especially of a charitable nature, to the Christian community. For example, seven Greek-speaking deacons looked after the needs of Hellenistic Christians in Jerusalem (Acts 6:1–6). In Christian art, *Stephen, Cyriacus, *Laurence,

and *Vincent of Saragossa were depicted as deacons. As the ecclesiastical hierarchy became more institutionalized, the office of deacon became transitional as a preparation for ordination to the priesthood.

Deaconess. From the Greek for "to serve" and "server." Pious women, usually widows, who cared for the sick, the poor, and the elderly, and assisted in the *baptism of women in the early church. With the coming of the institutionalized church in the fourth century and the eventual decline of the practice of adult baptism, the office of deaconess faded and the title was retired in the tenth century. In 1861, the Anglican Church reinstituted the office of deaconess. In early Christian art, deaconesses were depicted as women assisting in the care of the sick, the administration of the *Eucharist of *milk and *honey, and the baptism of female catechumens.

Death. Personified by a *skeleton or mummified corpse, Death was garbed in *black *robes, and held either an *hourglass, which measured the passage of life, or a *scythe, which quickly cut off life. A creature of the night, Death was often fused with *Time. In Christian art, the common symbols for death were the *skull or death's head moth as memento mori signifying the transitory nature of life; a skull with wings indicating death's swiftness; and an hourglass suggesting the passage of life. Scriptural sources for the imagery of Death were the meditation on the vanities of life (Eccl 3) and the description of the *Four Horsemen of the Apocalypse in which Death rode a Pale Horse (Rv 6:8). The symbolism of Death was popular in *medieval art, especially during the era of the Black Plague.

Death of the Virgin Mary. *See* Dormition of the Virgin Mary.

Deborah. Only female judge of Israel, and a prophetess (Jgs 4:4). "The Song of Deborah" is the oldest written biblical text. She directed the war against the Canaanite general, Sisera, who was eventually killed by *Jael (Jgs 4:17–22). Representations of Deborah were rare in Christian art; when they did exist, she was in the context of either the female worthies (classical and biblical women of valor including *Lucretia and *Judith) or *Old Testament foretypes of *Mary.

Decalogue. From the Greek for "ten words." Term signifying the Ten Commandments.

Decapolis Deaf Mute (Mk 7:31–37). A deaf mute was brought to Jesus for a cure in Decapolis. Through a series of gestures and physical contact with the man's ears and tongue, Jesus restored his voice and hearing. This miraculous healing was very rare in Christian art, and was usually fused with other "healings."

Deer. An animal symbol for the Christian *soul thirsting for God (Ps 42:1). In association with a particular saint or martyr, the deer denoted either the moment of conversion, miraculous salvation, or martyrdom. A deer whose *head rested on a man's lap signified *Giles, while a stag with a *crucifix between its antlers was an *attribute of *Eustace and *Hubert.

Deesis. From the Greek for "entreaty." The grouping of the Resurrected Christ enthroned in majesty with *Mary and *John the Baptist, on either side. As the two intercessors, Mary and John typified the sacrifices of the flesh and the spirit. This motif was first developed in byzantine *iconography and transferred to northern *medieval art, as exemplified by *Hubert and Jan van Eyck's *The Ghent Altarpiece*. By the High Renaissance, the deesis became the central grouping in depictions of the *Last Judgment.

Delilah. From the Hebrew "to enfeeble." A woman from the Valley of Sorek who became *Samson's lover (Jgs 13:5). After repeated goadings, she learned that the secret of Samson's strength lay in his unshorn locks. She betrayed him for eleven hundred silver shekels to the Philistines, who captured him in Delilah's bedroom before cutting off his *hair and blinding him. A favorite subject of northern artists including *Lucas Cranach and *Rembrandt van Rijn, Delilah became one of the great temptresses of western art. She was categorized along with Tomyris, *Judith, and *Salome as a headhuntress. In Christian art, the story of Samson and Delilah was popular in manuscript *illuminations which depicted Delilah herself cutting Samson's hair. Delilah's betrayal of Samson for *silver shekels was a foretype of the *Betrayal by Judas for thirty pieces of silver.

Delivery of the Law (*Traditio Legis*). The transfer of the *scroll of the new law of Christianity from *Jesus Christ to *Peter and *Paul, who symbolized the *church. Without literal scriptural foundation but based on Matthew 16:13, this scene was popular on early Christian *sarcophagi from the fourth century and in ecclesial *mosaics from the fifth century. In several of the earliest representations of the Delivery of the Law, Jesus Christ handed the scroll to Paul as Peter watched. The more traditional and numerous depictions of this scene had Peter receiving the scroll from Jesus Christ and acclaim from Paul. These visual images were used as evidence to defend the primacy of the Papacy in medieval theology, as well as counter-reformation theology and *iconography.

Demeter. The Greek goddess of the *earth, donor of the earth's abundance, and patroness of agrarian civilizations. The abduction of her daughter, *Persephone (or Kore), by *Hades, the god of the Underworld, was central to the worship of Demeter. In sorrow, Demeter abandoned Mount Olympus and walked the earth in the form of an elderly woman. The earth became bare and humanity was subject to famine and death. Despite all the entreaties by *Zeus, Demeter demanded the return of Persephone. Hades agreed on the condition that Persephone spend six months of the year, equal to the number of *pomegranate seeds she had eaten in the underworld, with him. This story explained the cyclic patterns of the seasons, and the rhythm of the sowing and harvesting of crops. Demeter was a classical Greco-Roman foretype for *Mary both as an earth mother and a sor-

rowing mother. Many of her physical characteristics and attributes were assimilated into the early and byzantine Christian images of Mary. In classical Greco-Roman and *renaissance art, Demeter was depicted as a mature woman, fully clothed with a *veil over her *head, and often accompanied by Persephone. Her *attributes were sheaves of *wheat or corn, or *baskets of *fruits and *flowers, denoting the earth's abundance, and *poppies signifying sleep and death.

Demon in Chains. A symbol of the defeat of heresy. A Demon in Chains was an *attribute of *Bernard of Clairvaux.

Demon. The "fallen angels" who accompanied the *Devil (Satan, Lucifer) in his rebellion against God, and who served in *Hell as tormentors of the damned. Demons were identified by their dark color, usually *black, and sinister gestures in *medieval and *renaissance art, especially in depictions of the *Last Judgment.

Denial of Peter (Mt 26:69–75; Mk 14:66–72; Lk 22:54–62; Jn 18:15–18, 25–27). When Jesus prophesied at the *Last Supper that *Peter would deny him three times before the *cock crew, the *apostle protested. Nonetheless, the triple denial occurred just as Jesus had predicted. When Peter heard the cock crow for the third time, he cried with shame and remorse. Representations of the Denial of Peter were included within the Passion cycle and was rarely depicted as an independent topic. The motif of Peter in Tears derived from the Denial of Peter and became popular in

*Counter-Reformation art and spirituality.

Denis, Saint (d. 272). First bishop of Paris and patron of France. Denis was a Roman missionary who evangelized Gaul until his martyrdom in 272. Immediately following his decapitation, Denis reputedly carried his severed head some six miles from Montmarte (Martyrs' Hill) to the site of the future Benedictine Abbey and Cathedral which bore his name. Denis was one of the *Fourteen Holy Helpers and one of the Seven Champions of Christianity. He was commonly confused with Dionysus the Areopagite, the famed companion of *Paul, and Pseudo-Dionysus, who authored the *Celestial Hierarchies*. In the twelfth century, the Abbot Suger based his development of gothic architecture while building the new Cathedral of Saint Denis upon the conflated figures of Denis, Dionysus, and Pseudo-Dionysus, utilizing the theology of light and color espoused in the *Celestial Hierarchies*. In Christian art, Denis was depicted dressed in a bishop's attire and carrying his severed head.

Deposition (Mt 28:58–60; Mk 15:46; Lk 23:53; Jn 19:38–40). Scriptural event signifying the removal of the body of Jesus from the cross. Following Jewish law, bodies could not hang on the gallows or the cross after sunset, and the burial of the body was an act of Jewish piety. According to all four Gospels, *Joseph of Arimathea received permission from *Pontius Pilate to remove the body from the cross. In the earliest depictions of the Deposition, also identified as the De-

62. Hubert and Jan van Eyck, detail of *Last Judgment (Deesis)* detail from *Ghent Altarpiece*.

63. Rogier van der Weyden, *The Deposition*.

scent from the Cross, Joseph acted alone to remove the body from the cross. In the ninth century, the figure of *Nicodemus entered this scene, either assisting Joseph with the body of Jesus or removing the *nails from the body. In tenth-century byzantine icons of this theme, *Mary and *John the Evangelist watched as Joseph and Nicodemus removed the body. By the thirteenth century, the *iconography of the Deposition expanded to include a larger group of mourners, including *Mary Magdalene, and more dramatic action, no doubt in tandem with the development of liturgical drama and devotional practices. From the late medieval into the baroque periods, the characters and symbolic objects become more exaggerated. The expressions of grief, most especially Mary Magdalene's, became heightened as this scene became the moment in which the followers recognized what they believed to be the death of Jesus. As Joseph of Arimathea was a man of wealth and social status, he became the scriptural basis for the late medieval and renaissance inclusion of the portraits of wealthy *donors into this scene. The *Three Marys were included in the background of this scene to indicate the anointing of the body prior to the *Entombment. The *Lamentation, a variant of this theme, denoted the mourning and grief of the gathered followers over the crucified body which had been removed from the cross. A popular variant, the *Pietà, was developed in medieval German art and depicted only *Mary mourning her dead son. In the course of Christian art, the Deposition and its variants became conflated with the Entombment.

Descent from the Cross. *See* Deposition.

Descent into Hell. Event signifying the ancient belief canonized by the Apostles' Creed and alluded to in the *New Testament (Acts 2:27–31; 1 Pt 3:18–19, 4:6) that as the body of the crucified Jesus rested in the *tomb, his *soul descended into Hell. This topic was also identified as the Descent into Limbo (literally the "lip" of Hell, understood as the place where the souls of unbaptized children and the righteous born before Jesus rested). According to the apocryphal *Gospel of Nicodemus*, Christ descended into Limbo to crush *Satan and free the souls of the dead, including *Adam and *Eve; the *prophets, heroes, and rulers of the *Old Testament; and the other righteous. This event was also identified as the Harrowing of Hell. In the Eastern Orthodox Church, this event and its *iconography was identified as the *Anastasis* or *Resurrection. This event was prefigured by *Jonah in the belly of the whale, *Daniel in the lion's den, *Samson opening the lion's mouth, and *David saving the lamb from the bear. A popular theme in Christian art, especially during the medieval period, but rare after the sixteenth century, the Descent into Hell was characterized by the shining *white garments and *banner of the Risen Christ whose *body bore the marks of his *wounds, and the varied personages such as *David and *Moses he released from Hell (Limbo).

Descent into Limbo. *See* Descent into Hell.

Desert. Ambiguous symbol for desolation or contemplation. In the *Old Testament, the desert typified separation from God and the place of his special intense presence. In the *New Testament, it was the place of retreat and of trial for both Jesus and *John the Baptist. Hermit saints and the famed desert fathers of earliest Christianity withdrew to the desert in order to meditate, be close to God, and be free of temptations.

Devil. Symbol for evil personified. The *Devil was also identified as *Satan (from the Hebrew for "adversary" and possibly an ancient desert deity) and *Lucifer ("the morning star"). The devils were the *angels who fell with Lucifer in his unsuccessful rebellion against God. In Christian art, these devils were usually depicted as evil angels, that is, formed like angels but covered from *head to toe in *black. As the tormenters of *souls in *Hell and the tempters of *saints, these devils came to be imaged as small *animals, especially as *cats or *monkeys, or in horrific shapes, and were seen whispering in the ears of those being tempted. In certain depictions of the temptations of saints, especially those of *Anthony the Abbot, the devil adopted the guise of a beautiful woman. Devils were popular elements in depictions of the *Last Judgment and the temptations of saints in *medieval and *renaissance art.

Dextera Domini. The right hand of God. In both the Hebraic and Chris-

tian traditions, the right hand of God was a sign of energy and power, as this was the hand with which God created and judged. The *Dextera Domini* was one of the earliest symbols in Christian art for God the Father.

Diana. Virginal Roman goddess of the *moon and the hunt, and the protectress of chastity, women, and childbirth. The twin sister of the sun god, *Apollo, Diana's most celebrated shrine was in Ephesus, which was visited by those who saw her as the Great Mother. She was a foretype of *Mary, whose imagery assimilated many of Diana's attributes including the *crescent moon. The Council of Ephesus (431) decreed Mary as Theotokos ("God-bearer") and defined her role in the Christian mysteries. The site of this council was carefully selected to signify that Mary fulfilled and superseded the place of the virgin goddess of the moon and the hunt. In Hellenistic, early Christian, and *renaissance art, Diana was represented as a beautiful young woman clad in a tunic with a crescent moon in her hair who carried a bow and arrow over her shoulder and was accompanied by her faithful *dogs.

Dice. A visual reference to the soldiers who cast lots for the clothing of Jesus at the Crucifixion (Jn 19:23–24), and a symbol of the Passion.

Dikir. From the Greek for "two candles." A double-branched *candlestick which was employed by an Eastern bishop along with the *trikir* (three-branched candle holder) to bestow blessings on the faithful. The *dikir* denoted the two natures of

*Jesus Christ while the *trikir* represented the *Trinity.

Dionysus. Greek god of fertility and wine, the patron of choral song and drama, and the youngest of the Olympian gods. As the son of *Zeus and the human Semele, Dionysus was the only god to have a human parent. As the male equivalent of *Persephone, Dionysus belonged to two worlds—*earth and underworld—and his autumnal sojourn in the underworld was interpreted as a death experience which resulted in resurrection each spring. The rites held to mourn both his symbolic death and celebrate his rebirth were given over to wild reveleries led by the maenads and bacchae. With his half-human, half-divine form and his cyclic death and resurrection, Dionysus became a classical Greco-Roman foretype of *Jesus Christ. Many of his attributes and physical characteristics were assimilated into the early and byzantine Christian images of Jesus Christ. In classical Greco-Roman and *renaissance art, Dionysus was portrayed as either an ancient, bearded man or as a youthful, but feminine, male figure whose long *hair was crowned by a wreath of grapevines. His *attributes included the *grapevine, *ivy, *rose, *panther, *lion, *ox, and *dolphin.

Diptych. From the Greek for "a pair of tablets." Originally a pair of ivory, wood, or metal tablets hinged together. The cover tablet was decorated with Christian imagery and the inside tablet was covered with wax to allow for a written text, which was a record of the names of the living and the dead which was to be read during liturgical services. In the medieval and renaissance periods, the term diptych became associated with a picture consisting of two parts that were usually hinged together. In the medieval diptych, the portrait of the *donor in a position of prayer was on one panel and a depiction of the *Madonna and Child on the other panel. These medieval diptychs served either as objects of private devotion or as memorial portraits. The original concept of the diptych was related to the renaissance style of portraiture in which two painted panels were hinged together with the outer panel, and designed with symbols and *attributes of the person whose portrait was inside, acting as a cover.

Dish. A symbol or *attribute for certain biblical events or persons. A paten, or shallow dish, signified the *Last Supper, and often contained a *fish or *bread. A dish with bread and fish typified the miracle of the Multiplication of *Loaves and Fishes. A dish with a man's *head was an attribute of *John the Baptist. A dish with an *eye or eyes symbolized *Lucy, while a dish with *roses represented *Dorothea. A dish with female *breasts denoted Agatha, and a dish with a *bag of money signified *Laurence.

Dishonest Manager. *See* Parables.

Dismas. The name of the "good" thief crucified with Jesus and *Gestas the "bad" thief according to the apocryphal *Gospel of Nicodemus.*

Dispute in the Temple. *See* Christ Among the Doctors.

Doctors of the Church. These Christian theologians were distinguished for their *wisdom, sanctity, and theological learning. Originally this term signified the Four Fathers of the Western Church: *Gregory the Great, *Ambrose, *Augustine, and *Jerome; and the Four Fathers of the Eastern Church: *Basil the Great, *Athanasius, Gregory Nazianzus, and *John Chrysostom. As an honorific title, Doctor of the Church was expanded to a group of about thirty including *Thomas Aquinas and *John of the Cross, but only two women—*Catherine of Siena and *Teresa of Avila. In Christian art, the title normally signified the Four Fathers of the Western Church who were each depicted with a *book inscribed with the title(s) of their works. Ambrose and Augustine were identified by bishop's *robes and *miters; Gregory by the papal robe and *tiara; and Jerome by the cardinal's robe and *hat.

Dog. An ambiguous animal symbol in Christian art denoting either fidelity or evil. When the negative aspects of the dog's nature was emphasized, the dog was an abusive and reprehensible figure (Rv 22:15; Phil 3:2). It was a sign of evil as "the hound of Hell" or the *Devil; *black dogs were the companions of *witches; a lascivious female was referred as a "bitch" (female dogs were associated with the goddesses Cybele and *Artemis); the howling of the dog was an omen of death; and anal copulation was typified as "dog style" and interpreted as bestial. In *medieval art, dark dogs symbolized disbelief and/or the heathens. But a dog could also be a symbol of fidelity, devotion, courage, and watchfulness (Jb 30:1; Is 56:10). The dog was the first animal to be domesticated, and therefore a sign of human dominion over animals. When a dog was at the *feet of or stood between a man and woman, it signified the fidelity of marriage. In medieval times, a dog placed at the feet or on the lap of a recumbent female figure on a *tomb sculpture indicated faithfulness unto death. The dog was sometimes used as a symbol for the priest who protected and guided his human flock to eternal salvation. Tobias's dog was his faithful companion on his travels (Tb 6:2). Generally. the dog, played an important and positive role in Christian hagiography and *iconography. *Roch was nurtured by the *bread brought to him by his dog. *Vitus was accompanied by his faithful dog on his *pilgrimages. A dog carrying a torch signified *Dominic's attempts to spread the gospel. The mothers of *Bernard of Clairvaux and Dominic dreamt of dogs before the births of their sons, and these dreams were interpreted as prophetic of the sons becoming propagators of Christianity. Black and white dogs denoted the Dominican Order in a visual pun on the colors of the Dominican habit, and as a verbal pun, the faithfulness and devotion of the dog is part of the pun that the "Domini canes" were the dogs of the Lord.

Dolphin. A symbol for resurrection and salvation. Represented more often than any other form of *fish in Christian art, the dolphin was an elegant and friendly animal. When depicted by itself, the dophin as the swiftest of all animals transported the

*souls of the dead to the next life. A dolphin with an *anchor signified the Christian traveling to salvation or the *church being guided to salvation by *Jesus Christ. A dolphin with a trident represented the Crucifixion. Occasionally, the dolphin substituted for the sea monster in early Christian depictions of the story of *Jonah, whereby the dolphin became a symbol of resurrection and of Christ.

Dominations. *See* Angels.

Dominic, Saint (1170–1221). A Spanish mendicant and theologian renowned for his intellectual learning and his successful campaigns against the Albigensian heresy. Originally a *Benedictine *monk, he established the Dominican Order (1215), which was dedicated to the harmonizing of intellectual life with popular devotion. He was reputed to have initiated the use of the *rosary as an aid to devotion for the illiterate. He was the patron of astronomers. In Christian art, Dominic was depicted in the black-and-white robes of the Dominican Order. A *star over his chest referred to the legend that at the moment of his *baptism, a star shone over his *head. He was occasionally accompanied by a *dog with a *torch in its mouth, denoting his pregnant mother's dream that she had given birth to a dog carrying a flaming torch that would light the world and which was interpreted as a prophecy of his own and his order's missionary activities. His *attributes included the *lily and *rosary.

Dominicans. The Order of Preachers established by *Dominic between 1215 and 1221 to preach and teach the faith, and to combat the heresy of Catharism. A highly influential group of teachers and preachers in the intellectual life of late medieval Europe, the Dominicans were mendicants dedicated to the study and preaching of the *Gospel and to poverty. They were entrusted with the tribunal of the *Inquisition. They were also known as the Black Friars because their *habits that consisted of a long *white garment with a black-hooded *cloak (signifying the death of *Mary). The *scapular, a long flat piece of cloth which hung from the shoulders beneath the cloak and symbolized the yoke of *Jesus Christ, was also part of the Dominican habit. In Christian art, the Dominicans were represented by Dominic, Albertus Magnus, *Thomas Aquinas, and *Peter Martyr.

Dominions. *See* Angels.

Donatello (c. 1386–1466). The greatest Florentine sculptor and the most influential individual artist of the Early Renaissance. His development of heroic types, religious emotion, and measurable space influenced painters in late fifteenth-century Florence and Padua as well as *Andrea Mantegna and *Giovanni Bellini. Influenced by classical Hellenistic and early Christian art, figures such as Donatello's *David* and *Judith* exemplified a new humanity—slightly larger-than-life, with those qualities of valor and will so highly admired in the Early Renaissance. In his later works, such as *The Magdalene*, he emphasized the dramatic impact of extreme ugliness through the dis-

64. Fra Angelico, *Calvary with Saint Dominic.*

torted expression of religious emotions in the gestures and poses of the *human body.

Donkey. *See* Ass.

Donors. Commissioners of a votive work of art, usually an *altarpiece for a *church. The donor was identified as the figure kneeling in prayer with his or her attention focused upon the central theme of the altarpiece, notably the *Madonna and Child or the Crucifixion. If the donor was a man, he was accompanied by his wife and/ or family. The donor was immediately identifiable as being smaller in scale than the other figures in the painting or sculpture. This practice of including the donor's portrait within the work of art began in northern European painting. By the fifteenth century, the inclusion of donor portraits had three advantages: the donor earned indulgences or spiritual merit for the gift of the work of art to the Church, the incorporation of the donor's portrait into the same frame as that of the Madonna and Child rendered social prestige, and the artistic immortality offered to the donor by the portrait.

Door. A symbol of entry. In works of art dedicated to the theme of the *Annunciation to Mary, the door signified a feminine symbol of entry. A door placed by the figure of *Jesus Christ referred to the pronouncement that he was the entry to eternal salvation (Jn 10:7–9). The *three doors on the facade of medieval *cathedrals were interpreted as signs of *faith, *hope, and *charity.

Dormition of the Virgin Mary. From the Greek for "sleep" (apocryphal *Gospel of the Assumption of the Virgin* and *The Golden Legend* 119). Legendary event signifying the "falling asleep" of *Mary at the end of her earthly life. Following the Ascension, Mary reportedly went to live in Ephesus with *John the Evangelist and *Mary Magdalene. After some time, she prayed to be released from this life. *Michael the *Archangel appeared and presented her with a palm branch as a sign that her request was granted by God. According to pious legend, she "fell asleep" in *Jerusalem with all the *apostles present, except for *Thomas. In Christian art, the Dormition and the Assumption were divided into a series of events starting with the *Annunciation of the Death of Mary and ending with her being assumed into *heaven with the assistance of *angels. In the Eastern Orthodox Church and byzantine *iconography, there was a pious belief that after Mary fell asleep, *Christ carried her *soul to heaven. A vivid and lengthy description of the Dormition of the Virgin Mary in *The *Golden Legend* influenced the many medieval paintings on this theme. The Annunciation of the Death of Mary was rarely represented in Christian art, while scenes of her Dormition were popular in the byzantine, medieval, and renaissance periods. In late *renaissance and *baroque art, this theme was misidentified as the Death of the Virgin.

Dorothea of Cappadocia, Saint (d. 303). Virgin *martyr from Caesarea who died during the Diocletian persecutions. Esteemed for her

65. *Dormition of the Virgin.*
66. Michelangelo Merisi da Caravaggio, *Death of the Virgin.*

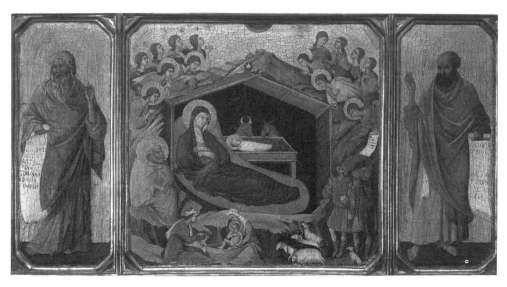

67. Duccio di Buoninsegna, *The Nativity with the Prophets Isaiah and Ezekiel.*

beauty, she was accosted by two apostate women who attempted to defile her. Instead, Dorothea's piety brought them back to the Christian faith. She refused to worship idols and to marry a pagan. Condemned to death, she was taunted by the Roman lawyer, Theophilus, to send him *flowers from *paradise, where *fruits and flowers were believed to be eternally in bloom. Immediately upon Dorothea's decapitation in midwinter, an *angel presented Theophilus with a *basket of *apples and *roses. Stunned, he converted to Christianity and was martyred. Dorothea was the patroness of florists, brides, brewers, and midwives. In Christian art, she was depicted as a beautiful and elegantly garbed young woman with roses in her *hand or on her *head, or with a basket of apples and roses.

Dossal. A richly embroidered or brocaded hanging placed behind the *altar or on the sides of a chancel.

Doubting Thomas (Jn 20:24–29). Scriptural event signifying the *Resurrection of Jesus Christ. As *Thomas was not with the other *apostles when the Resurrected Christ appeared to them on *Easter Sunday, he did not believe in this miraculous event. Eight days later the Resurrected Christ appeared and encouraged the stunned Thomas to place his hands inside the wounds to affirm his belief. Originally included as a part of the Resurrection cycle, the theme of the Doubting Thomas became an independent topic which paralleled the *Noli me tangere. According to legendary sources,

Thomas also doubted the *Assumption of the Virgin Mary.

Dove. An avian symbol for the *soul and for the *Holy Spirit. By nature, the dove was characterized by gentle affection and simplicity. In classical Greco-Roman art, the dove signified purity and peace, and was an *attribute of *Aphrodite. In Christian art, it became the symbol for the Holy Spirit (Jn 1:32). In the *Old Testament, the dove typified both peace and ritual purity. The dove that *Noah sent forth from the ark in search of dry land returned with an olive branch (Gn 8:11). Under the law of Moses, the offering for the purification of a newborn child was the sacrifice of a dove. Seven doves indicated the seven gifts of God's grace (Hos 11:11). In the New Testament, *Joseph (of Nazareth) carried two *white doves in a *basket as an offering when the infant Jesus was brought to the temple to be purified along with his mother (Lk 2:24). The dove perched upon Joseph's blossoming *staff symbolized Mary's purity. The dove denoted the Holy Spirit in scenes of the *Annunciation to Mary, *Baptism of Jesus Christ, *Pentecost, and *Trinity. Twelve doves implied either the Twelve Fruits of the Holy Spirit (Gal 5:22–23) or the twelve *apostles. The imagery of the dove departing the body of Mary or the lips of any of the *saints suggested the departure of the soul at death. Doves shown pecking at *bread or drinking from a *fountain denoted the Christian soul being nourished by the *Eucharist. As an *attribute of any of the Apostles or Christian saints, the dove typified divine inspiration. *Cathe-

68. Albrecht Dürer, *The Four Apostles.*

rine of Siena had a dove perched on her *head when she prayed as a *child; and according to a medieval legend, the Holy Spirit in the form of a dove dictated theological treatises to *Gregory the Great. The dove was an attribute of *Basil the Great, *David of Wales, Eulalia, *Benedict of Nursia, *Thomas Aquinas, *Scholastica, and Hilarius.

Dragon. Symbol of the *Devil or evil. The dragon typified primal powers that were hostile to God and thereby had to be overcome. This legendary *animal was imaged as a ferocious winged beast with *lion's claws, *eagle's *wings, a *serpent's tail, scaly skin, and fiery breath. The dragon's tail was its greatest weapon; it killed either by engulfing a person or by swift and violent blows. This enemy of God symbolized heresy in *medieval art and theology (Rv 12:7–9). The dragon's mouth was the model for the mouth of Hell devouring the souls of the damned as the dragon devoured beautiful princesses or chivalrous knights. As a sign of their victories over the Devil (or evil), the Resurrected *Christ, *Mary (Rv 12:1–6), and the *Archangel *Michael (Rv 12:7–9) were depicted with a dragon crushed by their *feet. *George of Cappadocia, *Martha of Bethany, and *Margaret of Antioch were all shown with the dragons they fought and vanquished; these images were interpreted as fulfillments of *Old Testament prophecy (Ps 91:3). The dragon was also an *attribute of the *Philip and *Sylvester.

Draught of Fishes. *See* Miraculous Draught of Fishes.

Dreams of Joseph. *See* Saint Joseph (of Nazareth).

Drunkenness of Noah. *See* Noah.

Duccio di Buoninsegna (c. 1255/60–1315/18). The first major Sienese painter and an iconographic innovator, especially in terms of his images of *Mary. His art was categorized as Italo-Byzantine in style; that is, incorporating both the austerity and severity of byzantine icons with a growing interest in human emotions, a product of *Dominican and *Franciscan spirituality. An artistic innovator of the highest order, Duccio was also an effective storyteller and a master of traditional *iconography. His masterpiece was the *Maestà,* created for the Cathedral of Siena in 1311. Dedicated to Mary, the *Maestà* was an enormous *triptych whose central front panel featured the *Madonna and Child enthroned in majesty and surrounded by all orders of *angels and *saints. The other panels were filled with depictions of the life of Mary. The center back panel was filled with twenty-six scenes of the *Passion, while the side panels depicted the events in the life of *Jesus Christ. In his *Maestà,* Duccio fused the contemplative and devotional aspects of the icon with the narrative cycles of the humanity of Mary and Christ.

Dürer, Albrecht (1471–1528). One of the leading German artists of the sixteenth century. Dürer brought renaissance art forms and ideas to the northern parts of Europe through his own works of art and his books, including his treatises on measurement

(1525) and on proportion and artistic theory (1528). Dürer sought to combine the renaissance concept of individualism with the Gothic tradition through his emphasis on vivid imagery, technical refinement, draftsmanship, and complex *iconography. From 1490 to 1494, Dürer went to Strasbourg, Basle, Colmar, and Venice. He made a second trip to Italy in 1505 to study the works of *Leonardo da Vinci and *Andrea Mantegna; during his two-year stay he also came to know *Giovanni Bellini. He was appointed Court Painter to the Emperor Maximilian I in 1512 and to the Emperor Charles V in 1520. Dürer admired the works of *Martin Luther and Erasmus, and was a friend of Melanchthon. His greatest legacy to the history of Christian art were his woodcuts, for books including the *Apocalypse* (1498), *Great Passion* (1498–1510), *Little Passion* (1509–1511), and *Life of the Virgin* (1501–1511); and his individual prints, engravings, and plates which later accompanied the writings of Reformed theologians, including Luther and Melanchthon.

Eagle. A symbol of the soaring spirit, justice, generosity, and the virtues of courage, faith, and contemplation. The eagle, according to Aristotle, could look directly into the *sun and trained its young to do the same; those offspring incapable of staring into the sun were discarded. The eagle thus symbolized *Jesus Christ, whose Ascension was a soaring upwards and who could look directly at God without blinking. The *Physiologus* characterized the eagle like the *phoenix which in old age, after finding a *fountain, would fly very close to the sun to burn off its aging *wings and dimming eyes, and then plunged into the fountain three times. These birds thereby typified the new life available through the ritual cleansing of *baptism and of the rebirth of the Resurrection (Ps 103:5). The eagle was an *attribute of *John the Evangelist because his gospel's philosophical nature allowed it to soar about the other three gospels. Lecterns were shaped like winged eagles as a sign of the inspiration of the gospels. As a motif on the baptismal font, the eagle represented new life (Is 40:31). As a bird of prey, however, the eagle typified the ambiguity of generosity (leaving part of its prey for others) and evil (ravishing life).

Ear. Symbol for hearing, communication, and obedience. In the *Garden of Gethsemane, *Peter cut off Malchus's ear, thereby signifying the *Betrayal by Judas. The ear was also a symbol of the Annunciation, according to the medieval belief that *Mary conceived the Word of God through her ear.

Earth. The solid element offering humanity sustenance through its production of *flowers, vegetation, and *trees, and by providing sites for habitation. The earth symbolized the *church as a provider of spiritual nourishment and shelter. In Christian art, the earth was represented by the *globe or a human being, such as *Atlas, supporting a heavy weight.

East. One of the four cardinal points, the east signified the sunrise; the

Christian tradition, it was a sign of *Jesus Christ as the "sun of righteousness." The east was the source of light and truth. The *altars of Christian churches were "oriented" towards the rising sun in anticipation of the Second Coming of Jesus Christ.

Easter. Liturgical feast of the *Resurrection of Jesus Christ celebrated on the first Sunday after the full moon following the spring equinox. As the central feast of the Christian calendar, Easter determined the calendar for all other movable feasts. The English name "easter" denoted the Anglo-Saxon spring goddess, Eostre, whose sacred rites were celebrated following the spring equinox. *White and *gold were the liturgical *colors for Easter services.

Ecce Agnus Dei (Jn 1:36). Latin for "Behold the Lamb of God." The proclamation of *John the Baptist when Jesus approached the River Jordan for *baptism.

Ecce Ancilla Domini (Lk 1:38). Latin for "Behold the Handmaid of the Lord." The proclamation of *Mary in accepting the role God ordained for her. In depictions of the Annunciation, especially in *medieval art, this phrase was found on a *scroll or *book which was either held by Mary or placed on a table or *prie-dieu near her.

Ecce Homo (Jn 19:5). Latin for "Behold the Man." The proclamation of *Pontius Pilate when he handed the flagellated and weakened Jesus over for crucifixion. This phrase became the title for this iconographic motif,

which developed as a devotional or narrative image in the Renaissance. *See also* Flagellation and *Imago Pietatis*.

Ecce virgo concipiet (Is 7:14). Latin for "Behold, a virgin shall conceive." The prophecy of *Isaiah, taken as a foretype for the Annunciation. In depictions of the Annunciation and the Nativity, especially in northern *medieval art, this phrase was written on a *scroll or *banner held by Isaiah.

Ecclesia. From the Greek for "assembly" or "gathering." The name given to the gatherings of Christians, eventually identified as the *church. In Christian art, Ecclesia was depicted as a young woman with a *crown of *flames, and was wide-eyed in contrast to the blindfolded *Synagoga. In *medieval art, Ecclesia's size was dependent upon the narrative context in which she was represented; in scenes of the *Nativity of Jesus Christ, she would be diminutive as the church was just being born.

Eden, Garden of (Gn 2). The site of the original *paradise created by God. Located somewhere in the "east," it was filled with an abundance of every kind of fruit, flower, and tree. As the first home of human beings, from which *Adam and *Eve were expelled, the Garden of Eden became the image for that perfect, peaceful, and idyllic setting to which all human beings seek to return. In Christian art, it was represented as a lush and lovely garden filled with blooming flowers, fruit-laden trees, sparkling *waters, and all kinds of animals. The Garden of Eden was

typified by the *Enclosed Garden in representations of the *Madonna and Child, and was also signified by a *rose without *thorns.

Education of the Virgin Mary (*The Golden Legend*). Legendary instruction of *Mary in reading and needlework by the angels or her mother, *Anne at home, not within the Temple. The motif of Anne Teaching the Virgin to Read (or to Sew) was popular in *medieval and *baroque art.

Egg. A dual symbol, first for *hope and resurrection as the chick broke out of the egg at birth; and second for chastity and purity like the innocence of the newborn chick. Ostrich eggs signified the *Virgin Birth as the ostrich laid her eggs on the ground and allowed them to hatch independently of her (Jb 39:13–14).

Eight. A symbol of rejuvenation, purification, eternity, and the Resurrection, for *Christ rose from his *tomb on the eighth day after his entry into *Jerusalem, eight persons were saved in Noah's Ark, and Jesus was circumcised and named on his eighth day of life. Thus, the octagon became the favored form for both baptismal fonts and early Christian basilicas.

Elephant. An animal symbol for modesty and chastity, especially of *Adam and *Eve before the Fall. According to the *Physiologus, the elephant's sexual organs were reversed because it was a shy and modest creature. Further, the elephant's supposed practices of monogamy, low sex drive, and copulation only for reproduction allowed it to become a

metaphor for the ideal Christian marriage. As a trampler of *serpents, it also signified *Christ trampling on the *Devil.

Elijah (ninth century B.C.). *Hebrew *prophet who sought the destruction of the worship of foreign idols and the restoration of God's justice. Several episodes in Elijah's life were depicted in Christian art, including his miraculous feeding by *ravens (1 Kgs 17:1–7); the contest with the priests of Baal on Mount Carmel (1 Kgs 18:17–40); the miraculous feeding by *angels in the *cave (1 Kgs 19:12); and his departure for *heaven in a fiery *chariot (2 Kgs 2:11). The most important image of Elijah in Christian art was the prophet in conversation with Jesus and *Moses in representations of the Transfiguration (Mt 17:2; Mk 9:2). In Christian art, Elijah was depicted as an unconventional, unkempt elderly male figure who wore a loincloth and a *cloak of animal skins. He ·was the *Old Testament foretype for *John the Baptist. Pious legends identified Elijah as a hermit on Mount Carmel, and thereby the founder of the *Carmelite Order. In this context, he was characterized by the Carmelite *habit.

Elizabeth, Saint (first century). Cousin of *Mary, and mother of *John the Baptist. Elizabeth was present in representations of the Nativity of John the Baptist, and with her young son was included in representations of the *Madonna and Child. The most important presentation of Elizabeth in Christian art was that of the *Visitation, the encounter between the then pregnant Mary and

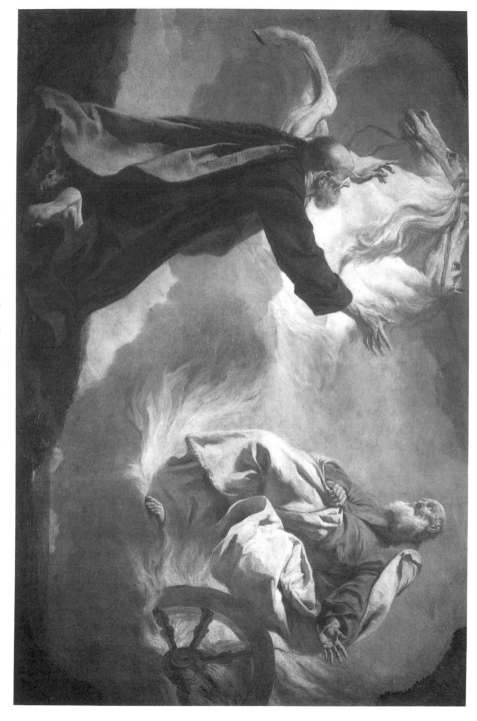

69. Giuseppe Angeli, *Elijah Taken Up in a Chariot of Fire.*

her pregnant cousin (Lk 1:39–55). In Christian art, Elizabeth was depicted as an elderly woman who offered through her gestures both affection and respect to Mary. She has no identifiable *attributes.

Elizabeth of Hungary, Saint (1207–1231). Also identified as Elizabeth of Thuringia, a model of Christian piety and *charity. This daughter of King Andreas II of Hungary was betrothed as an infant to Louis (Ludwig) II of Thuringia. During her childhood when she lived with her future husband's family Elizabeth was reportedly maltreated. In her loneliness, she turned to religion, devoting her time to charitable activities, especially feeding the hungry. Once, when she was smuggling *bread in her apron, her suspicious husband confronted her only to find her apron filled with *roses. As a young widow expelled from the castle by her greedy brother-in-law, Elizabeth was forced to abandon her *children. She joined the Order of Saint Francis in 1228 in Marburg, where she continued her work for the poor. Elizabeth was the patroness of beggars, bakers, lacemakers, queens, Catholic charities, and the Third Order of Franciscans, and was invoked against toothache. In Christian art, Elizabeth was depicted as a beautiful young woman dressed in a *Franciscan *habit and wearing either a *crown or a triple crown as she was a queen by birth, marriage, and glorification in *heaven. Her *attributes were a *basket of roses or an apronful of roses.

Elm. A tree symbol of the dignity of life. The breadth of its growth and the span of its branches in all directions typified the stability and strength that derived from Christian faith.

Emmaus. Town in Judea that was the site of several scriptural events signifying the Resurrection. Later that Easter Sunday afternoon, the Resurrected *Christ appeared to Cleophas and another disciple as they walked to Emmaus and pondered the meaning of the Crucifixion. The disciples did not recognize their companion until he broke and blessed the *bread at the supper they are shared. These two events, the Road to Emmaus (Lk 24:13–28) and the *Supper at Emmaus (Lk 24:30–31), were included within the context of the Passion and Resurrection cycles. The Supper at Emmaus developed as an independent topic with its own *iconography during the *Counter-Reformation.

Emmaus, Road to. *See* Emmaus.

Emmaus, Supper at (Lk 24:30–31). Scriptural event signifying the importance of the ritual act of breaking *bread for Christian liturgy and spirituality. The Supper at Emmaus symbolized the *Eucharist and the Resurrection experience combined, and was prefigured by the miraculous feedings in the *Old and *New Testaments, the *Passover meal, and the *Last Supper. Having encountered two unnamed disciples on the *Road to Emmaus on the first Easter afternoon, the unrecognized Risen *Christ walked with them to this city outside of *Jerusalem, and joined them for supper. Only at the moment that he blessed and broke the *bread did his companions recognize Christ,

70. Michelangelo Merisi da Caravaggio, *Supper at Emmaus.*
71. Rembrandt van Rijn, *Supper at Emmaus.*

72. Attributed to Fra Angelico, *The Entombment.*

who immediately disappeared out of their sight. In Christian art, depictions of the Supper at Emmaus were distinguished from those of the Last Supper by the number of companions surrounding Christ. In late *medieval and *renaissance art, the innkeeper and his wife—who remained unaware of the identity of Christ—signified the unconverted and countered the reactions of the two disciples. With the theological disputes over the meaning of the Eucharist between *Roman Catholicism, *Lutheranism, and the Protestant traditions, the theme of the Supper at Emmaus became especially popular among baroque artists, including *Michelangelo Merisi da Caravaggio and *Rembrandt van Rijn.

Enclosed Garden. A characteristic of the beloved bride (Song 4:12), and a symbol for the perpetual virginity of *Mary. In northern *medieval art, the Enclosed Garden became the setting for the *Madonna and Child, and signified both the restoration of *paradise through the *Passion, Death, and *Resurrection of *Jesus Christ, and Mary's foreknowledge that her son was born to die.

Entombment of Jesus Christ (Mt 27:59–61; Mk 15:46–47; Lk 23:50–56; Jn 19:39–42). Scriptural event signifying the burial of the crucified body of Jesus in the tomb of *Joseph of Arimathea following the anointing of the body according to the Jewish customs. In early Christian and *byzantine art, this theme was an element in the narrative scene into which the Deposition, Lamentation, and bearing anointing of the body were compressed. The Entombment became an independent topic in *medieval art with the development of the medieval passion plays and lay devotions. In early medieval art, Joseph of Arimathea and *Nicodemus were depicted placing the linen-wrapped body of Jesus into a coffin. In the early twelfth century, *Mary and *John the Evangelist were included in the burial motif; and with the expansion of the cast of characters in the liturgical dramas, the Holy Women, including *Mary Magdalene, and an occasional disciple were present by the end of the century. In the thirteenth and fourteenth centuries, the Entombment became conflated with (and indistinguishable from) the *Lamentation.

Entry into Jerusalem (Mt 21:1–11; Mk ll:1–11; Lk 19:29–40; Jn 12:12–19). Scriptural event signifying the first event of the Passion narrative as described in all four gospels. Sunday afternoon as he entered *Jerusalem to celebrate *Passover, Jesus rode a *donkey and was greeted by the multitude offering *palm branches, cries of thanksgiving, and spreading their garments on the road. All of these activities fulfilled the *Old Testament prophecies (such as Zec 9:9) signifying that Jesus was the *Christ. The Entry into Jerusalem was the scriptural source for the celebration of Palm Sunday. Depictions of this event were found as early as the fourth century and related to both the liturgical celebrations of Palm Sunday, and the related metaphor of the "heavenly Jerusalem." In these early Christian images, Jesus was depicted riding on a donkey as one disciple preceded and

another followed him. The interpretation of the *palm as both a classical Greco-Roman symbol of victory and peace and a Middle Eastern symbol for paradise (the oasis in the desert) were assimilated into Christian art and liturgy. A popular theme in the history of Christian art, the Entry into Jerusalem reflected the changes in liturgical practice and the liturgical dramas. By the medieval period, the crowds expanded to include mothers with *children, and the little man in the *tree (*Zaccheus). The disciples wore liturgical garments, carried *censers, and walked either before or after Jesus in a liturgical procession. From the Renaissance into the nineteenth century, the Entry into Jerusalem became an illustration of an immense crowd scene in a broad landscape.

Epiphany. From the Greek for "manifestation." Originally the commemoration of the four manifestations of Jesus as the Christ: *Adoration of the Shepherds; *Adoration of the Magi; *Baptism of Jesus Christ; and the *Marriage at Cana. Celebrated on January 6, the Feast of the Epiphany was accepted by the Eastern Christian Church in the third century and by the Western Christian Church in the fourth century. The liturgical *color for Epiphany was *white. In the Eastern Orthodox Church, "Little Christmas" was the day for the exchange of gifts with "Big Christmas" reserved for spiritual reflection and religious celebration. In Western Christianity, the Feast of Epiphany was identified as Twelfth Night.

Ermine. An animal symbol for chastity, innocent, incorruptibility, and purity. According to the medieval *bestiaries, this small animal was so concerned about its *white fur that it would allow itself to be captured by hunters rather than run through or hide in mud. Thus, the ermine became associated with the motto, "Better death than dishonor." A symbol for the miraculous conception of *Jesus Christ and of *Mary's perpetual virginity, the ermine, according to the *Physiologus, conceived through its *ear, paralleling the medieval belief that Mary conceived the Word of God through her ear.

Esther. A Jewish heroine, one of the female Worthies (classical and biblical models of ideal womanhood, including *Lucretia and *Jael), and a foretype of *Mary. The adopted daughter of the king's minister, Mordecai, Esther became Ahaseurus's Queen, while her Jewish heritage was hidden from him. On the counsel of his chief minister, Haman, the King issued a decree that all the *Hebrews were to be killed and their property reverted to the state. In a daring action, Esther made an unsummoned appearance before the king to announce her Jewish heritage and to plead for her people. Under threat of imminent death, Esther was saved by the touch of Ahaseurus's *scepter. Moved by Esther's beauty and intelligence as well as her courage, Ahaseurus canceled the edict against the Hebrews. Haman was revealed as a traitor and hanged. The Jewish festival of Purim commemorated Esther's successful intervention on behalf of her people. Esther's coronation as queen by Ahaseurus

prefigured the *Coronation of the Virgin Mary as Queen of Heaven, while Esther's act of intercession prefigured Mary's intercession at the *Last Judgment. In Christian art, Esther was depicted as a beautiful young woman wearing a *crown either in the company of the Worthies, the foretypes of Mary, or *Old Testament heroines; or in a narrative depiction of Esther swooning (or fainting) before Ahaseurus.

Etimacia. Symbolic motif of the preparation of the throne for Christ's Second Coming as adapted from the practice of the Byzantine Imperial Court. The *Etimacia* was typified in Christian art by the placement of an empty throne with any of the following *attributes of *Jesus Christ—*lamb, *dove, *book, *scroll, *crown, or royal purple cloak—before a golden *cross.

Eucharist. From the Greek for "thanksgiving." The central sacrament of Christianity, and with *baptism, one of the two sacraments celebrated by most Christians. The origin of the Eucharist was in the action of the blessing and offering of *bread and wine by Jesus at the *Last Supper. The primary symbols for the Eucharist were *grapes, signifying wine and *blood, and *wheat signifying bread and *body. Signifying both the sacrament and sacrifice of the Eucharist, and by symbolic extension *Jesus Christ, the grapes and sheaves of wheat, became important elements in Christian art. Sheaves of wheat in scenes of the Nativity or the *Adorations of the Shepherds and of the Magi revealed the divine mission of the newborn child. Bunches of grapes in the *hands of the infant Jesus represented the Passion. The Eucharist was prefigured by the *manna of the *Old Testament (Ex 16:4–15). In early Christian art, a *basket or *dish with bread and *fish denoted the Eucharist.

Euphemia, Saint (d. c. 307). One of the most famous female saints of the Eastern Orthodox Church. According to legend, she was persecuted for her Christian faith by being condemned to death by *fire. When that form of martyrdom failed, she was offered to *lions who refused to devour her. Eventually, she was beheaded. In Christian art, Euphemia was depicted as a beautiful young woman holding either the *palm of victory or the *sword of her martyrdom. Her other *attributes included the *lily and a lion.

Eurydice. *See* Orpheus.

Eustace, Saint (d. c. 118). A captain in the Emperor Hadrian's guards who encountered a *stag with a *crucifix between its antlers while he was hunting. Originally known as Placidus, this guard took the name of Eustace at his Christian *baptism. In a vision, he was warned by *Christ that like *Job, he would face much suffering but that God would not forsake him. Soon after, he lost his home and possessions, fled to Egypt, his wife was kidnapped by pirates, and his sons carried off by wild beasts. After fifteen years, the family was reunited, but because they refused to worship pagan gods, they were roasted to death inside a large brass *bull. One

of the *Fourteen Holy Helpers, Eustace was also the patron of huntsmen. In Christian art, he was depicted as a Roman soldier or a medieval knight with his *horse and hunting *dogs. His *attributes included the *crucifix, *stag, bull, and oven.

Evangelists. From the Greek for "messenger of good tidings." The traditional authors of the four *Gospels of the *New Testament. Popular figures in Christian art, they were initially represented as four adult males each holding a *book, or by the symbols of four *scrolls placed in the corners of a Greek *cross, the four *rivers of *paradise or the four *fountains which flowed from a *mountain upon which stood *Jesus Christ. By the fourth century, the Evangelists were signified by the *tetramorphs as described in the apocalyptic visions of the *Old Testament *prophet *Ezekiel (Ez 1:4–10) and *John the Evangelist (Rv 4:6–7). *Matthew was represented by the winged young man as his gospel emphasized the humanity of Jesus Christ. *Mark was signified by the winged *lion as his gospel proclaimed the divinity and kingship of Jesus Christ. *Luke was symbolized by the winged *ox as his gospel concentrated on the sacrificial aspects of the life of Jesus Christ. John was identified by the *eagle as his gospel transcended all the others with its philosophical language and its concern for Jesus Christ's immortality. The tetramorphs were found on the central *tympanum of medieval *cathedrals and in manuscript *illuminations for *bibles, psalters, and sacramentaries.

Eve. According to biblical etymology "the Mother of All Living," but actually "serpent." The first woman and wife of *Adam in the *Old Testament. Eve was created from Adam's rib (Gn 2:21–23). Tempted by the *serpent in the *garden, she ate of the Tree of Knowledge and then offered the forbidden *fruit to Adam, an act of disobedience for which they were expelled from the *Garden of Eden (Gn 3:1–24); and, condemned to die; Eve was also to suffer pain in childbirth (Gn 3:16). She was the mother of *Cain and *Abel (Gn 4:1–2), and Seth (Gn 4:25). According to Christian doctrine, sin entered the world through the disobedience of Adam and Eve, but by the medieval period, the blame for the entry of sin into the world was directed solely upon Eve. The early church fathers beginning with Justin followed *Paul's lead in characterizing *Mary as the Second Eve—as the First Eve's disobedience brought sin into the world, the Second Eve's obedience enabled human salvation. Eve became a foretype of *Mary and the *church; thus the Creation of Eve from Adam's side paralleled the Creation of the Church from the wounded side of the Crucified Christ. A popular topic in Christian art, Eve was depicted first on the sarcophagi and *frescoes of the early Christian *catacombs as a beautiful nude young woman with long *hair who held an *apple as the sign of her disobedience. She was presented with Adam in scenes of the Temptation and Fall. In *medieval art, Eve became an independent topic and began to be included in depictions of the *Madonna and Child, or as a visual comparison

between herself as the First Eve and Mary as the Second Eve.

Ewer and Basin. Sign of the act of cleansing the body, especially the ritual washing of *hands or *feet. In the classical Greco-Roman world, the act of washing one's hands was a symbolic act of innocence and purity as in *Pontius Pilate washing his hands (Mt 27:24). In scenes of the *Annunciation to Mary, especially in northern *medieval art, the ewer and basin symbolized the spiritual and physical purity of *Mary. The ewer and basin were also liturgical vessels and were used when the celebrant washed his hands during the preparation for the *sacrament of *Eucharist.

Exhortation to Watch. *See* Parables.

Expulsion from the Temple. *See* Cleansing of the Temple.

Extreme Unction. From the Latin for "near the end." The sacrament of holy unction, or the final anointing of the eyes, lips, ears, *hands, and *feet with holy oil. This was the final act of absolution for human sinfulness and consecrated the illness to God in attempt to strengthen the individual either for recovery or death. In Christian art, extreme unction was signified by a *dove with an olive branch in its mouth.

Eyck, Hubert (d. 1426) and **Jan van** (d. 1441). Netherlandish artists traditionally credited with the invention of oil painting, and best known for the *Ghent Altarpiece*. This large *polyptych featured a complex *iconography of judgment and salvation with its central upper register depicting the first western presentation of the *deesis while the lower center panel represented the Adoration of the Lamb. Jan van Eyck created many iconographically complex images of *Mary which reflected the Marian devotions then popular among the laity. He was also well-known for his intricate combinations of sacred iconography within the context of a secular theme, such as *The Arnolfini Wedding Portrait*, which was prophetic of the fusion of sacred and secular that dominated sixteenth and seventeenth century Netherlandish *still-life and *vanitas paintings.

Eye. A symbol for the omniscience, vigilance, and omnipresence of God the Father. Enclosed in a *triangle, the Eye of God denoted the *Trinity; whereas this same symbol enclosed in a *circle and radiating rays of lights signified the infinite holiness of the Triune God (1 Pt 3:12; Prv 22:12). The *cherubim and *seraphim, two of the highest orders of *angels, had winged bodies which were covered with eyes. When carried on a platter or held in a *hand, eyes were an *attribute of *Lucy.

Ezekiel (sixth century B.C.). One of the major *prophets of the *Old Testament and the recipient of extraordinary visions concerning the sixth-century fall of *Jerusalem. Four of his prophecies were influential upon Christian *iconography. Ezekiel's description of the four *beasts around the throne of God symbolized the four *Evangelists (Ez 1:4–28). The resurrection of the dead at the *Last Judgment was prefigured by his vi-

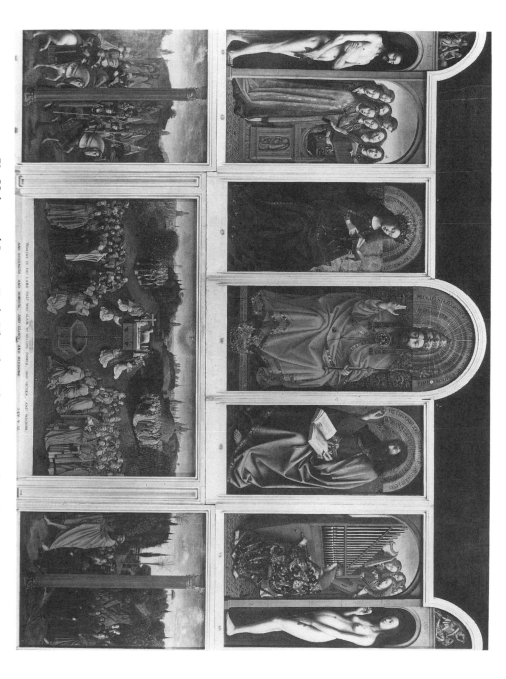

73. Hubert and Jan van Eyck, *The Ghent Altarpiece*, second opening.

sion of the dry bones in the valley (Ez 37:1–4). His vision of the four-wheeled creatures characterized the physiognomy and categories of *angels (Ez 1:5–11). His prophecy of the shut gate prefigured the teachings on Mary's perpetual virginity, and was included in representations of the Annunciation, Nativity, and *Madonna and Child. In Christian art, Ezekiel was depicted as an elderly man with a long *beard who held a *scroll inscribed with his text, *Porta haec clausa erit; non aperietur* (Ez 44:1–3).

F

✦

Fabulous Beasts. *See* Mythical Beasts.

Faith. One of the three theological virtues of faith, *hope, and *charity. Also one of the *Seven Virtues, faith was represented as a woman who held a *cross and *chalice, and was seated in a place of honor at the right of *Christ in *medieval art. In *baroque art, she held an open *Bible with a cross.

Faith, Saint (second century). Personification of the cult of Divine Wisdom (Sophia) in the eastern Mediterranean. According to this tradition the Roman widow *Sophia had three daughters—Faith, *Hope, and *Charity. The mother and her daughters were tortured and beheaded under the Emperor Hadrian.

Faithful or Unfaithful Steward. *See* Parables.

Falcon. An ambiguous symbol for evil or for righteousness. The wild falcon personified evil thought or action, while the domesticated falcon denoted the righteous or the pagan converted to Christianity. A favored hunting bird, the domesticated falcon was included in renaissance depictions of the *Adoration of the Magi.

Fall of Adam and Eve (Gn 3). Scriptural event signifying the fall of humanity and the entry of sin into the world. *Adam and *Eve's sin was in disobeying God's command and eating of the forbidden *fruit of the Tree of Knowledge in the *Garden of Eden. Eve was tempted by the *serpent, sometimes represented in late *medieval and *renaissance art as having the *head and torso of a woman. Eve then tempted Adam by offering him the forbidden fruit. The *apple became the forbidden fruit due as much to the pun of *malum* (Latin for "apple") and *malus* (Latin for "evil") as to mispronunciation. Having eaten of the apple, Adam and Eve "knew they were naked" and tried to hide from God. They attempted to cover

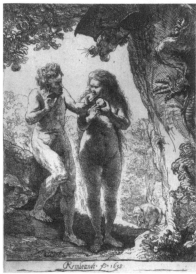

74. *The Fall* detail from *Sarcophagus of Junius Bassus.*
77. Rembrandt van Rijn, *Adam and Eve.*

75. Hieronymus Bosch,
The Temptation and the Fall.

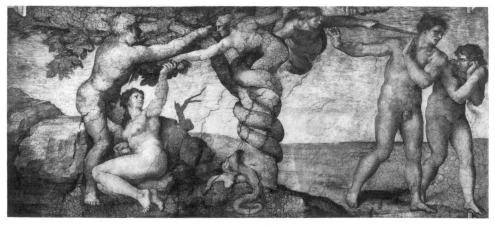

76. Michelangelo Buonarroti, *The Temptation and the Fall.*

FIG · 131

themselves with garments made from *fig leaves. As punishment for their act of disobedience, Adam and Eve, and all their descendants, were condemned to die; further, during their lives men were to labor in the fields and women to suffer in childbirth.

Father Time. *See* Time.

Feast in the House of Levi (Mt 9:10–13; Mk 2:15–17; Lk 5:29–32). Scriptural event signifying Jesus' commitment to repentent sinners. To the dismay of the Scribes and Pharisees and to several of his own disciples, Jesus invited himself to be a dinner guest at the house of Levi, a tax collector. Despite the "unclean" nature of Levi's profession as well as those of his other dinner guests, Jesus announced that he had not come to consort with the saved but to bring the sinner to repentance. Included in the context of the life cycle of Jesus Christ, this event was rarely depicted in Christian art in favor of the theme of the *Anointing at Bethany and the *Feast in the House of Simon. The Feast in the House of Levi was distinguished from the Anointing at Bethany and the Feast in the House of Simon, in which female anointers played a central role. It was further distinguished from depictions of the wedding feast at the *Marriage at Cana, at which *Mary was placed at the center of the table. By the High Renaissance, these *three meal scenes were conflated into one large feast scene.

Feast in the House of Simon (Mt 26:6–13; Mk 14:3–9; Lk 7:36–50; Jn 12:1–8). Scriptural event signifying the forgiveness of sins. In this variant of the *Anointing at Bethany, Jesus came to the house of Simon the Leper to dine. An unknown woman entered with an alabaster box of precious ointments, she broke the box and anointed Jesus' *head. Many were angered by this extravagance, but Jesus rebuked them in a manner similar to the Anointing at Bethany. In the Western Christian Church since *Augustine, this unnamed woman was conflated with several other anonymous women into the person identified as *Mary Magdalene. As she participated in other anointing (and attempted anointing) scenes, and was identified as the Repentent Sinner, this conflation was appropriate. Occasionally depicted in Christian art, the Feast in the House of Simon was distinguishable from other "meal scenes" by the presence of the female figure anointing Jesus's head or feet.

Feather. A sign of faith and contemplation or as the quill of a *pen, the Word of God. The *peacock feather was an *attribute of *Barbara.

Fern. A symbol for humility, sincerity, and frankness. The fern concealed its graceful elegance and delicacy in the shadow of larger plants.

Fetters. A symbol of the Passion, particularly the *Flagellation. Fetters were an *attribute of *Leonard and Clovis.

Fig. A symbol for fertility, fecundity, and good works because of its many seeds. In relation to *Adam and *Eve,

the fig, fig tree, and fig leaves symbolize lust.

Fig Tree. *See* Parables.

Finding of the True Cross. According to medieval legends and pious traditions, *Helena, the mother of the emperor *Constantine, began a new journey following her son's order that Christians not be fed to the *lions. Helena dedicated her life to good works and founded churches in the Holy Land. According to legend, Helena located three crosses but needed to discover which one was used for Jesus, so she ordered that a corpse be laid on all three crosses. The cross that was identified as "giving life" was taken by her back to her son's new capital city of Constantinople (Istanbul).

Fir Tree. Symbol for penitence, or the virtuous aspirations of the elect in *heaven.

Fire. Sign of religious fervor and martyrdom, or the torments of *Hell. In the *Old Testament, fire was used as a metaphor for God—a column of fire and the *burning bush. Tongues of fire appearing above the *heads of the twelve *apostles at the Pentecost symbolized the gift of tongues; that is, the ability to speak in all languages. A flaming tunic was an *attribute of *Laurence. *Anthony of Padua was the patron of fire fighters.

Fish. Primary early Christian symbol for *Jesus Christ and signifier of *baptism, the *Eucharist, the *Last Supper, the Resurrection, and immortality. As the cross denoted the ever-present danger of persecution until the middle of the fourth century, the fish identified individuals as Christians. The initial use of the symbol of the fish was related to the acrostic formed by the Greek word, *ichthys,* for fish, which was understood to refer to the words, "Jesus [*i*] Christ [*ch*] God's [*t*] Son [*y*], Savior [*s*]. The fish typified baptism, for just as the fish cannot live without *water, neither can the Christian survive without baptism. One of the earliest metaphors for Jesus and his *apostles was that of the fishermen who were in fact fishers of souls. Whenever *Peter held a fish in his *hand, the image could be read as "the fisherman" "the Christian convert" or "the Christian apostle who is a fisher of men." The fish was an *attribute of *Peter, *Simon, *Zeno, and *Anthony of Padua. *Philip was identified by fish and *bread in a *basket as he distributed the food at the miraculous event of the *Loaves and Fishes. The fish was also seen in early Christian and early medieval images of the *Last Supper. The *Old Testament story of *Tobias, the young hero who restored his father's eyesight with the gall of a fish, prefigured the Christian symbolism of the fish.

Five. Symbol for the number of the *wounds of the Crucified Jesus, and of the Wise Virgins or Bridesmaids.

Flag. A sign of military victory adopted by Christians in the fourth century as a symbol of *Christ's victory over death. The *white flag with a *red *cross was commonly found in depictions of the Resurrection, or held by the Resurrected Christ. In

*renaissance and *baroque art, Christ descended into *Hell holding his flag of victory. The flag was an *attribute of all military *saints, including *George of Cappadocia, *James, *Ursula, and *Joan of Arc.

Flagellation (Mt 27:26; Mk 15:15; Jn 19:1). Scriptural event signifying the fulfillment of the *Old Testament prophecies of the "suffering servant." As was the Roman custom, *Pontius Pilate ordered that Jesus be whipped before he was crucified. The Flagellation was included within the narrative cycle of the Passion. This event became conflated with the *Crowning of Thorns (Mt 27:29; Mk 15:17; Jn 19:2) and the *Mocking of Christ (Mt 27:27–31; Mk 15:16–20; Jn 19:2–3) into the image of the *Ecce Homo. During those times of a heightened interest in the empathetic response of the believer to the sufferings of Jesus, the Flagellation was a popular image. In Christian art, the flagellation was represented by the figure of Jesus stripped to the waist and tied to a *pillar while two or more Roman soldiers scourged his back. As an independent topic the Flagellation was found in *renaissance and southern *baroque art.

Flames. Symbol for religious zeal and martyrdom as well as for the torments of *Hell. Flames were an *attribute of *Anthony the Abbot, *Anthony of Padua, and *Agnes. A tunic of flames signified *Laurence. Flames over the *heads of the twelve apostles at *Pentecost represented the gift of tongues; that is, the ability to speak all languages.

Fleur-de-Lis. Symbol for the *Trinity. Chosen by King Clovis as an sign of his purification, the fleur-de-lis became an emblem of French royalty and as such the attribute of *Charlemagne, *Louis of France, and *Louis of Toulouse. It was also a symbol of *Mary as Queen of Heaven.

Flight into Egypt (Mt 2:13–15). Scriptural event signifying the necessary journey of the *Holy Family so that like *Joseph and *Moses, Jesus would be called from Egypt by God, thus fulfilling the *Old Testament prophecy (Hos 11:1). Following Joseph's (of Nazareth) second dream in which the *Archangel *Gabriel warned of the *Massacre of the Innocents, *Mary and the infant Jesus left with him to seek shelter in Egypt. A popular theme throughout the history of Christian art, the imagery and *iconography of the Flight into Egypt was dependent upon apocryphal and legendary texts. In the Arabian *Gospel of the Childhood of Christ* as well as the apocryphal *Gospel of Pseudo-Matthew*, the episode of the "falling idols" at the Temple in Heliopolis signified the fulfillment of the Old Testament prophecies (Is 19:1 and Jer 43:13), and affirmed the divinity of *Christ and the superiority of Christianity over all forms of idolatry. The story of the Flight into Egypt was also interpreted as a sign of the revelation of Jesus as the Christ to the heathens. Representations of the Flight into Egypt included one or all of these symbols and legendary attributes, including the signs of the victorious *palm, falling idols, and images of Joseph or Moses in an oasis setting of palm trees, watering hole, and flow-

ering shrubs. Mary and the Child were posed either sitting in the oasis (a motif of the *paradise or *Enclosed Garden) or riding astride the *donkey. Joseph was either attempting to gather *fruit or *water for his family with the assistance of *angels, or walking before the donkey. The use of the palm and the palm trees prefigured the Entry into Jerusalem. Baroque artists represented the Flight into Egypt as a night scene, while later artists with their growing interest in the *landscape expanded the naturalistic setting of the event and minimized the figures and symbolism.

Flight into Egypt, Rest on the (Mt 2:13–15). A separate motif from the *Flight into Egypt in the late fourteenth century, and as such a popular theme of northern late *medieval art. Without scriptural authority, this event naturally evolved in Christian art and devotional texts in the medieval period. In early fifteenth-century representations, *Mary breasted her son. Following contemporary representations of the Nativity, the *Madonna and Child loomed large while *Joseph (of Nazareth) all but disappeared from the scene. The intricate and complex symbolism of the flowering shrubs and other vegetation at the "rest stops" were directly related to late medieval Marian devotions. A popular motif in *medieval and *baroque art, the Rest on the Flight into Egypt continued to fascinate artists into the late nineteenth century because of the *landscape setting.

Flood, The. See Noah.

Florian, Saint (d. 304). A Roman soldier who converted to Christianity. Reputedly a miracle-worker, this warrior *saint extinguished the *flames of a burning city with a single bucket of *water. Florian was thrown into the water with a stone attached to his neck. The patron of Poland, Austria, and textile merchants, Florian was invoked against fire. In Christian art, he was depicted as a youthful male figure dressed as a Roman soldier who held either a bucket of water or a *banner with an inscribed *cross in his *hands and had a *millstone around his neck.

Flowering Staff. See Aaron; Joseph (of Nazareth).

Flowers, symbolism of. The botanical cycle of life, death, and resurrection in the fullness of the four seasons. As the blossoms of the earth, flowers like *fruits and *vegetables contained the seeds for each new and successive generation. As a generic symbol, a flower indicated the beauty of the *earth, fertility, and earthly desires associated with fecundity and creation of new life. In Christian art, flowers were purely decorative while a specific flower was an integral element of the theological intent of the image; for example, *violets signified *Mary's humility while the *iris represented her sorrow. A *basket of *roses was an *attribute of *Dorothea. See also Almond, Anemone, Bluebell, Carnation, Cherry, Columbine, Cyclamen, Daffodil, Forget-me-not, Hyacinth, Iris, Jasmine, Lady's Bedstraw, Lady's Mantle, Lady's Slipper, Lavender, Lily, Lily-of-the-Valley, Marigold, Narcissus,

Pansy, Peony, Periwinkle, Poppy, Primrose, Rose, Snowdrop, Sunflower, and Violet.

Fly. Bearer of bad tidings, evil, and pestilence, hence the symbol for sin. In depictions of the *Madonna and Child, the fly represented the sin that the child conquered. As a symbol of the plague, the fly was accompanied by the *goldfinch as a protector against the plague.

Foot. A bodily symbol of humility and willing service touching the "dust of the earth." In a ritual of penitence and humility, an unknown woman washed the *feet of Jesus with her tears (Lk 7:38). In an action of humble service and of hospitality, Jesus washed the feet of the *apostles at the *Last Supper (Jn 13:5). As a symbol of both humility and bondage, certain religious orders of male and female monastics either went barefoot or wore only sandals.

Forest. Symbol for the dangerous, uncontrollable power of nature and the wilderness.

Foretype. The classical mythological or Old Testament figure or prophecy that will be fulfilled in Jesus Christ, Mary, or the Christian saints.

Forget-me-not. Floral symbol for fidelity in love.

Fortitude. One of the Seven Virtues. Fortitude was personified as a female figure with a *sword, *shield, *club, *globe, lion's skin, or *column, all in allusion to *Samson's destruction of the pagan temple. Samson rested at her feet.

Fortress. A sign of refuge in God or faith. A fortress was protection against *demons.

Forty. The number associated with trials or probation, as exemplified by the forty years the Israelites spent in the wilderness and in bondage to the Philistines, the forty days and forty nights of the Flood, and the forty days that *Moses stayed on Mount Sinai. Jesus spent forty days of prayer and fasting in the wilderness. The Christian fast of Lent in preparation for *Easter lasted for forty days.

Fountain. Symbol for cleansing, purification, and salvation as Jesus was the "fountain of life." As a closed container of *water, the fountain related to *Mary (Ps 36:9; Song 4:12). The fountain was an *attribute of *Clement and *Ansanus. *See also* Well.

Four. A number of completion and fulfillment, as in the four *Evangelists, the four corners of the earth, the four *rivers of *paradise, the four elements, the four seasons, the *Four Horsemen of the Apocalypse, the four *gospels, and the four ages of man.

Four Fathers of the Eastern Church. *See* Doctors of the Church.

Four Fathers of the Western Church. *See* Doctors of the Church.

Four Horsemen of the Apocalypse. Symbol for the plague, war, famine,

and death that will devastate the earth at the end of time. The four horses— *white, *red, *black, and pale—will be released from the first four of the seven *seals of God's *scroll as seen in an apocalyptic vision of *John the Evangelist (Rv 6:1–8). The Four Horsemen of the Apocalypse was a popular theme in *medieval and northern *baroque art, especially in cathedral carvings and prints and engravings.

Fourteen. A number of goodness and mercy, as it was comprised of a double seven.

Fourteen Holy Helpers. A group of *saints whose identities varied, but who were quick in their responses to prayers for recovery from disease or for a good death. Both the *iconography and cult of the Fourteen Holy Helpers was popular during the Black Plague.

Fox. Symbol for cunning, guile, heretics, and the *Devil.

Francis of Assisi, Saint (c. 1181–1226). Founder of the Franciscan Order. Although he was frivolous as a young man, his experiences as a prisoner of war and a serious illness caused him to empathize with the situation of the poor and underprivileged. Following his conversion experience before the Crucifix in the Church of San Damiano, the young Francis dedicated himself to a life of service to the meek and the poor. He was famed for his love of and devotion to animals and *birds. His example of humility, simplicity, lowliness, and evangelical freedom was en-

hanced by his spiritual marriage to Lady Poverty to create a spiritual fervor of the highest order. With *Clare of Assisi, he established the first community of Poor Ladies in 1212, one year after the Order of Minor (Lesser) Friars was accepted by Pope Innocent III. During a period of intense prayer and silent contemplation in 1224, Francis received the *stigmata, or the wounds of the crucified Jesus. A popular figure in Christian art, Francis was depicted as a lean, young man who wore the *brown *habit of the Franciscan Order. Usually accompanied by animals and birds, the most popular image of Francis was that of his preaching to the birds. He was also imaged with the wolf of Gubbio, a violent animal to whom Francis spoke with such sincerity that the animal became a peace-loving creature, thus symbolizing Christian evangelization of the barbarians. Episodes from the life of Francis were popular in late *medieval, *renaissance, and *baroque art, including his denunciation of family wealth, his cure of lepers, and his receipt the stigmata. Often depicted in prayer, he was identified by his many *attributes, including a *skull, *crucifix, *lily, *lamb, or *wolf. He was also represented symbolically marrying Lady Poverty or being handed the Christ Child by *Mary. Francis's influence on Christian art was apparent in the development of devotionalism and humanistic themes by artists from the late medieval period into the baroque period.

Francis Xavier, Saint (1506–1552). Apostle of India and Japan, and the pioneer Jesuit missionary to the Ori-

78. Bacchiacca, *The Flagellation of Christ.*
79. Gerard David, *The Rest on the Flight into Egypt.*

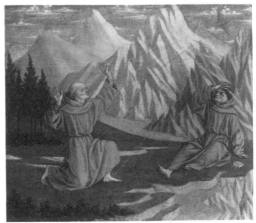

80. Giotto, *Saint Francis Preaching to the Birds.*
81. Domenico Veneziano, *Saint Francis Receiving the Stigmata.*

ent in the sixteenth century. Francis Xavier was the patron of Roman Catholic missionaries in foreign countries. A popular figure in southern *baroque art, he was depicted as a balding man with dark *hair and *beard who wore a *black *cassock with a *white *surplice. His *attributes included a *lily, *crucifix, *flame, *torch, or * scroll inscribed *"Satis est, Domine."*

Franciscans. A mendicant order established by *Francis of Assisi between 1209 and 1211. Committed to issues of social justice and charitable service to the poor, Franciscans were also dedicated to popular spirituality and devotionalism, especially of the *Madonna and Child. They encouraged the popular devotions of the *Stations of the Cross, the Nativity creche, and the Angelus, as well as fostering the development of the Marian doctrine of the *Immaculate Conception. The Franciscan *habit of *brown or *gray was distinguished by the rope *belt with *three knots. As a sign of humility, Franciscans were either barefooted or wore only *sandals.

Frankincense. Literally, "true or pure incense." A rare and expensive ceremonial incense which when it burned rose as *white wisps of *smoke, signifying the offering of prayers and petitions to *heaven. The Romans burned frankincense to disguise the odor of burning bodies at funerals. Balthazar, one of *three *Magi, offered frankincense as a gift to the infant Jesus in recognition of his divinity.

Fresco. Wall painting on plaster. In its best form ("buon fresco"), this art medium developed in the thirteenth century and was perfected in the sixteenth century. The artist prepared the surface to be painted with rough plaster upon which a cartoon (or model) was drawn. The actual working area was then covered with a final layer of plaster which was painted while still damp. The careful preparation of the fresco's surface and the proper combination of the damp plaster, paint pigments, and lime water resulted in a work of art which lasted through the centuries, such as *Michelangelo Buonarroti's frescoes for the Sistine Chapel ceiling. An improperly prepared surface or improper combination of damp plaster, paint pigments, and lime water could result in premature peeling or fading, as in the instance of Leonardo da Vinci's *Last Supper.*

Friend at Midnight. *See* Parables.

Frog. Symbol for repulsive sin, worldly pleasures, and heretics. The frog was also a sign of the Resurrection as it hibernated during the winter and awakened in the spring.

Frontal. A decorative covering, usually movable, for the front of the *altar. Normally oblong in shape, the altar frontal was richly figured with painted or carved relief, or an elegant piece of fabric toned to the liturgical season.

Fruits, symbolism of. Symbols for the cycle of life, death, and resurrection in the fullness of the *four seasons. As the produce of the *earth,

fruits—like *flowers and *vegetables—contained the seeds for each new and successive generation. As a generic symbol, fruit indicated the abundance of harvest, fertility, and earthly desires (as associated with fecundity and creation of new life). In Christian art, a specific fruit was an integral element of the theological intent of the image; for example, the combination of *peaches, *pears, and cucumbers represented good works, while the *apple referred to the Temptation and Fall. A variety of fruit signified the twelve fruits of the spirit: peace, love, joy, faith, gentleness, goodness, patience, modesty, meekness, chastity, temperance, and long suffering. Fruit in a *basket was an *attribute of *Dorothea. See also Apple, Cherry, Fig, Grapes, Lemon, Orange, Peach, Pear, Plum, Quince, Strawberry.

G

Gabriel, Archangel and Saint. From the Hebrew for "God is my strength." The Angel of Mercy, Guardian of the Celestial Treasury, and chief messenger of God the Father. As guardian of all church entrances, Gabriel prevented the *Devil, *witches, and evil from entering. As God's messenger, he explained the vision of Ram and the He-God (Dn 8:16–26) and the prophecy of the end of the exile and the coming of the Messiah (Dn 9:21–27). He helped *Joseph find his brothers (Gn 37:15–17) and destroyed the hosts of Sennacherib (2 Kgs 19:35) and Sodom (Gn 3:10). Gabriel was the "great announcer of births" including *Samson (Jgs 13:3–7), *John the Baptist (Lk 1:11–20), and Jesus (Lk 1:26–38). The patron of television and telecommunications, Gabriel was also the protector of women in childbirth. A popular figure in Christian art, Gabriel was most often depicted in the *Annunciation to Mary as a beautiful young man richly dressed in a *dalmatic or *cope and had multicolored or elaborate *wings. He held a *lily, *scepter, olive branch, or *scroll, usually inscribed *Ave Maria, Gratia Plena* (Latin for "Hail Mary, Full of Grace"). In byzantine and early medieval presentations of the Annunciation, he was the physically dominant figure who symbolized the majesty and sovereignty of God the Father. He raised his right *hand in salutation and blessings. As devotion to Mary increased, and the cult of Mary grew in the medieval period, she became the physically dominant figure in the Annunciation scenes as Gabriel diminished in physical stature and began to be rendered as kneeling before her in a posture of adoration and respect.

Gadarene Demoniac (Mt 8:28–34; Mk 5:1–20; Lk 8:26–39). Jesus cleansed a madman, identified as Legion, of the *devils that possessed him by having these devils enter a herd of swine, which proceeded to run violently over the side of the cliff into the sea. This event was rarely depicted as

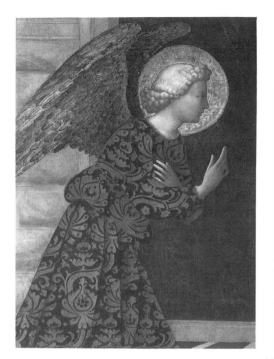
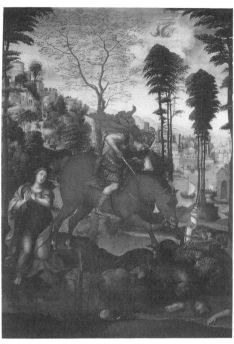

82. Masolino da Panicale, *The Archangel Gabriel.*
83. Sodoma, *Saint George and the Dragon.*

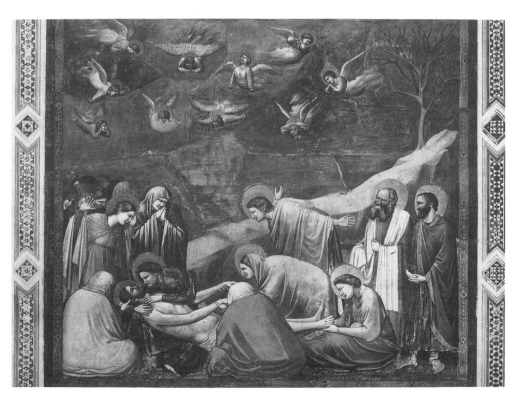

84. Giotto, *Lamentation.*

a separate topic in Christian art, but was included within the byzantine and medieval cycles of the life of Jesus Christ.

Garden. Symbol for disciplined and controlled nature as opposed to the unruliness and power of the wilderness. As the opposite of the city, the garden was the primal sin-free condition of humanity. In Christian art, the garden abundant with *flowers and *fruits signified *Paradise. In northern *medieval art, the motif of the Madonna and Child in the Enclosed (or Rose) Garden represented the belief that through *Mary's current action and the Child's future sacrifice, humanity would be able to return to the *Garden of Paradise. The enclosed, or walled, garden (*hortus conclusus*) was a biblical metaphor (Song 4:12) for Mary's perpetual virginity, and was included in medieval and renaissance depictions of the *Annunciation to Mary, *Nativity of Jesus Christ, *Madonna and Child, and in baroque presentations of the *Immaculate Conception and the *Assumption of the Virgin Mary.

Garden of Eden. Paradisiacal first home of humanity. A fertile place abundant with *fruits and *flowers, crystal-clear *waters and tamed animals, the Garden of Eden was an idyllic place where no one went hungry, thirsty, loveless, or suffered illness or death. God the Father not only placed *Adam and *Eve but the Tree of Knowledge and the *Tree of Life there. Eve, in her innocence, was beguiled by a *snake or *serpent to disobey God's single command not to eat of the fruit of the Tree of Knowl-

edge. She then tempted Adam also to disobey God, and the result of their actions was that were aware of their bodily nature which they described as a state of nakedness. God learned of their disobedience when he found them covering themselves with *fig leaves. He cursed the snake (or serpent) commanding that it should crawl on its belly for all eternity and be the enemy of humanity. Adam and Eve were expelled into the world where they and all their descendants would suffer death, where Adam and all men would have to labor, and Eve and all women would suffer pain at the birth of their children. In Christian art, the Garden of Eden was depicted as a lush, lovely green place covered with beautiful flowers, trees, and bushes, and in which wild animals lay peacefully together. The Garden of Eden was included in depictions of the Creation of Adam, the Creation of Eve, the Marriage of Adam and Eve, the Temptation and the Fall, and the *Annunciation to Mary. The iconography of Mary in the Rose Garden in northern *medieval art was directly related to the medieval legend that in the Garden of Eden roses grew without thorns, for thorns like death and labor pains were the result of *Original Sin. The Garden of Eden prefigured *heaven and *paradise.

Garden Enclosed (*Hortus Conclusus*). Sign for the perpetual virginity of *Mary (Song 4:12). The Garden Enclosed was found in medieval and renaissance depictions of the *Annunciation to Mary, *Nativity of Jesus Christ, and *Madonna Child, and in the baroque presentations of the *Im-

maculate Conception and the *Assumption of the Virgin Mary.

Garden of Gethsemane. *See* Agony in the Garden.

Gate. Symbol for multiple and ambiguous meanings as both exit and entrance. The gate into the *Garden of Eden as *Paradise was the same gate through which *Adam and *Eve were expelled. The gate separated the damned from the saved in depictions of the *Last Judgment, and the gate broken open signified the *Descent into Hell (or Harrowing of Hell). The closed gate denoted the perpetual virginity of *Mary (Ez 44:1–3).

Gazelle. Animal whose acute vision symbolized penetrating spiritual insight. The gazelle's natural speed, which allowed it to escape its predators, represented Christians fleeing from earthly passion.

Genevieve, Saint (c. 420–500). Renowned for her charitable works, mystical visions, and prayer. Devout from childhood, she became a *nun at fifteen. Genevieve alleviated the starvation of Paris when she led wagonloads of food through the Frankish blockade. Eventually she persuaded King Clovis to release the prisoners of war. Her prayers saved Paris from an attack by Attila the Hun in 451. The patroness of Paris, Genevieve miraculously intervened against the plague and several invasions of the city. In Christian art, she was depicted as a young woman dressed either as a shepherdess or as a *nun with the *keys to the city of Paris

either in her *hand or attached to her *belt.

George of Cappadocia, Saint (d. 303). Legendary warrior saint. The historic George of Cappadocia was a Roman soldier who was martyred during the Diocletian persecutions. According to *The *Golden Legend,* the story of George and the *Dragon, a variant of *Christ's triumph over the *Devil, dated from the medieval period. The Princess Cleodolinda was prepared as a sacrificial offering to the dragon that was pillaging and burning the kingdom of Silene. In full *armor and on horseback, George made the sign of the *cross and slew the dragon. Witnessing this combat, the *king of Silene and his people witnessed were converted to Christianity. According to one legend George married the Princess, while another legend placed him in Palestine where he defied Diocletian's decrees against Christianity, and thereby was tortured and beheaded. One of the *Fourteen Holy Helpers, George was the patron of England, Portugal, Germany, Greece, Catalonia, Venice, Ferrara, the Order of the Garter, soldiers, armorers, and the boy scouts; he was also the protector of women and the code of chivalry. In Christian art, George was depicted as a handsome young *knight in shining armor. His *banner, *shield, and/or breastplate were inscribed with a *red cross. He was represented on horseback thrusting a *lance into the fire-breathing dragon as the beautiful princess dressed in pure *white watched. His *attributes included a lance, *sword, shield emblazoned

with a cross, and white banner inscribed with a red cross.

Gestas. The name of the "Bad Thief" crucified with Jesus and *Dismas, the "Good Thief," according to the apocryphal *Gospel of Nicodemus* (Greek Rec, Part B, C. 10).

Giles, Saint (d. c. 712). A popular medieval hermit *saint and Benedictine abbot credited with building a Benedictine monastery in Provence (Saint-Gilles, a popular medieval pilgrimage center). During his forest retreat, Giles's faithful companion was a small *hind who was hunted one afternoon by the Visigothic King Wamba. The *arrows wounded the hermit, who was found with the beloved hind protected in his arms as the hunters' hounds stood motionless before him. Preferring mortification of the flesh as a sign of his humility, Giles refused treatment for his *wounds and was crippled. According to another version of this legend, Giles was wounded in the leg. One of the *Fourteen Holy Helpers, he was the patron of cripples, the indigent and blacksmiths. According to tradition, *Charlemagne having committed some an unnamed sin and fearing confession, was absolved by Giles who was invoked by those who fear the *sacrament of confession. In Christian art, he was depicted with a *white *beard wearing the white *habit of the reformed Benedictines. His *attributes included a *crosier (as founder of his monastery), arrows, and a hind.

Giotto (1266/7–1337). The acknowledged founder of modern painting and an innovator infusing human emotions into Christian art. A Florentine by birth, Giotto trained under Cimabue from whom he learned the traditional manner of painting, perception of form, and *iconography. In his great *frescoes at the Scrovegni Chapel in Padua and the Basilica of San Francesco in Assisi, he broke with the Italo-Byzantine tradition and instilled solidity and naturalism to his figures, and spatial perceptive. Using nature as his foundation, Giotto turned his attention to a careful rendering of shapes and forms, and naturalistic background. In keeping with this emphasis on naturalism, Giotto also instilled his human figures with the expression of human emotions and passions through gestures, facial expressions, and body postures. In his narrative cycles of the life of *Mary and *Jesus Christ for the Scrovegni Chapel, Giotto emphasized the humanity of their experiences, from the touching gestures of the *Anne and *Joachim at the Golden Gate to the tortured, sorrowing *angels of the *Lamentation. His interpretation of the *Last Judgment based on his conversations with his friend, the poet *Dante, transformed the iconography of this theme, specifically in terms of the illustration of the *Devil as a motionless *blue monster trapped in ice and of the torments of *Hell. In his frescoes for the Basilica of San Francesco in Assisi, Giotto imbued the visual image with the humanity and spirituality of *Francis of Assisi.

Giraffe. A strange-looking and rare creature, and a popular animal in *renaissance art. Included in the *Nativity of Jesus Christ and the *Adoration

of the Magi, the giraffe had no specific symbolic referent.

Girdle. Worn over one's clothing as an item of protection, ornamentation, and purse in the classical Greco-Roman world. Young girls received an ornamental girdle from their parents at puberty as a symbol of their womanhood and their chastity. This girdle was replaced at marriage with one given by her husband as a sign of marital fidelity. In Christian art, the girdle signified obedience and chastity (Lk 12:35 DR; Eph 6:14). A girdle of cords represented Jesus at the *Flagellation. In the *Old Testament, prophets wore leather girdles as a sign of their humility and contempt for the world, while the monastic girdle symbolized the vows of poverty, chastity, and obedience. In byzantine and baroque depictions of the *Assumption of the Virgin Mary, she dropped her girdle on the *head of *Thomas, who doubted her death and assumption.

Glass. Symbol with multiple meanings including purity and the *Incarnation. In its clarity and transparency, glass signified the purity of *Mary, and was included in representations of the Annunciation and the *Immaculate Conception. Glass also typified the Virgin Birth, following the medieval understanding that just as light penetrated glass but did not shatter it, so *Mary conceived and bore Jesus but her virginity was not impaired. In medieval depictions of the creation narrative, God the Father held a glass (or crystal) ball which denoted the divine world of light before he created the *earth. A crystal glass

with a *serpent or a broken glass was an *attribute of *Benedict of Nursia.

Globe. A symbol for the *earth, and thus of terrestrial power and sovereignty. The globe was an *attribute of God the Father, *Christ as King, and monarch saints such as *Louis of France and *Charlemagne. A globe surmounted by a *cross represented the universal Triumph of Christianity.

Glory. From the Latin for "splendor." A luminous glow surrounding the head and the body of either God the Father or *Jesus Christ. The emission of light around the entire body was a sign of the most elevated divine state. The glory was bright *white or soft *gold or *yellow in *color. The glory was to be distinguished from an *aureole, which only surrounded the body and was *blue, rainbow-hued, gold, or white in color, and from the *nimbus or *halo, which only encircled the head.

Goat. An animal signifying lasciviousness, *Jesus Christ, and sacrifice. In Christian art, a group of goats symbolized the sinners and the damned who were separated from the *sheep at the *Last Judgment (Mt 25:31–46). The domestic male goat was a lascivious creature as his genitals were large in proportion to his *body. The *Devil had several characteristics of the goat like cloven hoofs, or the even the body of the goat at a *witches' coven which was believed to be an orgiastic rite. A *white *mountain goat represented Jesus Christ in search of the *church, or of the all-seeing power of God.

The wild goat capable of selecting only the safe grasses and weeds to feed on denoted the Christian who had chosen the path of virtue over vice. *See also* Scapegoat.

Goblet. An *attribute of several *saints including Donatus and *Benedict of Nursia, who each miraculously restored a smashed communion *cup. A goblet with a *serpent was an attribute of *John the Evangelist and Benedict of Nursia.

God the Father. The First Person of the *Trinity. Rarely depicted in early Christian art until the middle of the fourth century when a series of symbols and images were used to signify God the Father's presence such as the right *hand with which he created and judged, the *triangle inscribed with an *eye, the initial *T (for *Theos*), and a *triangle surrounded by rays of light. By the eleventh century, anthropomorphic representations of God the Father had appeared, including the Ancient of Days, which corresponded to Daniel's vision of an elderly man with a long *white *beard, dressed all in white, and seated on a throne. This early *iconography for God the Father was adapted from the classical Greco-Roman images of *Zeus and *Jupiter. In northern *medieval art, God the Father was depicted with the regalia of the pope. The triangular *halo, signifying the Trinity, was reserved for God the Father. His *attributes included a *globe, *book, triangle inscribed with an eye, and *eagle.

God the Holy Spirit. The Third Person of the *Trinity. In Christian art, the Holy Spirit was signified by the *white *dove (Jn 1:32) or as rays of light or *flames (Acts 2:2–4).

God the Son. The Second Person of the *Trinity, and identified with *Jesus Christ. Particular images of God the Son included him seated at the right *hand of God the Father, as the Judge of the living and the dead. In early Christian art, God the Son was signified by the *lamb, *fish, the sacred monogram (*Chi-Rho), the *Good Shepherd, and the *Philosopher-Teacher. In *byzantine art, he was illustrated as an enthroned *king with dark *hair and *beard. In *medieval art, one motif for God the Son was the *Salvator Mundi* ("Savior of the World") in which he held a *globe, wore the crown of thorns, and carried his *cross. The *attributes of God the Son included the cruciform nimbus, cross, *stigmata, *book, or any of the monograms of Jesus Christ.

Gods and goddesses. The personifications of the mythological figures of classical cultures, especially of Greece and Rome. The presentations of these gods and goddesses in human forms in classical literature and art influenced the development of Christian art and legend. The positive attributes or characteristics of these gods and goddesses, particularly of the most powerful ones, were assimilated into the iconographies of *Jesus Christ, *Mary, and several Christian *saints. *See also* Aphrodite, Apollo, Ares, Artemis, Athena, Ceres, Cupid, Demeter, Diana, Dionysus, Helius, Hera, Hermes, Hestia, Jove, Juno, Jupiter, Mars, Mercury, Minerva,

Neptune, Oceanus, Poseidon, Venus, and Zeus.

Gold (as a color). A color signifying wealth, power, divine energy, and light.

Gold (as an element). An element signifying precious offering, divinity, kingship and the ambiguity of material wealth. Gold was the gift offered to the newborn Christ Child as a sign of kingship by Caspar, one of the *Magi. Liturgical vessels and vesture, religious objects, and religious art have been encrusted with or formed from gold as a sign of offering only the best and most precious to God. The *Old Testament story of the *Golden Calf indicated wealth and power gone astray and offered not to God but to an idol.

Golden Calf. *See* Calf, Golden.

Golden Legend, The (*Legenda Aurea*). A thirteenth-century compilation of legends, lore, verses from scripture, and Christian theology about the saints arranged according to the Church Year by *Jacobus de Voragine (c. 1230–1298), a Dominican friar and confessor to a Dominican convent. According to tradition, he prepared this text as appropriate readings for the Dominican *nuns. *The Golden Legend* was an influential sourcebook for Christian *iconography.

Goldfinch. A *bird which fed on *thorns and *thistles, thereby symbolizing the Passion. When held by the *Christ Child, the goldfinch signified that this *child was born to die and had foreknowledge of his sacrificial death. If held by *Mary, whether or not her son was present, the goldfinch denoted her foreknowledge of this sorrowful event. According to medieval legend, the goldfinch was characterized as a "savior" because of its connection to the Passion, and thereby became an amulet against the plague.

Golgotha. From the Hebrew for "skull." The location of the *Crucifixion of Jesus Christ. It was also identified by its Latin name, *Calvary. According to pious legend, this same site was the traditional burial place of *Adam and *Eve as found in medieval images of the crucifixion. Thus, the *cross became the "*Tree of Life" which redeemed humanity which "fell" at the Tree of Knowledge.

Good Samaritan. *See* Parables.

Good Shepherd. A popular image from classical Greco-Roman art also identified as the Calf-bearer (or Hermes Criophorus), it was assimilated into earliest Christian art as a symbol of *Jesus Christ as the caretaker of Christian *soul and as the *shepherd for each of his *sheep (Mt 18:10–14). The Good Shepherd and the *Resurrection of Lazarus were the two most popular themes in early Christian art. The motif and symbolism of the bishop as a shepherd derived from the *iconography of the Good Shepherd.

Goose. A classical Greco-Roman sign of providence and vigilance. In Christian art, the goose was an *attribute

of *Martin of Tours, and Werburga. In *medieval art, a gaggle of geese listening to a *fox was a metaphor for innocent Christians confused by false preachers.

Gospel. From an Anglo-Saxon compound word for "good news." The collection of texts by the four *evangelist which narrated the events in the life of *Jesus Christ. Understood to be "glad tidings" or the "good news," these accounts were the scriptural foundation of all forms of Christianity. The first four books of the *New Testament—*Matthew, *Mark, *Luke, and *John—were characterized as both divinely inspired and as eyewitness narrations of events and teachings of Jesus Christ. In Christian art, the gospel was denoted by a large *book on the cover of which was incised the *tetramorphs (or signs of the four evangelists) or an image of Christ.

Gothic art. From the architectural style of the twelfth to the sixteenth centuries, the great age of cathedral building, a style of visual art predicated upon verticality, spaciousness, and a fascination with light. The elegant figures of Gothic art were characterized by the S-shaped curve of their bodies, which gave a sense of elegance, movement, and grace. This was the idealized art style of the medieval synthesis as evidenced in *altarpieces, tapestries, cathedral carvings, sculptures, and manuscript *illuminations.

Gourds. A vegetable symbol with multiple meanings, including brevity and frailty of life, *pilgrimage, and

resurrection. As the sign of *pilgrims and pilgrimage, dried and hollowed-out gourds were used as drinking flasks for *water. They were an *attribute of several Christian pilgrims including *James Major, the two disciples with the Risen *Christ on the Road to Emmaus, and the *Archangel Raphael. Gourds also signified the Resurrection as *Jonah refreshed and renewed himself under an arbor of gourds after having been spewn out of the great *whale. In the *hand of the Christ Child, or in *Mary's hand as she held her son on her lap, the gourd denoted the Resurrection. When placed near each other in a work of Christian art, the gourd canceled out the evil and death signified by an *apple. In Christian art, the gourd resembled in shape and *color the cucumber.

Grail, The Holy. The legendary *chalice used by Jesus at the *Last Supper. According to the apocryphal *Gospel of Nicodemus*, *Joseph of Arimathea preserved both the grail and several drops of the precious *blood that fell from the crucified *body. He brought them to England, ostensibly to Glastonbury, and buried them in a soon-to-be forgotten site. The quest for the Holy Grail became the focus of many medieval—especially English legends—including the Arthurian tales of the Knights of the Round Table. It was believed that if any impure person approached the Holy Grail, it would disappear; therefore only the purest of Christian *knights could retrieve it. The honor of England depended upon the safe recovery and continued preservation of the Holy Grail. The theme of the "quest for the

85. Francesco di Giorgio Martini, *The Nativity,*
with God the Father Surrounded by the Angels and Cherubim.
86. El Greco, *The Holy Family with Saint Anne
and the Infant John the Baptist.*

87. Mathias Grünewald, *The Mystic Nativity,*
second opening of *The Isenheim Altarpiece.*

Holy Grail" or the pure knight with the Holy Grail was popular in the decorative motifs of medieval cathedral carvings.

Grain. A sign for *bread, and thereby human sustenance. In Christian art, grain signified the humanity of Jesus Christ (Jn 12:24). Representations of ears of grain and bunches of *grapes represented the bread and wine of the *Eucharist.

Grapes. Fruit symbol with multiple meanings in Christian art, including the *blood of Jesus, the *Eucharist, or *Jesus Christ as the "true vine" from the *parable of the laborers in the vineyards. In the *hands of the Christ Child, or of *Mary as she held him, the reference was to both his future sacrificial death and the sacrament of the Eucharist. In *medieval art, the depiction of two men laboring with their burden of enormous bunches of grapes was very popular as a sign of the Promised Land (Nm 13:23).

Grapevine. Symbol of abundant life. In the *Old Testament, the grapevine was a sacred plant signifying Israel and the *Messiah; while in the *New Testament, it represented *Jesus Christ as the "true vine."

Grasshopper. One of the plagues God sent to Egypt when Pharaoh continued to deny the *Hebrews freedom to leave (Ex 10:14). According to legend, *John the Baptist fed on grasshoppers during his time in the wilderness. In the *hands of the Christ Child, the grasshopper de-

noted the evangelization of the pagan nations.

Gray. The color of ashes, mourning, and humility. In Christian art, Jesus was often dressed in gray garments as a sign of his humility, and in relation to the Passion it typified his eminent death. The Vallombrosian Order of the *Benedictines wore gray *habits.

Greco, El (Domenikos Theotocopoulos) (1541–1614). A leading painter of the Spanish baroque style, originally trained in the byzantine iconic tradition on his native Crete. El Greco traveled to Venice to study the late renaissance master, Titian, and went to Rome in 1566, where he studied *Mannerism. His personalized ecstatic and passionate style of painting was a fusion of these three artistic traditions—byzantine icons, Venetian renaissance, and Mannerism. He relocated to Spain in 1572, where he was influenced by the *Counter-Reformation, in particular the spirituality and immediacy of religious experience advocated by both *Ignatius of Loyola and *John of the Cross. El Greco created a style of Christian art which advocated the Tridentine position. His elongation of the human figure combined with the contortions of perspective and space to create an aura of nervous tension in his paintings. His use of color was a study in sharp contrasts and heightened the emotional intensity of his work. His extraordinary ability to represent air, especially in the billowing drapery of his garments, permitted a spiritual sensuality to permeate his work. In his paintings, El Greco transformed mystical experi-

ence into spiritual catharsis. His floating, elongated, pinhead figures closely resembled the shapes of *candle *flames, and signified a conflation of both the byzantine tradition of divinization and Spanish mysticism, creating a vision of spiritual energy and ecstasy.

Green. A symbol of fertility, regeneration, and hope. The color of spring vegetation, green represented the restoration of nature's bounty over the barrenness of winter. As a fusion of the two primary colors, *yellow and *blue, green denoted the regeneration of the *soul brought about through acts of *charity. As the signs of victory over death, especially of a martyr's death, the palm branch and the *laurel wreath were composed of evergreen leaves. Green was the color worn during pagan rites of initiation, and was associated in classical Greco-Roman culture with *water. In Christian art, *John the Baptist wore a green mantle over his hair shirt to indicate the Christian ritual of *baptism as a spiritual initiation and the promise of new life through the *Resurrection of Jesus Christ.

Gregory the Great, Saint (c. 540–604). One of the Four Fathers of the Western Church and the Father of the Medieval Papacy, Gregory left his wealthy family to dedicate his life to the *church. He became a *monk, and spent much of his time establishing *monasteries and serving the popes. An able administrator as pope, Gregory decreed priestly celibacy, reformed the calendar and the liturgy, established choirschools and the Gregorian chant, and sent *Augustine of

Canterbury to convert the English. Gregory established the medieval model of the papacy as an institution of spiritual and temporal power. He was associated with many miraculous and visionary tales including the release of *souls from Purgatory following intercessory prayers and the Mass of Saint Gregory at which the bloodied body of *Christ appeared over the Host. In Christian art, Gregory the Great was depicted as a tall, beardless, dark-haired man dressed in papal robes with the papal *tiara and *crosier at his side. The motif of the Mass of Saint Gregory was popular during the medieval and counter-reformation controversies over the meaning of real presence.

Gridiron. An *attribute of *Laurence in Christian art.

Griffin. A mythical beast with the head, wings, and feet of an eagle, and the body of a lion. A popular motif in classical Greco-Roman and *medieval art, the griffin signified heroes and great *knights renowned for their valor and magnanimity. Reputed to walk on four *feet, it was identified as an unclean animal (Lv 11:20–23) and came to typify the *Devil or the Antichrist. The griffin, paradoxically, also denoted *Jesus Christ in Christian art and in the writings of *Dante.

Grill. An *attribute of *Vincent of Saragossa in Christian art.

Growing Seed. *See* Parables.

Grünewald, Mathias (Mathis Neithardt Gothardt) (c. 1470/80–1528). A sixteenth-century German artist

about whom little biographical information was known. His masterpiece, *The Isenheim Altarpiece,* was well known to students of Christian art. Grünewald employed a complex iconographic scheme for this *polyptych which integrated medieval legend and symbolism with a recognition of renaissance perspective and presentation of spatial relationships. His use of exaggerated gestures and bodily forms heightened the emotional impact of his paintings.

Gryphon. *See* Griffin.

Guarded Tomb (Mt 27:62–66). Acceding to the fears and demands of the High Priests, *Pontius Pilate ordered that the Roman soldiers seal the *tomb of Jesus and guard it throughout the night so that the body could not be stolen and his followers claim a resurrection. A part of the Passion narrative, this episode was rarely represented as an independent topic. The Guarded Tomb became conflated with the Empty Tomb or *Three Marys at the Tomb.

Habit. The distinctive garb worn by religious orders of *monks and *nuns. Each order was identified by their particular style of garment with the basic variations being in *colors and cloth. The basic habit of a monk or a friar consisted of a tunic, *girdle, *hood, and *scapular. The basic items of the nun's habit were similar, with the *wimple and the *veil added.

Hagar (Gn 16:1–15; 21:8–21). The Egyptian maidservant given to *Abraham by his barren wife *Sarah as was the custom of the time. Abraham fathered Hagar's son who was called Ishmael. Following the birth of Sarah's own son, *Isaac, much jealousy arose between the two women. Eventually Sarah forced her husband to expel the maidservant and her son with only minimal *bread and *water into the *desert. Miraculously, Hagar and Ishmael survived as God intervened by sending an *angel with water. Ishmael was identified as the father of the Arab nations. In Christian art, the topos of the Expulsion of Hagar and Ishmael was interpreted as a foretype of the *Cleansing of the Temple.

Hair. Symbol of energy and power premised upon its connections to the hair which covered the bodies of *animals as both protection and decoration. In classical Mediterranean culture, young unmarried women wore their hair loose and flowing, respectable matrons covered their hair with *veils and mantles, and prostitutes piled their hair upon their *heads. *Samson's strength was directly related to his unshorn hair. Loose, flowing hair became associated with penitence as the woman who anointed the *feet of Jesus during the *Feast in the House of Simon used her long hair to wipe his feet with her tears. This woman became identified with *Mary Magdalene, one of whose *attributes was her long, flowing hair which denoted spiritual regeneration. The male and female hermit *saints were characterized by their long, flowing hair which covered their bod-

ies and protected them. The sacrifice of hair—a sign of devotion and allegiance or penance—was the basis of the tonsure of *monks and clerics.

Halberd. An *ax blade mounted on a *staff, it signifies destruction. Used as spear, the halberd was an *attribute of *Jude and *Matthew.

Half-Shekel or Temple Tax. *See* Tribute Money.

Halo. From the Latin for "cloud." A circle of light surrounding the *head of a divine or sacred person. An *attribute of sanctity, the shape of the halo was its distinguishing characteristic. The triangular halo was reserved for God the Father, and the cruciform halo for the Resurrected *Christ. Square haloes identified persons who were alive when a work of art was made, circular haloes were reserved for *Mary, *saints, and *angels, and hexagonal haloes for allegorical or legendary persons. In Christian art, the halo was initially employed to denote the *Trinity and angels; however, by the byzantine and throughout the medieval period, use of the halo spread to Christ, Mary, and the saints. The growing renaissance interest in the human resulted in the diminished use of the halo. *See also* Aureole, Glory, and Nimbus.

Hammer. An *Instrument of the Passion and a symbol of the *Crucifixion of Jesus Christ. The hammer was an *attribute of *Jael, *Joseph (of Nazareth), and William of Norwich. A hammer with nails was an attribute of *Helena and *Nicodemus.

Hand. A symbol for creativity, judgment, anger, power, and affection. A open raised right hand was a sign of salutation and of blessing. The clasping of hands signified the solemnity of a vow, such as betrothal, marriage, or friendship. The most ancient and common symbol for God the Father was a right hand issuing from *clouds, perhaps holding thunderbolts or rays of light. Hand gestures were an important form of communication in both the visual arts and drama, as well as in everyday life. In Christian art, a raised right hand with the palm extended connoted the act of blessing, an open palm reaching outward to a person friendship or assistance. Hands clasped between a man and a woman implied intimacy and affection. An upright open hand with either three fingers raised or the thumb and first two fingers raised typified the *Trinity. The *Betrayal by Judas was denoted by pouring *coins from one hand into another. The washing of hands suggested cleanliness, ritual purification, and the act of *Pontius Pilate who "cleansed" himself from responsibility in the *Crucifixion of Jesus Christ. *Basil the Great was characterized by an outstretched hand on which a *dove rested.

Harbor. A sign of safety and eternal life. As ships sought harbor, so the Christian *soul sought *Heaven.

Hare. An ambiguous symbol for passivity and lust. In its meekness and passivity, the hare was defenseless against larger animals, so it relied upon its *wisdom for survival. Thus, the hare signified the Passion and

those Christians who placed their hopes of salvation in *Jesus Christ. Its fecundity and rapidity of movement also categorized the hare as a symbol of lust. In the *hands of either the Christ Child or *Mary, however a *white hare represented the triumph of chastity over lust.

Harp. A stringed musical instrument signifying celestial music and the glorification of God. The harp was an *attribute of *David and *Cecilia.

Hart. Symbol for the faithful Christian who longed for God (Ps 42:1). The hart was an *attribute of *Eustace, *Giles, and *Hubert.

Harvest. Symbol for fulfillment, completion, *Last Judgment, Ruth, and the *Flight into Egypt.

Hatchet. A sign of destruction. The hatchet was an *attribute of *John the Baptist, *Matthew, *Mathias, and *Joseph (of Nazareth).

Hawk. A solar *bird like the *eagle and a symbol for death in medieval art.

Hawthorn. An ambiguous symbol used either to represent chastity and virginity or the crown of thorns. In medieval art, the hawthorn signified caution and hope.

Hay. A scriptural symbol for the transitoriness of life and of the world.

Head. Uppermost part of the human *body, and site of the lifeforce, the brain, and the soul in the ancient world. As the part of the body closest to *heaven, the head signified spiritual nature. Decapitation was considered the most vicious punishments as the severed head would be buried apart from the decapitated body, so that the dead would know no rest. In Christian art, the severed head was the *attribute of many *saints who were beheaded, including *John the Baptist and *Denis. Following the classical Greco-Roman foretype of Perseus holding the severed head of *Medusa, the biblical hero *David was represented as a young man holding a severed head; and the apocryphal heroine *Judith also held a man's head in her right hand. A man's head on a platter signified John the Baptist and one on a Bible suggested Denis. A woman holding a cloth inscribed with a man's head denoted *Veronica.

Healing of the Blind. *See* Man Born Blind.

Healing of the Epileptic Boy (Mt 17:14–18; Mk 9:14–19; Lk 9:37–43). A father whose son was in the midst of an epileptic fit pleaded with Jesus for a cure. The father affirmed his own belief and asked for help with his unbelief. Jesus called forth the evil spirit from the son and he was cured. This miraculous healing was very rare in Christian art, and was fused with other "healings."

Healing of the Paralytic (Mt 9:2–8; Mk 2:1–12; Lk 5:17–26). A paralytic was brought to Jesus to be healed. The crowd around Jesus was so immense, however, that they had to take the paralytic to a rooftop and lowered him into the building through the tiles. Surrounded by skeptical scribes

and other *Hebrews, Jesus told the healed paralytic to pick up his bed and walk to his own home. The crowd was stunned and filled with awe as the man stood up, put the bed on his back, and walked away. A rare topic in Christian art, the healing of the paralytic was included in the byzantine and medieval life cycles of Jesus Christ. This miraculous healing was signified by the depiction of the paralytic standing up with the bed on his back.

Healing of Peter's Mother-in-law (Mt 8:14–15; Mk 1:30–31; Lk 4:38–39). When Jesus entered *Peter's house, he saw that Peter's mother-in-law was sick with fever. After he touched her *hand, the fever disappeared and she left her sickbed to prepare a meal. This event was rarely depicted in Christian art. It was however distinguished from the healing of Jairus's daughter because no one else was present in the room when Jesus raised the young girl from her sleep.

Heart. A symbol for understanding, love, courage, devotion, sorrow, piety, happiness, and joy. The central organ of the human *body coordinated the intellect and the emotions. Religious fervor was typified by a flaming heart, while contrition, repentance, and devotion under trial were represented by a heart pierced by an *arrow. A heart with a *cross was an *attribute of *Catherine of Siena, a simple heart of *Bernardino of Siena, and a flaming heart or one pierced by an arrow represented *Augustine and Anthony of Padua. The Sacred Heart of Jesus. as described in the mystical vision of Margaret Mary Alacoque (1647–1690), was the image of a flaming heart surmounted by a cross and enclosed in a crown of thorns. A heart pierced by seven arrows represented the Seven Sorrows of Mary, and a heart transfixed by a *sword and encircled by a *wreath of *roses represented *Mary. The heart crowned with thorns was an emblem of the *Jesuits and an attribute of *Ignatius of Loyola.

Heaven. The peaceful and bountiful kingdom in which God the Father reigned in love and justice. It was believed to be located in the highest celestial region and to be populated with the *souls of blessed. *Heaven was also called the Holy City, *paradise, New *Jerusalem, and the Garden of Paradise. In Christian art, heaven was depicted as either a verdant, lush garden filled with beautiful *flowers and *fruits, and *angels, or a light-filled glorious *cloud inhabited by the choirs of holy *angels, the blessed, God the Father, the Resurrected *Christ, and *Mary.

Hebrew Scriptures. *See* Old Testament.

Hebrews. Traditional designation for the Israelites starting with the patriarchs—*Abraham, *Isaac, and *Jacob—through the *Old Testament period embracing the twelve tribes, the era of development of the Kingdom of Israel, and the division of the kingdom into the Northern and Southern kingdoms. Following the Babylonian Captivity, the designation *Jews identifying the peoples of the Kingdom and province of Judea who

practiced the monotheistic religion of Judaism became the common usage. In Christian art, the Hebrews and the Jews were commonly misidentified as one and the same.

Hebrews in the Fiery Furnace, Three. *See* Daniel.

Hedgehog. An *animal hunter of *serpents, thereby a symbol of opponents. According to the *Physiologus, the hedgehog robbed the vine of its *grapes and thereby signified the *Devil in who took human *souls.

Helena, Saint (255–330). The Christian mother of Emperor *Constantine. A great *church builder distinguished for her *charity, Helena went on a *pilgrimage in quest of the True Cross which she believed she found when a sick or dead man—depending on which legendary account is used—was restored by touching it. She also located the *nails, and the site of the *Garden of Gethsemane and the *tomb of Jesus. She had the Basilica Church of the Holy Sepulcher built on the site of the tomb, and a golden cross erected on the site of the True Cross. She took the True Cross and the nails back with her to her son's capital, Byzantium. Helena was the patroness of dyers. In Christian art, she was depicted as an elderly woman dressed in regal garments with an imperial *crown. Her *attributes included a golden *cross, the model of the Holy Sepulcher, *hammer, and nails. The *iconography of the "The Invention of the Cross" celebrated her discovery of the True Cross. *See also* Finding of the True Cross.

Helius. Greek god of the *sun, the brother of the goddess of the dawn and the goddess of the *moon. Also identified as Helios, Helius was the god of the flocks. He became conflated with *Apollo. Symbolic of the rising sun, both Helius and Apollo were foretypes of *Jesus Christ. In classical Greco-Roman and *renaissance art, Helius was depicted as a strong, handsome man with wavy locks of *hair and a crown of rays who drove a *chariot symbolic of the sun across the sky.

Hell. The place of eternal punishment and damnation. As the opposite of *heaven, hell was perceived to be in the lowest regions of the *earth. Biblical references to hell suggested a place of perpetual *fires where sinners were tortured by the constant *flames and heat. Until *Dante revised this description of hell, Christian artists depicted it as a flame-filled place in which the damned suffered physical tortures and indignities. In this vision of hell, the *demons and the *Devil were represented as evil creatures blackened from the fires and the *smoke. In accordance with the medieval thinking about God as light, Dante conceived of hell as a cold and dark place deprived of the warmth and the light of God. In the lowest region of Dante's Inferno, Satan was an ice-blue creature trapped forever in a frozen lake. Dante's description of hell was represented by *Giotto, the poet's friend and companion in Padua, in his frescoes for the Scrovegni Chapel.

Helmet. A piece of military *armor which protected the *head, thereby a sign of spiritual protection.

Hemorrhissa. *See* Woman with the Issue of Blood.

Hen (with chicks). Symbol for *Jesus Christ with a flock of Christians.

Hera. Queen of the Greek *gods and goddesses, the lawful wife of *Zeus, and the personification of the feminine aspects of all natural forces. She was the goddess of woman and childbirth, as well as the protectress of marriage and domestic harmony. Hera was the classical Greco-Roman foretype for both *Anne and *Mary. In classical Greco-Roman and *renaissance art, Hera was depicted as a large, matronly woman fully clad in soft, flowing garments with a *crown or diadem on her *head and a *scepter in her *hand. Her *attributes included the cuckoo, *crow, *peacock, and *pomegranate.

Heracles. One of the most popular and illustrious heroes in Greek mythology, famed for his courage and strength, and his fortitude through his sufferings. Also identified as Hercules, he completed the Twelve Labors and hundreds of other legendary adventures. In classical Greco-Roman and *renaissance art, Heracles was the ideal of masculine prowess and physical strength with his muscular limbs, curly *hair and *beard, thick neck, and small *head. He was dressed in a lion skin and carried either a bow and arrows, or a *club. He was the classical Greco-Roman foretype for *Samson.

Hermes. Greek god of the flocks, commerce, wealth, rhetorical skill, inventions, and dreams. He was best known as the messenger of the gods and the one who led the dead to the Elysian Fields. In classical Greco-Roman and *renaissance art, Hermes was represented as either a young *shepherd with his *sheep, a mischievous little imp, or the god of wealth with a *lyre for a *purse. Most often, Hermes was depicted as a graceful young male figure who wore a winged *helmet and *sandals, and held the caduceus, a *staff entwined with *snakes, as his sign that he was the messenger of the gods. He was the classical Greco-Roman foretype of the *archangels.

Herod Antipas (first century A.D.). Son of *Herod the Great, and Tetrarch of Galilee and Petrea from 4 B.C. to 39 A.D. He illegally married his niece *Herodias, who was divorced from his half-brother, Herod Philip. *John the Baptist preached against this adulterous union. Entranced by the dancing of his stepdaughter, Herod agreed to give her up to half of his kingdom. After consulting with her mother, the scripturally anonymous daughter of Herodias—later identified by the Jewish historian *Flavius Josephus as *Salome—asked for the *head of the Baptist on a platter. Despite Herod's pleas, the girl wanted nothing else and the Baptist was executed. Later, Herod questioned *Jesus as to his true identity, and when he received no satisfactory response, Herod ordered him to be mocked and sent back to *Pontius Pilate in a gorgeous royal *robe (Lk 23:11). Herod was deposed and banished to Gaul where he died. In Christian art, Herod Antipas was depicted as a large male figure dressed

in royal robes and a *crown. In the earliest renderings of the theme of the Dance of Salome, Herod was characterized in a posture of disgust at the young girl's request. As the *iconography of the Dance of Salome became more lascivious, Herod became a lecherous elderly man.

Herod the Great (first century B.C.). A vicious and bloodthirsty man, and ruler of Palestine at the time of the Nativity. He was visited by the three *Magi who told him about the Christ Child's birth; out of fear for his throne, Herod then ordered the *Massacre of the Innocents (Mt 2:16). In Christian art, Herod the Great was depicted as an large, elderly man with long dark *hair and *beard who wore royal *robes and a *crown and was seated on a throne.

Herodias (first century A.D.). Granddaughter of *Herod the Great, she first married Herod Philip and then his brother, *Herod Antipas, the Tetrarch of Galilee. Her adulterous union was condemned by *John the Baptist, who she both feared and despised. She convinced her unnamed young daughter to dance at her stepfather's banquet, and when he was pleased enough to offer the dancer a prize, she consulted with her mother, who demanded the *head of the Baptist on a platter. In Christian art, Herodias was depicted as a royal but lascivious woman who was regally dressed and wore a *crown. She was distinguished from her daughter— later identified as *Salome by *Flavius Josephus—by her larger physical stature and by her legendary action of piercing the decapitated Baptist's

tongue with a fork. By the High Renaissance, the figures of Herodias and Salome become conflated into one woman.

Heron. A solar *bird like the *stork and the *crane, and a symbol of vigilance and quietude. As a destroyer of *serpents, the heron signified *Christ. According to Pliny, the heron's tears of pain foretold the tears Jesus shed at the *Agony in the Garden. The *gray heron typified penance.

Hestia. Greek virgin goddess of the hearth and household. In classical Greco-Roman and *renaissance art, Hestia was depicted as a serious but gentle woman in simple, flowing drapery with unadorned *hair who held a *scepter. She was a classical Greco-Roman foretype of *Mary.

Hexagonal Halo. A sign of an allegorical or legendary person such as the Virtues.

Hidden Treasure. *See* Parables.

Hieronymus, Saint. *See* Jerome, Saint.

Hind. *See* Hart.

Hippopotamus. A scriptural symbol for the brutal power that only God can subdue.

Historia Animalium. One of Aristotle's books on the natural sciences, in which he compiled and systematized all that was then known about animals. An early precursor of the medieval *bestiary, the *Historia Ani-*

malium was influential upon early Christian and *medieval art.

Hive. A sign of motherhood and industry. The hive was an *attribute of *Hope, and of *Bernard of Clairvaux who compared the ordered, cloistered community to a hive. *See also* Beehive.

Hog. Sign of the *demon of sensuality and gluttony. The hog was an *attribute of *Anthony the Abbot, who triumphed over these temptations.

Holbein the Younger, Hans (1497/8–1543). Most technically accomplished and realistic portrait painter of the northern *renaissance art. A friend of Erasmus, the great humanist, Holbein was also a book illustrator who designed illustrations for *Martin Luther's translation of the Bible into German, as well as two major series of prints on the *Dance of Death* (1523/4) and the *Alphabet of Death* (1524). In accordance with the reformist tendencies in northern Europe, Holbein's religious-theme paintings, especially his paintings of the *Madonna and Child*, were restrained and almost grimly realistic, verging more on the decorative than on the devotional.

Holly. Evergreen tree with prickly leaves that symbolized the Crown of Thorns. According to legend, the holly was the only *tree which did not splinter under the *ax, and therefore was used for the *cross of Jesus. The *red berries of the holly signified the suffering and sacrificial *blood of Jesus. In representations of *Jerome, the holly represented his meditations

on the Passion; while in depictions of *John the Baptist it symbolized the *Passion of Jesus Christ. As it was a Roman custom to distribute gifts of holly as a sign of good fortune for the new year, it became associated with the traditions of Christmas. The holly was also identified by its Latin name, *ilex*.

Holy Communion. Ritual reenactment of the *Last Supper, and the consecration of the *bread and wine into the *body and *blood of *Jesus Christ. *See also* Eucharist.

Holy Family. Title given to a variety of domestic scenes in which the *Madonna and Child were accompanied by other family members, including *Anne, *Joseph (of Nazareth), and/or *John the Baptist. In these images, Joseph taught Jesus about carpentry; or *Mary or Anne taught the *child to read; or either or both parents taught him to walk. The *Sacra Conversazione* (Holy Conversation) in which saints were included in teaching, reading, or conversing with the Christ Child in the presence of his parents, was a variant on the theme of the Holy Family.

Holy Kindred. Title given to the depiction of the three husbands, three daughters, and several grandchildren of *Anne. A popular theme in northern *medieval art, the Holy Kindred became popular during the Reformation when the cult of Mary was being silenced. As the Holy Kindred signified that Anne had three husbands and three daughters (one child by each husband) the uniqueness of

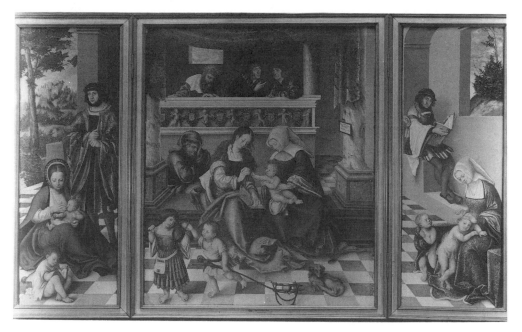

88. Lucas Cranach, *The Holy Kindred*.

89. William Holman Hunt, *The Light of the World*.

Mary's conception and birth were diminished.

Holy Orders. One of the Seven *Sacraments accepted by the *Roman Catholic, Eastern Orthodox, and Anglican churches. This act of ordination was the ritual of admission into the ministry of the *church. In Christian art, Holy Orders were symbolized by a *cup or *chalice with a *wafer on an open *Bible.

Holy Spirit. Third Person of the *Trinity. In Christian art, the Holy Spirit was typified by the *dove, or by rays of light or *flames.

Holy Trinity. The theological term for the three hypostases or persons in the singular Godhead as Father, Son, and Spirit. A metaphysical mystery: while indivisibly one, all three are equal and eternal. In Christian art, the Trinity was represented symbolically by the *triangle or three *doves; or more figurally by the three figures of God the Father as an elderly man with a *white *beard, God the Son as a younger man with a dark beard holding a *cross, and God the Holy Spirit depicted as a *dove. The Holy Trinity was prefigured by the three *angels who visited *Abraham and *Sarah.

Holy Week. The liturgical reenactment of the Passion beginning with Palm Sunday and concluding with *Easter.

Honey. A sign for sweetness and purity, and a symbol of *Jesus Christ's *ministry on *earth. Honey was also a sign of *paradise, "the land flowing with milk and honey," which was the biblical basis for the early Christian *Eucharist of milk and honey offered to children, the aged, the sick, and pregnant women.

Hood. Symbol for the concentration of spiritual power. A triangular piece of fabric which attached to a *cope, the hood was used to protect the wearer from the wind and the cold.

Hope. One of the three theological virtues of *faith, hope, and *charity. The symbol of hope was the *anchor. When personified as one of the *Seven Virtues, Hope had *wings which allowed her to soar towards *heaven. In Christian art, Hope was represented with *James Major at her *feet, and was identified by the anchor.

Hope, Saint (second century). The personification of the cult of Divine Wisdom (Sophia) in the eastern Mediterranean. According to tradition, the Roman widow, *Sophia, had three daughters—*Faith, Hope, and *Charity. The mother and her daughters were tortured and beheaded under the Emperor Hadrian.

Horns. An ancient symbol for strength and power, especially bestial strength. In Christian art, horns were an *attribute of the *Devil. *Moses was often depicted with horns as a result of *Jerome's translation of the Greek phrase "rays of light" into the Latin "horns of light."

Horse. Symbol of courage, generosity, virility and lust. According to legend, the horse was the only animal

that displayed emotion when it wept for its master. Another legend related that if the horse's mane was cut, the animal lost its sexual prowess. The rider who controlled the strength and power of the horse was the ideal of control and moral virtue. *George of Cappadocia, *James Major, and *Martin of Tours were represented on horseback in Christian art.

Hortus Conclusus. See Garden Enclosed.

Host. From the Latin for "victim" or "sacrifice." The flat, round piece of unleavened *bread consecrated with the wine during the *sacrament of the *Eucharist. The host and the *chalice signified the sacrificial death of Jesus as the Christ. The host was an *attribute of *Barbara, *Clare of Assisi, and Yves.

Hourglass. A sign of the passage of *time, and thereby the transitoriness of human life. The *hourglass was an *attribute of Time, Death, and the penitential *saints, especially *Jerome and *Mary Magdalene.

Hubert, Saint (d. 727). A young nobleman who turned to the spiritual life after the death of his wife. According to tradition, Hubert was a fine huntsman who went to the hunt on *Easter Friday morning, and was confronted by a pure *white *stag with a *crucifix between its antlers. He heard a voice warn him that he would spend eternity in *hell if he did not repent and live a Christian life. He dedicated his life to the *church and was responsible for ending all idolatrous practices in his dioceses.

As bishop of Liége, Hubert was credited with several miracles and visions. He was the patron of hunters, trappers, and mathematicians. In Christian art, Hubert was depicted as a handsome young hunter encountering the white stag with the crucifix between its antlers in front of the woods. He was also represented in bishop's attire while the stag with the crucifix between its antlers stood beside him or rested in an open wood.

Human Body. The physical symbol of the microcosm to the macrocosm that was the *earth or the universe. The human body had symbolic properties both as a whole, and in its individual parts. See also Breast, Eye, Foot, Hand, Head, Heart, Skeleton, Skull, and Teeth.

Hundred. A numerical symbol for heavenly bliss.

Hunt. Symbol for the *soul's quest for God or the striving for spiritual goals.

Hunt, William Holman (1827–1910). With *Dante Gabriel Rossetti and John Everett Millais, the founder of the *Pre-Raphaelite Brotherhood, and an innovator in Christian symbolism in nineteenth-century art. Hunt remained loyal to the ideals of the Pre-Raphaelite Brotherhood— truth to nature, accumulation of detail upon detail, retrieval of religious ideas and artistic community before *Raphael Sanzio, and the medieval synthesis of religion and art— throughout his career as evidenced in his paintings, *The Light of the World* and *The Scapegoat*. He made three

journeys to Egypt and the Holy Land (in 1854, 1869, and 1873) in order to imbue his biblical themes with accurate local settings, facial types, and clothing, thereby establishing a trend for other artists and writers.

Hyacinth. A floral symbol for prudence, peace of mind, and desire for heaven. According to the classical Greco-Roman myth, Hyacinth was a handsome youth who was accidently killed by *Apollo and from whose *blood sprang the *flower named in his honor. As an aromatic spring flower, the hyacinth signified the *Resurrection of Jesus Christ.

Hyena. A medieval symbol for greed, and for the *Devil feeding on the damned in Christian art.

Hyssop. A small *white or *blue blossomed labiate herb with white spicy leaves and with diuretic properties. Hyssop was used in the Jewish and Christian ritual of sprinkling the *blood of sacrificial animal or holy *water. By its natural characteristics, hyssop represented penitence and humility, and by its medicinal powers, *baptism (Ps 51:7) and *Mary.

I

❦

IC XC. A popular initial device in byzantine *icons representing the Greek abbreviations for *Jesus Christ. In combination with a Greek *cross and the word *nike* ("victory"), IC XC symbolized the phrase "Jesus Christ Conquers."

Ichthys. An acrostic formed from the first letters of the affirmation "Jesus[*i*] Christ[*ch*] God's [*t*] Son[*y*] Savior[*s*]." The acrostic of Greek letters spelled the Greek word for *fish, which became the central identifying emblem of early Christianity.

Icon. From the Greek for "image." A religious picture of *Jesus Christ, *Mary, or a *saint which was limited in subject matter and restricted in form. Icons were understood to be windows to the meaning of the event being depicted, not realistic renderings of persons, places, or events.

Iconoclasm. From the Greek for "image breaking." Destruction of images premised upon the conviction that all images were idolatry. In the Eastern Orthodox Church, the Iconoclastic Controversies raged from about 726 until 842, when the veneration and liturgical use of icons was restored. In Western Christianity, there was a brief eruption of the iconoclastic impulse under *Charlemagne, and the major wave of Protestant iconoclasm precipitated by the Reformation.

Iconography. The study of the meanings attached to pictorial representations, including signs, symbols, *attributes, and emblems.

Iconostasis. The screen dividing the sanctuary from the laity in Eastern Orthodox Churches. This screen was covered with *icons beginning with the Annunciation on the central doors ("Gates of Paradise"); to the left of the doors was an icon of the *Theotokos, to the right of the doors was an icon of *Jesus Christ as King and Judge, and immediately to the right another icon of the *saint to whom the *church was dedicated. The ico-

nostasis was the foundation for the development of the *rood screen in medieval *cathedrals.

Ignatius of Loyola, Saint (c. 1491–1556). Founder of the Society of Jesus (*Jesuits). As he recovered from a battle injury, Ignatius became interested in the spiritual life. After a period of intense contemplation, he had a vision of *Mary with her Child. A mystic as well as a missionary, Ignatius established the Society of Jesus along the lines of a military organization with the goal of reaffirming and or establishing the Roman Catholic Church as the "church universal." His book entitled, *Spiritual Exercises* was a manual for the perfection of the soul and remained a popular retreat manual. Ignatius was the patron of retreats and spiritual exercises. In Christian art, he was depicted as a balding middle-aged man with a dark *beard who was dressed in the Jesuit *habit. His *attributes included a *book, a *monstrance inscribed with *IHS, a *dragon, or a *heart pierced by *nails.

IHS/IHC. Capitalized forms of the Greek letters *iota, eta,* and *sigma*— the first three letters of *Iesous* (Jesus). These verbal symbols had several interpretations including the confusion between the two Latin phrases, *"In Hoc Signo"* ("In this sign conquer" identified with *Constantine) and *Iesus Hominum Salvator* ("Jesus Savior of Humanity"). IHS later became the emblem of the *Jesuits. The IHS inscribed in a *circle was an *attribute of *Bernardino of Siena, *Ignatius of Loyola, and *Teresa of Avila.

Ildefonso, Saint (c. 606–667). A *Doctor of the Church, a Spanish abbot, and archbishop of Toledo. Devoted to *Mary, Ildefonso was a distinguished musician, mystic, and writer who prepared a treatise on the perpetual virginity of Mary. The patron of Toledo, Ildefonso was credited with establishing the cult of Mary in Spain. In Christian art, especially in Spain, he was depicted receiving his *chasuble from Mary.

Ilex. *See* Holly.

Illumination. From the Latin for "light." The more elaborate depictions of a letter or image with richly colored paints, *gold leaf backgrounds, and elegant borders in medieval manuscripts.

Illustration. From the Latin for "clarity." The simple rendering or depiction of a story with colored inks or paints in medieval manuscripts. Illustrations contained no *gold leaf backgrounds or elaborate borders.

Image of Piety. *See Imago Pietatis.*

Imago Pietatis. The popular, late medieval representation of the dead Jesus standing upright in his *tomb. A devotional image, Jesus was surrounded by the *Instruments of the Passion or supported by *Mary, individual *saints, and/or *angels. The *Imago Pietatis* developed out of the byzantine *iconography of the *Threnos,* a liturgical image for the Holy Week liturgies, which visualized the sufferings of Jesus necessary for Redemption.

Immaculate Conception. The Roman Catholic dogma that *Mary had been especially graced and kept free from the stain of *Original Sin from the moment of her conception by *Anne and *Joachim. Mary's purity insured not only her special favor in God's *eyes but her ability to bear God's *child who must be born without the stain of Original Sin. A teaching of unfolding revelation, the Immaculate Conception created much dissension between the *Franciscans and the *Dominicans in the thirteenth and fourteenth centuries. Pope Pius IX officially defined the Immaculate Conception as a dogma of the faith in 1854. The Immaculate Conception became a major devotional theme in southern *baroque art as a part of the new *iconography of Mary which defended her position against the attacks of the Reformers. The symbols and images associated with the Immaculate Conception were derived from both the Song of Songs and the Book of Revelation. The most common *attributes of the Immaculate Conception were the *blue and *white dress, twelve *star *crown, and Mary's *feet resting on a *crescent *moon. Mary floated on *clouds and was surrounded by *cherubs holding roses of sharon, *lilies, *mirror, and *column.

Incarnation. From the Latin for "take on flesh." The Christian dogma that the Logos, the Word of God, took on human flesh and nature in the historic person of Jesus. The moment of this "enfleshment" was the *Annunciation to Mary when the *Holy Spirit descended upon her and she conceived miraculously.

Incense. Sign of the ascent of prayers and petitions to God the Father. In Christian art, incense was represented by a priest, *apostle, or holy person holding a *censer.

Initials. Monograms and abbreviations which served as both decorative devices and/or identifications. The most common initials in Christian art were *Alpha and Omega, the first and last letters of the Greek alphabet which signified the eternity of God (Rv 1:8) and were incorporated into portraits of *Jesus Christ; IC, the first letters of Jesus Christ in Latin which were *the* sacred monogram; *IC XC with a Greek *cross and the word *nike,* signifying the affirmation that Jesus Christ Conquers; *IHS or IHC, the first three Greek letters for *Jesus, which have come to represent "Jesus Savior of Man" and "In this Sign Conquer"; *INRI, which was the superscription, "Jesus of Nazareth, King of the Jews";* IR, the first letters of the Latin for "Jesus Redeemer"; *IS, which denoted "Jesus Savior"; *ICHTHYS,* from the Greek word for fish, representing the affirmation "Jesus Christ God's Son, Savior"; *MA, the first two Greek letters in *Mary; *T, from the Greek *theos,* for God; and *XP, for the first two letters from the Greek *Christos* for Christ, which were combined and superimposed over a cross to indicate the Latin word, *pax,* for peace.

Inquisition. An ecclesiastical tribunal first appointed by Pope Gregory IX in 1231 to root out heresy and prevent its spread. Administered by the *Dominicans and the *Franciscans, the Inquisition was granted permission to

90. Bartolomé Esteban Murillo, *The Immaculate Conception*.

torture its witnesses in 1252 as a means to halt the Catharist heresy. The Spanish Inquisition was established in 1478 to protect against the apostasy of Jewish, Moorish, and later Protestant converts from the Church of Rome.

INRI. The first letters from the Latin term for "Jesus of Nazareth, King of the Jews." As recorded in the *gospels, this phrase was inscribed in Hebrew, Greek, and Latin at the top of the *cross, and was known as the superscription. As an initial symbol it appeared throughout the history of Christian art.

Instruments of the Passion. Those historical and legendary objects which were associated with the *Passion of Jesus Christ. These included *nails, *hammer, *lance, *sponge, *column with *cord, *scourges, crown of thorns, *chalice, *wash basin, *lantern, *rope, *club, *sword, *pincers, *purse or *coins, *seamless robe, *dice, *ladder, *sun and moon, vinegar sponge, superscription, *Veil of Veronica, ointment *jars, *heart with five *wounds, Malchus's ear, and the *cock. These objects were found in appropriate narrative depictions of the Passion, in devotional images of Jesus as the "*Man of Sorrows," in scenes of the *Madonna and Child, or in representations of the *Last Judgment.

International Gothic. The style of art identified with the late fourteenth-century Franco-Burgundian courts which developed a realistic approach to details, especially of *landscape, animals, and costumes. The Interna-

tional Gothic style spread from France into Italy, Germany, and Bohemia.

IR. The first letter of the Latin for "Jesus Redeemer." This initial symbol was found throughout the history of Christian art.

Iris. From the Greek for "rainbow." A floral symbol for *Mary, and a sign of reconciliation between God and humanity. Since its leaves had a shape similar to that of *swords, the iris was also known as the "sword lily" and represented the *Seven Sorrows of Mary and her suffering during the Passion. In medieval Flemish painting, the iris replaced the *lily as Mary's botanical emblem. Spanish artists adopted the iris as an *attribute of Mary, especially in representations of the *Immaculate Conception.

IS. The first letters of the Latin phrase for "Jesus Savior." This initial symbol was found throughout the history of Christian art.

Isaac. The second of the great *Hebrew patriarchs and a foretype of *Jesus Christ in the *Old Testament. As a special child born to *Abraham and *Sarah in their old age, Isaac's was a miraculous birth, thereby making God's demand of Abraham's sacrifice of Isaac most poignant and inexplicable. The son promised to Abraham and Sarah (Gn 17:19), Isaac accompanied his father on the journey to the place of sacrifice only to be "saved" at the last minute by God's intervention through an angel who substituted the boy with a *ram (Gn 22:1–19). Isaac married Rebecca (Gn

24), and fathered two sons *Jacob and Esau, and symbolically the Israelite and Edomite peoples (Gn 25:19–26). In Christian art, Isaac was depicted as the young son about to be sacrificed. A popular theme throughout the history of Christian art, the Sacrifice of Isaac denoted a foretype of the sacrifice of Jesus Christ.

Ivory. Symbol of purity and moral fortitude. In *medieval art, ivory typified Jesus as the Christ as its *white *color and firm texture reflected his incorruptible *body, which lay in the *tomb for three days.

Ivory Tower. A symbol for incorruptibility, moral strength, and ascetic distance from the world. The ivory tower was an *attribute of *Mary and *Barbara.

Ivy. A green vine which clung tightly to its support and had multiple meanings: death and immortality, as well as fidelity and unceasing affections.

J

Jacob (Gn 25:19–36:43). An *Old Testament foretype for *Jesus Christ in Christian art, and father of the twelve tribes of Israel. *Isaac's Blessing of Jacob* (Gn 25:29–34; 27): The younger of *Isaac and *Rebecca's twin sons, Jacob was his mother's favorite. His elder brother, Esau, who was a hunter, sold his birthright to the younger brother in return for a pot of lentils. Conspiring with his mother, Jacob covered his *hands with animal skins pretending to be Esau ("a hairy man") in order to obtain the blessings and chief inheritance of his blind, aged father. *Jacob's Ladder* (Gn 28:10–17): The loss of his birthright so angered Esau that Jacob fled to his uncle Laban for safety. On the road to Laban's home in Haran, Jacob spent the night at Bethel. There he dreamt of the *ladder of *heaven on which *angels ascended and descended, and at the top of which stood God who blessed Jacob's descendants as the Chosen People. *Leah and Rachel* (Gn 29; 30:1–24): At Haran, Jacob met his uncle Laban's beautiful daughter *Rachel as she tended *sheep. Jacob fell immediately in love with her and bonded himself to Laban for seven years, at which time he could marry Rachel. Laban, however, did not want to lose Jacob's skills and service, so on the appointed day he tricked Jacob into marrying *Leah, Rachel's elder sister. Jacob was thus forced into another seven years of bondage in order to marry his beloved Rachel. Leah bore him ten sons, while Rachel remained barren until the birth of her son, *Joseph. *Jacob Wrestling with the Angel* (Gn 32:22–32): In order to return to Hebron with his wives, children, and property, Jacob made a settlement with Laban. En route, he spent the entire evening wrestling with a man at Penuel. In reality, the man was an *archangel (identified as either *Uriel or Chamael) who then returned and blessed Jacob, who was favored in the eyes of the Lord. As a sign of this favor, Jacob was renamed Israel as he struggled with both God and humanity. Reunited with his brother, Esau,

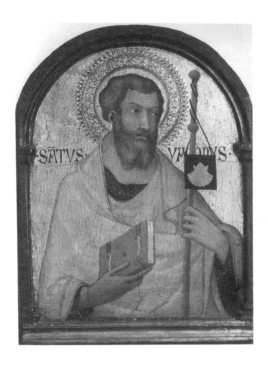

91. Workshop of Simone Martini,
Saint James Major.

92. Master of Saint Francis,
Saint James Minor.

Jacob arrived in time to be at his father's deathbed and burial. Esau chose to retire to Mount Seir, while Jacob and his twelve sons, signifying the twelve tribes of Israel, prospered in Canaan. The motif of Jacob wrestling with the angel was popular in the late middle ages as a foretype of the constant battle between *Ecclesia and *Synagoga, and the *Virtues and the *Vices.

Jacobus de Voragine (c. 1230–1298). A *Dominican friar and Archbishop of Genoa. Famed for his learning and piety, Jacobus de Voragine was the author of *The *Golden Legend (Legenda Aurea)*, the thirteenth-century text which became a major sourcebook for Christian art.

Jael (Jgs 4:17–22). Kenite woman who fulfilled *Deborah's prophecy that Israel's enemy, the Canaanite General, Sisera, would die an ignominious death at a woman's hands (Jgs 4:9). Following defeat in battle against Deborah and Barak, Sisera sought refuge with Heber and his wife Jael. Having been offered hospitality, Sisera was offered *milk to drink and a place to rest inside Heber and Jael's tent. Contrary to all the laws of hospitality, Jael murdered him as he slept by driving a tentpeg through his *head (often depicted as in his *ear or on his temple). Later, Jael displayed Sisera's corpse to Barak. In Deborah's song of victory, Jael was credited with slaying Sisera near the entrance to her tent. Although she was not Israelite, Jael was listed among the heroines of Israel. In Christian art, she was depicted as a beautiful woman holding a *hammer and a tent peg. Sisera's body was located nearby with the tentpeg visible in his head. Representations of Jael were rare in Christian art except during the medieval and early renaissance when her action of killing Sisera was a foretype of *Mary's crushing the head of the *serpent.

Jairus's Daughter (Mt 9:18, 23–25; Mk 5:22–24, 35–42; Lk 8:41–42, 49–56). An elder of the *synagogue, Jairus asked Jesus to restore his daughter's life. Jesus accompanied Jairus to his house where mourners scorned Jesus's claim that the girl was merely asleep. Ordering everyone out of the house, Jesus placed his *hand on the young girl's hand and she rose from her bed. In Christian art, representations of Jairus's Daughter were rare except for those within the byzantine and medieval life cycles of Jesus Christ. This episode was distinguished from the *Healing of Peter's Mother-in-law, in which story the crowd remained to witness the cure brought about when Jesus laid his hand on that of the sick woman.

James Major (or **the Great**), **Saint** (d. c. 44). One of the original twelve *apostles of Jesus. He and his younger brother, *John, along with *Peter were the select three who formed an intimate circle around Jesus as denoted by their presence at the Transfiguration and *Agony in the Garden. A son of Zebedee, a fisherman of Galilee, and Salome, James followed Jesus instead of becoming a fisherman. A seventh-century legend related that following his evangelization of Spain, James was decapitated by

order of Herod Agrippa. The remains of the first martyred disciple travelled by sailboat in one day to Spain. According to another legend, the location of James' body was revealed to Bishop Theodonurius who transferred these remains for burial in Compostella, the site where James reputedly established Christianity in Spain, and the site of many miracles. One of the great western Christian *pilgrimage centers, Compostella was the only site in western Europe which had the actual remains of an apostle. James was the patron of Spain and of furriers. In Christian art, James Major was depicted as a mature, bearded man with long, flowing *hair. As an apostle, he carried a *scroll as a sign of both that his Epistles and as a witness to the life and resurrection of Jesus Christ. As a *pilgrim saint, James Major held a *staff and *scallop shell or *gourd. In Spanish art and popular devotion, James as Santiago de Compostella was represented on horseback holding a *banner of victory for the liberation of Spain from the Moors. His *attributes included a pilgrim's staff, *wallet, gourd, and scallop shell.

James Minor (or **the Less**), **Saint** (d. c. 62). One of the original twelve *apostles of Jesus, and identified as the Brother of Jesus, or as the Just. A son of Cleophas and Mary who witnessed the Crucifixion and sought to anoint the crucified body, James was the eldest of the legendary three brothers of Jesus. Given the small amount of historical information about James, he is often confused with or may be one and the same with James the brother of Jesus. Following

a much later tradition than in scripture, James became the first bishop of *Jerusalem and leader of the Christianity community. James presided over the Council of Jerusalem (Acts 15) and instructed *Paul about demonstrations of loyalty to *Judaism (Acts 21). The Scribes and the Pharisees orchestrated his martyrdom— James was either thrown from the Temple, stoned, or beaten with a fuller's *club. He was the supposed author of the Epistle of Saint James. In Christian art, James was depicted as a dark-haired man with a full *beard who held a fuller's club and *saw as signs of his martyrdom. He was also represented in episcopal garments as Bishop of Jerusalem.

Jasmine. A floral symbol for *Jesus Christ because of the purity of its whiteness and the sweetness of its scent. A flower of grace, elegance, and amiability, the jasmine also signified *Mary.

Jehovah. The name used for the God of Israel in the King James Version of the Bible was a translator's error. The name was actually Yahweh, but because the *Hebrews considered it too sacred to be spoken, they spelled it in a totally artificial way to indicate that the word Lord (*adonai* in Hebrew) should be pronounced instead. They did this by combining the four consonants of Yahweh, or YHWH, the so-called tetragrammaton, from the Greek for "four letters," with the vowels (somewhat altered) of the Hebrew word *adonai*.

Jeremiah. One of the four great *prophets of the *Old Testament and

93. Paduan 15th Century,
Saint Jerome in the Wilderness.

94. Albrecht Dürer,
Saint Jerome in His Study.

distinguished by his lamenting and woeful warnings to the people of Israel lest they deny their unique relationship with God. His prophecies of suffering and destruction were foretypes for the Passion and Death of Jesus. Jeremiah's vision of the flowering *almond branch (Jer 1:11) prefigured the flowering *staff of *Joseph (of Nazareth) and was also a symbol of *Ecclesia. In Christian art, Jeremiah was depicted as a bearded elderly man who held a *scroll or a *book inscribed with one of his many prophecies or lamentations.

Jerome, Saint (c. 342–420). One of the Four Fathers of the Western Church, he revised and translated the Bible from its Greek and Hebrew sources into the Latin Vulgate (a revision of which was declared normative for Roman Catholicism at the *Council of Trent). Born of Christian parents in Dalmatia, he traveled to Antioch in 374 to study. Reprimanded by *Christ in a vision for his study of pagan literature, Jerome took refuge in the *desert for four years and studied Hebrew. Following his ordination to the priesthood in Antioch in 378, Jerome lived briefly in Rome where his criticism of the clergy and of clerical abuses won him few friends. He established a *monastery and the Jeronymite (Hieronymite) Order in Bethlehem, and benefited from the financial patronage of a wealthy woman and her daughter, who were later identified as Eustochium and Paula. A popular figure in Christian art and legend, Jerome's story was retold and embellished in several medieval texts including The *Golden Legend. Among those episodes was the story in which Jerome appeared in *church garbed in female dress after his spiteful fellow students stole his clothes while he slept. On another occasion, the legendary limping *lion appeared and frightened off the monks, except for Jerome, who examined the animal's paw and removed a deeply embedded, prickly *thorn. The tamed lion became Jerome's constant companion. When the monastery's *donkey was stolen by some merchants while the lion slept, the lion was unjustly accused of having eaten it. As an act of contrition, the lion completed the donkey's daily labors. Some time later, the lion recognized the donkey in the merchants' caravan and with a fearsome roar proved his innocence to the monks. Jerome was the patron of students. In Christian art, he was depicted as a bearded, ascetic elderly man who was accompanied by a lion. Although the cardinalate was unknown in his day, Jerome was represented dressed in the *red *robes of a cardinal, or by the red hat. The two most popular motifs of Jerome were either reading or writing in his study, or as the repentant hermit in the *desert who beat his chest with a stone to signify both his repentance and the mortification of the flesh. His *attributes included the *crucifix, *skull, lion, and *owl.

Jerusalem. The holy city of the three monotheistic traditions of *Judaism, Christianity, and Islam. As a symbol of political and religious identity of the Jews, Jerusalem was the royal city of King *David and the national Temple of King *Solomon. The destruction of the Second Temple in A.D. 70 by the Romans was both a national

and a religious disaster still remembered by the Jewish people. Many significant events in the life of Jesus occurred in Jerusalem as a sign of the fulfillment of both *Old Testament and Messianic prophecies, thereby reaffirming the psychological importance of that city to the Hebraic and Christian consciousness. Given its geographic location on a hilltop, and the repeated biblical references to the *mountain as both God's home and as symbol for God, Jerusalem was interpreted as a sacred site for the Second Coming of Christ. As further evidence of the importance assigned to Jerusalem, medieval mapmakers situated Jerusalem in the "center of the world." Jerusalem was the background for many of the events from the Old and *New Testaments in Christian art, however, the concept of the "Heavenly" or "New Jerusalem" had its own specific *iconography (Rv 21:2). As the symbol for the Kingdom of God ruled by the Risen Christ, the Heavenly or New Jerusalem was represented as being a city of elegant, golden buildings on a hilltop.

Jesse. A prosperous farmer in the *Old Testament, the grandson of Boaz and Ruth, and father of the shepherd boy *David, who would be anointed by Samuel as the second *Hebrew *King and successor to *Saul. As the progenitor of the princely "House of David," Jesse was the ancestor of Jesus. In Christian art, Jesse was depicted as an elderly man seated or recumbent at the base of the *Tree of Jesse (Is 11:1-2).

Jesse, Tree of. A botanical symbol for the royal "House of David" from

which the *Messiah would come (Is 11:1-2). In Christian art, depictions of the Tree of Jesse included the aged Jesse seated or recumbent at the base of the *tree (or bush) which arose from his genital area and which blossomed with the *fruits or *flowers that signified the ancestors of Jesus. In some presentations, the ancestors were identified by *scrolls inscribed with their names or a biblical verse with which they were associated. The *iconography of the Tree of Jesse was established by the Abbot Suger in the designs for a stained-glass window for the twelfth-century Abbey Church of Saint Denis in Paris. A popular topic in late *medieval art and Netherlandish *renaissance art, the Tree of Jesse became an important Mariological symbol, and often had an image of the *Madonna and Child crowning the tree. Such Mariological presentations of the Tree of Jesse were a reversal of *Eve's act of disobedience at the Tree of Knowledge.

Jesuits. The common name for the religious order of clerics properly known as the Society of Jesus. Established by *Ignatius of Loyola in 1534, the Jesuits were dedicated to educational, diplomatic, and missionary endeavors. Often characterized as the most elite and brilliant of all the orders, the Jesuits were organized according to a military model and demanded a strict spiritual and physical discipline. As an influential element of the *Counter-Reformation, the Jesuits supported and used *baroque art and architecture as a visualization of the singular glory of the Church of Rome, especially in its role as the Church Militant on *earth. In

Christian art, Jesuits were depicted wearing their *black *habits with a high collar and the small *tonsure on the back of their *heads. They were responsible for the development of the "art of missions" in China, Japan, and Central and South America.

Jesus Christ, life and works of. The son of *Mary whose surrogate father was *Joseph of Nazareth and whose divine father was God. The basic biographical sources for the life of Jesus were the four *Gospels of the *New Testament—*Matthew, *Mark, *Luke, and *John—and a brief reference in the writings of the Jewish historian, *Flavius Josephus. Miraculously conceived by Mary, Jesus was identified as the long-anticipated *Messiah of the *Jews. His teachings, as reported in the four gospels, formed the basis of Christianity. His life and his teachings were interpreted first by his followers, including the twelve *apostles, and later by the early church as the fulfillment of the *Old Testament prophecies. The narrative events of his life were the central focus of Christian art. Two of the most popular motifs for the depiction Jesus Christ in Christian art were either as an infant or young child, and as the crucified Jesus on the *cross. In images of the *Madonna and Child, he signified the *Incarnation, while the object (*fruit, *flower, *animal, and so on) which he held had theological or devotional significance. He was also depicted, during the years of his public ministry, as a young man with flowing *hair and a *beard in the midst of a narrative event or healing-preaching scene. Depictions of the Risen Christ featured a young man

who displayed his *wounds. In this guise, he was characterized as a man younger than God the Father but seated at his right *hand, as the judge of the living and the dead.

The major events of the life and work of Jesus Christ were depicted in Christian art as narrative cycles. (A) *Birth and Childhood*. These chronological events narrated the early life of Jesus and affirmed his unique birth and childhood as the fulfillment of Old Testament prophecies. Several of these events remained popular throughout the history of Christian art: *Nativity of Jesus Christ, *Annunciation and *Adoration of the Shepherds, *Journey of the Magi, *Adoration of the Magi, *Circumcision of Jesus Christ, *Presentation of Jesus of Nazareth in the Temple, *Massacre of the Innocents, *Flight into Egypt, *Rest on the Flight into Egypt, Return from Egypt, and *Christ Among the Doctors. (B) *Public Ministry*. These events continued the chronology of the life of Jesus, and included the public pronouncements and teachings of his mission. The parallels between his life and those of his Old Testament foretypes were highlighted by the Church Fathers and Christian artists. Several of these events remained popular throughout the history of Christian art: *Baptism of Jesus Christ, *Temptation in the Wilderness, *Calling of the Apostles (or Vocation of the Apostles), *Feast in the House of Levi, *Sermon on the Mount, *Anointing at Bethany, *Woman of Samaria, *Transfiguration of Jesus Christ, *Tribute Money (or Half-Shekel Tax), *Blessing the Little Children (or Suffer the Little Chil-

dren), *Woman Taken in Adultery, and *Feast in the House of Simon. (C) *Miracles.* These biblical accounts of the many wonders and physical healings performed by Jesus were interpreted as a sign of his divinity. Each physical healing was a metaphor for a spiritual healing. Depictions of the Miracles of Jesus were popular in *byzantine and *medieval art: *Marriage at Cana, *Healing of Peter's Mother-in-law, *Multitudes Possessed by Devils and Sickness, *Stilling of the Water (*Navicella*), *Gadarene Demoniac, *Healing of the Paralytic, *Jairus's Daughter, *Woman with the Issue of Blood, *Decapolis Deaf Mute, *Capernaum Man Possessed of the Devil, *Mute Possessed by the Devil, *Loaves and Fishes (or Multiplication of the Loaves and Fishes), *Walking on the Water, *Canaanite Woman's Daughter (or Syrophoenician Woman's Daughter), *Healing of the Epileptic Boy, *Blind Beggar of Jericho, *Man Born Blind, and *Resurrection of Lazarus. (D) *Parables.* These stories challenged the casual listeners to pay attention and required contemplation in order to decipher the hidden spiritual message. Jesus used parables to explain his mission and his teachings to those who accepted him as the Christ. The majority of the parables were rarely, if ever, depicted in Christian art. Nonetheless, as a group topic, the parables were popular in *byzantine and *medieval art: New Cloth and Old Garments, New Wine and Old Wineskins, Growing Seed, Two Foundations, Two Debtors, Lamp under a Jar, *Good Samaritan, Friend at Midnight, The Sower, Lost Sheep, Pearl of Great Value, Net, Rich Fool,

Exhortation to Watch, Barren Fig Tree, Weeds among the Tares, Mustard Seed, Yeast, Hidden Treasure, Lost Coin, *Prodigal Son, Dishonest Manager, Rich Man and Lazarus, Master and Slave, Widow and Unjust Judge, Pharisee and the Tax Collector, Laborers in the Vineyard, Two Sons, Wicked Tenants, Wedding Feast, Fig Tree, Ten Bridesmaids (or Wise and Foolish Virgins), Talents, Judgment of the Nations (or Sheep and Goats), and Faithful or Unfaithful Steward. (E) *Passion.* The events prior to the Crucifixion of Jesus Christ were identified as "The Passion of Jesus Christ." In this specialized context, the Passion referred to the sufferings of Jesus which were represented either as a narrative cycle of images related to the liturgical services of Holy Week, or as individual images in Christian art since the fourth century: *Entry into Jerusalem, *Cleansing of the Temple (or Expulsion from the Temple), *Washing the Feet of the Apostles, *Last Supper (or Lord's Supper), *Agony in the Garden (or Garden at Gethsemane), *Betrayal by Judas, *Trial before the High Priests Annas and Caiaphas, *Trial before Pontius Pilate, *Flagellation, *Crowning with Thorns, *Mocking of Jesus Christ, *Road to Calvary (or Golgotha), *Crucifixion of Jesus Christ, *Denial of Peter, *Deposition (or Descent from the Cross), *Entombment of Jesus Christ, and *Guarded Tomb. (F) *Resurrection and Postresurrection.* This series of scriptural and legendary events affirmed the miraculous Resurrection of Christ and his final activities on *earth: *Resurrection, *Descent into Hell (Descent into Limbo),

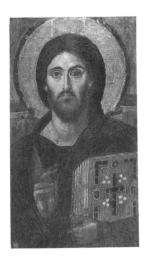
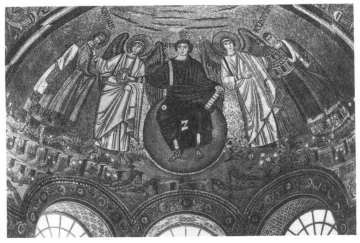

95. *Icon of Christ as Pantocrator.*
96. *Christ as Ruler of Heaven.*

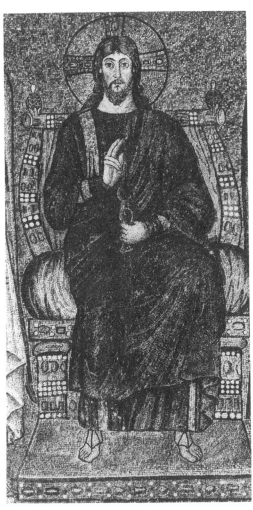

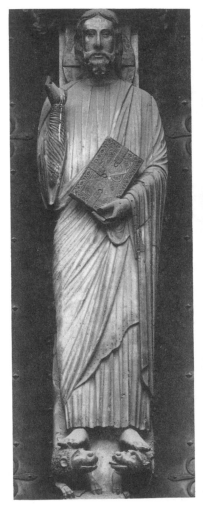

97. *Christ as the Enthroned Emperor.*

98. *Le Beau Dieu.*

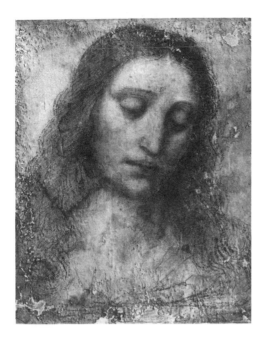

99. Leonardo da Vinci, *Salvator Mundi.*
100. Andrea Mantegna, *The Christ Child Blessing.*

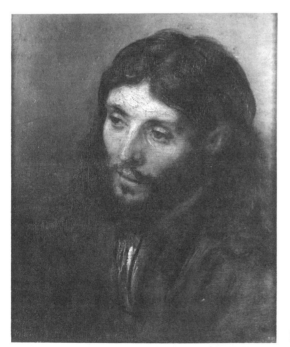

101. Rembrandt van Rijn, *Portrait of Christ.*
102. Georges Rouault, *Head of Christ.*

Three *Marys, *Appearance to Mary Magdalene (*Noli me tangere*), *Appearance to His Mother, *Emmaus, *Doubting Thomas, *Sea of Tiberias, *Mountain in Galilee, *Ascension of Jesus Christ, and *Last Judgment.

Jesus Christ, symbolism of. The central figure of the Christian faith, around whom all Christian art and iconography revolved. Almost every image or symbol in Christian art related directly or indirectly to Jesus Christ, his life story, his teachings, or his influence on his followers. Christian art and its symbolism was a visual demonstration and clarification of the humanity and divinity of Jesus as the Christ. Christian art was influenced by the culture in which it was created, and was also responsive to and/or reflective of the evolving theological concerns of each cultural epoch. In earliest Christian art, the central theme was the message of Resurrection and Eternal Salvation. Given both the culturally induced attitudes against anything "pagan" and the covert nature of the Christian experience, Christian art operated primarily on a symbolic level, employing either animal or natural symbols, or *Old Testament and classical Greco-Roman heroes as foretypes (and substitutes) for anthropomorphic images of Jesus Christ. At this time in Christian history, the most popular symbols for Jesus Christ were a *lamb, *fish, *Orpheus, *Good Shepherd, *Philosopher-Teacher, and the sacred monograms. An influential and pivotal epoch in Christian history, the fourth century witnessed Christianity's political toleration (315) and elevation to official state religion (325),

and the initial Christological controversies. Just as the liturgy, architecture, and theology of Christianity were transformed by this shift from the church of Jesus Our Brother to that of Christ Our King by the middle of the fourth century, Christian art and its inherent iconography were also radically changed as the etiquette and fashion of the Imperial Cult entered into the visual documentation of the Christian story. The theological debates on the nature of the humanity and divinity of Jesus Christ, and of his exact relationship to God the Father, resulted in a visual concern with anthropomorphic representation. At this time in Christian history, the most popular symbols for Jesus Christ were as the Enthroned Emperor, *Pantocrator, Transfigured Lord, Resurrected Christ, sacred monograms, and an image fused from the iconographies of emperor, warrior, and Good Shepherd.

The eighth- and ninth-century Iconoclastic Controversies resulted in a clarification of the role and understanding of the visual arts in Christianity (eastern and western), and a codification of iconic models and style in Eastern Christianity. In byzantine iconography, the most popular symbols for Jesus Christ were the Pantocrator, Son of God, Logos, lamb, sacred monograms, and the gestures and postures of the child in his mother's arms. As the prime example of a theocentric culture, the Middle Ages modeled the concept of their social-political structure, the feudal system, upon *Augustine's *City of God*, and sought connections between the sacred and secular realms of "Christendom." The medieval

concern for philosophical and theological synthesis combined with a growing interest in personal piety and devotionalism, and a new Christian iconography emerged which was complex, detailed, and emphasized Christ as Judge and Redeemer. At this time in Christian history, the most popular symbols for Christ were the lamb, *majestas domini, *Mystical Winepress, *Tree of Jesse, sedes sapientiae, *Holy Grail, judge, sacred monograms, *Instruments of the Passion, and animal or natural symbols held by the child as he rested in his mother's arms.

As the prime example of an anthropocentric culture, the Renaissance witnessed both a rebirth of interest in human dignity, human potential, human intellect, and the human body, and also a new interest in "modern" science and medicine. Combined with the widespread influence of *Thomas Aquinas's scholastic theology (which attempted to construct a model of Christian faith through Aristotlean philosophy), the renaissance Christian looked to the human as a model for the divine, and was deeply concerned with the theology of the *Incarnation. These cultural and theological factors influenced the development of a new iconography of the humanity of Jesus Christ. At this time in Christian history, the most popular symbols for Jesus Christ were the *Salvator Mundi, animal or natural symbols held by the child as he sat on his mother's lap, the lamb, and the Redeemer. A time of political, social, cultural, economic, and religious revolution, the Reformation and *Counter-Reformation was a time in which clear lines were drawn in terms of Christian attitudes, especially the definition of Jesus as the Christ and of Christian art. In the Reformed traditions, the role of the visual arts was minimized to the possibility of religious pedagogy through historical events in the life of Jesus as depicted in prints and engravings for bible illustrations. The Protestant emphases, even into the twentieth century, would be on naturalistic, historic, and anthropomorphic representation of Jesus, without an interest or regard for the symbolism of earlier Christian art. In contrast, the *baroque art of those parts of Europe influenced by the Counter-Reformation developed a new Christian iconography to support and defend the teachings of the Church of Rome. Given the importance of lay and spiritual devotions, sacramentalism, and the role of "good works," the iconography of baroque art (which influenced the Christian art of the Church of Rome into the twentieth century) favored representations of *saints and other holy persons engaged in their good works, their spiritual encounters with God the Father, Jesus Christ, or *Mary, and anthropomorphic images of Jesus Christ. At this time in Christian history, the most popular symbols for Jesus Christ were devotional and sacramental symbols related to the *Eucharist, such as the *monstrance, Host, *grapes and wheat; the Sacred Heart; sacred monograms; the Shroud of Turin; and the *Veil of Veronica.

For other symbols of Jesus Christ, see individual entries on specific *animals, *flowers, *fruits, *plants, and *saints; *alphabetical symbolism, *initials, and *letters; and see also in-

dividual entries under *Jesus Christ, life and works of.

Jews. Originally identified as the people of the tribes of Judah and Benjamin, and later those from the Roman Province of Judaea who professed the monotheistic tradition known as Judaism. These are the descendants of *Abraham, *Isaac, and *Jacob who were constituted as a unique people by the Mosaic covenant with Yahweh. According to both biblical texts and their own self-description, the Jews were the "chosen people" of God who after the Babylonian destruction of the Kingdom of Judah awaited the coming of the *Messiah to free them from all forms of bondage and to reestablish the Kingdom of *David. From the earliest beginnings of Christianity, Jews who continued in the tradition of Judaism were seen in conflict with the new religion. Innumerable historic disputes occurred in which the early Christians were denounced as polluting or debasing the Hebraic tradition, while the Jews were characterized as the "Christ killers." This mutual religious intolerance led to multiple persecutions and injustices as Christianity became the dominant religious and sociopolitical power throughout western culture. In Christian art, the heroes and heroines, *prophets and prophetesses of the *Old Testament were depicted with sincerity and respect. However, "the Jews" became characterized as evil and villainous figures who had *red *hair and large noses, and wore conical hats and *yellow badges—all of which signified that they were outcasts, and possibly the children of the *Devil (in which case, the Jews had

cloven hoofs for feet and a tail). *Medieval and *renaissance art was replete with anti-Semitic signs, symbols, and depictions of the Jews. In Christian art, the *Hebrews and the Jews were commonly identified as one and the same.

Joachim. The wealthy husband of *Susanna in the *Old Testament. He was rarely depicted in Christian art, except within the context of the episode of Susanna's trial in *medieval art.

Joachim, Saint. The husband of *Anne and the father of *Mary. According to the *Protoevangelium of James,* Joachim, a rich and devout man, was childless. The elders of the temple reprimanded him and refused to allow his offerings at the *altar because he had failed to produce a child for Israel. Retreating into the *desert for forty days to make his offering to God, Joachim left his desolate wife, Anne, behind. In a dream, an *angel told him to rejoin his wife at the Golden Gate as they had been divinely blessed. He greeted his wife with a *kiss on the cheek as she hung on his neck—this is the legendary description for the *Immaculate Conception of the Virgin Mary. In Christian art, Joachim was depicted as an elderly man with long graying *hair and a *beard who held a *basket with two *turtledoves signifying his offering for the ritual purification of his daughter. His *attributes included a *lamb, *lilies, and a *basket with *turtledoves.

Joan of Arc, Saint (c. 1412–1431). A thirteen-year-old French peasant girl

who began to hear "inner voices" calling her to save France from the English and Burgundian invaders. Following several audiences with the dauphin, she persuaded him to be crowned as Charles VII in Rheims. Provided with a suit of *armor, Joan led the French army to victory at Orléans, Patay, and Troyes. She was captured by the Burgundians in Compiègne and sold to the English. Following brutal maltreatment, she was confined and ridiculed by the English soldiers and priests. She was tried by a Burgundian ecclesiastical tribunal on charges of witchcraft and heresy, and found guilty. At the age of nineteen, Joan of Arc was burned at the stake in the marketplace of Rouen. A patroness of France and of the radio, Joan of Arc was a symbol of inspiring female leadership and was prefigured by other female warriors like *Athena, *Minerva, and *Judith. In Christian art, she was depicted as a young woman dressed in a suit of armor, often on horseback, who held a *banner of victory inscribed with the *fleur-de-lis and a *palm. She was also represented as a young woman in peasant dress who knelt in prayer as she heard "her voices."

Job. Just man tested by God for his faithfulness in the Old Testament, and a foretype of the suffering Jesus. Job was deprived of all his property and possessions, and suffered insurmountable difficulties and indignities, but sought to maintain his personal integrity and faith in God. During his constant dialogue with God and his three friends, Job looked for a reason for his misfortunes and deprivations. In his acceptance of God's mysterious

meaning in the suffering and travails of the innocent, Job became a symbol for faith and trust in God. Job was a popular topic in *medieval art, especially in the decorative carvings on *cathedrals and manuscript *illuminations. In Christian art, Job was depicted as an elderly man with a *white *beard, normally nude, seated in a contemplative pose on a dung heap, and pondering his travails.

Joel. A minor *Old Testament *prophet whose prophecies of the signs preceding the *Last Judgment were influential on Christian art (Jl 1:6, 2:24–27, 3:18). His description of the pouring out of God's spirit was interpreted as a prophecy of the descent of the *Holy Spirit at the *Pentecost (Jl 3:2). Rarely depicted in Christian art, Joel was represented among the Old Testament prophets and held a *scroll inscribed with one of his prophecies.

John the Baptist, life and works of (first century). The final *Old Testament *prophet and the herald of the *New Testament. He was characterized as the "forerunner" or the "one who points the way" to the Messiah. His Old Testament foretype was the prophet *Elijah. John was the patron of many cities, including Florence, and of missionaries and tailors. An important figure in the history of Christian art because he was the first person to recognize Jesus as the *Messiah, John the Baptist was included within the narrative events of his own life cycle. In Christian art, he was depicted as an emaciated but muscular man with dark *hair and *beard dressed in animal skins. His *attri-

butes included a *staff with a *banner inscribed *Ecce Agnus Dei (Latin for "Behold the Lamb of God") (Jn 1:36), *lamb, reed cross, and baptismal cup. Birth and Naming: The priest *Zacharias was struck dumb with disbelief in an angelic message that his wife *Elizabeth, who was past the age of childbearing, was to become pregnant with a special child to be named John. The pregnant Elizabeth was visited by her kinswoman, *Mary, who was also pregnant with a special son. The encounter between these two women, the *Visitation, was important in the narrative cycles of the lives of both John the Baptist and Jesus as the infant John leapt with joy inside his mother's womb in recognition of the *Messiah in Mary's womb. According to the apocryphal texts and popular legend, Mary remained with her cousin until the birth of her son John. Following the nativity of his son, Zacharias was presented with a tablet upon which he wrote the child's name. As he did so, Zacharias's speech was restored. In *medieval art, Mary was shown either presenting Zacharias with his newborn son or the tablet upon which to write the child's name. Depictions of the nativity of John the Baptist were distinguished from the nativity of Jesus or of Mary by the presence of the father who was seated either writing or holding a writing tablet. The Holy Family: The young Baptist, identifiable by his hairshirt and staff and by his companion lamb, was frequently included within the context of this domestic scene of Mary and the child Jesus. Other persons included were *Anne and *Joseph (of Nazareth). In the *Holy Family, John was characterized as a little older (in size and stature) than his cousin, and through symbolic gesture, bodily postures, or attributes, he "pointed" out the future Messiah. John the Baptist in the Wilderness: His special birth and early religious discipline destined the young John to the spiritual life. He led an austere existence in the desert, and was represented barefoot and accompanied by wild *animals. Execution of John the Baptist: The unnamed daughter of *Herodias (who was later identified as *Salome) danced and so pleased her stepfather Herod that he offered anything up to half of his kingdom. After conferring with her mother, the young girl requested the Baptist's *head on a platter. Depictions of the Execution were conflated with Herod's Banquet, the Dance of Salome, the conference between Salome and Herodias, the execution proper, and the presentation of the Baptist's head on a platter to Salome and from Salome to her mother. As John the Baptist became an important devotional figure within Christianity, and as the rite of *baptism increased in significance to the Christian Church, so did the depictions of this event of the martyrdom of the first to recognize Jesus as the Christ.

John the Baptist, symbolism of. The Baptist was represented in Christian art within the context of the narrative or devotional themes as a rugged and bearded young man dressed in a hairshirt or animal skins with a leather *girdle (Mt 3:4). John the Baptist carried either a *staff or wooden *cross with a *banner or *scroll inscribed with *Ecce Agnus Dei (Latin for "Be-

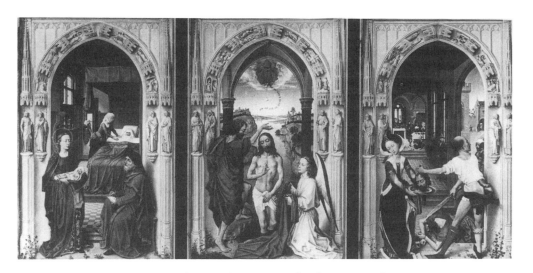

103. Rogier van der Weyden, *Saint John the Baptist Altarpiece.*

104. Titian, *Saint John the Evangelist on Patmos.*
105. Giovanni Dominico Tiepolo, *Saint Joseph with the Christ Child.*

hold the Lamb of God") (Jn 1:36). This biblical verse identified him as the "forerunner" or the "one who points" the way to the *Messiah, the "lamb of God." The Baptist was accompanied by a *lamb to which he pointed or carried as a sign of *Christ. His *attributes included a lamb, staff, reed cross, and *scroll. A *book upon which a lamb reclined signified John, or held in his *hands a sign of his messianic prophecies. His severed *head on a platter denoted his presence or when held in his hands typified his execution as the first martyr. John was represented as a young boy with either a lamb as a companion or holding a reed cross in scenes of the Holy Family. He was recognized by his hairshirt or animal skin garment, and slightly larger stature. John was represented in his role as intercessor at the *Last Judgment when he sat or stood to the left of the Resurrected Christ who was postured as the Judge. As the first person to recognize and die for Jesus as the Christ, John was paralleled both visually and devotionally to *Mary.

John Chrysostom, Saint (c. 347–407). The greatest of the Fathers of the Eastern Christian Church, and an archbishop of Constantinople. Exiled from his position by the empress Eudoxia and Archbishop Theophilus of Alexandria, John Chrysostom was restored to his see following an opportune earthquake. Later exiled to the Black Sea, he either died naturally or was killed. His eloquence made him a legend in the early *church, and led to his name, "chrysostomos," from the Greek for "golden-mouthed." According to legend, a swarm of

*bees encircled his mouth as an infant signifying his future "honeyed" words. In Christian art, John Chrysostom was depicted as a bishop. His *attributes included a swarm of bees, *beehive, and *dove whispering into his *ear.

John Climacus, Saint (c. 569-c. 649). A famous holy man and *monk, and the author of *The Ladder of Divine Ascent,* which described the hierarchical path towards moral perfection through the thirty "rungs" that form the text. The name "Climacus" was derived from the Greek for "*ladder." A common image in byzantine and medieval *iconography, this ladder signified the ascent into *heaven and was prefigured by *Jacob's Ladder. In Christian art, John Climacus was depicted as an elderly hermit with a long *white *beard and *hair, and was usually dressed in a hairshirt. He was represented seated writing his text as a vision of the ladder with ascending *angels and/or *saints floated in the sky.

John of the Cross, Saint (1542–1591). A *Doctor of the Church, one of the greatest Christian mystics, and author of the classic text *The Dark Night of the Soul.* John of the Cross became the spiritual confessor of his fellow Spaniard *Teresa of Avila, and worked closely with her to establish a Reformed Carmelite Order for men. Both the monastic work and spirituality of John and Teresa played significant roles in the resurgence of the Counter-Reformation Church. Imprisoned in Toledo on the order of the prior of the *Carmelites, John was subjected to brutal and harsh treat-

ment. During this confinement, he began his written descriptions of his mystical experiences as well as his mystical poetry, including *The Spiritual Canticle* and *The Living Flame of Love*. Following his escape from prison and a brief period of public life, John was either ill or maltreated by his fellow Carmelites until his death in 1591. Although he himself was rarely depicted in Christian art, his texts, notably *The Dark Night of the Soul*, became an influential source for the new *iconography of the Counter-Reformation Church, especially among Spanish baroque artists including *El Greco and *Bartolomé Esteban Murillo.

John Damascene, Saint. *See* John of Damascus, Saint.

John of Damascus, Saint (c. 675–c. 749). A *Doctor of the Church, and the last of the Fathers of the Eastern Christian Church. A brilliant theologian and pious monk, John of Damascus dedicated the major portion of his life to the defense of orthodoxy and of *icons during the Iconoclastic Controversies. For the history of Christian art, his most famous and influential text was *On the Divine Image*, in which he laid out the theological and spiritual rationale for the use and veneration of the icon in orthodox Christianity. His interpretation of the icon as an extension of the most central of Christian teachings, the *Incarnation, became the foundation for the Eastern Christian Church's formal teaching and positions, and was also voiced by defenders of the image throughout the history of western Christianity. In Christian art,

John of Damascus was depicted as a monk seated writing his sermons and texts defending orthodoxy and icons. He was occasionally represented in byzantine iconography as a priest painting or venerating an icon.

John the Evangelist, Saint and Apostle (first century). Traditionally the youngest of the original twelve apostles, and identified as the "beloved disciple" in recognition of his special relationship with Jesus. The son of Zebedee, a Galilean fisherman, and Salome, a female follower of Jesus, John was called to discipleship one day when he and his brother, *James Major, were mending fishing *nets. Along with James and *Peter, John was included in the intimate circle of the first three disciples who were present at the *Transfiguration and the *Agony in the Garden. As the "beloved disciple" John was privileged to lean his *head on Jesus' *heart at the *Last Supper. At the Crucifixion, the crucified Jesus entrusted the care of his mother to John. As he ran ahead of Peter on *Easter morning to see the *empty tomb, John immediately believed in the Resurrection, and later recognized the Risen Christ at the *Sea of Tiberias. According to legend, John established seven churches in Asia Minor and returned to Ephesus where he and *Mary Magdalene cared for *Mary until her *dormition. He was supposed to be the same "John the Elder" who wrote the Book of Revelation during his exile on the island of Patmos. He endured persecution under the Emperor Domitian, who tried to poison. The attempt failed when the tainted wine was trans-

formed into a *snake(s). John later survived torture in a cauldron of boiling oil. At an old age, John died in his sleep in Ephesus, the only apostle not to be martyred—a sign of Jesus' special affection. The individual identified as John was a conflation of three separate historic figures: the apostle, the evangelist, and the author of the Book of Revelation. He was referred to as "John the Divine" in recognition of the theological and philosophical brilliance of his texts. In Christian art, John was depicted as a youthful, beardless, and effeminate man with long curly *hair and was dressed in *red. His *attributes included a *book, *scroll, *chalice especially one with *serpents or snakes, cauldron, *palm, and *eagle signifying the elevated inspiration of his Gospel, Epistles, and Book of Revelation. He was distinguished from the other apostles in the narrative scenes of the life of Jesus by either his bodily proximity at the *foot of the *cross or his head on Jesus' heart at the Last Supper, or by his red robe which symbolized divine love. A popular figure in Christian art and legend, John was identified in The *Golden Legend as the bridegroom at the *Marriage at Cana.

John Scholasticus, Saint. *See* John Climacus, Saint.

Jonah. A minor *Old Testament prophet famed for his travails in the belly of the *whale (or sea *monster or great *fish). Originally called by God to reform Nineveh, Jonah feared the awesomeness of this task and sought refuge in a journey to Tarshish. A terrible storm plagued this journey, so the repentant Jonah, rec-

ognizing the sign of God's anger, asked to be thrown overboard to calm the seas and was swallowed by the whale. For three days and nights, Jonah prayed in the belly of the whale and was regurgitated onto the shore. He then proceeded to Nineveh, where he railed against the evils of the city and prophesied its destruction within forty days. Called to repentance, the citizens of Nineveh dressed themselves in sackcloth and *ashes, rejected their former way of life, and begged for God's mercy. Jonah was angered when God forgave Nineveh and spared it from destruction. God then taught Jonah the importance of mercy by creating a great *gourd which shaded the prophet from the heat of the *sun. This *vine, however, soon withered and Jonah was left with no protection from the sun which caused him to complain angrily to God. God indicated that although Jonah never created or destroyed the gourd, he was saddened at its loss as God would have been at the destruction of Nineveh. A favorite subject in early Christian and *medieval art, Jonah was a sign of God's promise of salvation and a foretype of *Jesus Christ. He was depicted in the context of the narrative of his being thrown overboard, swallowed by the whale, praying in its belly, being spewn forth from the whale onto the shore, and then resting under the refrigerium of gourds. This last scene was a conflation of the story of Jonah and the whale, and of Jonah's preaching in Nineveh. The refrigerium of gourds symbolized the oasis, or *paradise.

Jonathan. *Saul's eldest son, a brave soldier, and a friend of *David. Cog-

nizant that he would not succeed his father as King of Israel, Jonathan was the ideal friend to David, whom he saved from Saul's wrath and also from death. In Christian art, Jonathan was depicted as a handsome young soldier but always in reference to David. In particular the theme of the friendship of David and Jonathan was popular during the medieval period as both a sign of the chivalric *knight's loyalty to his earthly king and as a sign of personal honor.

Joseph. An *Old Testament foretype for *Jesus Christ, and the first-born and favorite son of *Jacob and *Rachel. The birth of Joseph to the long-barren Rachel in her old age was interpreted as a special birth. Rachel died following the birth of her second son, Benjamin. *The Coat of Many Colors* (Gn 37:3, 17–35): As a sign of his father's favor, Joseph was given a *coat of many *colors—a holiday garment—and was granted the time and freedom to walk and meditate. Resented by his ten half-brothers, Joseph was imprisoned in a pit and eventually sold by Ishmaelite traders into slavery in Egypt. To hide both their crime and their resentment, his brothers stained Joseph's coat of many colors with animal *blood and presented it as evidence to Jacob that Joseph had been killed by wild animals. *Joseph and Potiphar's Wife* (Gn 39): Joseph became the trusted slave of Potiphar, captain of the Pharaoh's guards. Potiphar's wife, infatuated with the handsome young man, sought to seduce him. Joseph resisted fleeing her bedchamber in such haste that he left behind his cloak. Unjustly accused of assault by Potiphar's wife,

Joseph stood in silence before his accuser and was thrown into prison. *Joseph's Dreams* (Gn 40–41): During his imprisonment, Joseph became known for his interpretation of dreams. He was called to explain a recurrent, troubling dream of the Pharaoh in which seven fat cattle ate seven lean cattle, and seven good ears of corn were eaten by seven poor ones. Joseph predicted seven years of plenty and seven years of famine, and was asked by Pharaoh to oversee the granaries and harvests. Through careful planning during the seven years of plenty, Joseph was able to store enough food to feed Egypt and its neighbors during the seven years of famine. *Joseph and His Brothers* (Gn 42): When his half-brothers came to Egypt to buy food during the famine, they did not recognize Joseph, but he recognized them. He required that they bring Benjamin on their next trip for food, and after a feast, he hid a golden cup in Benjamin's sack. Unjustly accused of theft, the brothers were stunned when Joseph revealed his identity and granted them pardons in an emotional reunion.

Joseph of Arimathea, Saint (first century). A wealthy and pious Jew, and possibly a secret disciple of Jesus. Joseph of Arimathea was present at the Crucifixion, and petitioned *Pontius Pilate for the body of the crucified Jesus so that it could be buried before the Sabbath in accordance with Jewish law. He offered his own newly hewn *tomb, and provided the linen shroud for the burial of Jesus. Following the Resurrection, Joseph was believed in pious legend to have led a group of twelve missionaries to Brit-

ain. According to tradition, the Tomb of the Resurrection was discovered by *Helena in the fourth century and became the site of the Church of the Holy Sepulcher. Medieval legend recorded that Joseph preserved several precious drops of the blood of Jesus in the chalice used at the *Last Supper. He then took this chalice with him to Britain, where it became fused with the ideal of the honor of England. This was the source of the medieval legends concerning the *Holy Grail. In Christian art, Joseph was depicted as a richly dressed, elderly man with a gray *beard in scenes of the Crucifixion, *Deposition, *Lamentation, and Entombment. His *attributes included the shroud, crown of thorns, and *nails.

Joseph of Nazareth, Saint (first century). A carpenter and descendent of the royal House of *David, the husband of *Mary and the surrogate father of *Jesus. According to both the Apocryphal Gospels and legends, Joseph was a widower and much older than Mary; and he therefore assumed a role of guardian-protector over her and her son. Joseph's sons by his first wife were thought to be those identified in the Bible as the "brothers of Jesus." Joseph was the patron of carpenters, married couples, househunters, and pioneers. In Christian art, Joseph was depicted as an elderly man with a *gray or *white beard and simply dressed. His *attributes included a carpenter's saw, a *plane, a *hatchet, a *lily, and the flowering *staff. *Betrothal of Mary* (*Protoevangelium of James*): The High Priest *Zacharias (father of *John the Baptist) supervised the search for a proper husband for the young *Mary. He summoned all the local widowers, including Joseph, to bring his walking *staff to the temple and leave it overnight so that God could identify the appropriate spouse. In the morning, Joseph's staff was identified as the one that had blossomed into *flower, while a *dove hovered over his head. *The Marriage of the Virgin Mary* (*Protoevangelium of James*): The High Priest Zacharias blessed this marriage as Joseph, identified by his flowering staff, joined *hands with Mary before the temple. Occasionally, the other suitors were depicted as younger men who broke their staffs in anger at not having been selected as Mary's bridegroom. *Joseph's Dream of the Incarnation* (Mt 1:18–25): Following their betrothal, Joseph learned that Mary was pregnant. That evening the *Archangel *Gabriel appeared to him in a dream and told him that this child was conceived of the *Holy Spirit, and that he was to name this special child Jesus. In *medieval art, this motif became fused into the larger context of the Annunciation. *Journey to Bethlehem* (Lk 2:1–5): Being of the House of David and following the tradition, Joseph's birthplace had been Bethlehem. Therefore in order to fulfill both the command of Caesar Augustus and the *Old Testament prophecies, Joseph took his pregnant wife with him to Bethlehem for the census. He was depicted as an elderly man who walked with the aide of a staff and guided the *donkey upon which his pregnant wife rode. *The Nativity* (Mt 1:18–25; Lk 2:1–20): As the surrogate father and earthly protector of this newborn child, Joseph was depicted

standing guard near Mary and the infant. *The Adoration of the Child (Revelations of Saint Bridget of Sweden)*: This variant of the Nativity depicted the aged Joseph kneeling alongside his earthly spouse in prayerful contemplation and awe of the Christ Child. *Joseph's Dream* (Mt 2:12): In a dream following the birth of Jesus, Joseph was advised to take his wife and newborn child into Egypt because *Herod was about to order the *Massacre of the Innocents. *The Flight into Egypt* (Mt 2:14–15): Joseph was shown walking with the aide of his staff and guiding the donkey upon which his wife and newborn child rode. *The Rest on the Flight into Egypt* (Mt 2:14): Joseph either stood watch over Mary and the Child, or attempted to procure for them some fresh dates or other *fruits. *Joseph's Dream in Egypt:* In a third and final dream, Joseph was told of the death of Herod. In order to fulfill the Old Testament prophecy and foretypes, Joseph then journeyed with Mary and the young Jesus out of Egypt. *Christ Among the Doctors* (Lk 2:41–52): Joseph brought the twelve-year-old Jesus to *Jerusalem for the *Passover. The young boy disappeared, and his parents searched fruitlessly for him throughout the city. They found three days later him discussing esoteric matters with the elders in the Temple. At this time, Jesus cryptically acknowledged that God was his father, not Joseph. According to tradition, Joseph died before Jesus began his public ministry. Joseph was included within the themes of The *Holy Family and The *Holy Kindred. In *medieval art, Joseph was often represented making a mouse-

trap to capture the *Devil, according to the writing of *Augustine. The art of the Counter-Reformation Church established a new and popular *iconography of Joseph with the Christ Child. These images of the "fatherhood" of Joseph represented him as a younger man alone with his son. From this time forward, artists began to depict Joseph as a more youthful and vigorous male figure.

Josephus, Flavius (c. 37–d. early second century). Jewish historian and Pharisee who had close associations with both the Roman Imperium and apparently the Essene Community. His significance to Christian art and legend was his many texts, particularly *History of the Jewish War* and *Jewish Antiquities.* In these, Josephus sought both to record the history of his people and also to rehabilitate their position with Rome, especially following the revolt in A.D. 66. As an "objective" source, his texts historically verified the existence of *John the Baptist (*Antiquities* 18:166) and *James Minor (*Antiquities* 18:200), and his *History of the Jewish War* contained a passage which was a reference to the ministry, passion, death, and resurrection of *Jesus Christ. He identified the unnamed daughter of *Herodias as "*Salome," but made no mention of her dancing, and placed the blame for the execution of the Baptist on *Herod Antipas.

Joshua. A trusted companion to *Moses during the Exodus, and leader of the Israelites on the final stages of their journey into the Promised Land. Joshua was an *Old Testament prototype of Jesus as the Christ

and of God's promise of salvation. *Land of Milk and Honey* (Nm 14:7–8): Twelve young men including Joshua were sent to see and report on Canaan. They described what they had seen as a "land flowing with milk and honey." *Battle of Jericho* (Jos 3:6–17): After the Hebrews reached the Jordan valley, God held back the River Jordan, allowing Joshua to lead his army into battle and to capture Jericho. *Joshua's Vision* (Jos 5:13–15): One of God's *angels (ostensibly the *Archangel *Michael) appeared to Joshua dressed as a warrior and pronounced himself the commander of God's army. Joshua was ordered to remove his shoes as he stood on holy ground. At this site, Joshua constructed a *ring of twelve *stones to signify the twelve tribes of Israel. This image prefigured the twelve *apostles.

Journey of the Magi (Mt 2:1–9). Following the birth of Jesus, the *Magi (traditionally thought of as three kings) saw the extraordinary *star which announced the nativity of the King of the Jews. With the star as their guide, they journeyed to see him. *See also* Adoration of the Magi.

Jove. *See* Jupiter.

Judaism. The form of religious monotheism practiced by the Jews of the Rabbinic tradition. The historic religion could be traced back to the prophetic ministry of *Moses, who received the Covenant and Torah from God on Mount Sinai during the forty years of wandering in the *desert, and the teachings of the *Old Testament *prophets. The history of the religious tradition was recorded in the Old Testament, and was seen as the foundation for Christianity. As the *Christ, or *Messiah, Jesus was interpreted by the early Christians as the fulfillment of the prophecies and promises of the Old Testament. In Christian art, Judaism was represented by a series of symbols and images which affirmed it as a preparation for Christianity, for example the foundation level of a building was represented as an antique (older) architectural style such as the romanesque while the building was represented in the modern (newer) style such as the gothic. There were also derogatory (anti-Semitic) images throughout the history of Christian art, including the *ass, the *scapegoat, the blinded *Synagoga, and the chamber pot; individual Jews were identified by their conical hats, *yellow badges, large noses, *red hair, and *horns. *See also* Hebrews, Jews.

Judas Iscariot. The *apostle who betrayed Jesus, thereby becoming the paradigmatic image of the traitor. As he was probably from Kerioth, not Galilee, Judas felt estranged from the other apostles. He was present in a series of narrative episodes in Christian art including the *Anointing at Bethany at which he had a disgruntled facial expression, suggesting his displeasure at the extravagance of wasting precious oils. At the *Last Supper, Judas was identified by both his traditional physiognomy and his physical distance from the other disciples. He was also distinguished by his gestures as recorded by the *Evangelists; he was the one who dipped his *hand in the *dish, took the *bread sop, or had

his hand on the table. In the sequences of the Betrayal which included Judas conspiring with the High Priests, he was characterized by the *bag of money or thirty pieces of *silver. In the actual *Betrayal by Judas, he was typified by his traditional physiognomy and the act of kissing Jesus. Following the betrayal, Judas recognized that his action resulted in the condemnation and death of Jesus. He returned the thirty pieces of silver to the High Priests, and was represented leaving their presence with the *coins scattered upon the ground. He then hung himself. His suicide was often included in narratives of the Crucifixion. In Christian art, Judas was depicted as a physically small man with *red *hair and *beard and a large nose—thus establishing the basic physiognomy of the Jew in Christian art—who was dressed in *yellow—the Jews were later required to wear yellow badges to identify themselves as the "Christ killers." His *attributes were a bag of money, thirty pieces of silver, and a noose. His betrayal of Jesus was prefigured in Christian art and theology by the Old Testament narratives of *Joseph's entrapment by his brothers, *Delilah's seduction of *Samson, and Joab's murder of Abner.

Jude Thaddeus, Apostle and Saint (first century). One of the original twelve apostles and about whom little information was given either in biblical or historical sources. He was identified with both the disciple named *Thaddeus and the other disciple called *Judas (not Iscariot). He queried Jesus at the *Last Supper and was present at the *Pentecost. Biblical scholars continue to dispute whether Jude the disciple and Jude the author of the Epistle were one and the same person. According to tradition, he was identified as a kinsman of *Mary and a brother of *James Minor. One legend recounted that Jude evangelized parts of Syria and Asia Minor with *Simon the Zealot. According to another tradition, he was the emissary Jesus sent to King Abgar of Edessa with the legendary *Mandylion of Edessa. He suffered martyrdom either by beating beaten to death with a *club, transfixed with a *spear, or beheaded with a *halberd. Jude was invoked for the return of lost objects and by those in desperate, perhaps hopeless, situations. In Christian art, he was depicted with one of his *attributes: a *palm, lance, *halberd, or club.

Judgment. An early belief of the Christian tradition, confirmed at the Council of Florence (1438–45), that as soon as the *soul departed the dead body it appeared before God for individual judgment. Pure souls entered *heaven, imperfect souls went to purgatory for purification, and unrepentant sinful souls were condemned to *hell. All souls awaited the general *Last Judgment in one of these three locations. The *iconography of individual Judgment developed in Christian art as an infant, signifying the soul, was carried in the arms of the guardian *angel before God for judgment. Beside or in front of God the Father stood the *Archangel *Michael, holding the *scales upon which the good and evil actions of the person were weighed.

106. Giotto, *The Last Judgment*.

107. Michelangelo Buonarroti, *The Last Judgment*.

Judgment Day. The *Old Testament teaching of the day when sin and goodness received their just rewards. A carefully detailed angelology and demonology distinguished the Judgment Day from all other days by the second century B.C. This teaching of the apocalyptic day—when the world order ended and replaced by the new kingdom—fed the messianic fires of the first century B.C. and was the foundation for the Christian teaching of the *Last Judgment.

Judgment of the Nations. *See* Parables.

Judgment of Solomon (1 Kgs 3:16–28). The story of the two women, ostensibly prostitutes, who lived in the same house and who each bore a son on the same day. One of the infants died, and each claimed the living child as her own. Brought before *Solomon for judgment, the two women each made an emotional appeal for the living child. Solomon ordered that the healthy child be cut in two with a half given to each woman. One woman agreed to this act, but the true mother of the child relinquished her claim so that the child might live. Solomon then granted this mother her child. In Christian art, depictions of the Judgment of Solomon signified both the *wisdom of the *king, and prefigured the *Last Judgment.

Judith. An apocryphal heroine and one of the Female Worthies (models of ideal womanhood such as *Susanna, *Lucretia, and *Jael). The widow of Manasseh, Judith came out of her seclusion to save Israel from Nebuchadnezzar. The city of Be-

thulia was besieged by the Assyrian army and its general, Holofernes. As the elders of the city led by the high priest Ozias prepared to surrender, Judith upbraided them and declared that God would save the city. She returned to her home, praying to God for inspiration and help, took off her widow's weeds, bathed and anointed her body, dressed in her finest clothes and jewels, and gathered a sack of ritual foods. She and her maid then departed for the camp of Holofernes. She met Holofernes and declared that she could lead him to victory at the cost of only one life. For three days and nights she stayed at his camp, but was allowed free access to the river each night to bathe and eat her ritual foods. Captivated by her beauty, Holofernes rejoiced when Judith informed him that she would eat with him on the fourth day of her visit. He prepared a lavish feast for her, hoping to seduce her. At the appropriate moment, his commanders and soldiers withdrew from the tent, and Judith and Holofernes were alone. Already drunk into a state of semiconsciousness, Judith seized his *sword and with two blows decapitated him. She placed his severed *head in her food sack, and with her maid left the enemy camp without arousing any suspicion. When she displayed the severed head upon the ramparts of Bethulia, the Israelites vanquished the stunned Assyrians, and Judith was declared a heroine of her people. In Christian art, Judith was interpreted as a foretype of *Mary as the Second *Eve (crushing the *head of the *serpent). Judith was represented as a chaste but beautiful widow who holds the severed head of Holofernes by the

*hair. In *medieval art, she was the virtuous foretype of Mary, a descendent of *Athena Nike, and an ancestress of the female warriors *saints like *Joan of Arc. Judith was sometimes depicted in the act of slaying Holofernes, but more often shown with his severed head in her hand. During the Renaissance, she became fused with the feminine personification of democracy and the city, and prefigured Ladies Liberty and Democracy. From the *Counter-Reformation period forward, Judith was represented as a seductive femme fatale who rejoiced in the dreadful deed she had committed.

Julian the Hospitaler, Saint (ninth century). A legendary huntsman who captured a *stag which prophesied that he would kill his parents. In an attempt to escape from this prophecy, Julian took refuge in a foreign land and married a rich widow named Basilissa. Mourning the disappearance of their son, Julian's parents set to look for him. While Julian was away, his parents found his new home and were joyously greeted by his wife. Allowing them to rest from their travels in her bed, Basilissa went to church. Mistaking his parents for his wife and her lover, Julian slew them in his bed. Distressed at his action, Julian sought God's mercy and forgiveness. Basilissa and Julian founded a hospice for the poor near a dangerous river. Julian risked his life one evening to ferry a leper across the stormy river one winter's night, and then allowed the leper rest in Julian's own bed. In the morning, Julian found an *angel in his bed who announced that his penance was accept-able to God. Within a few days, the aged Julian and Basilissa died. Julian was the patron of innkeepers, circus people, travelers, minstrels, ferrymen, and hospitality. In Christian art, he was depicted as a young huntsman accompanied by a stag, with a stormy river and boat. His *attributes included the *falcon, *sword, oar, and stag.

Juno. The Roman goddess of womanhood identified with the Greek *Hera. As the queen of the gods and goddesses, Juno symbolized the ideals and honor of womanhood. She was the protectress of marriage, and of women in childbirth (*gold *coins were offered to her following the safe delivery of a male child). In classical Greco-Roman and *renaissance art, Juno was represented as a full-bodied, properly dressed matron who held either an infant in swaddling clothes in her left *hand and a *flower in her right, or a *shield and a *spear, and was accompanied by a *serpent. Her *attributes included the *peacock, *girdle, and *pomegranate. She was a classical Greco-Roman foretype for both *Anne and *Mary.

Jupiter. The most powerful of all the Roman gods, identified with the Greek god *Zeus, Jupiter was the highest symbol of civilization, ethics, justice, and law. Simultaneously, he was the symbol of male energy and power, signified by his ability to control thunder and lightning. In classical Greco-Roman and *renaissance art, Jupiter was depicted as a muscular, handsome male figure with a *gray *beard and long *hair, dressed in a toga with his torso and strong arms

exposed. He was seated on an extravagant throne, accompanied by the *eagle, a sign of *wisdom, and held a *scepter or thunderbolts. He was the classical Greco-Roman foretype for God the Father.

Justice. One of the Four Cardinal Virtues (and one of the *Seven Virtues). Usually personified as a female, Justice was represented in Christian art as blindfolded (impartiality) and holding a *sword (temporal power) and *scales (a weighing of arguments and evidence for and against). In *medieval and *renaissance art, Justice was identified by the scales and sword she held, and the representation of Emperor Trajan at her *feet. As a female figure, *Justitia* was a metaphorical foretype for *Athena, *Minerva, *Judith, *Mary as the personification of *wisdom, and *Sophia.

Justina of Antioch, Saint (early fourth century). A virtuous and beautiful young woman whose commitment to Christianity brought about the conversion of the pagan magician, Cyprian. Although he conspired with her pagan suitor, Aglaides, to destroy Justina's virtue, Cyprian came not only to lust for her but to admire and respect her ability to deny the temptations of the *Devil. They were tortured in a cauldron of boiling pitch, and then transferred to Nicodemia and beheaded under the orders of Diocletian. In Christian art, Justina of Antioch was depicted as a beautiful young woman who was identified by her *attribute, the *unicorn.

Justina of Padua, Saint (early fourth century). Daughter of the pagan King Vitalcino of Padua, and raised a Christian by Prosdochimus, the first bishop of Padua. The imprint of her knees were visible on the bridge over the Po River where she was seized by Roman soldiers and knelt to pray for strength. She was martyred by a *sword thrust into her side. Justina was a patron of Padua and Venice. In Christian art, she was depicted as a beautiful, regally dressed young woman. Her *attributes included a *sword, *crown, *palm, and *unicorn (hence the confusion with *Justina of Antioch).

K

❧

Keys. Symbol of authority and ownership. As the guardian of the *gate of *heaven, *Peter (and all his successors on the papal throne) were typified by two or three crossed keys (Mt 16:19). Keys on a woman's *girdle or *belt denoted *Martha of Bethany, while keys in a woman's *hand were an *attribute of *Genevieve.

King. A male sovereign characterized by superior judgment, *wisdom, and power. In the Hebraic and Christian traditions, the governing principle of "kingship" and the king as an anointed lord were established by God. During medieval times, one of the functions of the *Holy Spirit was to guide the actions and decisions of the king. In Christian art, the king or kingship was symbolized by the signs of authority: the *scepter, *crown, *orb, and throne.

Kingfisher. According to medieval tradition, the kingfisher renewed its *coat of *feathers annually, and thereby symbolized the *Resurrection of Jesus Christ.

Kiss. A sign of physical and spiritual love. This act of physical intimacy was interpreted as a moment of bodily union and pleasure which prophesied the fuller ecstasy of the union with God. In Christian art, a kiss denoted the *sacrament of marriage, whether of an earthly or mystical nature. A kiss also typified the veneration of a sacred person, relic, or object by the pious believer. It was also a sign of respect, loyalty, and humility, as exemplified by the eldest of the three *Magi, who kissed the *foot of the Christ Child. The Christian liturgical gesture of the kiss of peace indicated fellowship. The Betrayal of Jesus by *Judas's kiss was therefore a complete reversal of the symbol of the kiss, and thereby a despicable betrayal of all the meanings associated with this gesture of love, loyalty, respect, veneration, and fellowship.

Kitchen Utensils. *Attributes of *Martha of Bethany.

Knife. Symbol of sacrifice, vengeance, and death. The knife was

both an *attribute of *Abraham (alluding to circumcision as a sign of entry into the community of the covenant and the Sacrifice of *Isaac) and a sign of the *Circumcision of Jesus Christ. In relation to Christian *saints, a knife signified the instrument of their martyrdom. Thus, *Bartholomew held both a knife and a flayed human skin, while *Peter Martyr held both a knife and his *head or *hand, and Edwin Martyr a knife and a *cross.

Knight. Symbol of the superior man who was master over his *horse, his body, and his mind. The rigorous physical training and mental discipline required to become a knight paralleled to the training of the classical Greco-Roman athletes who sought to unify and control body and mind for spiritual goals. In the Middle Ages, the code of chivalry and the establishment of a permanent military class in the feudal society expanded the symbolism and importance of Christian knighthood. A medieval knight was interpreted as a "guardian protector" of his *church, his people, and his home. A knight's *armor and *helmet signified divine protection from both evil and physical destruction. The great Christian knight *saints, including *Michael, *George of Cappadocia, and *Joan of Arc, led lives that were interpreted as illustrations of the triumph of good over evil. In Christian art, the knight was distinguished by armor and helmet, and the appropriate weapons of war.

Knights of the Round Table. Symbol for the ideal of medieval knighthood and chivalry. These knights of Arthu-·rian legend met around a round table which symbolized their equality at King Arthur's court in Camelot. The illegitimate son of King Uther Pendragon, Arthur revealed his royal *blood by drawing a *sword from a stone. Later, the Lady of the Lake presented him with the famed sword, Excalibur. His wife, Queen Guinevere, was unfaithful; her love for Sir Launcelot resulted in the war which destroyed the Knights of the Round Table and precipitated Arthur's premature death. The father of Sir Galahad, Launcelot represented fidelity, bravery, frailty in love, and repentance as he retired to a monastery following Arthur's death. Sir Galahad signified chastity and Christian innocence; Sir Gawain, chivalric courtesy; Sir Kay, rude boastfulness; and Sir Modred, treachery. The Arthurian legends, in particular the quest for the *Holy Grail, were a medieval Christian revision of the *Iliad* and the *Odyssey*, especially, the story of the Judgment of Paris and the Trojan War. The literary symbolism of the Round Table as an *altar or the table of the *Last Supper, Arthur as a Christ-figure, and Launcelot as the betrayer, were transferred into Christian art in both the medieval and mid-nineteenth-century periods. The German literary parallels of the legends of Tristan and Isolde, and Parsifal were contemporary to the Arthurian legends. All of these stories and their visual depictions were focused on the central concept of the medieval spiritual quest.

Koimesis. From the Greek, for the "falling asleep (of Mary)." *See also* Dormition of the Virgin Mary.

Labarum. The *purple *banner inscribed with the *Chi-Rho and the words *in hoc vinco* and borne on a golden *spear which was adopted as the military standard of Imperial Rome after *Constantine's victory at the Milvian Bridge in 312.

Laborers in the Vineyard. *See* Parables.

Labyrinth. A maze constructed in such a complicated and intricate fashion that it was too difficult to clearly define one's path. In classical Mediterranean mythology, a great labyrinth was created by Daedalus for King Minos, who sought to restrain the Minotaur inside it. When the princess Ariadne was to be sacrificed to the Minotaur, she helped Theseus rescue her by dropping string from her web as the Minotaur carried her into the depths of the labyrinth. Theseus killed the Minotaur, rescued Ariadne, and freed the Cretan people from the curse of this monster. In medieval Christian liturgical and devotional practice, a labyrinth was constructed on the pavement of the *nave in *cathedrals such as Chartres, and served as the ritual area for the liturgical *dance of the labyrinth which was derived from the mystery cults. The dancers sought to journey to the center of the labyrinth and back out again as a metaphor for their spiritual journey with *Christ. According to legend, the labyrinth was also a symbol for *Jerusalem; *pilgrims could try to travel to its center as a form of spiritual pilgrimage to the Holy City without leaving the confines of their own cathedral.

Ladder. A sign of the *Passion of Jesus Christ, especially of the *Deposition. In the *Old Testament, *Jacob dreamed of a ladder upon which *angels ascended to *heaven and descended to *earth, and at the top of which stood God proclaiming Jacob's family the Chosen People. The ladder was an *attribute of *Andrew, *Romuald, and *John Climacus.

Ladle. An *attribute of *Martha of Bethany.

Lady's Bedstraw. A floral symbol both for the *Nativity of Jesus Christ and for the humility of *Mary and her son. A wildflower which grew low to the ground, lady's bedstraw was traditionally believed to have been mixed with the straw which *Joseph (of Nazareth) laid in the manger for the newborn child.

Lady's Mantle. An herbal symbol for *Mary in *medieval art.

Lady's Slipper. A variety of orchid associated with *Mary in *medieval art.

Lamb. A symbol of innocence, purity, meekness, humility, and docility. The lamb was both a sign of sacrifice and initiation. A popular symbol in Christian art, the lamb denoted *Jesus Christ as prefigured by the *Old Testament references to the "lamb of God" (for example, Ex 12). Depending upon its bodily posture and *attributes, the lamb implied multiple meanings within the context of Christian spirituality and theology. Whenever the lamb was identified by *John the Baptist, either through a gesture or an inscription, it denoted the sacrifice of Jesus on the *cross as the fulfillment of the Old Testament prophecies (Is 53:7; Ex 12). A upright lamb with a *staff and a *banner inscribed with the cross connoted the Resurrection and *Christ as the Redeemer (Jn 1:29). A standing lamb with a cross and *blood flowing from its wounded side was the *Lamb of God (*Agnus Dei*)—a symbol for the Crucified Christ and the *Eucharist. In early Christian art, a recumbent lamb implied the wounded flesh of Jesus, while the upright lamb was the Church Triumphant on earth. A standing lamb with a cruciform nimbus indicated the Resurrected Christ. When the lamb stood on a *mountain from which four *rivers flowed, it referred to the Resurrected Christ who stood atop the church as the four *Gospels or Rivers of Paradise flowed to evangelize and nurture the world. A lamb seated on a *book with seven seals was the Lamb of the Apocalypse (Rv 5:12); while twelve lambs represented the twelve apostles. The lamb also typified sinful humanity being rescued by Christ as the *Good Shepherd (Lk 15:1–7). In early Christian art (pre-fourth century) when the anthropomorphic image of Jesus on the Cross was considered a sacrilege, the lamb was substituted. Such artistic use of the lamb on the cross was forbidden by the Council of Trullo (692). The lamb was an *attribute of *Joachim, *Clement of Rome, *Genevieve, *Agnes, and *Francis of Assisi.

Lamb, Adoration of the. One of the visions of John recorded in the Book of Revelation, and a popular topos in northern *medieval art. The *lamb wore a cruciform nimbus and held a *white *banner inscribed with a *red *cross. It rested or stood upon a *book with seven seals and was positioned on an *altar or a *mountain in order to be adored by the twenty-four Elders, the *tetramorphs, and various *saints and *martyrs who were identified by their *attributes. All of these persons were redeemed

and washed clean in the *blood of this lamb.

Lamb of God (*Agnus Dei*). The Christian evolution of the *Old Testament teaching of the lamb as a sacred ritual animal as witnessed by Isaiah 53, John 1:29, and the twenty-eight references to the Lamb of God in the Book of Revelation. This image was also identified as the Mystic Lamb. In Christian art, the Lamb of God was depicted as an upright *lamb which held a *cross or *banner of victory, and had *blood flowing vigorously from a wounded side into a *chalice. The Lamb of God denoted both the sacrificial death of Jesus and the *sacrament of the *Eucharist.

Lamentation. A variant of the Crucifixion narrative. Following the *Deposition or Descent from the Cross, the body of the crucified Jesus was received by his mother, who was joined in her mourning and grief by *John the Evangelist, *Mary Magdalene, *Joseph of Arimathea, *Nicodemus, the Holy Women, and other followers. This scene was distinguished from the *Pietà by the presence of mourners other than *Mary, and from the Deposition as the body was completely removed from the *cross. The Lamentation preceded the scenes of the anointing and burial of the body of Jesus. Ostensibly derived from the byzantine liturgical *icon of the *threnos,* the Lamentation developed in the narrative art of the medieval period, and reached its zenith in the Renaissance. It was sometimes conflated with the Deposition and the *Entombment of Jesus Christ.

Lamp. A source of light signifying enlightenment, intelligence, and piety. The Word of God was characterized as a "lamp unto the faithful." Depictions of the *parable of the *Ten Bridesmaids (Wise and Foolish Virgins in DR) emphasized the lighted lamps of five bridesmaids, and downturned dark lamps of the other five bridesmaids. The lamp was an *attribute of *Lucy.

Lamp Under a Jar. *See* Parables.

Lance. An *Instrument of the Passion, and a sign of the Crucifixion. As a part of the Roman practice of a quicker, less painful death, the soldiers broke the legs of the crucified. In the case of Jesus, and as a fulfillment of the biblical requirements of the *Passover *Lamb, his bones could not be broken, so a Roman soldier (later identified as *Longinus) pierced Jesus' side with a lance. According to tradition, two streams of fluid (*blood and *water) sprang from that wounded side, as symbols of the two central *sacraments of Christianity: *baptism and *eucharist. According to tradition, the lance of Longinus was recovered by *Helena in the fourth century and taken to Constantinople. The lance was transferred to Paris and lost during the French Revolution. The lance was an *attribute of Longinus, *Matthew, *Thomas, *George of Cappadocia, and all warrior *saints.

Lancet. A two-edged, small surgical *knife used to perform the ritual of *circumcision. The lancet was an *attribute of *Zacharias, the High Priest who performed the *Circumcision of

Jesus Christ, and also of *Cosmas and Damian.

Landscape. A background element in paintings used to signify location or place of an event. Beginning with the Renaissance, the landscape reinforced the moral or Christian allegory of a painting; for example the inclusion of an ecclesiastical building to represent holy ground or secular persons to designate the separation of the sacred and the profane.

Lantern. As a source of light, a symbol for piety, *wisdom, and intelligence. The lantern was an *attribute of *Christopher, the *Ten Bridesmaids, and several of the *Sibyls.

Lark. A sign of a good priest, as this bird only sang as it flew upwards to *heaven.

Lash. An *attribute of *Ambrose.

Last Judgment (Mt 24:30, 25:31–46, 26:64; 1 Cor 3:13). Scriptural event signifying the final dramatic episode of Christian history, in which the Resurrected *Christ will return to reward or punish the living and the dead and bring to fulfillment the Kingdom of God on earth. An evolution of the Hebraic teaching of the Judgment Day (as in Dn 7:9–10), the Last Judgment will be a general resurrection; all tombs will be opened, the gates of purgatory and *hell destroyed, and the *souls in Limbo released to stand for final judgment. As an important tenet of *church teaching, the Last Judgment was vividly described in terms of the torments of hell and the glories of heaven. A popular theme

throughout the history of Christian art, the *iconography of the Last Judgment became more elaborate as the church's teachings on eschatology and sin developed. In early Christian art, depictions of the Last Judgment were composed of the simple image of Christ in a long regal *robe and seated on a throne as he separated the *sheep from the *goats. During the byzantine period, interest in this theme shifted towards representations of the *Descent into Hell (Limbo, or the *Anastasis*). By the Middle Ages, the Last Judgment became a crucial element in the Church's political position as the only institution able to intercede for the sinner. The depiction of the Resurrected Christ as the Judge surrounded by the tetramorphs, the signs of the four Evangelists, was found on the central *tympanum of all medieval *cathedrals. At Christ's *feet were representations of the damned suffering the tortures of Hell and the saved the pleasures of Heaven. Northern *medieval art began to include representations of *Mary and *John the Baptist to the right and left respectively of Christ the Judge in their roles as intercessors in final appeal for the *souls being judged. *Hubert and Jan van Eyck introduced the byzantine iconic motif of the *Deesis* into the upper register of the *Ghent Altarpiece*. A major shift in the iconography of the Last Judgment occurred in the art of *Giotto who—influenced by his friend, *Dante—created an image of a multi-leveled Hell as a site of both eternal tortures and of freezing cold temperatures in which the ice-blue *Devil was frozen eternally and unable to move. Early renaissance artists like *Fra An-

gelico continued the iconographic innovations of Giotto, while High Renaissance artists like *Michelangelo Buonarroti focused on the role of the Resurrected Christ as Judge and Mary and John the Baptist as intercessors. Later representations of the Last Judgment were dependent upon both earlier artistic models and the contemporary eschatology and Mariology, since *Mary's role as intercessor became a source of debate between the Roman Catholic Church and the Reformers.

Last Supper (or **Lord's Supper**) (Mt 26:20–30; Mk 14:17–25; Lk 22:14–23; Jn 6:22, 13:21–30; 1 Cor 10:16–17, 11:23–27). Scriptural event signifying the final recorded meal shared between Jesus and his chosen twelve apostles. At this meal, Jesus announced that one of those present would betray him, resulting in his death, and instituted the sacred ritual meal which established the *sacrament of the *Eucharist. The *Old Testament and *New Testament prototypes for the Last Supper included the Sacrifice of *Cain, the Meeting of *Abraham and *Melchizedek, the Philoxeny of Abraham, the *Passover Meal, the *Manna in the Wilderness, the Miracle of the Water in the Rock, the Multiplication of the *Loaves and Fishes, and the *Marriage at Cana. A popular theme throughout the history of Christian art, the topos of the Last Supper offered the artist three moments of high drama: the announcement of the betrayal, the identification of the traitor, and the institution of the Eucharist. The identification of the traitor was the most commonly represented theme of this story. In

early Christian art, the Last Supper was depicted either as an episode within the Passion Narrative or as the Communion of the Apostles. In both variants, the "celestial banquet" was emphasized by the typical semicircular table decorated with a *fish and wine ewers, and not the historic event. Byzantine artists concentrated upon the Communion of the Apostles. Medieval artists sought the high drama of the moment of the identification of the traitor and the method of identification varied in the scripture: Judas dipped his *hand in the *dish (Matthew and Mark), had his hand on the table (Luke), or took the bread sop from Jesus (John). The general depiction of this scene—instruments on the table (beyond the bread and wine), the size and shape of the table (either circular or rectangular), and the costumes of the full contingent of twelve disciples—became elaborate elements in *medieval art. The motif of the close intimacy between Jesus and *John the Evangelist was signified by the gesture of John's *head resting on Jesus' *heart in northern medieval art (and identified as the *Christus-Johannes Minne*). With the renaissance interest in spatial relationships and composition, the representations of the Last Supper were transformed into elegant banquets on a rectangular table with the simplest of the elements on the table and the costumes of the disciples. *Leonardo da Vinci's masterful presentation of the *Last Supper* (1498) revolutionized the iconography of this theme. For the first time, the dramatic moment of the announcement of the betrayal was portrayed with a multiple visual emphasis on the reactions of all the disciples.

108. Leonardo da Vinci, *The Last Supper.*

109. Salvador Dali, *The Sacrament of the Last Supper.*

This was the first presentation of the Last Supper which espoused an interest in human psychology. The Last Supper became a controversial subject in the art of the Reformation and *Counter-Reformation as both the eucharistic event and the liturgical presentation of the sacrament were vigorously debated; in fact, neither of the two great artists of this time, *Michelangelo Merisi da Caravaggio and *Rembrandt van Rijn, painted a Last Supper, favoring instead the *Supper at Emmaus. The theme of the Last Supper was later retrieved as the historic event of the institution of Eucharist in the Christian art of biblical illustrations and altarpieces. Several leading artists of the twentieth-century—including Emil Nolde and Salvador Dali—painted the Last Supper as evidence of enduring interest in this theme.

Laurel. A sign of immortality, triumph, and chastity. Sacred to *Apollo and the Vestal Virgins, laurel was assimilated into Christian art and practice as a sign of the chastity and the victory of Christian faith over death.

Laurel Tree. An evergreen *tree signifying eternity, and sacred to *Apollo.

Laurel Wreath. A symbol of virtue and victory. Originally, the sign of the champion at the Delphic and Olympic games, as well as the annual Drama and Poetry Contests which were dedicated to *Apollo, the laurel wreath became a Roman symbol of both triumph (athletic, cultural, or military) and virtue (consecrated to the Vestal Virgins). It was assimilated into Christian art and practice as a sign of *Christ's victory over death, and the spiritual virtue of Christian *martyrs (1 Cor 9:24–27). The laurel wreath was a common symbol on the *sarcophagi and *frescoes of the Christian *catacombs, and one of the earliest symbols for the body of Jesus on the cross.

Laurence, Saint (d. c. 258). A Spanish treasurer of the *church famed for his humility and miraculous cures. A caretaker of ecclesial service *books and scriptures, Laurence was commanded to surrender the wealth of the church to Roman officials. Having distributed all the money and property to the poor, Laurence presented the Roman officials with the poor, the sick, the blind, and the widows and orphans as the "treasures of the church." After he was scourged, Laurence was roasted to death upon a gridiron. *The *Golden Legend* presented a lively account of his martyrdom. According to tradition, he was identified as the "courteous Spaniard" who moved over and offered his hand to Stephen when Laurence's tomb was opened to receive the martyr's body. As a sign of his spiritual humility, he was accorded the privilege of leading a *soul from purgatory every Friday. He was the patron of librarians, the poor, and cooks. In Christian art, Laurence was depicted as a young man with a short dark beard and *hair who was dressed as a *deacon. His *attributes included a *palm, *gridiron, and *bag of money or *gold.

Lavender. Fragrant labiate flower whose medicinal properties signified *Mary in *medieval art.

Lazarus, Saint (first century). Brother of *Martha of Bethany and *Mary (who was conflated with *Mary Magdalene). Biblical information about Lazarus was limited to the story of his resurrection (Jn 11:1–45). Mary and Martha sent word to Jesus that their brother was seriously ill. By the time Jesus arrived in Bethany, Lazarus had been dead for four days. Upon entering Bethany, Martha reported her brother's death and was comforted with the proclamation that Jesus was the Resurrection and the Life. Mary fell at Jesus' *feet and affirmed her faith. Accompanied by the disciples and disbelieving neighbors, Jesus and the two sisters went to the cemetery where Lazarus had been buried. In a loud firm voice, Jesus called Lazarus forth from his grave. Lazarus returned to life to the amazement of all present. A popular figure in Christian legendary and devotional texts, Lazarus and his whereabouts following the *Resurrection of Jesus Christ were the subject of several legendary accounts. In one version, Lazarus accompanied his two sisters, Maximus, and others to the south of France to spread the *Gospel. Lazarus became the first bishop of Marseilles and was martyred under Diocletian. According to the Eastern Christian tradition, Lazarus and his sisters were placed in a leaky boat and set adrift on the sea. They landed safely on Cyprus, where Lazarus became bishop of Kition and died a peaceful death. In another legend, Lazarus became the companion of *Peter in his travels through Syria. In Christian art, Lazarus was depicted within the context of the *Resurrection of Lazarus which was a foretype of both the Resurrection of Christ and of the general Resurrection of the Dead at the *Last Judgment. One of the most popular themes in the history of Christian art, the Resurrection of Lazarus signified the Christian promise of life after death. One of the two most common themes in the catacombs—the other being the *Good Shepherd—the Resurrection of Lazarus developed the pictorial formula of a upright figure of Jesus who held a wand (the thaumaturgical *staff of the healer and of the magician) in his right *hand while Lazarus partially covered by wrapping cloths or a shroud, stood at the entrance of a sepulcher. In the fourth century, Mary of Bethany, prostrate at Jesus' feet, was added in accordance with the biblical text. The two sisters were represented prostrate before Jesus from the fifth century on. In sixth-century images, one of the sisters, ostensibly Martha in accord with the biblical text, covered her mouth and nose with her *veil to protect herself from the "stink" of her brother's putrefied flesh. From the seventh century, this gesture was enacted by a male figure or figures. In byzantine *iconography, the setting for this event became a rocky cave from which Lazarus came forth as his sisters lay prostrate at Jesus' feet. The standing Jesus raised his right hand in a gesture of speech. The cave's entrance was surrounded by the disciples and the disbelieving neighbors, many of whom had raised their hands in awe or as a gesture of protecting themselves from the "stink." In early *medieval art, Lazarus, either in loosened burial cloths or the nude, sat astride his coffin or attempted to raise the coffin's lid, conforming to the

change in burial practices. In accordance with the liturgical and passion plays, the ensemble grew larger and the gestures of Jesus more dramatic. Another iconographic innovation was the separation of the Resurrection of Lazarus into two moments: the conversation between Jesus and the two sisters, and the Resurrection itself. Renaissance artists like Sebastiano del Piombo sought to depict the spiritual tension of this event by emphasizing the gestures of Jesus and the resurgence of life in Lazarus's nearly nude body. The art of northern baroque artists such as *Peter Paul Rubens and *Rembrandt van Rijn sought to retrieve the early Christian drama of this event by simplifying the settings and an emphasizing the encounter between Jesus and Lazarus.

Leah. Elder daughter of Laban, *Jacob's first wife substituted for her younger sister, *Rachel. In order to marry Rachel, Jacob was forced to serve Laban for an additional seven years. Leah bore Jacob ten sons and a daughter (Gn 29). In Christian art, Leah was depicted as a matronly woman in contrast to her lithesome, beautiful sister Rachel.

Lectern. A reading desk upon which ecclesial, biblical, or sacramental *books, or *Books of Hours, were placed in Christian art, especially in depictions of the *Evangelists, *Doctors of the Churches, Theologians, and the *Annunciation to Mary. Originally simple in design and functional in purpose, the lectern became more ornate and multipurposed as the Christian liturgy evolved. The relationship between these liturgical de-

velopments and the importance of the "Word of God" can be studied through the *iconography of the lectern.

Leek. An *attribute of *David of Wales.

Leg of a Horse. An *attribute of Eloi.

Legenda Aurea. *See The Golden Legend.*

Lemon. A sign of fidelity in love. In medieval art, the lemon signified the purity of *Mary; it was also a symbol of life and protection against hostile forces such as poison, magic, and the plague.

Lent. From the Old English for "spring." The forty-day period of fasting, penitence, abstinence, and prayer which preceded the celebration of *Easter. The forty-day period paralleled the time Jesus, *Moses, and *Elijah each spent in the wilderness.

Leo I the Great, Saint. (d. 461). A *Doctor of the Church and one of the great pontiffs of the early *church. Devoted to the ideal and performance of religious duty, Leo firmly opposed schism and heresy, and affirmed papal authority over bishops. Leo convened the Council of Chalcedon (451), which affirmed and clarified his definition of the two natures and one person (hypostasis) of *Jesus Christ. In a face-to-face confrontation which according to tradition included divine intervention, Leo persuaded Attila the Hun not to attack Rome in 452. Three years later, he persuaded the

Vandal Chieftain Genseric not to burn Rome. Following Genseric's sack of Rome, Leo worked to rebuild the city and its churches, and ministered to the wounded and sick. His text on the two natures and one person of Jesus Christ was influential in the development of Christian art, especially in terms of the *iconography of Christ. In Christian art, Pope Leo I was depicted as an elderly man dressed in papal regalia who sat on horseback in confrontation with Attila the Hun. He was also represented ministering to the wounded and sick following the Sack of Rome.

Leocritia, Saint. *See* Lucretia, Saint.

Leonard, Saint (d. c. 559). One of the *Fourteen Holy Helpers, a godson of King Clovis of France, and a convert to Christianity under the spiritual direction of *Remy. Joining the monastery at Micy, he retired as a hermit to Limoges. According to tradition, his prayers helped the queen to safely deliver her child, and so he was awarded all the land he could cover in one day on a donkey. He established the Noblac monastery and the town of Saint-Leonard on this land. Famed for his legendary visits to the imprisoned, Leonard was granted permission to release the prisoners he met. Leonard was the patron of prisoners and popular among the crusaders. He was invoked by women in childbirth and prisoners of war. In Christian art, Leonard was represented dressed as a *deacon who visited the prisons, or as a hermit in prayer. His *attributes included a *chain and *fetters, or prisoners kneeling at his *feet.

Leonardo da Vinci (1452–1519). A Renaissance man well versed in the arts, science, philosophy, and military engineering. Trained as an artist under Verrocchio, Leonardo was one of the three great artists of the High Renaissance (along with *Michelangelo Buonarroti and *Raphael Sanzio). His studies of human anatomy and of the scientific properties of light and color led to the refinement of the renaissance concepts of pyramidal composition, natural lighting, and one-point perspective. In terms of both *renaissance art generally, and Christian art specifically, Leonardo was distinguished by his ability to concentrate upon the psychology of his subjects and the tension of the dramatic moment. His most famous work on a Christian theme, *Last Supper, was the first depiction of this theme to focus on the moment of Jesus's announcement that one of his *apostles would betray him and the reaction of the apostles.

Leopard. An animal with ambiguous meaning, perhaps stemming from the belief that it was the result of the union of a *lion and a *panther or pard. The leopard signified cruelty, sin, the *Devil, and the Antichrist (Rv 13:2). It also typified the *Incarnation as the fusion of the humanity and divinity of *Jesus Christ. Therefore, the leopard appeared in representations of the *Adoration of the Magi.

Letter in the Hand of a Prone Man. An *attribute of *Alexis.

Letter of Lentulus. A famous document in the history of Christian art

which allegedly contained the only first-hand description of Jesus. The author of this letter, Publius Lentulus, had been governor of Judea before *Pontius Pilate. Lentulus described Jesus to the Roman Senate as a man of median height with a reverent countenance and curly *brown *hair. The Letter of Lentulus was proved to be a thirteenth-century forgery.

Letters Symbolizing Jesus Christ. A common way of symbolizing or signifying *Jesus Christ in Christian art, especially in the early periods when artists were hesitant to depict an anthropomorphic image for fear of idolatry or impinging upon the dignity of Christ's divinity. The most common and prevalent letters symbolizing Jesus Christ included *Alpha and Omega as the first and last letters of the Greek alphabet (Rv 1:8); *IC as the first Latin letters for the name Jesus Christ; *IHC and *IHS, as the first three Greek letters for Jesus; *INRI, as the first four Latin letters for *Jesus Nazarenus Rex Judaeorum* ("Jesus of Nazareth, King of the Jews") from the titulus of the *cross (Jn 19:19); *IR, for Jesus the Redeemer in Latin; *IS, for *Jesus Salvator* (Savior) in Latin; *ICHTHYS, Greek for *fish, from the acrostic formed by the letters from the phrase, "Jesus Christ God's Son, Savior"; XC, as the first and last letters of the Greek *Christos*; *XP, or the Greek letters Chi and Rho, the first two letters of *Christos*; and NIKA, from the Greek for victory, which was combined with the monogram IC XC NIKA ("Jesus Christ Victor"). When IHS denoted the first letters of the Latin phrase *Jesus Hominum Salvator*

("Jesus Savior of Man"), it was an *attribute of *Ignatius of Loyola and *Bernardino of Siena.

Leviathan. The mythological, multiheaded sea *monster with which God troubled Job (Jb 41:1). A resident of the sea (Ps 104:25–26), the Leviathan was believed to be the great *fish or *whale that swallowed *Jonah.

Liberal Arts. A classical Greco-Roman convention in learning and art which often accompanied the *Seven Virtues in *medieval and *renaissance art. The established course of studies in medieval education, the Liberal Arts were grammar, rhetoric, logic, arithmetic, music, geometry, and astronomy. Usually personified as female figures, the Liberal Arts were distinguished by their *attributes: two pupils reading *books were placed at Grammar's *feet; Logic held a *snake, *scorpion, *lizard, *flowers, or *scales; Rhetoric held either a *scroll, book, *sword, or *shield; Geometry held a compass, terrestrial *globe, set-square, or *ruler; Arithmetic held a tablet, abacus, or ruler; Astronomy held a celestial *globe, compass, sextant, or sphere; and Music held an instrument such as a *triangle, *lute, viol, small *organ, or *bells.

Light. A sign of spiritual and intellectual brilliance. As the direct source of clarity, light typified divine power and holiness, and became a symbol for both *Jesus Christ and the *Holy Spirit in Christian art. An unlit or smoking *candle was a popular medieval device to indicate the presence of either Christ or the Holy Spirit.

As a sign for goodness and wisdom, light was a positive force in contrast to the evil and ignorance of the darkness.

Light Rays. Sign for the presence of the *Holy Spirit.

Lightning. A sign of divine power, thereby an *Old Testament symbol for God's judgment.

Lilith. According to the Talmud, Adam's first wife, created before *Eve, who refused to submit to Adam and was expelled from Paradise (Gn 1:27). Lilith became a screech *owl, a demonic creature who visited lonely husbands, frightened pregnant women into miscarriage, and stole male children less than seven days old in the middle of the night. Even the pronouncement of her name conjured Lilith's presence and struck fear in the hearts of Jewish and Christian women. In Christian art, Lilith was depicted as a female *head and/or torso on a serpentine body rendered within the context either of the Temptation and the Fall, or the *Madonna and Child. By the High Middle Ages, Lilith was conflated with the *serpent in the *Garden of Eden, as the cultural evidence suggested that a naive Eve would have trusted another woman not a serpent. Lilith was found at the base of images of the Madonna and Child, where she signified the serpent whose head was crushed by *Mary. The inclusion of the image of Lilith in Christian art corresponded to the development of and interest in the esotericism of the Kabbalah.

Lily. A floral symbol for purity, innocence, rebirth, and royalty, and sacred to the virgin and mother goddesses of the Mediterranean world. In early Christian art, the *white *lily identified as the "Easter Lily" was a symbol for the *Resurrection of Jesus Christ and the early virgin *martyrs. By the medieval period, this same flower signified *Mary, especially in the context of the Annunciation. This transformation from a symbol of *Christ to one of Mary, especially to the Virgin Annunciate, had as much to do with the rising Mariology of medieval theology as to the simple fact that this *flower bloomed around the time of the feast of the Annunciation, and had the shape of a trumpet which announced the birth (and hence also the death and resurrection) of *Jesus Christ. According to tradition, the lily sprang from the tears of the repentant *Eve as she departed the *Garden of Eden. As Mary became the "Second Eve" in Christian art and theology, this flower was reclaimed for her as she became our entryway into *paradise. Generally, the lily typified Mary's perpetual virginity and purity, while a lily enframed by *thorns implied the *Immaculate Conception. The lily was an *attribute of the *Archangel Gabriel, the infant Jesus, *Joseph (of Nazareth), *Dominic, *Francis of Assisi, *Anthony of Padua, *Clare of Assisi, *Euphemia, *Scholastica, *Francis Xavier, *Louis of France, *Philip Neri, *Thomas Aquinas, and *Louis of Toulouse. The *fleur-de-lis, a variant of the lily, was selected by King Clovis of France to represent both the purification of Christian *baptism and the Christianization of France.

As an attribute of royalty, the fleur-de-lis was depicted on the *crowns or *scepters of royal *saints, and of Mary as the Queen of *Heaven.

Lily of the Valley. One of the earliest of all spring *flowers, and a sign of humility, virginity, and sweetness. The lily of the valley was a symbol for the *Immaculate Conception (Song 2:1) and of the promise of new life through *Jesus Christ. In its pure *white color and sweet aroma, the lily of the valley was an *attribute of *Mary.

Limbo. From the Latin for "lip." The place between *heaven and *hell reserved for those righteous people who died before the coming of *Jesus Christ, and for unbaptized infants. It was traditionally divided into the *Limbus Patrum* (for righteous adults) and the *Limbus Infantium* (for unbaptized infants) who were awaiting the *Judgment Day (or *Last Judgment). Limbo was a place of "no pain or suffering" but of undifferentiated waiting. It was distinguished from purgatory, which was the place where *souls in need of cleansing were purged of their sins in order to achieve the Beatific Vision. According to Christian art and legend, the Resurrected Christ descended into Limbo to release all the souls of the righteous before he ascended into Heaven.

Lion. An ambiguous and multivalent animal symbol for strength, courage, majesty, fortitude, pride, wrath, and brute force. According to the *Physiologus*, the lion cub was born dead and kept warm by its mother for three days, at which time its father breathed upon it and gave it life. Classical Greco-Roman mythology had the wild lion tamed by *Androcles, who removed a prickly *thorn from its paw and became its lifelong companion. The medieval *bestiaries recorded that the lion slept with its eyes open as a sign of watchfulness and vigilant protection of its family. Legends recounted the lion as the "King of the Beasts," a sign of majesty, *wisdom, and valor. In the *Old Testament, the lion was the emblem of the tribe of Judah (Gn 49:9), the enemy destroyed by *Samson (1 Sm 14:5–7), the intended executioner of *Daniel (Dn 6:7), and a sign of the *Devil (Ps 91:13). In the *New Testament, the lion was the earthly counterpart of the *eagle (Rv 5:5) and a metaphor for *Christ's ability to convert the heathen and bring peace. From the classical Greco-Roman and Hebraic foretypes, the lion became a symbol for *Jesus Christ, especially for the Resurrection. The lion was an *attribute of *Jerome, *Mary of Egypt, *Euphemia, *Paul the Hermit, and *Ignatius of Loyola. The winged lion was the attribute of *Mark the Evangelist and of his patronal city, Venice.

Liturgy. The ecclesial service of the celebration of the *Eucharist and also of the canonical Office of the Hours. The term was associated with the generalized Sunday service of the Christian traditions.

Lizard. A sign of old age, evil, or the *Devil. According to the *Physiologus*, the aged lizard was as blind as the Christian *soul who sought out

*Christ as the Light of the World. The lizard's annual molting signified the Resurrection. In classical Greco-Roman and *renaissance art, the lizard was an *attribute of logic, one of the seven *Liberal Arts.

Loaves and Fishes (Mt 14:13–21; Mk 6:30–44; Lk 9:10–17; Jn 6:1–14). Scriptural event signifying the miraculous feeding that foretold the *Last Supper as an institution of the *Eucharist and fulfilled the *Old Testament foretype of the *Manna in the Wilderness and the *New Testament symbol of the *Marriage at Cana. The multitude followed Jesus when he went into the *desert after the death of *John the Baptist. As Jesus preached late into the evening, the *apostles urged him to send the multitude away because they had only five loaves of bread and two fish, and so could not feed the crowd. Jesus calmly sent for this minimal amount of food, instructed the multitude to sit, blessed the five loaves and two fish, and directed his apostles to distribute the food. Miraculously, all of the multitude were fed, and twelve extra *baskets of food remained. In a variation of this event, there were seven loaves and a few fish (Mt 15:32–39; Mk 8:1–9). The representation of this topos in Christian art emphasized the eucharistic symbolism. All representations of this topos in early Christian art, as with all visual references to loaves and fishes, were interpreted as eucharistic. In *byzantine art, the theme of this miraculous feeding became an identifiable pictorial formula of two or three male figures, ostensibly Jesus in a central frontal pose with a disciple to each side. He blessed the loaf and fish offered him by the disciples. Eventually the group size expanded, and the loaves and fishes were offered in baskets with extra baskets waiting in the foreground. In *medieval art, this scene was part of the narrative cycle of the life and works of Jesus. In *renaissance art, the eucharistic emphasis was retrieved, and the episode placed within a lavish landscape. This miraculous feeding was rarely depicted after the Renaissance.

Locusts. A form of *grasshopper and one of the plagues God placed upon Egypt when Pharaoh refused to let the *Hebrews leave with *Moses. In Christian art, the locust represented God's punishment. In the *hands of the Christ Child, the locust denoted the unconverted.

Longinus, Saint (first century). From the Greek for "lance" or "spear." According to pious legend, the Roman soldier who plunged the *lance into the side of Jesus at the Crucifixion (Jn 19:34), and who subsequently converted to Christianity and became a missionary. He became conflated with the Roman centurion who recognized Jesus as the Christ at the Crucifixion (Mt 27:54; Mk 15:39; Lk 23:47). Several legends recounted Longinus's conversion experience at the *foot of the *cross and his life after the Crucifixion. In all of these legends, the metaphor of physical blindness was crucial. According to one legend, Longinus was blind until he rubbed his *eyes with the *blood of the Crucified Jesus, while in another version he became blind when the innocent blood of Jesus covered

his face but had his sight restored on *Easter. In another legend, Longinus, having converted many to Christianity, was condemned to death by a blind Roman governor who Longinus claimed would regain his sight at Longinus's execution. Once Longinus was beheaded, the blind governor could see and was converted to Christianity. As the patron of Mantua, Longinus allegedly deposited a *pyx with several drops of the precious blood of Jesus Christ in the city's cathedral. In Christian art, Longinus was included in scenes of the Crucifixion. He was depicted as a middle-aged man dressed as a Roman centurion who was on horseback and held a spear in his right hand. He was positioned at the foot of the cross and looked up at the body of Jesus. He was also identified as one of the two centurions who stood watch at the *tomb of Jesus. In that episode, Longinus was depicted standing with his right hand extended as he held a *staff or lance for support. In Christian art, his *attribute was the lance or spear.

Lord's Supper. *See* Last Supper.

Lost Coin. *See* Parables.

Lost Sheep. *See* Parables.

Lot. A nephew of *Abraham and a farmer in the fertile valley of Sodom. The city of Sodom however, was an evil and sexually perverse place. *Destruction of Sodom and Gomorrah* (Gn 19:1–29): Lot offered hospitality to two traveling *angels. In the middle of the night, his house was disturbed by local men who wanted to violate the angels. In the name of hos-

pitality, Lot offered these men his daughters in place of his guests. God struck the offenders blind for their perversity, and saved the angels, Lot, and his daughters. God warned Lot that Sodom would be destroyed along with the neighboring city of Gomorrah. Lot fled with his wife and daughters from the burning *ruins of Sodom; but against the direct instructions of God's angel, Lot's wife looked back and was instantly turned into salt. The story of the Destruction of Sodom and Gomorrah was a foretype for the *Last Judgment. *Lot and His Daughters* (Gn 19:30–38): After fleeing Sodom, Lot's daughters were convinced that there were no other human beings left alive, including their husbands. The two daughters intoxicated their father with wine, and laid with him in order to perpetuate the human race. Ammon and Moab, two male children, were the immediate results of these incestuous unions; their descendants were the Moabites and the Ammonites. These two narrative events in the life of Lot were popular themes in *medieval and *renaissance art.

Louis of France, Saint (1214–1270). Louis the Pious was the Christian ideal of kingship in his *wisdom, impartiality, prudence, peacemaking, dedication to God, and integrity. He led a crusade into Egypt and Palestine in 1248, and died en route to a crusade in 1270. France prospered under his rule, and his statesmanship and integrity were respected by his fellow monarchs. He built Sainte-Chapelle in Paris to house the relics (crown of thorns, drops of the precious *blood, and a fragment of the True Cross)

which he brought back from his crusade. Louis was the patron of Paris and Poissy. In Christian art, he was identified by his distinctive dress of a suit of *armor covered with a royal *robe inscribed with the *fleur-de-lis. His *attributes included the Crown of Thorns, a True Cross, a *sword, a *king's *crown, the fleur-de-lis, a *scepter topped with the *hand of God, and a *pilgrim's *staff.

Louis of Toulouse, Saint (1274–1297). Nephew of *Louis of France and *Elizabeth of Hungary, and a *Franciscan. A bishop of Toulouse, he served his diocese with devotion and zeal until his premature death. In Christian art, Louis of Toulouse was depicted as a youthful beardless man dressed as a bishop with a *crown and *scepter at his *feet. His bishop's *cope was embroidered with the *fleur-de-lis.

Lucia, Saint. See Lucy, Saint.

Lucifer. Name which *Jerome and other Fathers of the Church used to identify *Satan before his rebellious fall from *heaven. The name "lucifer" meant "morning or day star." By the medieval period, the name Lucifer became interchangeable with Satan and the *Devil to identify the enemy of God and *Jesus Christ.

Lucrece. See Lucretia.

Lucretia. One of the nine Female Worthies (along with *Jael and *Judith), and the model of wifely and womanly virtue in classical Rome. Lucretia played a significant role in the depiction of women in Christian

art. According to tradition, Lucretia was instrumental in the establishment of the Republic of Rome, and her story was recounted in Livy's *History of Rome* 1:57–9. Lucretia, the virtuous wife of Tarquinias Collatinus, was accosted by Tarquinias Sextus in her bedroom while her husband was away. He threatened to rape and murder her, and then lay a dead body next to her and tell her husband and father that he had caught her in an act of adultery. Lucretia submitted to his sexual lust. When her husband returned, she confessed her violation to both her husband and her father, then killed herself. Junius Brutus then organized a rebellion against the rule of the Tarquins, and the Roman Republic was established in 510 B.C. Two episodes in Lucretia's story—the Rape of Lucretia and the Death of Lucretia—were popular in classical Greco-Roman, *renaissance, and *baroque art. By the fourth century, Lucretia was contrasted to the chaste *Susanna by *Augustine in *The City of God* (1:16–19). He found Susanna the more admirable woman because she trusted in God when the elders sought to vanquish her and unjustly accused her adultery. Lucretia, Augustine advised, was found wanting, as her suicide was an act of hubris and guilt (for having enjoyed physical pleasure with Tarquinias Sextus). Representations of Lucretia found their way into Christian art as a classical Greco-Roman foretype of Susanna. In northern and southern baroque art, Lucretia was included within the topics of the moralizing prints which were created as a form of moral pedagogy for young, unmarried women.

Lucretia, Saint (d. 859). A beautiful young woman of Spanish Muslim descent whose secret conversion to Christianity caused her expulsion from her parents' home. After a period of seclusion and hiding, she was martyred with Eulogius. In Christian art, Lucretia was depicted as a beautiful young woman holding a *scourge and a *palm.

Lucy, Saint (d. c. 304). A beautiful young woman from Syracuse who converted to Christianity following the miraculous healing of her blind mother at the shrine of the Christian virgin *martyr *Agatha. Lucy gave all her wealth to the poor, which angered her fiancé. He identified her as a Christian to the Roman authorities. At first condemned to a brothel, Lucy survived to suffer other indignities, including a variety of tortures—being burned in boiling *oil; having her *breasts shorn; her *teeth pulled; and flagellation. According to legend, she tore out her own *eyes and handed them to a suitor who admired them too much. Another legend recounted that a part of her martyrdom included having her eyes plucked out. In any case, she escaped all these tortures, was healed miraculously of all her *wounds, and ultimately was stabbed to death. The connection between the conversion experience and the metaphor of sight was central to her story, for in Latin her name meant "light." The patron of opthamologists, optometrists, the blind, and those with eye diseases, Lucy was invoked against diseases of the eyes and throat. In Christian art, she was depicted as a beautiful young woman who held her eyes or a plate with her eyes. Her *attributes included a *lamp, *sword, *dagger in the neck, *palm, and a pair of eyes.

Luke the Evangelist, Apostle and Saint (first century). The "beloved physician," the author of the *Gospel of Luke and the Acts of the Apostles, and legendary companion of *Paul through Greece and Rome. Although identified by Paul as a physician, Luke was also believed to have been an artist and was credited in legend with creating the first images of the Virgin and Child. According to tradition, he returned to Greece following the death of Paul, and continued to preach the Gospel. He was reportedly martyred with *Andrew; otherwise he died a natural death in old age. Luke was the patron of doctors, butchers, goldsmiths, and painters. In Christian art, he was depicted as a middle-aged male figure who was dressed as a physician. His *attributes included a *book or *scroll, a winged ox, and paintings of the Virgin and Child or *painting materials. The motif of Luke painting the Virgin and Child was especially popular in Flemish *medieval art.

Lute. A stringed musical instrument signifying *Orpheus, especially in his role as the *good shepherd who charmed the wild *animals. In early Christian art, Orpheus with his lute was a sign of Jesus as the Good Shepherd. In northern *medieval art, the lute was an *attribute of *Mary Magdalene. In *renaissance art, the lute typified music as one of the seven *Liberal Arts.

Luther, Martin (1483–1546). A former Augustinian *monk distinguished

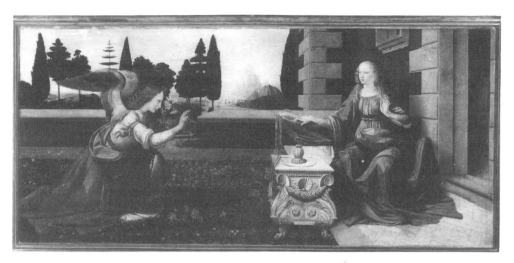

110. Leonardo da Vinci, *The Annunciation*.

111. Veronese, *The Martyrdom and Last Communion of Saint Lucy*.

as the "Father of the Reformation." His recognition of the need for church reform following a visit to Rome (1510–11), and a dramatic personal conversion experience led him to challenge the traditional teachings on the relationship between faith and meritorious works, the authority of scripture, and the mediatorial priesthood. Luther's personal conversion experience led him to advocate that "justification [was] by faith alone" (*sola fides*), that grace was freely given by God even to the unworthy, and the Bible alone was the final authority. His initial academic challenge on the question of indulgences, issued at the University of Wittenberg on October 31, 1517, led to a religious, social, cultural, political, and economic revolt against the Church of Rome which has been identified as the Reformation. In terms of Christian art, Luther's own position was more of a *via media* than outright *iconoclasm. In his 1525 sermon, "Against the Heavenly Prophets," Luther decried iconoclasm but supported the traditional Christian position on the role of images as a form of religious pedagogy and even developed a list of the "appropriate" images that could be used as text illustrations or wall decoration. A close friend of the artist, *Lucas Cranach, Luther included illustrations (woodcuts) by Cranach and *Albrecht Dürer in his German translations of the New Testament (1522) and the Old Testament (1524) as well as in the many pamphlets printed of his sermons and public letters. Luther himself became an iconographic topic for Lutheran artists, such as Cranach, who began to include Luther's portrait within the context of biblical paintings, such as the *Wittenberg Altarpiece*.

Lutheranism. Properly denominated "The Evangelical Church," Lutheranism was the first of the Reformed traditions. Dedicated to the primacy of faith over works, Lutheranism accepted the authority of the Bible over ecclesiastical councils or hierarchical offices, and affirmed the sovereignty of God including his freedom to dispense grace and redemption through *Christ. Liturgically the strongest of all the Reformed traditions, Lutheranism spread through northern Germany into Scandinavia and eventually into the American colonies.

Lynx. Animal signifying the *Devil in medieval art.

Lyre. A stringed instrument from classical Greece which tradition identified as being created by *Mercury for *Apollo as the patron of music, poetry, and the *Muses in classical Greco-Roman and *renaissance art. It also identified Erato, the Muse of lyric poetry, and *Orpheus. In early Christian art, the lyre was an *attribute of *Jesus Christ, whose words were as lilting and melodious as the music of Orpheus and capable of charming wild animals. Orpheus was also the mythological figure who with his music charmed the god of the dead, Pluto, into allowing the return of his recently deceased wife, Eurydice. Unfortunately, the condition for Eurydice's return to the world was that Orpheus not look back at her as she followed him during their journey from Hades. The loving husband could not resist the sound of his wife's

voice and he looked back at her, whereupon she vanished forever, thereby prefiguring Lot's wife. The lyre was also an attribute of *Cecilia as patroness of music. *See also* Harp and Lute.

M

M with a crown. This monogram of the Virgin *Mary was incorporated either into representations of her in Christian art, or within the symbolic and decorative design of liturgical vesture.

MA. This monogram of the Virgin *Mary was incorporated either into representations of her in Christian art, or within the symbolic and decorative design of liturgical vesture.

Madonna. From the Italian for "my lady." Appropriate to medieval etiquette, this honorific term was initially associated with idealized representations of *Mary with the Christ Child. By the Renaissance, the term became synonymous with Mary.

Madonna and Child. One of the most popular topics in Christian art and one which had no direct scriptural basis. The bodily postures and gestures of the Madonna and the Child as well as the symbolism of the objects he held were the clues to the devotional or theological message. The Madonna and Child were depicted by themselves, or in the company of *angels, *saints, or *donors; in fact, the faces of the Madonna and Child were in some instances portraits of the donor's wife and son. The basic rules for the symbolic types of the Madonna and Child were developed in byzantine art following the decree of the Council of Ephesus (431) that Mary was *Theotokos ("God-Bearer") and was to be venerated in that role, that is, with the Child. In *medieval and *renaissance art, the inclusion of symbolic objects such as the *apple (as a *fruit of salvation) or the *egg (as a sign of *resurrection) became a common and recognizable visual vocabulary of Christian art. *See* entries on specific animals, birds, flowers, fruits, objects, plants, and vegetables held by either the Madonna or Child for their symbolic value.

Maestà. From the Italian for "majesty." Title given to representations of

112. Anonymous Byzantine, *Enthroned Madonna and Child.*
113. Andrea di Bartolo, *Madonna and Child.*

114. Raphael, *The Alba Madonna.*
115. Albrecht Dürer, *The Madonna and Child.*

the Madonna and Child Enthroned in Majesty surrounded by *angels, *saints, devotees, and/or *donors. Popular in twelfth and thirteenth-century Italian art, this theme was a part of the glorification of Mary in *medieval art and theology. One of the finest examples of a *Maestà* was the *altarpiece created by *Duccio for the High Altar of the Cathedral of Siena.

Magi. From the Persian term for a member of the hereditary priestly class of Zoroastrianism. The original designation of the three "Wise Men" who followed the Star of Bethlehem and brought gifts to the newborn Jesus in recognition of his special person and mission. These three visitors have been alternately identified as the *Magi, Wise Men, and Kings. Following the tradition of Herodotus, the classical Greek historian, the magi were identified as a sacred caste of Medeans who received and imparted sacred truths and wisdom, hence the association of the Magi as Wise Men. According to the *Old Testament prophecies (Dn 1:20, 2:27, 5:15), these three visitors were assumed to be interpreters of the signs and omens revealed by the stars, hence the *New Testament emphasis on the Star of Bethlehem. According to legend, *Helena, mother of the emperor *Constantine, discovered the skulls of the three Magi and transferred them to Cologne, where they are among the prized relics of the Cathedral. *See also* Adoration of the Magi.

Magnificat. From the Latin for "My soul doth magnify the Lord." The re-

sponse of Mary to the greeting of her cousin *Elizabeth at the *Visitation (Lk 1:46–55 DR).

Magpie. This *bird symbolized either evil, persecution, early death, vanity, or the *devil in medieval Christian art.

Majestas (or Maiestas) Domini. From the Latin for "the Lord's Majesty." Title given to representations of the Resurrected Christ as Ruler (and Judge) of the Universe surrounded by the *tetramorphs (signs of the four *Evangelists), as described in the visions of *Ezekiel and *John the Evangelist. Most often, this image was found over the central *tympanum of romanesque *cathedrals, and was replaced in the fourteenth century with a representation of the *Last Judgment.

Man Born Blind (Jn 9:1–12). Making a clay mixture of *earth and his own spit, Jesus anointed the eyes of the man born blind. He then sent the man to the pool of Siloam to wash, after which he was able to see. Although rarely depicted as a separate topic in Christian art, this miraculous healing of the Man Born Blind can be distinguished from other healings as Jesus was depicted placing the clay mixture on the man's eyes.

Man of Sorrows. A devotional image of Jesus which emphasized the enormous suffering he experienced on behalf of sinful humanity. He was depicted wearing his crown of thorns, seated on the edge of the sepulcher (or standing before it), with his arms either crossed in a gesture of submis-

116. *Majestas Domini.*

 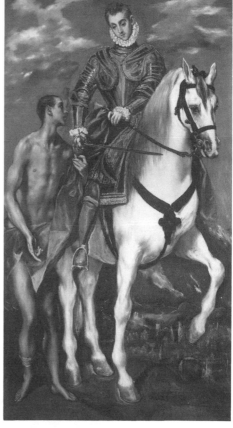

117. Master of the Catholic Kings, *The Marriage at Cana.*
118. El Greco, *Saint Martin and the Beggar.*

sion and humility or extended to display his *wounds as *blood flowed from his side (into a *chalice). The *Instruments of the Passion were included in the foreground or around the inner frame of this image. The Man of Sorrows was derived from the Suffering Servant of Isaiah 53:3. This image was included in late medieval German and early Italian renaissance renderings of the Mass of Saint Gregory.

Mandorla. From the Italian for "almond." An almond or oval-shaped *aureole (or *glory) which surrounded the whole body of a holy or sacred person. This encasement of radiance was most common in Christian art in representations of *Christ as the Judge of the *Last Judgment, as the *Majestas Domini, at the *Transfiguration of Jesus Christ, or at the *Assumption of the Virgin Mary.

Mandylion of Edessa. One of the greatest of all Christian *acheiropaeic images, and one of the few which had been historically documented. According to the church historian, Eusebius, there was an exchange of letters between Jesus and Abgar V Ukkama ("the Black") (9–46), ruler of Mesopotamia. Eusebius translated these letters from Syriac into Greek and included them in his *Ecclesiastical History* (I.13). There was also an extravagant fourth-century Syrian document, *The Doctrine of Addai the Apostle,* which further confirmed this correspondence and the existence of the Mandylion of Edessa. Abgar had supposedly heard of the miraculous powers of the teacher identified as Jesus. Recognizing that this teacher

was the *Messiah, Abgar wrote to Jesus asking that he come to Edessa to cure the king's affliction. Jesus responded that he could not leave *Jerusalem at this very pivotal moment but that Abgar's faith would be confirmed by a cure and by the invincibility granted to Edessa following the *Ascension of Jesus Christ. Accompanying this last letter was a miraculous imprint of the face of Jesus upon a piece of linen. When Abgar beheld this acheiropaeic image, which Jesus himself had formed by placing the linen upon his face, the king's affliction was cured. Abgar commanded that the city of Edessa become a Christian city. According to tradition, the display of the Mandylion of Edessa warded off invaders at the city's gates several times and was reported to be in Edessa in 544. By 944, the Mandylion had been transferred to the Basilica of Hagia Sophia in Constantinople, from whence it was allegedly stolen by Crusaders in 1207 and lost at sea. According to other traditions, the Mandylion of Edessa was among the relics of Saint Peter's Basilica Church in Vatican City, the Cathedral of San Silvestro in Rome, and the cathedrals of Genoa and Venice.

Manna in the Wilderness. The small rounds of miraculous breadlike food provided by God to the Israelites during their forty years of wandering in the desert (Ex 16:13–17, 31; Nm 11:7–9). During the Hebrews' wandering, God provided manna and quails on a daily basis, except on the Sabbath. Descriptions of manna vary from its tasting like honey to fresh oil to coriander. In Christian art, the

Manna in the Wilderness was interpreted as a prefiguration of the Multiplication of *Loaves and Fishes, the *Last Supper, and the *Eucharist. Representations of a basket of manna with a *fish signified these *New Testament events, especially the Eucharist. For many early Christian and Jewish authors, manna represented the Logos.

Mannerism. A transitional stylistic movement in Italian art between 1520 and 1600. As a reaction against the High Renaissance, especially the art of *Raphael Sanzio, and as a foreshadowing of the Baroque, Mannerism emphasized the primacy of the figure, which it distorted and elongated, and a forced composition whose focal point was located in the background of the canvas. Mannerist colors were distinctive, acid (chartreuse, tangerine, cerise), and emotionally affective.

Man's Face with Wings Attached. The symbol for *Matthew the Evangelist, whose *gospel emphasized the humanity of *Jesus Christ. Matthew was also represented by a winged young man.

Mantegna, Andrea (c. 1431–1506). Painter of the Italian Renaissance and iconographic innovator. Influenced by *Donatello and classical antiquity, Mantegna included tinted stone or bronze into a position of prominence in his paintings. This visual motif provided both a sense of the sculptural (even in his renderings of the human figure) and a heightened awareness of perspective. He was an early exponent of placing the *Sacra Conversazione as a group of figures in a unified, comprehensible space as opposed to the format of the medieval triptych. Both a compositional and iconographic innovator, Mantegna was best known for paintings such as the *Dead Christ* and the *Salvator Mundi.*

Margaret of Antioch, Saint (c. late third century). A legendary virgin *martyr who died during the Diocletian persecutions. Although of a delicate physical constitution and the daughter of a prince, she was raised in the country by a secret Christian. A beautiful young woman, Margaret was courted by Governor Olybrius, but refused him having dedicated herself to *Christ. Denounced as a Christian, she was confronted by a *dragon in prison. Depending on the version of her legend, Margaret either forced the dragon to disappear by making the sign of the cross, or by cleaving the dragon in two with her pendant cross, which grew enormous when the monster swallowed the martyr whole. Witnesses to the trials of Margaret stood in awe of her constancy and faith, and were converted to Christianity. Ultimately she was beheaded. Hers was one of the voices heard by *Joan of Arc. One of the *Fourteen Holy Helpers, Margaret of Antioch is the patroness of women in childbirth, nurses, and peasants. In Christian art, she was represented as a beautiful young woman, often in peasant dress, wearing a caplet or crown of pearls, holding a palm branch and a *cross, and accompanied by a dragon.

Margaret of Cortona, Saint (1247–1297). Maltreated by her stepmother, Margaret sought refuge in the home of her lover. She lived with this nobleman for nine years and bore him a son. Her conversion to Christianity occurred when she discovered her lover's murdered body. A member of the Order of Franciscans Tertiaries, Margaret of Cortona led an exemplary life of prayer and devotion. She was honored when the Crucified *Christ tilted his head towards her as a sign of forgiveness during an ecstatic vision. Credited with many miraculous healings, "La Povorella" lived a model life of Franciscan prayer, poverty, and humility. In Christian art, Saint Margaret of Cortona was represented by a beautiful young woman wearing a *veil and the knotted *girdle of the Franciscan Order, and was accompanied by her faithful spaniel. The most popular narrative representation is the *Ecstasy of Saint Margaret of Cortona*, in which she was depicted in ecstatic prayer as the Crucified Christ nodded to her.

Marguerite. From the Latin for "pearl." A floral symbol for the suffering and death of Christian *martyrs, this member of the daisy family was associated with pearls and drops of blood.

Marigold. A floral symbol for fidelity. This member of aster and sunflower families was a common and thereby humble flower which signified the Virgin *Mary.

Mark the Evangelist, Saint and Apostle (d. c. 74). Author of the second *Gospel, and supposed companion of *Barnabas and *Paul in Cyprus, and of *Peter in Rome. Mark was later identified as the first bishop of Alexandria. When he was imprisoned for his Christian faith, he was visited in prison by the Resurrected *Christ. His martyred body was dragged through the streets of Alexandria. According to tradition, Mark's body was stolen from its original burial site and moved to Venice in the ninth century. He was the patron of Venice, notaries, and glaziers. In Christian art, he was identified as an *evangelist by his *attributes of a *book or a *tablet and a *pen, or by the winged *lion which signified his Gospel's emphasis on the royal dignity and bloodline of *Jesus Christ. He was also represented dressed as a bishop (of Alexandria) presenting the Doge or other Venetian dignitaries to Mary.

Marriage at Cana (Jn 2:1–12). The first public miracle of Jesus described in John's *Gospel. Jesus' presence at this event signified the Christian validation of marriage. Having attended a wedding ceremony with his mother and other followers in Cana, Jesus partook of the wedding banquet. Before the banquet ended, the host ran out of wine. *Mary told this to Jesus, who reminded her that his time had not yet arrived. Unperturbed, Mary instructed the servants to do whatever he asked. Six jars of *water were brought to him and then were miraculously turned into the finest wine. Several medieval texts, including *The *Golden Legend* (96), followed the Venerable Bede in identifying the bridegroom as John the Evangelist. *The Golden Legend* (96) identified the

bride as *Mary Magdalene. The Marriage at Cana had several *Old Testament foretypes, and was itself interpreted as a foretype of the miraculous feedings, varied feasts, *Last Supper, and Celestial Banquet of the *New Testament. In the history of Christian art and devotion, the Marriage at Cana became important for both its eucharistic symbolism and its account of Mary's role as intercessor. The initial visual interest in the Marriage at Cana arose thematically, as it was considered one of the three festivals of *Epiphany (with the *Adoration of the Magi and *Baptism of Jesus Christ). Established early in the history of Christian art, the *iconography of the Marriage at Cana was composed of the standing figure of Jesus who was either holding a thaumaturge or healer's *staff (in the earliest images) or extending his right hand (in later images), over several large water jars in the presence of one or more servants. By the sixth century, the figure of Mary began to be included in this motif. In medieval art, the composition was expanded to include the bridal couple and the wedding guests. By the thirteenth century, with its interest in Mariology, Mary had become more influential, especially in her role as intercessor. Artistic representations of this theme diminished between the mid-fourteenth and mid-sixteenth centuries. Revived in *baroque art, this motif was transformed into a presentation of a great wedding banquet in which it became difficult to locate either Jesus or Mary.

Marriage of the Virgin Mary. *See* Betrothal and Marriage of the Virgin Mary.

Mars. The Roman god of war and father of Romulus and Remus, thereby of Rome. Believed to have originally been an indigenous fertility god, Mars not only supported armies in battle, but also guarded their fields during their periods of military duty. In classical Greco-Roman and *renaissance art, Mars was depicted as a physically handsome and muscular man who wore *armor and held one of his *attributes—*sword, *shield, *spear, *wolf, or *woodpecker. He was the classical Roman foretype of Christian warrior and military saints.

Martha of Bethany, Saint (first century). An admirable woman of faith and action, sister of *Lazarus and *Mary of Bethany, and friend of Jesus. Following tradition, her sister Mary of Bethany was conflated with *Mary Magdalene, and thereby Martha was identified as the person who led her sister to conversion (a popular motif among southern baroque artists). In the Eastern Orthodox Church, she was included among the Holy Women who brought ointments and spices to anoint the body of the crucified Jesus at the *tomb. According to *The *Golden Legend,* Martha of Bethany accompanied her brother and sister to Marseilles, helped to evangelize Provence, and rescued the people of Aix from a terrible *dragon which she drove away with holy *water sprinkled from an *aspergillum. As the paragon of domestic virtues and skills, Martha was the patroness of housewives and cooks. She was depicted in Christian art as a mature, plainly dressed woman who is identified by one of her *attributes—*kitchen utensils,

most often a *ladle; household *keys, usually on her *belt; an aspergillum; or a dragon or jar of holy water at her feet.

Martha and Mary of Bethany (Luke 10:38). Sisters of *Lazarus who entertained Jesus in their home. Martha complained vigorously that she had completed all the necessary work while her sister had sat at Jesus' feet and received spiritual instruction. Jesus countered that Mary had chosen the better part. Martha was thought of as the personification of the active life, and was characterized as domestic, efficient, industrious, and pragmatic; while Mary was the personification of the contemplative life, and was characterized as spiritual, passive, and mystical. Several early Church Fathers, including Tertullian, conflated Mary of Bethany with *Mary Magdalene. Representations of this scriptural event in Christian art depicted Mary seated at the feet of Jesus while an erect Martha gestured angrily before him. A secularized presentation of the two sisters—one working in the kitchen while the other watches—became a popular motif in seventeenth-century northern art and nineteenth-century American art.

Martin of Tours, Saint (c. 316–397). A Roman soldier who converted to Christianity and symbolized Christian *charity. One cold, wintry night, Martin saw a ragged beggar and immediately took off his own *cloak which he cut in two with his *sword for the beggar. Later that evening he had a vision in which the beggar proved to be the Resurrected *Christ.

Martin of Tours was renowned as a preacher, a builder of French monasteries, and a destroyer of pagan idols. Appointed bishop of Tours, he hid to avoid accepting the office until the loud cackling of a *goose revealed his whereabouts to the ecclesiastical emissaries. According to another tradition, when Martin offered the sacrament to a dying woman in Tours, the people surrounded him and insisted that he be consecrated bishop. One of the patron saints of France, Martin of Tours also watched over beggars, tailors, drunkards, and innkeepers. In Christian art, he was represented as a young man dressed in *armor and seated on horseback who offered half of his cloak to a naked beggar. Martin was also dressed as a bishop with a cackling goose at his side.

Martyrs. From the Greek for "witness." Those who testified, even unto death, for their faith. In Early Christianity, a martyr was synonymous with one who died for the faith. With the establishment of Imperial Christianity under Constantine, martyrdom shifted towards a witnessing of one's faith by the quality of one's life. In medieval popular devotional literature, the term "red martyrdom" signified Christians who had testified for their faith with their lives, and "white martyrdom" with the pledge of celibacy.

Mary, life and works of. The mother of *Jesus Christ and the model for Christian women in Christian art and devotion. The minimal biblical references to Mary were supplemented by the many legendary and devotional books such as The *Golden Legend,

119. Master of the Saint Lucy Legend, *Mary, Queen of Heaven*.
120. School of Amiens, *The Priesthood of Mary*.

121. Vittore Carpaccio, *The Virgin Mary Reading*.
122. Filippino Lippi, *Adoration of the Child*.

and the *apocryphal gospels, especially the *Protoevangelium of James.* This scarcity of biblical evidence permitted the formation of many symbolic types of representation based purely on devotionalism and spirituality. Since the Early Christian Church was concerned with the issues of daily survival and the theology of the Resurrection, images and devotion to Mary were minimal. The cult of Mary began to flourish in the fifth century following both the establishment of the Imperial Church (325) and the decree of the Council of Ephesus (431). The *iconography of the *Theotokos (Mary as "God Bearer"; that is, with her son) developed according to the conciliar decree. The major events in the life of Mary were described in either the apocryphal gospels or legendary texts, and increased in mid-twelfth-century western art. In Christian art, the major events in the life of Mary which became identified as the narrative cycle of Mary were: *Meeting at the Golden Gate, *Nativity of the Virgin Mary, *Presentation of the Virgin Mary in the Temple, *Betrothal and Marriage of the Virgin Mary, *Annunciation to Mary, *Visitation, *Nativity of Jesus Christ, Purification of the Virgin Mary, *Marriage at Cana, *Crucifixion of Jesus Christ, *Mourning (including *Deposition, *Lamentation, and *Pietà), *Pentecost, *Annunciation of the Death of the Virgin Mary, *Dormition of the Virgin Mary, *Assumption of the Virgin Mary, and *Coronation of the Virgin Mary.

Mary, symbolism of. A major focus of Christian art as influenced by popular devotions, and by apocryphal and legendary texts. As the second most important personage in Christianity, the symbols and images of Mary proliferated throughout the history of Christian art. She was represented as the Ideal Woman, the Mother of God, the Second Eve, and the Ideal Mother (Madonna and Child). Her most common *attributes were the *lily, *rose, *book, *crown, *apple, *mirror, and *moon. Christian art was influenced by the culture in which it was created, and was also responsive to or reflective of the evolving theological concerns of each cultural epoch. In earliest Christian art, there were minimal references to Mary as the central theological concern was the Resurrection, not the *Incarnation. The Cult of Mary developed in the fifth century following the establishment of the Imperial Church and the decree of the Council of Ephesus (431) that Mary was *Theotokos (from the Greek for "God-bearer"). At that time in Christian history, the most popular images of Mary were as Theotokos, that is, hieratic images of the Virgin and Child, in which their gestures and postures signified differing theological or spiritual meanings. By the seventh century, these Byzantine iconographic models were transferred to western art and further influenced by the legends that *Luke the Evangelist had painted a portrait (or series of portraits) of Mary.

Spiritual and devotional interest in Mary abounded during the twelfth century as she became the focus of much theological and iconographic innovations. At that time in Christian history, the most popular (and new-

est) images of Mary were as *Sedes Sapientiae* or *Virgo Sapientissima* (Throne of Wisdom), *Mater Ecclesia* (Mother Church), Queen of Heaven, Virgin and the *Unicorn, *Pietà (*Vesperbild*), *Maria Lactans* (Nursing Mother), Virgin of Mercy, Intercessor, Madonna and Child in the Rose Garden, the *Holy Family, Madonna and Child with Saint *Anne, and the idealized images of the *Madonna and Child, in which the objects held by the Christ Child signified the theological or spiritual intent. Other topics of importance to the growing interest in Mary were reflected in the *Seven Joys and Seven Sorrows of the Virgin Mary. The Renaissance interest in humanism and the theology of the Incarnation resulted in an interest in the spirituality of the *mater amabilis*, or maternal love, of Mary for her child. During that period, the most popular images of Mary were the Madonna of Humility, the Pietà, and the Madonna and Child. The resurgence of devotion to Mary in the Counter-Reformation Church led to the development of new iconographic motifs including the *Immaculate Conception, *Assumption of the Virgin Mary, Madonna and Child with *Joseph (of Nazareth), Woman of the Apocalypse, Pietà, and Virgin of Solitude. Northern baroque artists embellished the *iconography of the *Holy Kindred as a visual motif which diminished Mary's status in Christian spirituality.

For other symbols of Mary, *see* individual entries on specific animals, flowers, fruits, plants, heroines of the Old Testament and classical Greco-Roman mythology, initials and monograms, saints, and narrative entries listed under both Jesus Christ, life and works of, and Mary, life and works of.

Mary of Bethany, Saint (first century). Sister of *Lazarus and Martha who received spiritual instruction at the feet of Jesus. Mary of Bethany was identified as the anointer at Bethany, and was also present at the Resurrection of her brother Lazarus. She was often confused with *Mary Magdalene, and by the fifth century, the two women were identified in the West as one woman. The Eastern Orthodox Church identified Mary of Bethany as a distinctive person from Mary Magdalene. *See also* Anointing at Bethany, Martha of Bethany, and Mary Magdalene.

Mary Cleophas (or **Clophas**), **Saint** (first century). One of the Holy Women who followed Jesus, stood witness at the foot of the *cross, and with *Mary Magdalene and *Mary Salome brought unguents and spices to the *tomb. Mary Cleophas was identified as the sister of *Mary, the wife of Cleophas, and the mother of *James Minor and Joses (Mt 27:56; Mk 15:40; Lk 24:10; Jn 19:25). Following the northern medieval tradition of the *Holy Kindred, she was the daughter of *Anne by her second husband, Cleophas, and thereby the Virgin Mary's half-sister. Another tradition identified her as a companion to *Lazarus, Martha, and Mary Magdalene in the mission to evangelize Provence. In Christian art, Mary Cleophas was included in the relevant biblical narratives and the Holy Kindred, and was included as "one of the Marys."

Mary of Egypt, Saint (fifth century). A legendary Alexandrian prostitute who converted to Christianity. Mary of Egypt was mystically obstructed from entering the Church of the Holy Sepulcher in *Jerusalem. She had a vision of *Mary, to whom she pledged renunciation of her unseemly lifestyle, and thereby was granted permission to enter the church. Once inside, Mary of Egypt heard a voice telling her she would find "peace" on the other side of the Jordan. She left Jerusalem with only three loaves of *bread, crossed the River Jordan, and became a hermit in the Syrian desert. During her solitary life of penance, her clothes rotted away and her *hair grew long to cover her wasted body. Zosimus, a priest on a Lenten retreat, saw her over the River Jordan. After he offered her a blessing, he watched in awe as she was carried across the river by angels in order to receive the *Eucharist. The following year he found her dead body, which he buried with the assistance of a *lion. A popular figure in medieval legends and devotions, Mary of Egypt was confused (and later conflated) with Mary Magdalene. In Christian art, Mary of Egypt was depicted as a haggard elderly woman with long, disheveled, white (or gray) hair which covered her wrinkled body. Her wasted face was highlighted by sunken cheekbones and the loss of her teeth. She was usually postured in prayer and had three loaves of bread or a lion by her side.

Mary Magdalene, Saint (first century). Model of the female penitential *saint, first witness to the *Resurrection of Jesus Christ, and one of the most popular and complex of all Christian saints. Following the model of the early church fathers, Western Christianity combined three women—Mary of Magdala, *Mary of Bethany, and an unnamed female sinner—into Mary Magdalene. The Eastern Christian Church recognized them as three separate women. Mary of Magdala was the woman from whom Jesus cast seven devils (Mk 16:9; Lk 8:2–7); she stood at the foot of the cross (Mt 27:56, Mk 15:40; Jn 19:25), was one of the Holy Women who brought spices and unguents to the tomb (Mt 28:1–8, Mk 16:1, Lk 24:1–10), and was the first witness to the Resurrection (Mt 28:9, Mk 16:9, Jn 20:4–18). Mary of Bethany received spiritual guidance at the feet of Jesus in the home she shared with her sister *Martha (Lk 10:38–42), was present at the Resurrection of her brother *Lazarus (Jn 11:1–44), and anointed Jesus at Bethany (Jn 12:1–8). The unnamed repentant sinner who anointed Christ's feet in the *House of Simon (Lk 7:36–50) was alleged to be a harlot and was conflated with the unnamed *Woman Taken in Adultery (Jn 8:1–11). All these women, due either to similarity in name or character, were fused into one female personality whom Western Christians came to identify as Mary Magdalene. Patroness of penitents and flagellants, the Magdalene was invoked by women in childbirth and in cases of infertility.

In early Christian art, Mary Magdalene was identified by her role as the first witness to the Resurrection, and was included in the appropriate narrative events in the life of Christ. By the early medieval period, how-

123. Rogier van der Weyden, *The Magdalen Reading*.
124. Michelangelo Merisi da Caravaggio, *The Repentant Magdalene*.

125. Master of the Magdalene Legend, *Mary Magdalene Preaching*.
126. Donatello, *The Magdalen*.

ever, she became an independent personality as the first witness to the Resurrection in the *Noli me tangere, as the disciple to the disciples, and as the archetypal female penitential saint. Medieval legendary and devotional texts, including The *Golden Legend, identified the Magdalene as the evangelist of Provence with Lazarus and Martha. According to tradition, she retired to a cave in the woods near Sainte Baume where she lived in solitude for thirty years meditating upon her sins, eating only celestial foods, and being serenaded by angelic songs during her daily "elevations." She received her last communion from Maximin just before her death. Her relics were reported to have been buried in the Cathedral of the Magdalene in Vézélay, an important twelfth-century pilgrimage site. Medieval artists depicted the Magdalene as a preacher; a penitent with a *skull, *crucifix, and open *bible in front of her cave; on her daily assumptions (or mystical elevations); and at her last communion. The Cult of Mary Magdalene developed, and individual images of the Magdalene as penitent, as contemplative reader, and as miracle-worker formed the devotional *iconography. Her legend and iconography became confused (and later conflated) with that of *Mary of Egypt, so that physical representations of the Magdalene alternated between those of a beautiful young woman either elegantly dressed (before her conversion) or simply attired (after her conversion), and those of a haggard, elderly naked woman with a sunken face, disheveled *hair, and wasted body covered with her long flowing hair. The *iconography of the

Magdalene flourished anew in southern *baroque art as she became a symbol for the defense of and devotion to the *sacraments, especially the sacrament of penance (Penitent Magdalene in the Wilderness, Conversion of the Magdalene), against the Reformers. Throughout the history of Christian art, Mary Magdalene was distinguished by her perennial trademarks of long, flowing red hair and an unguent jar.

Mary Salome, Saint (first century). One of the Holy Women who followed *Christ, stood at the foot of the *cross, and with *Mary Magdalene and *Mary Cleophas carried unguents and spices to the *tomb. Ostensibly Mary Salome was the mother of *James Minor and John and the wife of Zebedee (Mt 20:20; 27:56). Following the medieval tradition of the *Holy Kindred, she was the daughter of Anne by her first husband, Salomas, and thereby half-sister of *Mary. According to legend, she either accompanied the Magdalene to evangelize Provence, or traveled alone to evangelize Spain. She is not to be confused with the other "Salomes"—the midwife at the *Nativity of Jesus Christ according to the Protoevangelium of James, and the unnamed daughter of *Herodias who was identified as Salome by *Flavius Josephus. In Christian art, Mary Salome was included in the relevant biblical narratives and in the Holy Kindred, and was identified as "one of the Marys."

Marys, The Three (Mt 28:1–8; Mk 16:1–8; Lk 24:1–11; Jn 20:1–9). The Holy Women who went with spices

and unguents to anoint the body of the crucified *Christ. These women were identified as *Mary Magdalene, *Mary Cleophas, and *Mary Salome.

Marys at the Tomb (Mt 28:1–8; Mk 16:1–8; Lk 24:1–11; Jn 20:1–9). The holy women identified as the Three Marys (ostensibly *Mary Magdalene, *Mary Salome, and *Mary Cleophas) who brought anointing spices for the body of Jesus to his *tomb. Arriving at the tomb, they found the sepulcher stone moved away and the tomb empty except for a radiant *angel who advised them that Christ had risen from the dead. In early Christian and *byzantine art, this motif symbolized the *Resurrection of Jesus Christ. After the thirteenth century, this event was fused with the Resurrection and *Guarded Tomb into one visual motif.

Massacre of the Innocents (Mt 2:16–18). Decree of *Herod the Great that all male *Jews under the age of two in Bethlehem be slaughtered. Warned by the *Archangel *Gabriel in a dream, *Joseph (of Nazareth) escaped with *Mary and the Christ Child to Egypt. By the fifth century, the Christian Church celebrated a feast day for the Cult of the Holy Innocents and regarded these children as the first *martyrs of the church. Representations of this event began in fifth-century Christian art. The basic *iconography of the Massacre of the Innocents was a courtyard setting in which Herod was seated on his throne overlooking agonized mothers holding their children and soldiers with drawn swords. By the sixth century, this theme was defined iconographi-cally with either the mothers holding their living children or a mixture of dead children on the ground and living children still in their mothers' arms. Two additional motifs entered the scene. Following the *Protoevangelium of James*, *Elizabeth was represented in a thick cloak under which she hid her newborn son, *John the Baptist, as she fled in the background of the scene. In those representations in which there are dead children, a seated female figure making gestures of mourning represented the *Old Testament motif of Rachel weeping for the children of Israel (Jer 31:15). The Massacre of the Innocents became a devotional topic in *medieval and *renaissance art in which the children were represented as a group holding martyrs' *palms either in an independent painting or within the context of an image of the *Madonna and Child.

Master and Slave. *See* Parables.

Matthew the Evangelist, Saint and Apostle (first century). A former tax collector, author of the first Synoptic *Gospel, and one of the original twelve disciples of *Christ. Matthew was in the midst of counting tax monies when he was called to discipleship by Christ (Mt 9:9–13; Mk 2:13–17; Lk 5:27–32). The author of one of the synoptic gospels, Matthew was reputedly the brother of *James Minor. According to tradition, he preached in Judea for fifteen years following the *Ascension of Jesus Christ, and eventually traveled to Ethiopia where he was martyred. Matthew was the patron of bankers, bookkeepers, and tax collectors. In Christian art, he was

depicted as an *evangelist with his *pen and *scroll, or his *book. An *angel was represented dictating the gospel to Matthew. His symbol was the winged young man or man's face, which signified that his gospel emphasized the humanity of *Jesus Christ (*Incarnation). His *attributes were the *ax, *purse, book, and pen and scroll.

Matthias, Saint (first century). A follower of Jesus from his baptism, a witness to the Resurrection, and the thirteenth disciple. Following a time of reflection and prayer, he was selected by lot as the successor to *Judas Iscariot. Little is known about the life of Saint Matthias, but he was reputed to have been a missionary in Galilee and to have been decapitated. In Christian art, he was identified by his *attributes—an *ax and an open *bible.

Maurice, Saint (d. c. 287). From the Latin for "moorish." Christian leader of a Theban legion which refused to sacrifice to the gods, despite an imperial order. Heartened by the faith and constancy of Maurice, his legion withdrew to Agaunum (now Saint-Maurice) only to be decimated by a Roman legion. The patron of Austria, Mantua, and the infantry, he was invoked against religious intolerance. In Christian art, Maurice was depicted as a dark-skinned man dressed in *armor who held one or usually two of the following items: *banner, *ax, *lance, *sword.

Medieval art. The umbrella identification for the varied artistic styles which developed in western Europe between the fifth and sixteenth centuries, including Italo-Byzantine, Carolingian, Ottonian, Romanesque, and Gothic. Medieval art was characterized as being predominantly Christian in content, nonnaturalistic in form, and without a sense of natural perspective. Medieval art excelled in the development of manuscript *illuminations and *cathedral architecture.

Meditations on the Life of Christ. An influential devotional text written in the late thirteenth century. Originally attributed to Saint *Bonaventure, this book was written by an anonymous Franciscan (Giovanni de Caulibus) normally identified as Pseudo-Bonaventure. The elaborate, humanized descriptions of the events in the life of Jesus and *Mary were prepared as pious reflections on the meaning of being a Christian. The fictional life events as narrated in this text were accepted as true by medieval and renaissance Christians. Like *The *Golden Legend* and *Revelations of Saint Bridget of Sweden*, the *Meditations on the Life of Christ* was influential in Christian art.

Medium of Endor. *See* Saul and Witch of Endor.

Medusa. A beautiful maiden in Greek mythology who was identified as the only mortal Gorgon. She was transformed into an ugly winged *monster as punishment for defiling *Athena's temple with *Poseidon. Athena turned Medusa's *hair into hissing snakes because of her hubris in claiming that her hair was more beautiful than the goddess's. Medusa's face be-

came so horrific that whoever looked upon her was turned into stone. The mythical hero Perseus tricked her into looking into a mirror and when she saw her reflection he decapitated her. Whoever held the *head of Medusa was able to immediately destroy his or her enemies. Eventually, Perseus gave the head of Medusa to Athena, who emblazoned it on her shield. In classical Greco-Roman art and *renaissance art, the youthful Perseus was depicted holding the head of Medusa by her snaky locks. This was the classical Greco-Roman foretype of *David with head of Goliath, *Judith with the head of Holofernes, and *Salome with the head of *John the Baptist.

Meeting at the Golden Gate (*Protoevangelium of James* 4:14 and *The Golden Legend* 131). The event which signified the conception of *Mary according to devotional and legendary texts. Although he was a pious Jew, the aged and childless *Joachim was denied the right to sacrifice in the Temple. He retreated into the wilderness (*desert) for forty days of prayers and fasting in order to offer his sacrifice to God. One night, an *angel appeared simultaneously to Joachim in the wilderness and to his wife *Anne in her bedroom to announce the coming birth of a special child. Following the angel's instructions, Joachim and Anne met at the Golden Gate of *Jerusalem. According to pious legend, when Joachim kissed Anne on the cheek she conceived Mary. Narratives of the life cycle of Mary flourished after the thirteenth century, but the motif of the Meeting at the Golden Gate

became a favored theme for late medieval and renaissance artists. This iconographic motif was replaced in the baroque period by the *iconography of the *Immaculate Conception.

Melchizedek. From the Hebrew for "king of righteousness." *King and high priest who brought food and wine to *Abraham in the *desert (Gn 14:18–20). As a king and high priest, Melchizedek was a foretype of *Christ; and this event was a foretype of the *Eucharist.

Memento Mori. From the Latin for "reminder of death." A physical object which signified the transitory and fleeting quality of human existence. The most popular memento mori in Christian art were a *skull, a skull with wings, a skull crowned with a *laurel wreath, a *skeleton, a hourglass, and a death's-head moth.

Mercury. The Roman god of commerce and science, and also the messenger of the gods and goddesses. Mercury guided the souls of the dead to the underworld. He was the patron of travelers, shepherds, flocks, rogues, vagabonds, and thieves. In classical Greco-Roman and renaissance art, Mercury was depicted as a muscular youth who wore a winged *helmet and winged sandals, and carried the caduceus. He was the classical Roman foretype of the *archangels, especially of *Michael. In *renaissance art and culture, Mercury was the personification of eloquence and reason, and was depicted as a figure of learning.

Mermaid. A mythical creature composed of a female torso and the lower

body of a scaly *fish with a double tail. The mermaid's songs were so ethereal and enchanting that sailors were bewitched by them and allow their boats to shatter on the *rocks. Riding a wave's crest while combing her *hair and looking in a *mirror, the mermaid was the feminine symbol of the seductive temptations that had to be conquered in order to achieve salvation.

Messiah. From the Hebrew for "anointed one." The title given the anticipated leader of the Jewish people who would lead them from bondage to eternal peace and self-sovereignty. Christians used the Greek form, *christos*, to identify Jesus.

Michael, Archangel and Saint. From the Hebrew for "who is like God." One of the seven *archangels of God in the *Old Testament. The guardian angel of Israel (Dan 10:13, 21), Michael brought the *ram to save *Isaac, witnessed the *burning bush, and watched over the battle of Jericho. As the protector of the Church Militant, Michael led the heavenly armies in triumph over the rebellion of *Lucifer and the fallen angels (Rv 12:7). He will sound the trumpet of the *Last Judgment and will wait at the side of *Christ the Judge with a balance *scale in which the souls of the dead will be weighed in judgment. As the conveyer of Christian souls, Michael brought *Mary a palm branch as the sign of the Annunciation of her prayed-for death. His was one of the voices heard by *Joan of Arc. The patron of the sick, of soldiers, and of all Christian souls, Michael was invoked in battle and in danger at sea. In early

Christian and byzantine art, he wore a winged *helmet and sandals, and held a caduceus like *Mercury (or Hermes). By the early medieval period, Michael was represented as a handsome young man clad in *armor, who carried a *sword, *spear, *lance, or *scales, and had a *dragon or *Satan at his feet.

Michelangelo Buonarroti (1475–1564). The greatest artist of the Italian Renaissance. An extraordinarily gifted individual, Michelangelo excelled in painting, sculpture, and architecture. His interest in depicting the glories of human anatomy with a complex *iconography and a concern for the renaissance commitment to balance and harmony resulted in his masterful presentations of biblical and saintly figures, including *Mary and *Jesus Christ. His lifelong spiritual quest was apparent in the innovative *iconography he created for the theme of the *Pietà, and the creation narrative. His most well-known works of Christian art include his three versions of the Pietà, the frescoes for the Sistine Ceiling, and the Pauline frescoes in the Pope's private chapel.

Milk. A symbol for both physical and spiritual nourishment. In the *Old Testament, the promised land was described as the land of milk and *honey. In the early Christian tradition, milk signified the Logos and simple spirituality for the newly baptized. The *Eucharist of milk and honey was prepared by *deaconesses for distribution among the *children, the aged, and the sick in the early church. The *iconography of the *Ma-

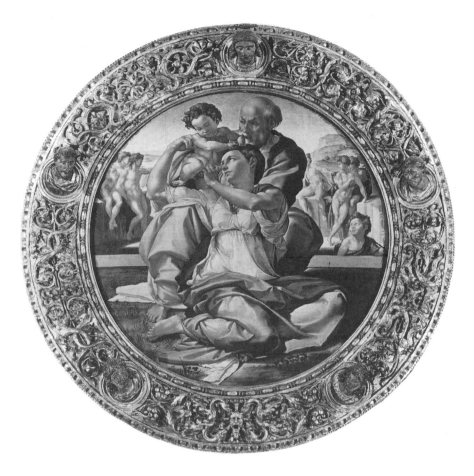

127. Michelangelo Buonarroti, *The Doni Tondo.*

ria Lactans (Nursing Mother) signified Mary as the good mother who nurses her child, as opposed to the bad mother who nursed *serpents. *See also* Charity.

Millstone. A large, circular stone threaded by a *rope was an *attribute of *Florian, *Christina, and *Vincent.

Minerva. The Roman virgin goddess of wisdom, war, industry, and the domestic arts. She was the patroness of schoolmasters and school children. In classical Greco-Roman and *renaissance art, Minerva was depicted as a majestic matron who wore a *helmet and a flowing toga with a coat of mail inscribed with an *owl. She held a *shield, *lance, or an image of Nike. Minerva was the classical Roman foretype for all Christian female warrior saints.

Ministry of Jesus Christ. These events continued the chronology of the life of Christ, and included the public pronouncements and teachings of his mission. The parallels between his life and those of his *Old Testament foretypes were highlighted by the church fathers and Christian artists. Several of these events were popular through the history of Christian art. *See also* Baptism of Jesus Christ, Temptation in the Wilderness, Calling of the Apostles (or Vocation of the Apostles), Feast in the House of Levi, Sermon on the Mount, Anointing at Bethany, Woman of Samaria, Transfiguration of Jesus Christ, Tribute Money (or Half-Shekel Temple Tax), Blessing the Little Children (or Suffer the Little Chil-

dren), Woman Taken in Adultery, and Feast in the House of Simon.

Miracles of Jesus Christ. These physical healings performed by Jesus signified his divinity. Each physical healing was a metaphor for a spiritual healing. Central to Jesus's public ministry, these miracles displayed his unique relationship to and with God the Father. In the history of Christian art, depictions of the miracles outnumber all other aspects of the public ministry and were found as early as the third century. The iconographic formulas for the miracles developed in the fifth and sixth centuries and influenced byzantine and medieval Christian art, when such thematic representations were especially popular. From the thirteenth century, however, Christian artists chose to concentrate upon the representation of the singular miracle—the *Resurrection of Jesus Christ—and presentations of the other miracles began to fade from Christian art, with the possible exception of the *Resurrection of Lazarus. Southern baroque artists emphasized the miracles of the *saints, while those northern baroque artists who continued to paint Christian themes emphasized the images of the *Sermon on the Mount and *Blessing the Little Children. *See also* Marriage at Cana, Healing of Peter's Mother-in-law, Multitudes Possessed of Devils and Sickness, Stilling of the Water (*Navicella*), Gadarene Demoniac, Healing of the Paralytic, Jairus's Daughter, Woman with the Issue of Blood, Decapolis Deaf Mute, Capernaum Man Possessed of the Devil, Mute Possessed of the Devil, Loaves and Fishes (or Multiplication

of the Loaves and Fishes), Walking on the Water, Canaanite Woman's Daughter, Healing of the Epileptic Boy, Blind Beggar of Jericho, Man Born Blind, and the Resurrection of Lazarus.

Miraculous Draught of Fishes (Lk 5:1–8). Having preached from *Peter's boat, Jesus directed that the nets be lowered despite Peter's doubts about a catch. Miraculously, the nets became so filled with fish that Peter needed the nearby boat of *James and John to bring the catch to shore. The soon-to-be disciples were advised not to be afraid, and to follow Jesus as "fishers of men." In Christian art, this iconographic motif became conflated with the *Calling of the Apostles (or Vocation to the Apostles) and confused with the *Stilling of the Water (or *Navicella*).

Miriam. From the Hebrew for "Mary." Sister of *Aaron and *Moses, and one of the saviors of the Children of Israel. She suggested that her mother become the wet nurse for the newly adopted son (Moses) of Pharaoh's daughter (Ex 2:1–10). One of only two women identified in the *Old Testament as a prophetess (the other being Deborah), Miriam led the ceremonial dancing and singing of the Hebrew women following the crossing of the *Red (Reed) Sea (Ex 15:20–21). Afflicted with leprosy as punishment for her criticism of Moses' marriage to an Ethiopian woman, she was healed by his intercession after seven days of suffering and ostracization (Nm 12:1–15). In Christian art, Miriam was depicted within the context of the life of Moses. In nineteenth-century American and British art, there was a renewed interest in the theme of Miriam dancing before the Lord.

Mirror. A complex and ambiguous symbol with both negative and positive connotations. *Athena's mirror symbolized her purity, wisdom, and chastity, but was also the death sign of *Medusa. As an *attribute of the Virtue Prudence a mirror signified self-knowledge, while as an attribute of *Narcissus or *Venus it implied self-love, vanity, and lust. Penitential saints were depicted with a mirror as a sign of their meditation upon and penance for their sins. The spotless mirror was an attribute of *Mary and an integral element in the *iconography of the *Immaculate Conception.

Miter. From the Greek for "turban." Liturgical hat worn by the pope, archbishops, and bishops as a symbol of authority. The miter derived from both the crown of the Byzantine emperor and the liturgical hat worn by the Jewish high priests. The shape of the western miter, established by the eleventh century, consisted of two points front and back—thought to allude to the two rays of light which issued from the head of *Moses after he received the Ten Commandments. The two lappets or fanons attached to the back of the miter and falling over the shoulders signified the *Old and *New Testaments. A white miter was an *attribute of *Benedict of Nursia, while three miters on the ground identified either *Bernard of Clairvaux or *Bernardino.

Mocking of Jesus Christ (Mt 27:27–31; Mk 15:16–20; Lk 22:63). Having

completed the legal process by which Jesus was prepared for crucifixion, *Pontius Pilate relinquished him to the Roman soldiers. Wearing the purple robe and crown of thorns, Jesus was spat upon and beaten with a reed which he was given to hold as a mock royal scepter. Depictions of the Mocking of Jesus Christ are often conflated with the *Ecce Homo or confused with the *Crowning with Thorns, distinguishable by the presence of the crown and Jewish mockers (not Roman soldiers).

Mole. Reported to be blind and deaf, this animal lived underground. In Christian art, the mole signified the *Devil.

Money (bag). A symbol of wealth, charity, and avarice. A sign of the Passion, a bag of money or two hands with money represented *Judas Iscariot. A bag of money was an *attribute of *Matthew, while a platter or *dish with money signified *Laurence. *Nicholas (of Myra or Bari) was represented by three bags of money. A bag of money was a general symbol for those saints famed for their acts of *charity, such as *Elizabeth of Hungary.

Monica, Saint (c. 330–387). A pious Christian, mother of *Augustine of Hippo, and a model of Christian motherhood. The wife of a pagan, Patricius, Monica devoted her life to the nurture of her children and their acceptance of the Christian faith. She struggled with the many trials and tribulations of Augustine's varied experiments in philosophies, esoterica, and mystery religions. Rejoicing in his baptism by *Ambrose of Milan on *Easter Sunday 387, Monica died several days later in Ostia as she journeyed back to Africa. The patroness of married women and of Christian motherhood, Monica was depicted in Christian art as an elderly woman dressed in the black *habit and white veil of the much later Augustinian Order. She held a *book.

Monkeys. See Apes.

Monks. Men who have dedicated their lives to the service of the *church as members of a religious order, and who lived within a communal religious life. In Christian art, monks were identified by the *habits of their individual orders.

Monster. Sign of evil and danger, and ostensibly the *Devil. These legendary animals combined the shapes or body parts of several animals with human beings to display super-human strength, thereby highlighting the hero or heroine who destroyed them. Common to Greek and Roman mythology as well as to Jewish apocalyptic literature, monsters were assimilated into Christian theology, legend, devotionalism, and art. See also Basilisk, Centaur, Dragon, Fabulous Beasts, Leviathan, Mythical Beasts, and Wild Beast.

Monstrance. From the Latin "to show." A liturgical receptacle developed in the fourteenth century to display the consecrated Host for adoration and meditation. The monstrance was an *attribute of *Clare, *Hyacinth, and Norbert.

Moon. A complex and ambiguous symbol in Christian art for the passage of time and of life, of the female cycle, and of the night. The moon had an ancient relationship with goddesses of fertility and virginity from Cybele and Isis to Artemis and Diana of Ephesus. Following the Council of Ephesus (431), many of the *attributes of Diana of Ephesus were assimilated into Marian symbolism including the crescent moon, which was a sign of virginity and chastity. Representations of *Mary standing on the crescent moon signified the triumph of Christianity over paganism; and in Spanish art (after 1492), Mary stood on an inverted crescent moon to represent the victory of Christianity over Islam. In depictions of the *Crucifixion and more rarely the *Nativity of Jesus Christ, the moon signified night.

Mortar and Pestle. These traditional instruments of physicians and pharmacists signified *Cosmas and Damian.

Morse. The brooch or clasp used to fasten a bishop's *cope. Morses were elaborately carved or decorated with stones, or incised metals, that contained symbols which identified the individual wearer or symbolized an important theological dogma.

Mosaics. Traditional but durable form of mural decoration created by the inlaying of small chips of stone, marble, and/or colored glass into cement to produce a design or figural representation. This medium survived into the thirteenth century, when it was surpassed by the development of *fresco.

Moses. Renowned Hebrew lawgiver and leader, brother of *Aaron and *Miriam, and principal *Old Testament foretype for *Christ. *Finding of Moses* (Ex 2:1–10): To avoid the decree of Pharaoh that all male *Hebrew infants be killed, Moses' mother placed her newborn son in a basket of *bulrushes in the Nile where it was found by Pharaoh's childless daughter. Adopting Moses as her own, Pharaoh's daughter innocently hired his birthmother as his wet nurse. This event was interpreted as a foretype of the *Massacre of the Innocents and *Flight into Egypt. *Pharaoh's Crown and the Burning Coals:* According to legend and the Jewish historian *Flavius Josephus (*Antiquities* 2.9:7), the Pharaoh playfully placed a *crown on the young child Moses' head as he rested in Pharaoh's lap. Moses threw the crown on the ground to the distress of the sages, who saw this as an omen that this child would overthrow Pharaoh. As a further test, two *dishes (or *chalices) were placed before the child who guided by God's *angel chose to place a burning coal in his mouth; had he chosen the ruby he would have been killed to preserve Pharaoh. Although his life was spared, the damage to Moses' tongue resulted in a permanent stammer. *The Burning Bush* (Ex 3:1–11): As he tended his father-in-law's flock on Mount Horeb, Moses was confronted by a flaming bush which burned but was not consumed. God told Moses to remove his shoes as he was on holy ground, and that he was destined to lead the Hebrews out of Egypt into the promised land of milk and honey. In Christian art, Moses was represented kneeling barefoot before a

flaming bush. This event was interpreted as a foretype for the perpetual virginity of Mary and the miraculous conception of Christ. *Passover* (Ex 12,13): After the plagues, Pharaoh's heart remained hardened and he refused to release the Hebrews from their bondage. God prepared to release his last plague upon Egypt—the death of the firstborn son of every family. In order to spare the sons of Israel, the Hebrews were told to kill a *lamb and with its blood mark (a *tau*-cross according to Christian legend) the doorposts and lintels so that the angel of death would pass over that house. The sacrificed lamb should then be roasted and eaten quickly by the Hebrews, who were to be dressed and packed for immediate departure from Egypt. In Christian art, the Passover meal was signified by the fact that all the participants were standing instead of seated around the table. This event prefigured the *Last Supper and the sacrifice of Jesus as God's firstborn son. *Crossing of the Red (Reed) Sea* (Ex 14:1–31): Regretting his decision to allow the Hebrews to leave, and in retaliation for his son's death, Pharaoh and his army set out in pursuit of the Hebrews. At the Red Sea, Moses stretched open his arms and the waters parted, allowing the Hebrews to pass to the other side. As Pharaoh's pursuing army neared the midpoint of the Red Sea, Moses closed his arms and the waters drowned the soldiers. This event prefigured both the ritual of Christian *baptism and the *Crucifixion of Jesus Christ. *Water from the Rock* (Ex 17:1–7, Num 20:1–13): As the Hebrews travelled through the desert, they thirsted. God ordered

Moses to strike his *staff against the rock from which sufficient *water flowed to quench the thirst of all the people and animals. This event prefigured Christian Baptism. *Battle of the Amalekites* (Ex 17:8–13): As the Hebrews battled the tribe of the Amalekites, Moses watched from a hill. If Moses kept his arms outstretched, the Hebrews would be victorious. When he tired, Moses sat on a rock as his brother, Aaron, and his brother-in-law, Hur, held his arms outstretched until the battle ended in a Hebrew victory. This event prefigured the *Crucifixion. *Tablets of the Law* (Ex 19, 21): On Mount Sinai, Moses received the Ten Commandments from God. This event prefigured the *Sermon on the Mount. *Brazen Serpent* (Num 21:1–9): Embittered by their life in the desert, the Hebrews complained about Moses and God. As a punishment, they were set upon by poisonous snakes. The Hebrews repented and Moses asked God to end the plague. God directed that Moses construct a brass image of the *serpent and elevate it on a pole. This image had curative powers and ended the siege of the poisonous snakes. This event prefigured the Crucifixion. In medieval Christian art, the brazen serpent was seen as a counterpart to the snake entwined around the Tree of Knowledge.

In nonnarrative contexts in Christian art, Moses prefigured *Peter as a lawgiver and a leader of institutional religion. Moses was represented as a majestic, muscular man with a long flowing gray beard and *hair, who carried a staff or the tablets of the law. A translation error in *Jerome's *Vul-

gate edition of the Bible resulted in Moses being depicted with *horns (instead of "rays of light" as a metaphor for Moses face shining with light, Jerome wrote "horns of light" [Ex 34:29]). Unfortunately, the *iconography of the horned Moses gave rise to anti-Semitic imagery in *medieval and *renaissance art. Moses was included in images of the *Transfiguration of Jesus Christ and the *Descent into Limbo (or Hell) where he rests among the Righteous. See also Manna in the Wilderness and the Golden Calf.

Mount of Olives. Location for many important events in the *Old and *New Testaments. This high hill located east of Jerusalem was the site of *David's tearful and barefoot flight during *Absalom's ill-fated revolt (2 Sm 15:30), a vision of *Ezekiel (Ez 10:4), Zechariah's vision of God (Zech 14:4), and the *Entry into Jerusalem (Mt 21:1–11, Mk 11:1–10, Lk 19:28–40, Jn 12:12-19).

Mount Olivet. See Mount of Olives.

Mountain. An *Old Testament symbol for God the Father or the home of God.

Mountain in Galilee (Mt 28:11–20). As the eleven disciples gathered together in Galilee, the Resurrected *Christ directed that they preach the Kerygma to all the peoples of the world.

Mourning (especially by the Virgin Mary). See also Deposition (or Descent from the Cross), Lamentation, and Pietà.

Mouse. An animal known for its gnawing away in the safety of the dark and as a sign of female sexuality, the mouse signified the *Devil in Christian art. See also Rat.

Multiplication of Loaves and Fishes. See Loaves and Fishes.

Multitudes Possessed by Devils and Sickness (Mt 8:16–18; Mk 1:32–34; Lk 4:40–41). The multitudes possessed of evil spirits and sicknesses, the two believed to be interchangeable at the time of Jesus, were brought to him to be healed. Jesus laid his hands on each of the "possessed" and they were healed. The common practice in Christian art was to depict a "generic" healing of the masses which might be combined with the *Sermon on the Mount. Representations of Jesus healing the sick were popular in byzantine and medieval Christian art.

Murillo, Bartolomé Esteban (1617/8–1682). One of the leading painters of Spanish *baroque art along with *Jusepe de Ribera and Diego Velásquez. As a devout *Roman Catholic, Murillo employed his art to defend the Tridentine Church and to support the development of new iconographies, especially for Marian devotions. Renowned for his depictions of the *Immaculate Conception, Murillo softened and sweetened the dramatic tension of the baroque style to create an accessible image for popular and pious devotion.

Muses. The Greek goddesses of the arts. Residing on Mount Parnassus, they were lead by Apollo as the god of the arts. In classical Greco-Roman

and *renaissance art, they were depicted as beautiful young women in flowing classical garments with *laurel wreaths on their heads. The individual muses were identified by their *attributes. Calliope was the chief of the Muses and the individual muse of epic poetry; her attribute was the *tablet and stylus, or a trumpet. The Muse of history, Clio, was represented by a *book, *tablet and stylus, a *scroll, or a trumpet, while the Muse of music and lyric poetry, Euterpe, held a double flute. Thalia, the Muse of comedy and pastoral poetry, carried a comic mask, a scroll, a shepherd's *staff, or an ivy wreath, while the Muse of tragedy, Melpomene, held a tragic mask, a *crown and scepter, an ivy wreath, a club, or a *sword. The Muse of choral dance and song, Terpsichore, held a *lyre or viol, while Polyphymnia, the Muse of heroic hymns and sacred dance, carried a *veil, a *lute, or an organ. Urania, the Muse of astronomy, held a celestial *globe and compass, while Erato, the Muse of lyric and love poetry, carried a lyre, a tambourine, or a *swan.

Musical instruments. Musical instruments could be purely decorative elements in Christian art, but the inclusion of a specific musical instrument such as an *organ or *lute as an integral element of a work of art related to the theological meaning of the image. Musical instruments in the hands of *angels or the celestial choir signified the eternal and harmonious praise of God. Musical instruments were *attributes of individual saints such as *Cecilia, the patroness of music. Musical instruments also symbolized the

varieties of human love from eros to agape. Reed instruments or pipes were seen as phallic symbols, while stringed instruments, like the lute, were viewed as vaginal symbols.

Mustard Seed. *See* Parables.

Mute Possessed by the Devil (Mt 9:32–34). Jesus called the *Devil out of a mute, and after he was cleansed the man spoke to the amazed multitude. Representations of this miraculous healing was very rare in Christian art; rather, it was fused with other "healings."

Myrrh. An aromatic gum resin used in the production of perfume, incense, medicines and unguents. It was an element instrumental in the anointing of the bodies of the dead. As a sign of prayer (incense) and death (perfumed ointment), myrrh was one of the three symbolic gifts of the *Magi to the Christ Child.

Myrtle. Dedicated to Venus, this evergreen plant was a classical Greco-Roman symbol of love and peace. Myrtle was combined with orange blossoms to form the bridal headpiece as a sign of auspiciousness. During the Renaissance, the myrtle represented conjugal love and fidelity. In Christian art, myrtle symbolized Gentile converts to Christianity (Zech 1:8). Christian *saints and *martyrs wore a sprig of myrtle as a sign of their individual witness to Christian faith.

Mystical Winepress. Medieval motif of *Christ kneeling under the *winepress with a basin or tub prepared to

receive his holy *blood. Following the writings of *Augustine, a cluster of *grapes from the Promised Land became symbolic of Christ. The visual and verbal metaphor of Christ in the Mystical Winepress was popular in the late medieval and southern baroque devotionalism which rendered a literal reading to the doctrine of "real presence" in the Eucharist. There were two *Old Testament foretypes for this motif: the spies sent into Canaan who returned with the large clusters of grapes (Nm 13:17–19) and the metaphor of the angry God who treads his enemies in the wine press (Is 63:1–6).

Mythical (or **Fabulous**) **Beasts**. Composite animals unlike any found in the natural world. These combinations of characteristics, shapes, or actual animal parts permitted freedom from the restrictive conventions of the phenomenal world, thus making the fiercesome *monsters more evil and the beautiful creatures more magnificent. Mythical beasts were common elements in early Christian, *byzantine, and *medieval art. Depending upon the narrative theme or context, the mythical (or fabulous) beast was either a part of the general composition or had symbolic value intrinsic to the theological or spiritual intent of the work of art. *See also* Basilisk, Centaur, Dragon, Griffin, Leviathan, Phoenix, and Unicorn.

N

Nails. An *Instrument of the Passion, a symbol of the *Crucifixion of Jesus Christ, and an *attribute of *Nicodemus. In early Christian and *byzantine art, depictions of the Crucifixion showed four Holy Nails being used; but that number was reduced to three by the early medieval period both in reference to the *Trinity and for the sake of a more dramatic suffering of the Crucified Christ. Pious legend related that the Holy Nails were found by *Helena, mother of the Emperor *Constantine, and that one of the Holy Nails was melted into his imperial crown and another in his bridle. According to medieval tradition, *Louis of France transferred the Holy Nails to Sainte-Chapelle following his participation in one of the crusades.

Narcissus. A floral symbol for vanity and self-love in Christian art. This lovely yellow spring flower was named after the Greek mythological figure who spurned the love of the nymph Echo, after which she faded

away from unreciprocated love. He was condemned by Aphrodite to fall hopelessly in love with his own reflection in the *water until he himself pined away. In late medieval and early renaissance depictions of the *Annunciation to Mary or of the Madonna and Child in the Paradise Garden, the narcissus represented the triumph of divine love and eternal love over human self-love and death.

Nativity of Jesus Christ (Mt 1:18–2:12; Lk 2:1–20). The narrative account of the birth of Jesus. Related by two of the four Gospels, this event was divided into four scenes—Journey of Joseph and Mary to Bethlehem, Nativity proper, *Annunciation to the Shepherds, and *Adoration of the Shepherds. Briefly reported in the *New Testament texts, the birth event was described in detail in the later *apocryphal gospels, and devotional and legendary texts. Throughout the history of Christian art, the Nativity of Jesus was conflated with representations of the *Annunciation to Mary,

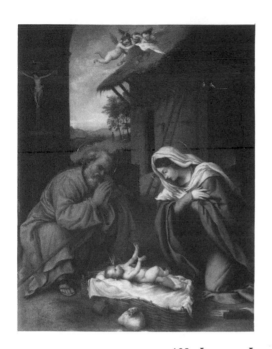
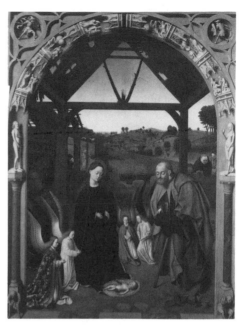

128. Lorenzo Lotto, *The Nativity.*
129. Petrus Christus, *The Nativity.*

130. Correggio, *Noli Me Tangere.*

Annunciation to the Shepherds, Adoration of the Shepherds, and/or *Adoration of the Magi. The major *Old Testament foretypes of the Nativity were identical to those for the Annunciation to Mary—*Burning Bush, Gideon's Fleece, Shut Gate, and Aaron's Staff. The earliest images of the Nativity were from the fourth century and sought to display the miracle of the *Incarnation rather than the historical event itself. Even in the fourth century, images of the Nativity were rare in comparison to those of the Adoration of the Magi and the *Baptism of Jesus Christ, which directly represented the Incarnation. The newborn child was represented tightly wrapped in swaddling clothes and laying in a *basket or trough. Even in these earliest images, the *ox and ass were present although Mary might have been absent. Mary was present in those early images when the Nativity was conflated with the Adoration of the Magi and the Adoration of the Shepherds. The presence of the ox and ass, along with the Magi and the shepherds, signified the recognition of the uniqueness of this child and that all—the highest and the lowest—came together to glorify him. Following the decree of the Council of Ephesus that Mary was *Theotokos, she became both a fixed element in representations of the Nativity and the second focal point of the composition. In byzantine art, the Nativity was depicted as occurring in a cave, signifying that Jesus was the *Philosopher-Teacher—the one who brought the light (wisdom) to the world as Plato's philosopher did for those in the cave. Mary as Theotokos was seated on a *kline* (or couch) to rest after having given birth to this special child (thereby emphasizing that this man was born of woman). The newborn infant, wrapped tightly in cloth simulating a shroud, rested atop a manger (resembling an altar, which emphasized that he was born to die) as the ox and the ass watched over him. Directly above was the Star of Bethlehem surrounded by *angels, and to the left of the cave were the shepherds and to the right the Magi. *Joseph (of Nazareth) was seated or stood leaning on his staff "off center" supervising the activities. In the foreground, the two midwives bathed the newborn child (as reported in the *Protoevangelium of James*) as an affirmation of the Virgin Birth. Representations of the Nativity in early *medieval art were rare in comparison to depictions of the Adoration of the Magi, Baptism of Jesus Christ, and Crucifixion. By the twelfth century, however, the sacramental aspects of this event were emphasized as it was placed in a space parallel to the *Last Supper. Between the twelfth and fourteenth centuries, two major shifts occurred in the *iconography of the Nativity which related as much to the changing attitudes towards humanism in medieval culture as to the growing devotionalism to Mary. In northern medieval art, the relationship between Mary and the newborn child became more naturalistic. Although Mary continued to recline on a couch, the child was no longer separated from her and placed upon a tablelike manger. Rather, Mary was depicted nursing her son or having him rest beside her on the couch. Joseph was an actor in the drama when he received the child from a midwife or passed the

child to his wife. In the late medieval period, the image of the *Adoration of the Child developed as both a form of visual devotion and as a theological teaching. In his *Meditations on the Life of Christ*, Pseudo-Bonaventure (Giovanni de Caulibus) described a vision of the Nativity in which he saw Mary leaning against a *column as she painlessly gave birth. She then proceeded to wrap her child in swaddling clothes and rest him in the manger, where he received warmth from the breath of the ox and the ass. Joseph joined his kneeling wife in a prayer of celebration and adoration. *Bridget of Sweden reported her own vision of the Nativity in her *Revelations*. She too witnessed a painless birth after which Mary immediately knelt to celebrate and adore her naked newborn son, who rested on the ground. By the fifteenth century, in both northern and southern art, the *Instruments of the Passion or other Passion motifs entered into representations of the Nativity. The cast of characters in these scenes varied as much with the devotional or theological attitudes towards the Nativity as with the liturgical dramas. By the sixteenth century, the Nativity became conflated with representations of either the Annunciation to Mary, Annunciation to the Shepherds, Adoration of the Shepherds, and/or Adoration of the Magi.

Nativity of the Virgin Mary (*Protoevangelium of James* 5:2, and *The Golden Legend* 131). Having no scriptural authority, this event was recounted in the apocryphal *Protoevangelium of James* with an expanded account in *The *Golden Legend*.

Rarely depicted in Christian art before the fourteenth century, when it became a popular motif, the Nativity of Mary was signified by the presence of *Anne resting in her bed and being attended to by midwives. In the foreground, the infant Virgin Mary was being bathed and/or nursed by midwives. As a parallel to the *Adoration of the Magi, neighbors bearing gifts were included in this scene. A popular topic in sixteenth-century northern art, the Nativity of the Virgin Mary occurred within an ecclesiastical interior, in reference to the fact that she was dedicated at birth to the service of God and would be raised in the Temple. Despite the efforts of the *Council of Trent to urge the avoidance in Christian art of apocryphal and legendary images, representations of the Nativity of the Virgin Mary continued into the seventeenth and eighteenth centuries. These later images were distinguished by the presence of the aged Joachim leaning on his *staff for support and gazing adoringly at his newborn daughter.

Nave. From the Latin *navis* for "ship." The central area of the *church which is reserved for the congregation. In early Christianity, the symbolism of the *ship related both to the idea of the saved being those who had been baptized (i.e., Noah's Ark) and also to the fact that some of the *apostles had been fishermen. The nave was separated from the *altar by an *iconostasis in the Eastern Orthodox Church or by a *rood screen in western medieval churches.

Navicella (or **Stilling of the Water**) (Mt 14:22–33; Mk 6:45–52; Jn 6:15–21). An early Christian symbol for *baptism. Having calmed the *waters during a storm, Jesus proceeded to walk across the water to the ship in which the disciples were located. *Peter, encouraged by Christ's action, tried to walk upon the water to meet him, but sank instead and cried aloud for help. As he saved Peter, Jesus told him that he was a man of little faith. As a sign of salvation through the immersion into water, the *Navicella* became an early Christian symbol for the ritual of Baptism, and images of the *Navicella* were found within the context of other *Old and *New Testament prototypes of Baptism. Rarely depicted in *medieval and *renaissance art, the motif of the *Navicella* was retrieved by *Rembrandt van Rijn, whose several baroque interpretations of this scriptural story influenced its revisioning by the nineteenth-century *Pre-Raphaelite Brotherhood and the *Nazarenes.

Nazarenes. Quasi-religious order of painters established by Johann Friedrich Overbeck and Franz Pforr in Vienna in 1809. This group of erstwhile young painters formed an "order" which would provide training, as well as moral and aesthetic support along the lines of the medieval guilds. Originally known as the Brotherhood of Saint Luke (after the patron saint of painters), the Nazarenes sought to regenerate German religious art. In 1810, the leading members of the Brotherhood established studios in Rome, and several converted to Roman Catholicism. Influential on the *Pre-Raphaelite Brotherhood in Lon-

don, the Academy of Saint Luke became identified as the Nazarenes once established in Rome.

Neptune. The Roman god of the sea. An indigenous Italian rain god and dispenser of life-giving water, Neptune was identified with the fertilization of vegetation. In classical Greco-Roman and *renaissance art, Neptune was depicted as a muscular, elderly man with a long graying beard and *hair who wore a crown of seashells and fish, and held a trident. As the *patron of *horses and horsemen, he was represented riding a *dolphin or seahorse. As with his brother *Jupiter, Neptune was a classical Roman foretype for the *iconography of God the Father in Christian art.

Net. An implement of fishermen which in Christian art and devotion alluded to the many scriptural and devotional metaphors relating to *fish, fishermen, and the sea. An ambivalent symbol signifying both the net of the *church and the net of the *Devil, the net was an *attribute of *Andrew. The net filled with fish signified the church. *See also* Parables.

New Garments and Old Garments. *See* Parables.

New Testament (or **Christian Scriptures**). Official canon of the Christian tradition which when combined with the *Old Testament constituted the Holy *Bible. The New Testament, consisting of texts written by the *apostles and *evangelists, related the story of the life and the teachings of Jesus and his disciples. It was identified as the New Testament in comple-

ment to the Old Testament of the Hebraic tradition (a New Covenant fulfilling an Old Covenant). In Christian art, the New Testament was signified by a *book or a *scroll in the hands of the evangelists or on a writing desk before each of them, or in the hands of Christ, *Mary, the saints, or theologians.

New Testament Apocrypha. Those writings rejected from inclusion in the canon of the *New Testament by the criteria of apostolic authorship and acceptance by the Christian churches. These rejected texts included texts relating the infancy, childhood, and *Passion of Jesus Christ, the life cycle of *Mary, and activities of the *apostles. The New Testament Apocrypha was accepted as inspirational but not canonical text, and retained a fascination and interest for Christians. Many of the stories of the New Testament Apocrypha were included in *The *Golden Legend,* which was an influential text for medieval devotionalism and art. The most important books of the New Testament Apocrypha for Christian art were the *Protoevangelium of James,* which details the Nativity and childhood of Mary, and the Nativity of Jesus Christ; the Gospel of Thomas, which described the childhood of Jesus; and the *Gospel of *Nicodemus* (also known as the *Acts of Pilate*), which elaborated upon the Passion and the *Descent into Hell.

New Wine and Old Wineskins. *See* Parables.

Nicholas, Saint (of Myra or Bari) (d. c. 350). One of the most popular and legendary of all Christian *saints. Im-

prisoned during the persecutions of Diocletian, Nicholas was renowned for his acts of Christian *charity, including the dispensation of three bags of gold as dowries for three impoverished young women who otherwise would have had to turn to prostitution to survive; the restoration of the lives of three little boys who were slaughtered by an innkeeper (or butcher) during a famine; and the rescue of a *ship from a horrific storm. Originally buried in Myra, Nicholas's body was stolen by Italian merchants in 1087 and transferred to Bari where it exuded a sweet-smelling oily substance, *"Manna di San Nicola,"* which was reputed to have medicinal value. The legend and figure of Nicholas was conflated with the indigenous northern folklore figure Father Christmas, who ultimately was traced to the god Thor who was worshiped at the winter solstice. Identified as Santa Claus ("Sinte Klaas," from Dutch dialect for Saint Nicholas), he became the legendary dispenser of gifts and toys to children. Nicholas was the patron of travelers, clerks, bankers, pawnbrokers, merchants, sailors, children, scholars, perfumers, Russia, Greece, Sicily, and Aberdeen, Scotland. In Christian art, Nicholas was represented as a large, elderly man with a long white beard and *hair who dressed as a bishop and was identified by one of his *attributes: three gold balls, three purses of gold, three little boys, an anchor, or a ship.

Nicholas of Tolentino, Saint (1245–1305). An Augustinian friar credited with many miracles, whose life was devoted to pastoral work and effective preaching. According to legend, a

*star flashed across the sky from Fermo, his birthplace, to Tolentino as a sign of his birth. *Mary appeared to him and related that her Holy House had been transported to Loreto. After his death, an erstwhile German friar in search of a relic cut off Nicholas of Tolentino's arms. The limbs were returned to Tolentino and enshrined in the Cathedral, and were reputed to bleed as a sign whenever a catastrophe was about to befall the city. Nicholas was invoked against the plague, and reportedly rescued souls from purgatory. He was represented in Christian art as a tall male figure who dressed in the black robe of the Augustinian Order with a star embroidered on his chest, and who held a lily-entwined *crucifix.

Nicodemus, Saint (first century). A Pharisee, a member of the Sanhedrin, and a secret follower of Jesus of Nazareth. According to the biblical and legendary accounts, Nicodemus was instructed by Jesus on the spiritual rebirth available through *baptism (Jn 3:1–21), and attempted to dissuade the High Priests and the Pharisees from condemning Jesus without a trial (Jn 7:50–52). He further assisted at the *Deposition by removing the *nails, and by bringing *myrrh and aloes to anoint the body. Nicodemus assisted *Joseph of Arimathea in wrapping the body in a linen shroud (Jn 19:39–42), and helped with the burial. According to medieval legend, Nicodemus was reputed to be a stonecarver (sculptor). In Christian art, Nicodemus was depicted as an elderly male figure with graying *hair and lengthy beard who was in conversation with Jesus. He was also included in representations of the Deposition, *Lamentation, and *Entombment of Jesus Christ. His *attribute was the Holy Nails.

Nightingale. This *bird's sweet and plaintive song signified the soul's longing for heaven. In Christian art, nightingales signified the Christian faithful and *martyrs.

Nimbus. From the Latin for "cloud." A technical name for *halo, the nimbus was a circle of light radiating from the *head of a holy individual.

Nine. A significant number relating to both the nine choirs of *angels and the nine *fruits of the *Holy Spirit (Gal 5:22–3). Nine was a number of fulfillment as it was the result of the mystical number three multiplied by itself.

Noah. *Old Testament foretype for *Jesus Christ, a tenth-generation descendent of *Adam, and the first grower of the vine. *Noah's Ark* (Gn 6:11–22): Enraged by human wickedness, God decided to destroy all humankind but the righteous family of Noah. He ordered Noah to build an ark which would be large enough to hold two of every animal as well as Noah's family. A popular topic in Christian art, Noah's Ark was a sign of salvation and of the Christian ritual of *baptism. In early Christian art, Noah's Ark was represented by a large *box from which a male figure in the *orans position emerged. By the medieval period, representations of Noah's Ark were more detailed, with two of every real and imaginary animal were included

in the lengthy parade waiting to board the *boat. *The Flood* (Gn 7, 8:1–19): When the rains came, Noah, his family, and the animals paraded onto the ark and were saved as all around them—people, plants, buildings—were destroyed. The rains lasted for forty days and forty nights, after which the *waters began to recede. As the ark came to rest on Mount Ararat, Noah hoped that the waters had receded so that he, his family, and the animals could return onto the *earth. To discover the condition of the land, Noah sent forth a *raven but it returned with an empty beak. Some time later, he dispatched a *dove, it returned with an olive branch, a symbol of peace which signified that the waters had receded sufficiently so that they could leave the Ark. *Sacrifice of Noah* (Gn 8:20–22; 9:1–17): Having left the ark safely, Noah built an *altar and sacrificed to God. A *rainbow appeared in the sky as a sign of God's acceptance of Noah's sacrifice and of a new covenant between God and the earth. *Drunkenness of Noah* (Gn 9:20–27): After working strenuously in the fields, Noah returned home to eat and drink. He drank too much and fell into a stupor in a state of undress. His son Ham, seeing his father's nakedness, called his brothers Shem and Jepheth, and the three sons proceeded to mock their father. Ham's son, Canaan, was cursed by God for this act of filial impiety. The Drunkenness of Noah was a foretype for the *Mocking of Jesus Christ.

Noli me tangere (John 20:17). From the Latin for "do not touch me." Episode in the Resurrection cycle in which *Mary Magdalene, mourning the loss of the body of the crucified *Christ from the *tomb, turned to respond to the query of the two *angels to find a man, ostensibly a gardener, standing before her. Thinking this man had been involved in the removal of the body, she asked where the body was. The man called her name and she recognized him as the Resurrected Christ. In awe, she reached out to touch him, but he warned her *"Noli me tangere,"* as he as not yet ascended to his Father. (Note that this was a different concept of Ascension than found in Luke.) This is the first reported scriptural appearance of the Resurrected Christ to anyone—disciple, follower, or family. He then called Mary Magdalene to be the "disciple to the disciples"—that is, to go and tell *Peter and the other disciples that Jesus was risen from the dead. In Early Christian art, the *Noli me tangere* was a significant element in the Resurrection cycle but was conflated with the *Guarded Tomb, *Three Marys at the Tomb, and the *Resurrection of Jesus Christ. By the *medieval period, this theme became an independent topic due as much to the growing cult of the Magdalene as to the influence of the passion plays. The Magdalene was depicted fully clothed, and in a posture of kneeling before and reaching her hands forward with palms extended towards the Resurrected Christ. He stood before her displaying the wounds of the Crucifixion. With his left hand, he gestured her to stop, while his right hand pointed upwards towards *heaven. In *renaissance art, the theme of the *Noli me tangere* became a popular topic as it permitted the representation of the male nude (or

seminude). The naturalistic depiction of the resurrected body of Christ became the focal point of this image, whereas the medieval artists had concentrated on the gestures and the distance between Mary Magdalene and the Resurrected Christ. In southern *baroque art, presentations of this theme were numerous owing to both the rekindled interest in the cult of the Magdalene and the miraculous moment of the first sight of the Resurrected Christ. As with other themes in Christian art, the *Noli me tangere* was rarely depicted in western art after the mid-seventeenth century.

North. One of the four cardinal points. The region of the cold and the night, the north signified the barbarians and the pagans in early Christian praxis. The act of reading the gospel from a position north of the *altar represented the desire to bring the barbarian and the pagan to Christianity.

Nudity. An ambiguous and complicated symbol in Christian art. Classically, nudity signified the unconcealed truth. Given, however, the ambivalence of the Christian tradition's attitudes towards human sexuality, representations of nude figures in Christian art had multivalent and controversial meanings, such as abasement and glorification. A figure of a female nude, like *Eve, in a state of total undress was interpreted as lascivious and wanton, while one of a male nude, like *David, was interpreted as the glorification of God's creation. Cultural and theological attitudes towards human sexuality governed the representation and the in-

terpretation of nudity in Christian art, as did the character or metaphoric allusion of the person being represented; thus, the nudity of Eve signified the opposite of the nudity of *Mary of Egypt. In *medieval and *renaissance art, there were four clearly defined and understood types of nudity: *nuditas naturalis*, or the natural state of human birth (I Tm 6:7); *nuditas temporalis*, or the voluntary lack of worldly goods and possessions in a willing surrender to serve God; *nuditas virtualis*, or the quality of the virtuous life; and *nuditas criminalis*, or the lustful, vain absence of all virtue.

Numbers, symbolism of. Numbers could be purely decorative elements in Christian art, but the inclusion of a specific number, especially a mystical number, as an integral element of a work of art was related to the theological meaning of the image. The prevalent mystical numbers in Christian art were three, signifying the *Trinity; four, the number of materials needed to create the earth; seven, the union of God and humanity (three plus four); eight, representing completion (*Easter, the eighth day of the week); and twelve signifying God's chosen people (the twelve Tribes of Israel or the twelve *apostles). These mystical numbers were included in Christian art in one of two ways—either by the inscription of their Arabic or roman numeral forms, or by the number of symbolic objects such as *fruits, *flowers, *animals, and so on.

Nuns. Women who had dedicated their lives to the service of the

*church as members of a religious or-
der, and who lived within a commu-
nal religious life. In Christian art,
nuns were identified by the *habits of
their individual orders.

Nuts. A classical Greco-Roman sym-
bol for fertility. In Christian art, spe-
cific types of nuts had individual
meanings—the most important being
the walnut, which was characterized
by *Augustine as a symbol for the hu-
manity and divinity of *Jesus Christ.
The shell of the walnut represented
the humanity of Jesus while the fleshy
meat of the walnut signified the divin-
ity of Christ. The walnut *tree was
one of the many trees identified
whose wood was used for the *cross.

Oak. A classical Greco-Roman symbol of strength, *faith, and *wisdom. The Celts and the Druids worshiped the oak tree, which was associated with the Roman god *Jupiter. In classical Greece and Rome, the *wreaths which crowned civil heroes were made of oak leaves. In Christian art, the oak tree became a symbol for *Jesus Christ or *Mary. The oak tree also signified the survival of Christianity against all adversity and challenge.

Oceanus. The salt river which flowed around the outer limit of a disk of the world in Greek mythology. In classical Greco-Roman and *renaissance art, Oceanus was depicted as a physically muscular and powerful elderly man with long, flowing *hair and *beard, who reclined on his side and held a conch shell or a crab's claw. He was the classical Greek prototype for all rivers, including the River Jordan, in Christian art. Oceanus was the mythological foundation for the visual and verbal metaphor of "Old Man River."

Oil. Signifier of God's grace and blessings. Oil was used as a sign of God's providence during the consecration of the believer during the rituals of *baptism, confirmation, ordination, and unction.

Old Testament (or **Hebrew Scriptures**). The received canon of *Judaism which when combined with the Christian *New Testament was identified as the Holy *Bible. The texts of the Old Testament recounted the history of the creation of the world, of humanity, and of the history of the Jewish people and their unique covenant with God. The writers of these texts were believed to have been inspired by God. Christian theologians and artists read the Old Testament both for its historical account of Jewish history and also for its prophecies relating to *Jesus Christ. The heroes and heroines of the Old Testament were interpreted as foretypes of

Christ and, later, of *Mary. Effort was made by Christian theologians and artists to parallel every prophecy or figure in the Old Testament with its fulfillment in Christ and Mary through the New Testament. In Christian art, the Old Testament was represented by a *scroll held in the hands of a *prophet, other Old Testament figures, a *saint, Mary, or Jesus Christ.

Olive. A general symbol for martyrdom, the *fruit of the *church, the faith of the just, and peace. The olive tree was a tree whose thick trunk represented the wealth of its oil. This richness of oil signified God's providence for the blessed (Jgs 9:8–9). The olive branch was a classical Mediterranean symbol of peace. In the *Old Testament, this symbolic value was transformed into a sign of God's peace and a new covenant with the *earth when the *dove returned to *Noah carrying an olive branch in its beak (Gn 8:11). The return of this dove represented the idea of the safe journey, and the image of the dove with an olive branch in its beak signified the peaceful departure of the soul at death. In paintings of the *Annunciation to Mary by Sienese artists, the *Archangel *Gabriel held an olive branch as opposed to the traditional *lily. The olive branch signified the city of Siena, while the lily symbolized Siena's bitterest enemy, the city of Florence.

One. A symbol for divinity, unity, and eternity. One hundred was a number of plenitude and one thousand a number of eternity.

Onuphrius, Saint (d. c. 400). A monk of Thebes who was called to live in hermetical solitude in the *desert for seventy years. According to legend, an *angel appeared every Sunday with the *Eucharist. Onuphrius was found in prayer by the Abbot Paphnutius, who was debating about becoming a hermit himself. Having spent the night, Paphnutius ate food delivered by angels and conversed with Onuphrius. The desert hermit announced that he was about to die, and that Paphnutius had been sent by God to bury him. Paphnutius buried Onuphrius, but realized that he was not called to be a hermit when both Onuphrius's grave and the cave disappeared before him without a trace. According to another legend, Onuphrius died alone in the desert and was buried by two *lions he had befriended. Onuphrius was a popular desert father from the sixth century. In Christian art, he was depicted as a wild, unkempt male figure covered with long *hair and a *beard who wore a girdle of leaves and was accompanied by two lions.

Orange. The "golden apple" which wrought such havoc in Greek mythology by initiating the Trojan War. This symbolic connection was apparent when the Tree of Knowledge was represented as an orange tree and *Eve held an orange, not an *apple. As a sign of purity, generosity, and chastity, the orange tree and its white, aromatic blossoms represented *Mary. During the late medieval period, the Saracen custom of adorning a bride with a wreath of orange blossoms became accepted practice in western Europe.

Orans. The original position of prayer in Christianity. An individual stood straight with arms extended and *head held high in imitation of the position of Jesus on the *cross. This posture signified openness to God. In Christian art, persons represented in this posture were referred to as "orants." Female orants denoted both a specific person and a generic Christian soul.

Orb. A small globe surmounted by a *cross which denoted sovereignty and power. Christian monarchs, the Christ Child, and Christ as *Pantocrator were identified by an orb which was held in their left hands.

Organ. An *attribute of *Cecilia as both patroness of music and reputed creator of this instrument. As a symbol of the praise continually offered to God, the organ was included within the heavenly concert and choirs of *angels.

Original Sin. The western Christian dogma that the effect of *Adam and *Eve's fall from grace was transmitted to all successive generations of human beings through natural descent. As a result of Adam and Eve's surrender to the temptation of seeking to attain divine wisdom by eating of the *fruit of the Tree of Knowledge, all men were condemned to labor, all women to pain in childbirth, and all human beings to eventual death. *Augustine, whose teaching on Original Sin became the basis for the church dogma, also taught that *baptism was both the sign of initiation into the Christian faith and the cleansing from Original Sin. The later Reformers taught that Original Sin produced the state of total depravity or corruption of human nature, rendering people completely unable to do good except by the intervention of God in Christ, who purged the evil from those who were destined for salvation through Grace. The Roman Catholic and Eastern Orthodox Churches held that the effect of Original Sin was a certain impairment of nature and an inclination to sin but not a total corruption. The varied interpretations of the meaning of this dogma paralleled the *iconography of the Temptation and the *Fall of Adam and Eve in Christian art.

Orpheus. One of the most important classical Greco-Roman foretypes for *Jesus Christ. As the master of the *lyre, Orpheus charmed wild animals, *trees, and *rocks. This musical ability was a prefiguration of the eloquence of Jesus Christ, who converted the heathens. In classical Greco-Roman art, Orpheus was depicted as a youthful and beardless *shepherd seated among his flock and holding a lyre—an image which was assimilated into early Christian art as appropriate to Christ. When Orpheus's beloved wife, Eurydice, died suddenly from a poisonous snakebite, Orpheus descended into Hades—the realm of the dead—in search of her. His music enchanted the King and Queen of Hades, who permitted Eurydice to return with him on one condition—that he not look at her until they reached the earth. During the long journey from Hades to the *earth, Orpheus withstood his personal desire and Eurydice's cries that he look at her. Finally he could hold

out no more, but when he turned back to see her she vanished into the shadows forever. Orpheus's descent into Hades to retrieve Eurydice was seen as a foretype of Christ's *Descent into Hell (Limbo) to retrieve the *souls of the righteous following his Resurrection. The grieving Orpheus returned to Thrace where his continual mourning and rejection of their advances so enraged the Maenads that they tore him into pieces in a bacchanalian orgy. This untimely death became the focus of the Orphic mystery cult that developed in sixth-century Greece and was similar to the other mystery cults, which were interpreted as a foundation for the acceptance of Christianity. In these mystery cults, the hero figure was killed violently and was resurrected from the dead. Participants in the sacred mysteries of these cults were promised the cleansing of their sins and thereby received rewards in the next life. Both the classical figure of Orpheus and his mystery cult were retrieved by late medieval and renaissance philosophers and artists.

Ostrich. The concealment of the ostrich's head in the ground in moments of danger denoted the moral lesson that material concerns were unnecessary for the true believer—only *heaven was important (Jb 29:13–14). According to the *Physiologus,* the ostrich did not brood its *eggs but watched over them until they hatched. In Christian art, the ostrich egg signified both meditation and the virgin motherhood of *Mary. If hatched by the sun, these eggs represented the *Resurrection of Jesus Christ.

Otter. An ambiguous symbol in Christian art for both the righteousness of *Christ and the evil of the *Devil.

Owl. Originally sacred to *Athena, this nocturnal animal had ambiguous meanings in Christian art. As an animal which favored the night and feared the light, the owl denoted either the *Devil or the *Jews, who in their blindness rejected Jesus as the Christ. Its presence in narrative events implied that the event depicted occurred at night. The owl's presence at the Crucifixion had a double meaning: as a positive sign, it indicated that the light of Christ was available to those who sat in the dark; as a negative sign, it signified that Christ was sacrificed as a decoy to the *Devil in order to save humanity (as the owl was used as a decoy by hunters in quest of other *birds). Following the classical Greek association of the owl with Athena as the goddess (and personification) of wisdom, the owl denoted the gift of wisdom in Christian art, and in this context was depicted with scholarly *saints such as *Jerome.

Ox. A sacrificial animal in the Hebraic culture, and a sign of docility, humility, patience, and strength. In the writings of several of the early church fathers, the ox was substituted for the *lamb as a symbol for *Christ's sacrifice. As a powerful animal which voluntarily bore the yoke to plow the master's fields, the ox was a symbol for Christ as the Redeemer who worked and suffered for the good of humanity. The winged ox signifies *Luke, whose *Gospel em-

phasized the sacrificial and redemptive aspects of the life and death of Christ. The ox was an *attribute of *Thomas Aquinas (mocked as a "dumb ox" by his academic opponents), *Lucia, *Sylvester, and *Luke.

Ox and Ass. An essential and popular element in depictions of the *Nativity of Jesus Christ from the earliest representations in Christian art. Without canonical scriptural foundation as a part of the Nativity, the ox and the ass were interpreted as both the recognition of this special child, and as symbols for the *Jews and Christians (Is 1:3). According to the apocryphal *Gospel of Pseudo-Matthew*, the ox and the ass were present at the Nativity, and knelt in recognition of the Christ Child. They were included in depictions of the *Flight into Egypt, *Rest on the Flight into Egypt, and *Return from Egypt.

Painting of the Virgin Mary or **Painting Materials (palette, brushes, easel, and canvas).** Representations of either a portrait of *Mary, an artist painting her portrait, or painting materials near Mary denoted *Luke the Evangelist. According to pious legend, this apostle was both physician and artist, and had painted the only portrait "from life" of Mary. This legend and its ensuing images were used as a defense of Christian art.

Palm. Classical Greco-Roman symbol of military triumph adapted by Early Christianity as a sign of *Christ's victory over death. The palm also signified immortality, divine blessings, triumph, *paradise, and resurrection. An attribute of all Christian *martyrs, it also denoted *Paul the Hermit, *Onuphrius, *Christopher, and *Michael the *Archangel.

Palm Tree. A symbol of immortality and the paradise garden. This evergreen tree signified the scriptural events of the *Rest on the Flight into Egypt and *Entry into Jerusalem. The original *Tree of Life was often represented as a palm tree in Christian art.

Panagia. From the Greek for "All Holy." Honorific title of *Mary in the Eastern Orthodox Church. The small icon of Mary worn by an Eastern Orthodox bishop was identified as a "Panagias."

Pandora. From the Greek for "all gifted." In Greek mythology, this beautiful young woman was given a series of gifts by the gods and goddesses. Her husband, Epimethius, warned her not to open the *box given her by *Zeus. When she was alone, Pandora opened the box and all the evils, sorrows, and pain that would besiege the human race were released. She closed the box fast enough, however, to retain hope. In both Christian art and tradition, she was the classical Greco-Roman foretype for *Eve. For example, the early church fathers drew parallels between

Pandora and Eve. In classical Greco-Roman and *renaissance art, Pandora was depicted as a beautiful nude young woman either seated or standing holding a box.

Pansy. From the French for "thought." Floral symbol for remembrance and meditation. This member of the *violet family was included in representations of penitential *saints and *Mary in *medieval art.

Panther. Animal symbol for *Jesus Christ. According to the *Physiologus*, the panther slept for three days after eating a full meal, and upon arising exuded an aromatic belch which attracted friends but dispelled enemies.

Pantocrator. From the Greek for "ruler of all." Iconic depiction of the Resurrected *Christ as Ruler and Judge. Such a representation was located in the domed ceiling of a basilica, and the figural image of *Jesus Christ was accompanied by the *sacred monogram or the *Alpha and Omega. This topos was adapted into the *Romanesque presentations of the *Majestas Domini* of *cathedral *tympanums, and eventually became standardized as Christ the Judge in the *iconography of the *Last Judgment.

Parables. These confusing stories challenged the casual listeners to pay attention and required contemplation in order to learn the hidden spiritual message. Jesus used parables to explain his mission and his teachings to those who accepted him as the *Messiah. The majority of the parables were rarely, if ever, depicted in Christian art. Nonetheless, as a group topic, the parables were popular in *byzantine and *medieval art. 1. *New Garment and Old Garments* (Mt 9:16; Mk 2:21; Lk 5:36). In order to mend a damaged garment, the mender had to use an old piece of fabric that matched because a new piece of fabric would shrink and tear. 2. *New Wine and Old Wineskins* (Mt 9:17; Mk 2:22; Lk 5:37). If new wine was put into old wineskins, the wineskins would have shattered. However, new wine poured into new wineskins resulted in their preservation. 3. *Growing Seed* (Mk 4:26–28). Even though a man knew that if he planted a seed a plant would grow and produce *fruit, he could not explain nor did he understand the process. 4. *Two Foundations* (Mt 7:24–25; Lk 6:46–47). The Christian believer was compared to the man who built his house on a foundation of *rock instead of sand. 5. *Two Debtors* (Lk 7:36–50). When an anonymous, weeping woman anointed Jesus' feet at the *Feast in the House of Simon, Simon was astonished that Jesus allowed this woman to touch him. Jesus responded with the parable of the man who forgave his two debtors, and asked Simon which debtor would have been the most grateful. Simon's answer was the one that owed the most. In agreement, Jesus indicated that the anonymous woman had given more of herself than had Simon. 6. *Lamp Under a Jar* (Mt 5:15–16; Mk 4:21–25; Lk 8:16–18). In order to light the house, *lamps should be put on lampstands, not under jars or beds. 7. *Good Samaritan* (Lk 10:30–37). On the road near Jericho, a man was robbed and

131. *Pantocrator.*

132. Bernardo Daddi, *Saint Paul.*
133. Rembrandt van Rijn, *The Apostle Paul.*

left for dead. A priest and a Levite each rode past the man and neither offered any aid. A Samaritan, who should have shunned a *Jew, rescued the man and brought him to an inn to rest. When he departed, the Samaritan left additional money with the innkeeper so that the injured man would receive the necessary care. 8. *Friend at Midnight* (Lk 11:5–8). When a man went to his friend's house at midnight and asked for food for an unexpected guest, the friend would have responded only if the man had been insistent. 9. *The Sower* (Mt 13:3–8; Mk 4:1–9; Lk 8:4–8, 11–15). Scattering seeds on the wayside, in stony places, and among *thorns, and on good soil, the sower sought a good *harvest. The *birds ate the seeds on the wayside, the *sun scorched the seeds on the rocks, the *thorns choked the seeds, but the seeds scattered on good soil produced a bountiful harvest. 10. *Lost Sheep* (Mt 18:10–14; Lk 15:1–7). Even though he owned a hundred *sheep, the *shepherd rejoiced more in the one lost sheep that was found than in the ninety-nine that were never lost. 11. *Pearl of Great Value* (Mt 13:45–46). To the knowledgeable merchant one pearl of great value was worth more than many pearls of lesser value. The kingdom of God was like such a pearl of great value. 12. *Net* (Mt 13:47–48). Like the *net cast by a fisherman into the *sea, so the kingdom of *heaven united all types of persons. 13. *Rich Fool* (Lk 12:16–21). Having had a series of successful harvests, a rich farmer no longer had any storage area. He decided to destroy his barns and erected larger ones so that his future was insured. However, God

wondered what good these riches would be if the man died that night. 14. *Exhortation to Watch* (Mt 24:36–44; Mk 13:32–37; Lk 21:34–36). Like the master who left his house and instructed his servants to await his imminent return, so the Messiah might come suddenly like a thief in the night. 15. *Barren Fig Tree* (Lk 13:6–9). After three years with no fruit, a man ordered his gardener to cut down a *fig tree. The gardener, however, persuaded the man to let him try some fertilizer first and see if the tree would then bear fruit. 16. *Weeds Among the Wheat* (Mt 13:24–30). Good seed having been sown in his fields, a man's enemy sowed weeds among the *wheat. As the weeds grew up alongside the wheat, the man's servants wanted to pull out the weeds. Fearful that the wheat would be damaged, the man ordered that they wait until the harvest when they could easily separate the wheat from the weeds. 17. *Mustard Seed* (Mt 13:31–32; Mk 4:30–32; Lk 13:18–19). The humble little mustard seed which grew into a great *tree upon which many birds rested was a metaphor for the kingdom of heaven. 18. *Yeast* (Mt 13:33–34; Lk 13:20–21). The yeast a woman hid in three measures of meal until it had risen was a metaphor for the kingdom of heaven. 19. *Hidden Treasure* (Mt 13:44). When a man found a hidden *treasure in a field, he sold everything in order to buy the field. This hidden treasure was a metaphor for the kingdom of heaven. 20. *Lost Coin* (Lk 15:8–10). Having lost one of her ten *silver dower *coins, a woman searched high and low for it. She rejoiced with her neighbors when she

found the coin. 21. *Prodigal Son* (Lk 15:11–32). The younger of a man's two sons asked for his inheritance, and then left his father's house for a foreign country. Having wasted all his inheritance, the young man was forced to become a swineherd. Remembering the care his father afforded his servants, he returned home and announced his repentance. Although he intended to become a servant in his father's home, the young man was greeted by his joyous father who hosted a feast of thanksgiving. The disgruntled elder son asked why no feast had ever been offered for him. The father replied that although the elder son was always with him, the dead son had returned to life. 22. *Dishonest Manager* (Lk 16:1–13). Accused of wasting his master's wealth, a manager sought to have all his master's debtors indebted to him so he lessened their debts by twenty to fifty percent. The master complimented the astuteness of his servant. 23. *Rich Man and Lazarus* (Lk 16:19–31). An ailing beggar, Lazarus, sought refuge by the door to the house of Dives, a wealthy man. Instead of offering aide to the sufferer, Dives and his household ignored the beggar, who soon died and was welcomed into heaven. When Dives died, he went to *hell and was shocked to look up into heaven to see Lazarus resting in Abraham's bosom. Dives asked *Abraham to send Lazarus to him with cool *water. Since Dives had done nothing to aide Lazarus during his earthly suffering, Abraham saw no reason to offer comfort to Dives in hell. Dives, however, asked that Lazarus be allowed to return to *earth to explain the meaning of sin to Dives's family.

Given that they took no heed of the *prophets, Abraham suggested Dives's family would not hear that a man risen from the dead. 24. *Master and Slave* (Lk 17:7–10). Although a servant had worked his master's fields and cared for his animals, the master did not reciprocate by either thanking or serving the servant. Rather, the master expected the servant to do his bidding, and afterward care for himself. Each person must act according to his duty. 25. *Widow and Unjust Judge* (Lk 18:1–8). Seeking help from an unjust judge, a poor widow found that he would only assist her in order to silence her continual pleas. 26. *The Pharisee and the Tax Collector* (Lk 18:9–14). As the Pharisee and the tax collector prayed in the Temple, the Pharisee thanked God for his personal righteousness while the tax collector publicly recognized his personal sinful nature. Jesus declared that the truly righteous man was the publican, as the mighty shall be humble and the humbled exalted. 27. *Laborers in the Vineyard* (Mt 20:1–17). Having hired laborers at the fee of one penny per day, a landowner told all those he hired that each would be paid fairly no matter what time of the day they were hired. When the day's labor ended, the landowner paid each laborer one penny without concern as to what hour each began his labor or how many hours he labored. Those who had worked a full day complained that their fee was no more than those who had worked only one hour. The landowner retorted that the last would be first and the first last, for many were called but few were chosen. 28. *Two Sons* (Mt 21:28–32). A man had two sons, both

of whom he asked to labor in his vineyard. Both sons initially refused but the elder worked in the vineyard while the younger did not. Questioned by the priests in the Temple, Which of these sons had done his father's will? Jesus responded not the elder son. 29. *Wicked Tenants* (Mt 21:33–41; Mk 12:1–12; Lk 20:9–19). Having planted a vineyard and built a wine vat and watchtower, a landowner leased the property to a tenant. During the harvest, the landowner sent a servant to collect the fruit of the harvest. The tenant beat the servant, who returned to the landowner empty-handed. The same occurred with the other two servants the landowner sent. In desperation, he sent his son to collect his portion of the harvest. In violation of the laws of hospitality and respect, the tenant killed the son with the hope of garnering his inheritance. The landowner then killed the tenant, and found another to tender the vineyard and give him the fruit of the harvest. 30. *Wedding Banquet* (Mt 22:1–14; Lk 14:15–24). In preparation for his son's wedding ceremony and feast, a *king sent his servants to summon the invited guests who would not appear. At the king's command, the servants went a second time to each guest. The king then sent his army to destroy all these invited guests and their homes. Deciding these guests unworthy of his invitation, the king sent his servants to find worthy guests. Bringing together as many persons as they could, the servants had hoped to please their master. Unfortunately, one guest appeared in ordinary clothes and when queried about his dress by the king made no reply. In righteous anger, the king had this guest bound and thrown into the darkness, for many were called but few were chosen. 31. *Fig Tree* (Mt 24:32–35; Mk 13:28–31; Lk 21:29–33). When the *fig tree, as all other non-evergreen trees, began to bud leaves, the summer was at hand, so also was the Kingdom of God. 32. *Ten Bridesmaids* (Mt 25:1–13). The ten bridesmaids who retired for the night with their lamps awaiting the bridegroom were like the Kingdom of Heaven. When the bridegroom arrived at midnight, the five bridesmaids who had wisely filled their lamps with oil rose and lit them, while the other five bridesmaids who were foolishly unprepared begged for oil to light their lamps. As the wise bridesmaids had no oil to spare, the foolish bridesmaids went in search of oil at midnight. The bridegroom came and went with the wise bridesmaids, and shut the bedroom *door. The foolish bridesmaids arrived some time later and knocked, but the bridegroom responded that he didn't know them. 33. *Talents* (Mt 25:14–19; Lk 19:11–27). When a frugal and unpopular nobleman traveled to a foreign place to inherit a kingdom, he left each of his servants some money. After he returned, he wondered how each servant fared with the money. The first servant answered that he had multiplied the money tenfold and was rewarded with authority over ten cities. The second servant who had gained fivefold was given authority over five cities. The third servant, however, had feared the master and cared for the original pound with his life. He rebuked his master for seeking profit without work. The noble-

man reprimanded the third servant for not investing the money on his master's behalf, and gave the one pound to the first servant who had invested wisely. For everyone had been given something, Jesus explained, but only from he who had nothing was everything taken away. 34. *Judgment of the Nations* (Mt 25:31–46). At the proper moment, all nations shall stand before the *Messiah in *heaven, where he will separate the righteous from the damned just as the shepherd separated the sheep from the *goats. 35. *Faithful or Unfaithful Steward* (Mt 24:45–51; Lk 12:41–48). The steward who respected his master during his absence would be rewarded, while the steward who took advantage of his master during his absence would be punished severely.

Paradise. From the Persian for "garden." Originally an enclosed park or pleasure *garden. This idealized garden of great physical beauty as the eternal dwelling place for the righteous became a standard in Christian art for *heaven and the *Garden of Eden, especially in those representations of the *Expulsion from the Garden (*see* under Adam).

Partridge. An avian symbol for deceit, theft, and the *Devil (Jer 17:11). In certain contexts, the partridge denoted the truth of *Jesus Christ.

Passion of Jesus Christ. Scriptural events prior to the *Crucifixion of Jesus Christ. In this specialized context, the word "passion" referred to Jesus' sufferings. Representations of the Passion of Jesus, both as a narra-

tive cycle of images related to the liturgical services of *Holy Week and as individual images were popular in Christian art since the fourth century. *See also* Entry into Jerusalem, Cleansing of the Temple (or Expulsion from the Temple), Washing the Feet of the Apostles, Last Supper (or Lord's Supper), Agony in the Garden (or Garden at Gethsemane), Betrayal by Judas, Trial of Jesus Christ Before the High Priests Annas and Caiphas, Trial of Jesus Christ Before Pontius Pilate, Flagellation, Crowning with Thorns, Mocking of Jesus Christ, Road to Calvary, Crucifixion of Jesus Christ, Denial of Peter, Deposition (Descent from the Cross), Entombment of Jesus Christ, and Guarded Tomb.

Passover. *See* Moses.

Paten. A symbol for the *Last Supper. This shallow, circular metal dish was used to serve the eucharistic *bread.

Patrick, Saint (c. 385–461). Son of a Roman official and a convert to Christianity while in servitude in Ireland. Escaping to Gaul, Patrick studied theology under *Martin of Tours and received his vocation to preach to the heathen in Ireland. Establishing *churches, and a *cathedral and monastery at Armagh, Patrick awed King Loigaire by igniting the Paschal Fire. Many legends arose about Patrick, including his use of the *shamrock to explain the *Trinity to King Loigaire, and the *box he built to trap the *snakes and expel them from Ireland forever. Patrick was the patron of Ireland. In Christian art, he was de-

picted dressed as a bishop and holding a *crosier, shamrock, and snake(s).

Patrons. *See* Donors.

Paul, Saint and Apostle (d. c. 67). Apostle to the Gentiles. Born into a prosperous Jewish Diaspora family in Tarsus, Paul was originally named Saul. As a Pharisee and a Roman citizen, he was trained in languages, philosophy, and law. *Martyrdom of Stephen* (Acts 7:54–60): Saul was a supposedly member of a group that persecuted Christians as blasphemers. He stood by at the stoning of *Stephen, the first *deacon and *martyr of Christianity. *Conversion* (Acts 9:1–9): Saul was on his way to persecute Christians in Damascus when he was thrown from his *horse and temporarily blinded by a great *light. A voice emerged from this light asking Saul why he persecuted *Christ. This dramatic moment was a favorite topic of renaissance and baroque artists, who represented Saul laying on the ground blinded by the light as his horse stood by calmly. *Restoration of Sight and Baptism* (Acts 9:10–19): Ananias, a Christian, visited the blinded Saul as he rested in Damascus. Ananias healed Saul's blindness (a consistent *New Testament metaphor for spiritual illumination) and baptized him with the name Paul, meaning "short." *Mission and Miracles:* Paul became the great Christian missionary, and was noted for his *healings. For example, the Healing of Elymas the Sorcerer (Acts 13:6–12) and the Curing of the Paralytic at Lystra (Acts 14:8–18) were depicted in *byzantine and *medieval art. *Imprisonment at Philippi* (Acts 16:16–

40): Paul was visited by an *angel who reassured him in his Christian faith, and then released the *apostle to continue his preaching to the Gentiles. *Preaching at the Areopagus* (Acts 17:16–34): Paul's most famous sermon, in which he identified the "Unknown God" was a popular topic in medieval and *renaissance art, as was the *Conversion of the Magicians at Ephesus* and *Burning of the Books* (Acts 19:19–20). *Execution:* As a Roman citizen, Paul was permitted to request a hearing before the emperor. Once Nero condemned him to death, Paul was allowed the privilege of decapitation (thus setting the model for later Christian martyrdoms). According to tradition, *milk—not *blood—flowed from the decapitated body of Paul as his *head bounced three times (in honor of the *Trinity) and three *fountains sprang up on these spots (Tre Fontane). In Christian art, Paul was depicted as a physically small but stocky man with a balding head, short dark *beard, and hooked nose. In *baroque art, he was represented like the other patriarchs—a tall man with long flowing white *hair and beard. His *attributes included an inverted *sword and a *book (or *scrolls) symbolic of his Epistles. In early Christian and *byzantine art, he was depicted in the legendary topic of the *Traditio Legis* (or "Giving of the Law"), in which he represented the Church of the Gentiles and *Peter the Church of the Circumcision. The two apostles were placed to the left and right of the Resurrected Christ who gave the law to the church. In the earliest Christian depictions of this topic, Christ handed the law to Paul as Peter made

134. Domenico di Bartolo, *Madonna and Child
Enthroned with Saint Peter and Saint Paul.*
135. Michelangelo Buonarroti, *Vatican Pietà.*

136. Bartolomé Esteban Murillo, *The Return of the Prodigal Son.*

a gesture of acclamation. After the fifth century, however, Peter received the law while Paul acclaimed him. Given his emphasis on the theme of "justification by faith," Paul became the ideal teacher of the Protestant Reformers and his *iconography was downplayed by Counter-Reformation artists except for the theme of his "Ecstatic Vision" (2 Cor 12:1–4).

Paul the Hermit, Saint (c. 229–347). Traditionally, the first *desert hermit in Egypt. According to legend, he spent over ninety years in meditation and prayer in the Egyptian desert. During that time Paul resided near a *well and a date *palm, while a *raven visited him daily with half-a-loaf of *bread. Eventually, he was discovered by *Anthony the Abbot and the two men lived together until Paul's death. Anthony buried the dead hermit with the aid of two *lions. Paul the Hermit was identified by *Jerome, his biographer, as the "founder of the monastic life." In Christian art, Paul the Hermit was depicted as a haggard old man with long, flowing white *hair and *beard, and occasionally was clothed in palm leaves. His *attributes included the raven and two lions.

Peach. A fruit *symbol for virtue, especially *charity. In the hands of the Christ Child, a peach signified salvation.

Peacock. An avian symbol for immortality from the legend that its flesh never decayed, while its tail's ability to perpetually renew itself represented the *Resurrection of Jesus Christ. As a symbol of resurrection, the peacock was included in represen-

tations of the *Nativity of Jesus Christ. According to the *Physiologus, whoever ate an entire peacock by himself or herself would live forever (*Augustine reportedly tried three times to do so but failed). The many *eyes on the peacock's tail represented either God's (or Christ's) ability to see all or vanity. Following tradition, the screeching of the peacock represented the pitiful cries of the Christian in need of God. The strutting and preening of the peacock was interpreted as a self-conscious display of a vain and narcissistic nature. Thereby, the peacock signified vanity and hubris, and in northern *medieval and *renaissance art was a symbol of the *Devil. The peacock was also an *attribute of *Barbara.

Pear. A *fruit symbol for the *Incarnation of *Christ, or of his love for humanity.

Pearl. A classical Greco-Roman symbol for the goddess of love and beauty, Venus, born of seafoam and carried to shore on an oyster *shell. As the "tears of the oyster," the pearl was a symbol of sorrow but also a precious and rare jewel. According to the *New Testament, pearls signified the Word of God (Mt 7:6), and represented purity and spiritual wealth (Mt 13:45). As a symbol of purity, spiritual wealth, sorrow, and tears, the pearl became associated with *Mary in *medieval art. Pearls, especially a pearl tiara or diadem, were an *attribute of *Margaret of Cortona.

Pearl of Great Value. *See* Parables.

Pelican. An avian symbol for God the Father and the crucified Jesus. Ac-

cording to tradition, baby pelicans violently flapped their *wings in their parents's faces, so that out of fear the father killed them. The mother pelican then pierced her *breast and revived her dead children with her *blood. The pelican symbolized God the Father, who in anger punished his children and then repented and forgave them. The *Physiologus recounted the devotion of the mother pelican who pierced her breast to feed her young with her own blood. The pelican thereby symbolized both the sacrifice of Jesus Christ and the *Eucharist. In *medieval and *renaissance art, the image of the mother pelican piercing her breast (with a nest of hungry young pelicans) was to be placed atop or near the *cross in representations of the *Crucifixion of Jesus Christ.

Pen. Instrument of authorship. The pen (or quill) was an *attribute of any (or all) of the four *Evangelists, *Doctors of the Church, or Christian theologians and writers.

Pentagram. A five-pointed, star-shaped form signifying either the followers of Pythagoras in classical Mediterranean culture or magicians in *medieval culture. The pentagram was used as an amulet to ward off sorcery. In Christian art, the pentagram signified either protection from the *Devil or the five wounds Jesus received on the cross.

Pentecost. From the Greek for the "fiftieth day." Originally the Jewish "Feast of Weeks," held fifty days after *Passover to commemorate the Giving of the Law to *Moses on Mount Sinai. In the Christian tradition, Pentecost commemorated the gathering of the eleven *apostles and *Mary on the fiftieth day after the Resurrection. The *Holy Spirit descended to illumine each of the apostles with the gift of languages which allowed them proclaim the kerygma throughout the world. Celebrated fifty days after *Easter and ten days after the *Ascension of Jesus Christ, Pentecost was interpreted as the foundation of the *church. In Christian art, Pentecost was signified by the flaming tongues of inspiration (and of languages) just above the *heads of each of the seated eleven apostles and *Mary while the *dove of the Holy Spirit hovered overhead. A popular image in *byzantine and *medieval art, Pentecost was rarely represented after the early Renaissance. The signification and interpretation of this event in Christian art was measured by the physical size and placement of Mary, whose eventual identification as *Mater Ecclesia* and as the intercessor resulted in her increased physical stature (until she dominated the scene) and was placed at the center of the group of apostles.

Peony. Floral symbol identified as the "rose-without-thorns," and thereby an attribute of *Mary in medieval Christian art.

Peppermint. An aromatic, herbal flower with medicinal properties symbolic of *Mary.

Periwinkle. Symbol for eternal life and fidelity. This evergreen plant with blue flowers signified protection from *witches and magicians.

Persephone. Daughter of the Greek goddess *Demeter (Roman *Ceres).

Peter, Saint and Apostle (d. c. 64). The fisherman originally identified as Simon, the leader of the twelve apostles, and one of Jesus' inner *circle. Peter was represented within the narrative context of Jesus life and ministry: *Miraculous Draught of Fishes, *Stilling of the Water (or *Navicella*), *Transfiguration of Jesus Christ, *Tribute Money, *Entry into Jerusalem, *Last Supper, *Agony in the Garden, *Betrayal by Judas, *Crucifixion of Jesus Christ, *Ascension of Jesus Christ, and *Pentecost. *Calling of the First Apostles* (Mk 1:16–18): Simon and his brother Andrew, both fishermen, were the first apostles called by Jesus to follow him and become "fishers of men." *Charge to Peter* (Mt 16:18–19): Cognizant of Simon's special gifts, Jesus called him "Peter" (from the Greek and Latin for "rock") and identified him as the first of the apostles, the foundation of the *church, and the keeper of the *keys. This scriptural passage was the foundation for the Primacy of Peter as an office, claimed by the bishop of Rome. In Christian art, the *iconography of this topos developed after the fifteenth century and became a visual defense of the Papacy against the criticisms of the Protestant Reformers. Peter was depicted either kneeling or standing before Jesus, who offered him a blessing and the keys. In early Christian and *byzantine art, the *iconography of the *Traditio Legis* fused with that of the Primacy of Peter. *Washing the Feet of the Apostles* (Jn 13:4–17): Peter objected to this act of humility and re-

spect when his turn came. Jesus insisted and proceeded to wash the *feet of the remorseful Peter. This motif was either included within the context of the theme of the Washing the Feet of the Apostles or treated as a separate topic, especially after the fifteenth century. *Denial of Peter* (Mt 26:69–75; Mk 14:66–72; Lk 22:54–62; Jn 18:15–18, 25–27): As Jesus predicted, Peter denied any relationship with the man from Nazareth three times before the *cock crowed on the morning following the betrayal and arrest. The *iconography of the Denial of Peter, which was dramatically represented as night scene, was especially popular as an independent topic during the Reformation and *Counter-Reformation period, and gave rise to the devotional image of "Peter in Tears" (or the "Repentant Peter"). Two scenes from Peter's own ministry were represented in Christian art: *Baptism of the Centurion Cornelius* (Acts 10:1–33) and *Peter's Release from Prison* (Acts 12:1–11). Several legendary images of Peter became popular in Christian art and devotions: the Fall of Simon Magus (*The *Golden Legend*); Resurrection of Petronilia (*The Golden Legend*); *Domine Quo Vadis* (*The Golden Legend*); and his upside-down crucifixion. Peter was the patron of fishermen and penitents. In Christian art, he was depicted as an aged, physically strong but balding man with a long, flowing white *beard. He was represented in a *yellow mantle signifying both his Denial of Jesus and his revealed faith. In early Christian and *byzantine art, he was depicted in the legendary topic of the *Traditio Legis* (or "Giving of the Law"), in which he

signified the Church of the Circumcision and Paul the Church of the Gentiles. They were placed to the left and right of the Resurrected Christ, who gave the law to the Church. In the earliest artistic depictions of this topic, Christ handed the law to Paul while Peter made a gesture of acclamation, but after the fifth century Peter received the law and Paul acclaimed him. After the fifteenth century, devotional images of Peter as one of the four Penitential Saints (the others were *David, *Mary Magdalene, and *Jerome) depicted him dressed in papal vesture and in tears. His *attributes included the *keys of heaven, a *fish, a cock, *chains, a *book or *scroll, a *palm, and a *sword.

Peter Martyr, Saint (1206–1252). Renowned for his eloquent and effective preaching as Inquisitor General (an office for the persecution of heresy), was a successful advocate for the authenticity of the *church against the Albigensian heresy. This *Dominican was murdered by two assassins hired by the Catharists (Albingensians). Peter Martyr was the *patron of Verona, inquisitors, and midwives. In Christian art, he was represented as being dressed in a Dominican *habit and carrying a *palm and a *cross, with either a *hatchet in his head or a *knife in his chest.

Petronius, Saint (d. c. 450). A noble Roman by birth who converted to Christianity, Petronius eventually became bishop of Bologna. A devout Christian, he was famed for building the Church of Santo Stefano. A *patron of Bologna, Petronius was grouped with the other patrons of the city, *Francis of Assisi and *Dominic, with the *Madonna and Child. In Christian art, he was depicted as being dressed in episcopal attire with a model of the city of Bologna in his hands.

Pharisee and the Tax Collector, The. *See* Parables.

Pheasant. An avian symbol for fidelity and monogamy in marriage. In scenes of the *Nativity of Jesus Christ, two pheasants signified the sacrament of marriage.

Philemon and Baucis. According to Ovid's *Metamorphosis* (8:621–96), this peasant couple extended hospitality to a disguised *Jupiter and *Mercury. In return for their exemplary act, they were rewarded with a never-emptied wine jug, and were spared the sorrow of each other's death by being transformed into intertwined *elm and *oak *trees. A popular topic in *medieval, *renaissance, and *baroque art, Philemon and Baucis were interpreted as foretypes of the Philoxeny of *Abraham, *Last Supper, and the *Supper at Emmaus.

Philip, Saint and Apostle (first century). Fisherman who was one of the first called apostles. A participant at the Multiplication of *Loaves and Fishes (John 6:5) and *Last Supper (John 14:9), he returned to *Jerusalem after the *Ascension of Jesus Christ (Acts 1:13). According to tradition, Philip was a missionary to Syria and Greece. Reportedly, he used a *cross to banish a *serpent (or *dragon) which became the object of

cult worship in the Temple of Ares. He was seized by the priests of that cult, and crucified upside down in Hierapolis. In Christian art, Philip was depicted as a bearded, middle-aged man. His *attributes included a cross fastened to a *staff, a *dragon or *serpent, a *palm, and the *loaves and fishes.

Philosopher-Teacher, Jesus Christ as. One of the earliest anthropomorphic symbols for *Jesus Christ in Christian art. Assimilated from classical Greco-Roman art, Jesus Christ was depicted as a fully-clothed male figure, usually seated reading a *scroll or making the gestures of teaching. A *basket of rolled scrolls, occasionally with several unrolled scrolls on the ground, identified this individual as a Philosopher-Teacher. Since Jesus Christ's teachings were the fulfillment of both the *Old Testament and classical Greco-Roman learning, he became identified as *the* Philosopher-Teacher. Popular in Christian art, including *catacomb *frescoes and *sarcophagi, into the middle of the fourth century, this image of Christ as Philosopher-Teacher was replaced by the image of Christ as the Enthroned Emperor or *Pantocrator.

Phoenix. Mythical bird of extraordinary beauty, composed of a *pheasant's *head and an eagle's body, which had a reputed life span of three-hundred-fifty years in the Arabian wilderness. Whenever it felt either old or its beauty waning, the phoenix burned itself upon a funeral pyre. In its *ashes was a small worm which in three days grew into a new youthful phoenix. The classical Mediterranean legend and image of the phoenix was assimilated into Christian art, especially early Christian funerary art, as a symbol of the *Resurrection of Jesus Christ. Clement of Alexandria provided a Christian gloss of the legend of the phoenix in his First Epistle to the Corinthians. The phoenix remained a popular symbol in *byzantine and *medieval art.

Physiologus. From the Greek for "discourse of nature." A third-century Alexandrian anthology of curious and idiosyncratic stories about real and mythical animals. The anonymous "naturalist" who compiled this text drew upon the natural histories of Aristotle, Pliny, and other classical sources. Each story was constructed as a moral allegory and was assimilated into early Christian art and spirituality as symbols for Jesus as the Christ. In terms of Christian art, the symbolic importance of the *Physiologus* was revived in the middle ages as the foundation for the medieval *bestiaries.

Pietà. From the Italian for "pity" or "compassion." This devotional variant of the *Lamentation was the representation of *Mary mourning her dead son. Without any scriptural foundation, this motif developed in twelfth-century *byzantine art as a liturgical icon. As the *Vesperbild,* this motif of the mourning mother and her dead son developed in German art at the end of the thirteenth century and was related to the devotionalism of the Vespers for Good Friday. The *iconography of the Pietà traveled from German art into French art, and then into early fifteenth-century Ital-

ian art where it reached its artistic and spiritual fullness in the art of *Michelangelo Buonarroti.

Pig. A symbol for lust and gluttony. The pig was an *attribute of *Anthony the Abbot.

Pilgrim. Personification of earthly life as a transition to spiritual life. This believer or devotee of a religious tradition undertook a journey (pilgrimage) to a sacred place or shrine out of a religious devotion or in search of spiritual renewal, a miraculous cure, a vision, or in fulfillment of a religious vow. In Christian art, pilgrims were identified by their common *attributes of a *staff, a *wallet, a *scallop shell, a *gourd, and occasionally a broad-brimmed *hat.

Pilgrimage. Activity of earthly life symbolic of the transition to spiritual life. This often arduous journey was undertaken by a believer or devotee of a religious tradition to a sacred place or shrine to fulfill a religious vow or obligation, or spiritual devotion, to worship, or for a miraculous cure or spiritual vision. The Christian practice of pilgrimage reached its height during the Middle Ages. *Pilgrims and pilgrimage *saints were popular motifs in *medieval art.

Pillar (or **Column**). A symbol for multiple associations—steadfastness, spiritual fortitude, God, and flagellation—in Christian art. Pillars of cloud and of fire led the *Hebrews out of Egypt (Ex 13:21–2). The blinded but physically renewed *Samson knocked down the pillars of the Philistine Temple (Jgs 16:23–31). The

pillar was an *Instrument of the Passion and signified the *Flagellation. According to the *Meditations on the Life of Christ, *Mary rested against a pillar during the birth of Jesus. The pillar was an *attribute of *Sebastian and Simon Stiletes.

Pincers (or **Shears**). An *attribute of *Agatha, *Apollonia, and Dunstan.

Pine. A symbol for strength of character, solitude, and vitality. This evergreen *tree was an allusion to the *Tree of Life.

Pitcher. A container for *water and a symbol for cleansing. A pitcher with a *washbasin and *towel was included in representations of the *Annunciation (to Mary) as a sign of her perpetual virginity. A pitcher or small flask was employed by *John the Baptist to baptize Jesus in northern *medieval and *renaissance art.

Plague Spot. An *attribute of *Roch.

Plane. See Carpenter's Plane.

Plane Tree. Mythological symbol for moral superiority, strength of character, and generosity. In Christian art, the plane tree was a symbol for *Jesus Christ.

Plantain (or **Way Bread**). A low-growing *plant common to the sides of roads and paths, plantain symbolized the common road used by the multitudes in search of *Christ.

Plants, symbolism of. Botanical symbols for the cycle of life, death, and resurrection as found in the natural

order. As part of the produce of the earth, plants as *fruits, *flowers, and *vegetables, contained the seeds for each new and successive generation. As a generic symbol, plants indicated the productive energies of nature. In Christian art, a grouping of plants was purely decorative while a specific plant was an integral element of the theological intent of the image; for example, hyssop signified *baptism and repentance. *See also* Acanthus, Aloe, Bramble, Bulrush, Clover, Dandelion, Fern, Hawthorn, Hyssop, Ilex, Ivy, Jasmine, Lady's Mantle, Lavender, Myrtle, Peppermint, Plantain, Reed, Sage, Tansy, Thistle, and Vine.

Plum. A botanical symbol for independence and fidelity.

Pluto. The ruler of the underworld in Greek mythology, famed for his roles in the abduction of *Persephone (the mythical explanation for the cycle of the seasons) and the story of *Orpheus and Eurydice. Pluto was the ruler of the area of Hades known as Tartarus where the wicked were tormented for eternity. In classical Greco-Roman and *renaissance art, he was depicted as a physically large and muscular man with a powerful, naked torso, and short dark *hair and *beard. He was the classical Roman foretype for images of the *Devil, *Satan, and *Lucifer.

Pole. A fuller's pole signified *James Minor.

Polyptych. An *altarpiece composed of one large central panel and several smaller but movable side panels or wings which revealed a series of iconographic topics relating to specific liturgical or devotional services.

Pomegranate. A classical Mediterranean symbol for fertility, immortality, and resurrection. Due to its abundance of seeds and red juice, the pomegranate was used in Greek mythology to explain the cycle of the seasons. A common symbol in Christian art, this red fruit had several meanings. In the *hands of the Christ Child, the pomegranate signified either the *Resurrection of Jesus Christ or the *church. *Gregory the Great identified it as the sign of the unity of all Christians. In the hands of *Mary, the pomegranate represented the totality and unity of the Christian Church. An open pomegranate's seeds and red juice symbolized the general resurrection when all the tombs of the dead will be opened. The pomegranate was one of the fruits of the Promised Land (Dt 8:8). *See also* Demeter.

Pontius Pilate (first century). Roman Procurator of Judea identified in the *Gospels as finding Jesus innocent of the charges of treason, washing his hands of the death of this innocent man, and releasing him to the mob with a troop of Roman soldiers to oversee his crucifixion on charges of blasphemy by the Sanhedrin. According to various traditions, Pilate either was brought to trial and executed in Rome, committed suicide in Switzerland, or converted to Christianity and was martyred under Nero. In Christian art, Pontius Pilate was depicted as a middle-aged man in a Roman toga or royal garments.

Poppy. Floral symbol for the *Passion of Jesus Christ.

Poseidon. God of the *sea and earthquakes in Greek mythology, who created and domesticated *horses, effected storms, and instigated shipwrecks. In classical Greco-Roman and *renaissance art, Poseidon was depicted as a physically powerful and muscular man with thick, curly *hair and *beard. Either nude or dressed in flowing wavelike robes, Poseidon held a trident and was accompanied by a *horse, *dolphin, or *pine tree. He was the classical Greek foretype for the anthropomorphic images of God the Father in Christian art.

Potiphar's Wife (Gn 39:1–22). Egyptian woman who unjustly accused the innocent *Joseph of assault with intent to rape. The sincerity of her false witness and the evidence of Joseph's *cloak in her bedroom convinced her husband, Joseph's master and head of Pharaoh's bodyguards, of the Hebrew's guilt. Joseph remained silent in his own defense, and was imprisoned for his "crime." In Christian art, the theme of Joseph and Potiphar's Wife prefigured the chastity of *Joseph (of Nazareth) in his marriage to *Mary.

Predella. From the Italian for "kneeling stool." A thin strip of paintings along the lower (or base) edge of an *altarpiece upon which were depicted narrative scenes from the life (or lives) of the *saint(s) represented in the altarpiece's central panels.

Pre-Raphaelite Brotherhood (PRB). A group of youthful English painters who, influenced by the model of the *Nazarenes, sought to emulate the Christian art (and communal life) of the time before *Raphael Sanzio. Established in 1848, the PRB was dedicated to serious religious subject matter, highly elaborate symbolism, fresh *iconography, and "truth to nature." Initially, they sought to reaffirm (and live by) the medieval synthesis of religion and art. The leading painters of the Pre-Raphaelite Brotherhood— *William Holman Hunt, John Everett Millais, and *Dante Gabriel Rossetti—received initial support from the critic John Ruskin.

Presentation of Jesus of Nazareth in the Temple (Lk 2:22–38). This scriptural event signified the dedication (not the circumcision) and "buying back" of the first-born male infant to God in the Temple following the Mosaic law (Ex 13:2). In accord with Jewish practice, five shekels were offered to God as the redemption price when the forty-day-old infant was presented to him (Nm 8:17; Lv 12:1–8). Both Christian art and scripture fused the presentation of the child with the purification of the mother, at which two *turtledoves were offered to God. The pious and blind Simeon was promised by God that he would live to see the *Messiah, and his blindness was cured when he "saw" the infant Jesus, whom he proceeded to carry into the Temple as a sign of his messiahship. The aged prophetess Anna also witnessed that Jesus was the Messiah and praised God. Representations of this theme in Christian art were rare before the eighth century; the earliest images represented the five major figures—the infant Jesus, Simeon,

Anna, *Mary, and *Joseph (of Nazareth) (holding two turtledoves)—within an ecclesiastical setting. Through the thirteenth century, the visual emphasis was on the manifestation of the child's divinity through the acclamations of Simeon and Anna. Late medieval artists began to emphasize the theme of the Purification of the Virgin Mary by depicting her as the physically dominant figure in the foreground, where she knelt with two turtledoves in a basket, and Simeon, Anna, and the infant Jesus in the background. Baroque artists retrieved the earlier *iconography of this theme as an epiphany in the encounter between the infant Jesus and Simeon.

Presentation of the Virgin Mary in the Temple. (*Protoevangelium of James* and *The Golden Legend*). At the age of three, *Mary was dedicated formally to God's service by her parents. She was brought to the Temple to live and serve God until the age of twelve or fourteen, when she would be married. Although a part of the narrative cycle of the life of Mary, the theme of the Presentation of the Virgin Mary in the Temple developed as an independent topic in fourteenth-century western art. In the foreground of the composition, *Anne and *Joachim watched as their small daughter walked the fifteen steps into the Temple where the High Priests waited to receive her into their care. Following *Flavius Josephus's report in his *History of the Jewish War*, there were fifteen steps from the Court of the Women to the High Temple of Jerusalem. According to The *Golden Legend, little Mary danced joyously as she approached the Temple; some

fourteenth- and fifteenth-century artists suggested this celebration by displaying her feet or allowing a billowing of her garments. In accord with the new devotionalism of the Counter-Reformation Church, baroque artists began to represent Mary kneeling before either the Temple steps or the High Priests.

Prie-Dieu. A kneeler or kneeling desk upon which *Psalters, prayer books, or *Books of Hours were placed during private devotions. In *medieval art, the Virgin Annunciate was represented at a prie-dieu.

Primrose (or Keys of Heaven). A floral symbol for purity and youth. The primrose was an *attribute of *Peter as the "keys of heaven."

Prodigal Son (Lk 15:11–32). Initially included in the cycle of the *Parables, the Prodigal Son became an independent and popular topic in thirteenth-century Christian art and flourished later in northern *baroque art. As a story of a repentant sinner, the Prodigal Son paralleled the four great Penitential Saints (*David, *Peter, *Mary Magdalene, and *Jerome).

Prophets. The inspired religious messengers of Israel in the *Old Testament who sought to purify and reform the people through their revelations, visions, and conversations with God. The four major prophets of Israel (Isaiah, *Jeremiah, *Daniel, and *Ezekiel) prefigured the four *Evangelists. In Christian art, the prophets were idealized male figures of majesty and dignity with long flowing *hair and *beards, dressed in

long flowing garments, and carrying *scrolls (except for the prophet Jonah who was accompanied by the *whale or sea *monster). From the fifteenth century, the pairing of the Old Testament prophets with the classical *Sibyls became a common motif in Christian art.

Protestantism. This theological and ecclesiastical movement separated from the Church of Rome in the sixteenth century primarily over the issues of the unique authority of the *Bible, justification by faith alone, and the rejection of papal authority. Protestantism emphasized the preaching and hearing of the Word, and lessened the role of the visual image except for religious pedagogy. The Protestant traditions have generally been regarded as iconoclastic for their denial of the devotional and sacramental aspects of Christian art, the minimalization of liturgical art, and their emphasis on poetry and music in worship.

Psalter (or **Book of Psalms**). A liturgical book which was used for private devotions. A popular prayer book for the laity during the medieval period, a Psalter contained an illuminated calendar as well as prayers. *See also* Book of Hours.

Public Ministry of Jesus Christ. These events continued the chronology of the life of *Jesus Christ, and include the public pronouncements and teachings of his mission. The parallels between his life and those of his *Old Testament foretypes were highlighted by the church fathers and Christian artists. Several of these

events were popular throughout the history of Christian art. *See also* Baptism of Jesus Christ, Temptation in the Wilderness, The Calling of the Apostles, Feast in the House of Levi, Sermon on the Mount, Anointing at Bethany, Woman of Samaria, Transfiguration of Jesus Christ, Tribute Money, Blessing the Little Children, Woman Taken in Adultery, and Feast in the House of Simon.

Purification of the Virgin Mary. *See* Presentation of Jesus Christ in the Temple.

Purple. A color which signified a variety of meanings: royalty, power, passion, suffering, and love of truth. Purple garments were worn by God the Father as a sign of his royal and powerful status, or by *Mary Magdalene as a sign of her penitence and her suffering during the *Passion of Jesus Christ, and by *Mary as a symbol of her compassion during her son's Passion.

Purse. An ambiguous symbol for either avarice, *charity, or wealth. An *attribute of *Judas Iscariot, the purse also signified those saints known for their charitable acts, such as *Nicholas of Tolentino and *Elizabeth of Hungary. Three purses identified *Nicholas (of Myra or Bari).

Putti. These depictions of naked children with *wings signified innocence in classical Greco-Roman art. Putti were incorporated into early Christian art as *angels. In *byzantine and *medieval art, angels were more often than not represented by adult figures. The image of the angelic putti re-

turned with the renaissance interest in classical Greco-Roman art, and flourished in *baroque and *rococo art.

Pyx. A boxlike container used to store the Host or to distribute the *Eucharist to the infirm and the elderly. The pyx was an *attribute of *Clare, *Longinus, and *Raphael the *Archangel.

Quail. An avian symbol of lasciviousness, evil, and the *Devil in Christian art.

Queen of Sheba. An *Old Testament foretype of *Mary whose gifts to *Solomon prefigured the *Adoration of the Magi and whose equality with Solomon signified the *Coronation of the Virgin Mary. The Queen of Sheba also denoted paganism recognizing Christianity as suggested by *Flavius Josephus's *Antiquities* (VI.5).

Quince. Yellow pear-shaped *fruit sacred to *Venus and a classical Greco-Roman symbol for marriage and fertility. In *medieval art, a quince held in the *hand of the Christ Child was a fruit of salvation.

R

Rabbit. An animal symbol for fecundity, lust, and timidity, and an attribute of *Venus. In the *hands of *Mary or the Christ Child, the *white *rabbit represented the triumph of chastity over lust.

Rachel. Beloved wife of *Jacob, the mother of *Joseph, one of the matriarchs of Israel, and a foretype of *Mary. She hid the "family gods" under her saddle at the departure for Canaan with Jacob and her sons, thereby prefiguring Mary on the *Flight into Egypt. In Christian art, Rachel was included in narrative paintings of the life of Jacob or Joseph, most especially in the departure for Canaan.

Rainbow. Meteorological symbol for God's peace. Following the Flood which destroyed the world, God told *Noah that the rainbow was the sign of his new covenant with the *earth (Gn 9:8–17). The *wings of the *Archangel *Gabriel contained a rainbow motif in representations of the *Annunciation to Mary, and the *throne of God the Father, *Jesus Christ, or *Mary in scenes of the *Last Judgment and the *Coronation of the Virgin Mary.

Ram. An animal symbol for male sexual energy and power. In the *Old Testament, the ram was a sacrificial animal and was substituted for Isaac (Gn 22:13). In Christian art, the ram symbolized the leadership of *Jesus Christ, while the image of the ram with the *wolf denoted the eternal struggle between God and the *Devil for Christian souls.

Raphael Sanzio (Raffaello) (1483–1520). One of the three great masters of the High Renaissance. A student of Perugino, Raphael creatively merged the innovations of *Leonardo da Vinci and *Michelangelo Buonarroti into a distinctive and perhaps more immediately palatable style. His interest in superhuman naturalism and spiritual sentiment led to an artistic style that epitomized monumentality

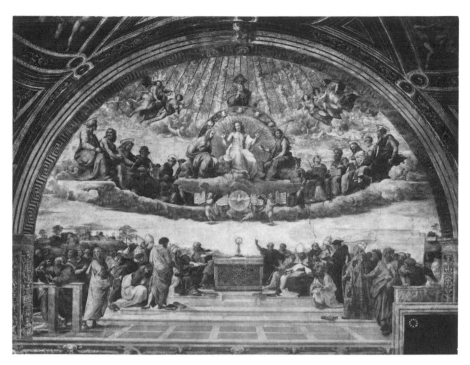

137. Raphael Sanzio, *The Disputation of the Sacrament.*

138. Rembrandt van Rijn, *Jacob's Blessing.*

and devotionalism without sentimentality, as in his *Disputation Concerning the Blessed Sacrament*. Raphael was renowned for his representations of the *Madonna as an individualized ideal figure, as in his *Sistine Madonna*.

Raphael, Archangel and Saint.

From the Hebrew for "God heals." The paradigm for the *guardian angel. In the *Old Testament, Raphael watched over *Tobias throughout his travels and assisted in the cure of his father's blindness. In the *New Testament, Raphael announced the *Nativity of Jesus Christ to the shepherds (Lk 2:10–11), and was identified in the Christian tradition as the guardian angel. Raphael the Archangel was the protector of the young, *pilgrims, and travelers. In Christian art, he was depicted as a muscular and winged young man dressed in elegant robes with a gold belt crossing his shoulder and chest and carrying a *sword. His *attributes included a *fish, a *staff, *sandals, and a *gourd.

Rat. An animal symbol for destructiveness and evil. The rat was an attribute of Fina. *See also* Mouse.

Raven. An ambiguous symbol for evil or spiritual blessings in Christian art. Its *black plumage and practice of scavenging identified the raven with evil and death, thereby making it a sign of the *Devil or an omen of death. According to Jewish legend, the *white raven turned black as punishment for its failure to return immediately to the Ark after *Noah dispatched it as a test for the ebbing of the Flood. Like many Christian hermit saints, the Old Testament prophet

*Elijah was miraculously fed by a raven in the *desert. The raven was an *attribute of *deacons, *Onuphrius, *Anthony the Abbot, *Paul the Hermit, *Benedict of Nursia, *Vincent of Saragossa, Meinrad, and Black Madonna of Einsiedeln.

Rebecca. Wife of *Isaac and mother of *Jacob and Esau, one of the matriarchs of Israel, and a foretype of *Mary. *Rebecca at the Well* (Gn 24): As the time approached for Jacob to be married, his father's servant Eliezer was sent to the family's ancestral home in search of a suitable bride. Arriving in Aram, Eliezer went to water the camels and came upon Rebecca filling her pitcher with water. As the bride of Isaac who was found by the *well, Rebecca prefigured the *Annunciation to Mary and the *Woman of Samaria. *Birthright of Jacob and Esau* (Gn 27:1–9): In her old age, Rebecca favored her younger son, Jacob, to receive Isaac's blessing, displacing Esau, the elder son from his rightful birthright and inheritance. She conspired with Jacob to confuse her aged and blind husband as to the identity of his sons, so that he gave the birthright blessing to Jacob. Thus, she prefigured Mary as *Wisdom.

Red. The color of passion, blood, and fire. An ambiguous symbol, red signified the emotional passion and lust of *Venus, the spiritual love of *John the Evangelist, and the true love of *Mary. As a symbol for blood, red represented the life-sustaining energy of the *Eucharist, the life-giving possibility of the menstrual cycle, and the faithfulness of martyrdom. As a sign

of royalty and sovereign power, red was associated with cardinals; and in relation to the color of fire, red signified the liturgical feast of *Pentecost.

Red Cross on a White Background. A symbol of *George of Cappadocia.

Red Sea (or **Sea of Reeds**). *See* Moses.

Reed. An *Instrument of the Passion and a sign for the *Mocking of Jesus Christ (or the *Ecce Homo*). Flourishing on riverbanks, the reed symbolized the just who lived by the *waters of grace, as well as the multitudes seeking Christian *baptism. *John the Baptist often carried a small *cross made of reeds.

Reliquary. A small, ornamented *box, casket, or shrine used as a depository for sacred relics. The design motifs on the reliquary related to the nature of the relic contained therein.

Rembrandt van Rijn (1606–1669). The leading northern artist of the *baroque period. Influenced by *Michelangelo Merisi da Caravaggio and Adam Elsheimer, Rembrandt extended their interest in tenebrism and dramatic theatricality to new heights. An extraordinary portrait painter, Rembrandt was gifted in his psychological penetration of his sitters. He transferred this ability to depict psychological insight and deep emotional content into biblical subject matter. Although he lived in a Reformation country, biblical themes dominated in Rembrandt's oeuvre, and he was identified as the great Protestant painter (as evidenced by his *Prodigal*

Son). His engravings and drawings, such as his famed *Christ Preaching (The Hundred Gilder Print)*, became popular as bible illustrations. His careful readings and renderings of biblical narratives extended further the Protestant *iconography initiated by *Lucas Cranach.

Remigus, Saint. *See* Remy, Saint.

Remy, Saint (c. 438–533). *Apostle of France and learned man who sought an end to the Arian heresy. Appointed bishop of Rheims, Remy officiated at the *baptism and royal consecration of Clovis I, King of the Franks, on Easter 496. According to tradition, Clovis—like *Constantine—became a Christian after the tide of battle turned in his favor. Clovis's wife, Queen Clothilde was a devout Christian. A zealous evangelist, Remy was credited with many *miracles. In Christian art, he was depicted dressed as a bishop in the context of the Baptism of Clovis. His *attributes included a *dove and a phial of chrism.

Renaissance art. From the Italian for "rebirth." The mid-fifteenth to mid-sixteenth-century style of painting and sculpture influenced by the retrieval of interest in classical humanism and the dignity of the human person. This cultural shift towards anthropocentricism (as opposed to medieval theocentricism), permitted both a retrieval of classical Greco-Roman art and philosophy as well as an acceptance of "modern" medicine and science. Renaissance art was characterized by its concern for a classical sense of balanced compositional har-

mony, a central vanishing point, natural perspective and light, a recognition of human anatomy, and fidelity to nature.

Reparata, Saint (third century). A virgin martyr from Caesarea who was paraded naked in the streets of Palestine, tortured, and beheaded. According to legend, a *dove (signifying her *soul) came out of her mouth (or decapitated torso) and ascended into *heaven. Reparata was a patron of Florence. In Christian art, she was depicted as a young girl with a dove coming out of her mouth. Her *attributes included a dove, a *palm, a *book, and a banner of resurrection.

Reredos. A fixed *altarpiece which was attached to either the back of an *altar or in the wall directly behind an altar.

Rest on the Flight into Egypt. *See* Flight into Egypt, Rest on.

Resurrection of Jesus Christ (Mt 28:1–10; Mk 16:1–8; Lk 24:1–12; Jn 20:1–10). Scriptural event signifying the distinctive but fundamental Christian doctrine that on the third day, Jesus Christ rose alive from the dead. A popular theme in Christian art, the Resurrection included the iconographic elements of the *Guarded Tomb; an empty *tomb signified by the open coffin lid or *door; and Jesus Christ dressed in radiant *white garments, displaying his *wounds and a cruciform *nimbus, and carrying a victorious white *banner inscribed with a red cross. In the earliest Christian art, the Resurrection was represented symbolically without an an-

thropomorphic depiction of the Resurrected Christ. Rather, the empty tomb, the sleeping guards, the attendant *angel, and/or the three Marys signified this event—as did the prototypes of the *Resurrection of Lazarus or the delivery of *Jonah from the *whale. In *byzantine art, the theme of the Anastasis conflated with the Resurrection and the *Descent into Hell (or the Harrowing of Hell). In western *medieval art, the *iconography of the Resurrection was modified to include the newly risen body of Jesus Christ. Initially, this body was delicately represented in a glowing *mandorla and with a careful display of the wounds. The Risen Christ holding a triumphant banner of Resurrection was posed standing or sitting near an empty sarcophagus. By the High Middle Ages and into the Renaissance, however, the Risen Christ had a gravity-free body which floated (or exploded) from the tomb. Baroque artists' concern for the Tridentine Decrees resulted in a return to the Risen Christ seated upon or standing outside of the empty tomb.

Resurrection of Lazarus. *See* Lazarus.

Retable. From the Spanish for "altarpiece." A decorated panel attached to or set directly behind the *altar.

Return from Egypt (Mt 2:19–23). In a third dream, the *Archangel Gabriel advised *Joseph (of Nazareth) that *Herod was dead. Thus, the *Holy Family returned safely to Nazareth. *See also* Flight into Egypt.

Revelations of Saint Bridget of Sweden. The record of this fourteenth-

139. Piero della Francesca, *The Resurrection*.

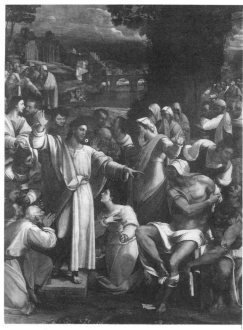

140. Mathias Grünewald, *The Resurrection* detail
from second opening of *Isenheim Altarpiece*.
141. Sebastiano del Piombo, *The Resurrection of Lazarus*.

century visionary's prophecies and communications from *Mary who related her perspective of the *Nativity and *Passion of Jesus Christ. A popular text of pious devotions, the *Revelations of Saint Bridget of Sweden* influenced medieval and renaissance Christian art. For example, this *book was the source for the motif of the kneeling Virgin Mary in depictions of the Nativity which eventually gave rise to the *iconography of the *Adoration of the Child. *See also* Bridget of Sweden, Saint.

Rhea. Great mother goddess of Greek mythology, consort of Cronos, and parent of most of the gods and goddesses of Mount Olympus. Originally worshipped as an earth mother, Rhea was associated with the Roman Magna Mater (Great Mother) or Ops. In classical Greco-Roman art, Rhea was represented as a matron wearing a *crown of *towers, enthroned between two *lions, and holding a small drum in her hand. She was a classical Greek foretype for *Anne.

Ribera, Jusepe or **José de** (1591–1652). One of the leading painters of Spanish *baroque art. Influenced by the northern Caravaggesti in Rome in 1615, Ribera blended Spanish realism with Italian idealism and *Michelangelo Merisi da Caravaggio's chiaroscuro. His paintings, including tender renderings of the *Nativity of Jesus Christ, and strongly characterized depictions of the *Passion of Jesus Christ or scenes from the lives of the *saints, became visual defenses for the teachings and doctrines of the Counter-Reformation *church. Ribera's art was categorized as a balanced

blend of emotion and devotionalism, as in his *Martyrdom of Saint Bartholomew* or *The Penitent Magdalene.*

Rich Fool. *See* Parables.

Rich Man and Lazarus. *See* Parables.

Ring. A completed circle symbolizing eternity and union. Two rings represented the *earth and the sky, while three rings signified the *Trinity. A symbol of permanent union, a wedding ring was an *attribute of *Catherine of Alexandria, *Catherine of Siena, and *Francis of Assisi. As a sign of their spiritual marriage to the church, ecclesiastical officials wore rings which identified their hierarchical position: plain metal bands were worn by *nuns, simple gemmed bands by abbots or abbesses, a ring set with a stone by bishops, a sapphire ring by cardinals, and a gold signet ring inscribed with the image of Peter Fishing by the pope.

River. A symbol for both journey or *pilgrimage, and the ritual cleansing associated with *baptism. According to tradition, the four sacred rivers—Pison, Gihon, Tigris, and Euphrates—were the four rivers of *paradise; they were depicted in Christian art as flowing from a single *rock (or *mountain) and signified the four *gospels.

Road to Calvary (Mt 27:32–33; Mk 15:21–23; Lk 23:26–32; Jn 19:17). Scriptural event signifying Jesus' journey to the site of his Crucifixion. His physical strength weakened by the *Flagellation and by having attempted to carry his own *cross, Jesus faltered

three times along the way (according to pious tradition). At his first fall, Jesus encountered his mother, and at the second fall, his sweat-covered face was wiped by *Veronica. Finally, the Roman soldiers commandeered Simon of Cyrene, a man in the crowd, to carry the cross. At Calvary, the Roman soldiers asked Jesus to drink a mixture of *myrrh and vinegar, but he refused. See also Stations of the Cross.

Road to Emmaus. See Emmaus, Road to.

Road to Golgotha. See Road to Calvary.

Robe. A garment associated with the *Passion of Jesus Christ. A scarlet or purple robe was an *Instrument of the Passion, and symbolized the *Mocking of Jesus Christ (or the *Ecce Homo) (Mt 27:27–30). A seamless robe signified the *Crucifixion of Jesus Christ (Jn 19:23–24).

Roch, Saint (1293–c. 1337). Christian saint associated with the plague. This protector of the sick was identified by the cross-shaped birthmark which signified his vocation to those suffering from the plague. Roch himself became afflicted with the plague and withdrew into the forest accompanied only by his faithful *dog who brought him food daily. Following his recovery, he was so scarred by his ordeal that when he returned home he was not recognized by his relatives and was imprisoned as a spy. He died in his prison cell and was identified later by a tablet upon which he had written an invocation against the plague. His legend, his cult, and his *iconography became popular after the Black Death. Roch was the patron of physicians, and was invoked against the plague, cholera, and other infectious diseases. In Christian art, he was depicted as a young *pilgrim with his *scallop shell, *staff, and *gourd; accompanied by his faithful *dog; and with his thigh exposed to reveal a plague spot.

Rocks. Geological symbols of strength, solidity, power, Christian fortitude, and *Jesus Christ as the *church. In the *Old Testament, rocks signified God, while the New Testament emphasized the metaphor of *Peter as the rock (Mt 16:18). Rocks with gushing *water denoted both *baptism and the church, while a large rock with four streams of water indicated Christ with the four *gospels.

Rococo art. From the French for "rock work." Popular in the mid-eighteenth century, this delicate, light, airy, and curvaceous style of art emphasized pastel colors and pastoral storybook themes.

Roman Catholicism. The Christian communion historically centered on the office of the Primacy of *Peter, accounted as the first bishop of Rome, and which identified itself as the universal and apostolic *church. Roman Catholicism affirmed that the successive bishops of Rome were the supreme teachers, pastors, and governors of the Church as Vicars of Christ on *earth; the authority of church councils and bishops, and the authentic teaching of doctrine derived from

their union with the popes as Petrine Bishops of Rome. As the Christian tradition in western Europe from the fourth century through the Reformation, Roman Catholicism was a powerful political, social, and economic force in the development of cultural attitudes and Christian art.

Romanesque art. A form of *medieval art which dated from the late tenth century into the thirteenth century. Its stylistic characteristics—thick-walled and low-ceiling churches, sharp architectural lines, and stylized, heavy figures in carved and illuminated works of art—sought to retrieve the imperial tradition of the Roman Empire. Deeply influenced by *byzantine art and *iconography, romanesque art represented sovereignty and power.

Romauld, Saint (c. 950–1027). Founder of the Camaldolese Order. Romauld joined the Order of Saint *Benedict as an act of atonement for the murder of a close relative by his father. Shocked at the moral laxity of his brother monastics and clerics, Romauld had a vision of San Apollinaris who directed him to establish a new monastic order dedicated to God. By 975, Romauld had established the Camaldolese Order with its austere rule for hermetical, cenobitic, and pastoral monks of perpetual silence and solitude. According to legend, while looking for the site of his new monastery, Romauld dreamed of a *ladder connecting heaven and earth upon which men in *white *robes ascended and descended. In Christian art, Romauld was depicted as an old man with a long white *beard and dressed

in the white *habit of the Camaldolese Order. His *attributes included the ladder to heaven, a *staff, a *skull, and the *Devil under his *feet.

Rood. From the Old English for "wood." This carved *crucifix had figures of *Mary and *John the Evangelist at its base.

Rood screen. An ornamental screen to which a rood was attached. A rood screen served as a partition between the *nave and the choir in a medieval English church or cathedral.

Rooster. *See* Cock.

Rope. An *Instrument of the Passion, and an *attribute of *Judas Iscariot. A rope signified the *Betrayal by Judas and his repentant act of suicide.

Rosalia, Saint. *See* Rosalie, Saint.

Rosalie, Saint (twelfth century). Christian virgin *saint carried by *angels to an inaccessible *mountain where she lived for many years a life of Christian prayer and devotion. Rosalie was the patron saint of Palermo. In Christian art, she was depicted as a young woman kneeling in prayer inside a cave with a *crucifix (or *cross) and *skull. She was also represented receiving a gift of *roses or a *rosary from *Mary.

Rosary. A string of one-hundred-and-fifty small beads (on which were said "Aves") and fifteen larger ones (on which were said "Pater Nosters") which served as an aide to prayer and devotions to *Mary. The rosary was

142. Stefan Lochner, *Madonna of the Rose Garden.*

143. Benozzo Gozzoli, *The Dance of Salome.*

an *attribute of *Dominic, *Catherine of Siena, and Mary.

Rose. A floral symbol sacred to *Venus and signifying love, the quality and nature of which was characterized by the color of the rose. A symbol of purity, a *white rose represented innocence (nonsexual) love, while a pink rose represented first love, and a red rose true love. When held by a *martyr, the red rose signified "red martyrdom" or the loss of life, and the white rose "white martyrdom" or celibacy. According to *Ambrose, the thorns of the rose were a reminder of human finitude and guilt as the roses in the Paradise Garden had no thorns. A thornless rose was an attribute of *Mary as the Second *Eve. A garland of roses denoted the rosary. Roses were an *attribute of *Elizabeth of Hungary, *Dorothea of Cappadocia, and *Benedict of Nursia.

Rose of Lima, Saint (1568–1617). First native-born individual in the Americas to be canonized a *saint (1671). A dedicated, poor young woman, Rose provided support for her aged parents. After joining the Dominican Order, she was renowned for the torturous penances she inflicted upon herself as well as her mystical visions. Rose committed her life to the care of sick Indians and slaves, and was identified as the founder of social services in Peru. In Christian art, Rose of Lima was depicted as a beautiful young woman who knelt in prayer and wore the crown of thorns or had a scourge nearby.

Rossetti, Dante Gabriel (1828–1882). A founder of the *Pre-Raphaelite Brotherhood. The son of an expatriate Italian Dante scholar, Dante Gabriel Rossetti dedicated his artistic vision to the retrieval of the medieval synthesis, especially with regard to art and religion. He joined with *William Holman Hunt and John Everett Millais to establish the Pre-Raphaelite Brotherhood. Although influenced by Dante and medieval art, Rossetti's paintings were of a poetic and neurotic intensity matched only by his poetry. His interest in Christian art survived his role in the Pre-Raphaelite Brotherhood, as evidenced by his painting of The Annunciation.

Rouault, Georges (1871–1958). A French Expressionist who reconciled his modern style with the traditional drama and form of medieval stained glass. Originally apprenticed to a stained-glass window maker, this French artist studied with Gustave Moreau. His oeuvre was topically divided into religious subject matter, austere landscapes, and occasional flower paintings. His biblical paintings, most often related to the *Passion of Jesus Christ, were distinguished by his use of heavy, dark contours and strong colors to express emotion and to emulate medieval glass.

Rubens, Peter Paul (1577–1640). Leading Roman Catholic painter of Flemish *baroque art. Influenced by *Michelangelo Merisi da Caravaggio, Rubens developed his own personal and passionately dramatic style which was highlighted by his use of high florid colors, as evidenced by his Ele-

vation of the Cross and *Descent from the Cross. An extraordinary portrait painter, Rubens was named court painter to several kings. Affiliated with the *Jesuits in Antwerp, Rubens was an iconographic innovator of the highest level.

Ruins. A sign of decay or death. The motif of ruined buildings became symbolic of the *church or Christianity evolving from or replacing the synagogue or Judaism, or classical pagan culture. The introduction of this motif into the *iconography of the *Nativity of Jesus Christ and the *Adoration of the Magi began in *medieval art.

Ruler. A carpenter's ruler or square signified *Thomas the Apostle.

S

❧

S. A letter symbol for the *Holy Spirit.

Sacra Conversazione. From the Italian for "holy conversation." Motif for the *Madonna and Child credited to *Fra Angelico. This representation of the Enthroned Madonna and Child with *saints and/or *donors who, while cognizant of each other's presence and united in a common action, were also aware of the spectator. All hierarchical barriers, social and historical, were removed as all the figures within the canvas functioned within a single unified space.

Sacraments. Believed to have been instituted by *Jesus Christ as outward and visible signs signifying the inner reality of divine grace. The *Old Testament rituals of anointing with holy oil, circumcision, and the sacrifice of the *Passover *Lamb prefigured the Christian sacraments. The seven sacraments recognized by the Roman Catholic and Eastern Orthodox Churches were *baptism, confirmation, *Eucharist, penance, confession, ordination, marriage, and extreme unction. The Protestant churches accepted only the two central sacraments of baptism and Eucharist, while the Anglican tradition accepted the two major sacraments of baptism and Eucharist and the five minor sacraments or ordinances of confirmation, confession, ordination, marriage, and extreme unction as defined by the Thirty-nine Articles of the Anglican Church. During the medieval period, the *iconography of the sacraments was used for *fonts and *altarpieces. However, in southern *baroque art the theme of the seven sacraments and of each of the separate sacraments became individual iconographic motifs in defense of the Reformers' criticisms.

Sacred Heart of Jesus. A devotional image of either a standing Resurrected Christ with his bleeding or flaming *heart exposed or the heart of *Jesus Christ pierced by *arrows. This iconographic motif was widely popularized by the mystical visions of Margaret Mary Alacoque, a seventeenth-century contemplative *nun of the Visitation Order.

Sage. An aromatic mint signifying healing and symbolic of *Mary in medieval Christian art.

Saint. From the Latin for "holy." Heroes and heroines of Christianity served as intermediaries and advocates between humanity and God the Father. Although originally applied to all Christians as it had been to all the faithful of the *Old Testament, the term "saint" became an honorific title reserved for outstanding holiness. The process of being canonically recognized as a saint (canonization) was a lengthy process during which the character and orthodoxy of the individual and the miracles attributed to him or her were investigated by the *church. The study of the lives of the saints was known as hagiography. Saints who had special relationships with individual cities, towns, countries, occupations, or guilds were defined as patrons. In Christian art, saints were identified by the distinguishable *attribute or symbol which related to the method of their martyrdom and/or their most important miracle or teaching.

Salamander. This small amphibious animal similar to a lizard signified faith over passion. Medieval *bestiaries described the salamander as impervious to *fire and capable of extinguishing *flames with its cold breath. In northern *medieval art, the salamander was depicted in either the *Annunciation to Mary as a sign of faith or the Temptation and the *Fall of Adam and Eve as a variant of the *serpent.

Salome (Mt 14:1–12; Mk 6:14–29; Lk 9:7–9). According to the *New Testament, the unnamed daughter of *Herodias danced at the birthday celebration for her stepfather, *Herod Antipas. Her dance so pleased him that she was promised anything she wished unto half of his kingdom. Consulting her mother, the obedient daughter requested the head of the imprisoned *John the Baptist, who had denounced Herodias for adultery. Despite Herod's pleas, his stepdaughter would not accept any other prize. As a result, the Baptist was beheaded, and the severed head was placed upon a silver platter for her. The Jewish historian Flavius Josephus identified this unnamed dancing daughter of Herodias as Salome in his *Antiquities of the Jews* (18.137), but made no mention of her dance or of her guilt in the death of John the Baptist. Rarely depicted in early Christian and *byzantine art, Salome and her dance became an artistic topic as the role of the Baptist (and the ritual of baptism) gained importance in Christian theology. In the earliest medieval images, Salome was represented as prepubescent girl engaged not in an erotic dance but in acrobatic or gymnastic feats. Herod, his guests, Herodias, John the Baptist, and the executioner(s) were included in these narrative representations, which conflated the Banquet of Herod, the Dance of Salome, and the Execution of John the Baptist into one scene. In *renaissance and *baroque art, artists focused not on the banquet or the dance, but rather on the depiction of the beautiful young Salome, often regally dressed, as she accepted the severed head of the Baptist on a silver platter. Almost separated, from the scriptural context these images of Salome emphasized the contrast be-

tween her youthful loveliness and the grotesque head of the Baptist. The iconographic distinction of Salome with the head of the Baptist from *Judith with the head of Holofernes was that the former held a platter while the latter held the severed head by its hair. In nineteenth- and twentieth-century western art, the theme of Salome was rediscovered within the context of the *femme fatale* and the eroticism of orientalism, including oriental dances.

Salome (Mary Salome). *See* Mary Salome, Saint.

Salome the Midwife. First witness to the newborn Jesus as the *Messiah. According to the apocryphal *Protoevangelium of James*, *Joseph (of Nazareth), after settling *Mary into the stable, went in search of a midwife to assist in the imminent birth. He found two midwives who debated the possibility of a virgin conceiving and bearing a child. Salome was punished for her doubt with a searing pain in her *hands which shriveled after she physically examined the new mother's virginity. Urged to place her painful hands upon the newborn infant, Salome recognized the singularity of his birth and her hands were healed in this apocryphal first miracle of Christ. In byzantine and Italo-Byzantine art, the two midwives were represented *bathing the newborn child in the foreground of Nativity scenes. This iconographic motif became rare after the fourteenth century and was one of many nonscriptural topoi banned by the *Council of Trent.

Salt. Symbol for protection against decay and evil. Salt was placed in the mouths of infants at their *baptisms (or bread and salt in the mouths of adults) as an emblem of the scriptural injunction to be "salt of the earth." In the Hebraic, Arabic, and many other cultures, bread and salt were offered as a sign of hospitality.

Salvator Mundi. From the Latin for "Savior of the World." A devotional image which originated in late northern *medieval art. *Christ was depicted with his right *hand raised in benediction and his left hand holding an *orb. More often than not, he wore the *crown of thorns, denoting that his imminent death would result in the salvation of the world.

Samaritan, The Good. *See* Parables.

Samaritan Woman. *See* Woman of Samaria.

Samson. An Israelite hero of extraordinary physical strength and cleverness, and a foretype of *Jesus Christ. Manoah and his wife, although pious, were childless for most of their natural lives until they miraculously conceived Samson. *Samson Slaying the Lion* (Jgs 14:5–9): This episode of physical struggle and Samson's triumph over the lion prefigured the eternal struggle of Christ with the *Devil. *Samson Smiting the Philistines with the Jawbone of an Ass* (Jgs 15:14–19): Another episode exemplifying Samson's superhuman strength, thereby prefiguring the *Descent into Hell. *Samson and Delilah* (Jgs 16:4–22): A foretype of the *Betrayal by Judas and the *Flagellation. *Death of*

Samson (Jgs 16:23–31): Led by a boy to the central *columns of the Philistine's temple, the blinded Samson called upon God, who restored his strength. He then proceeded to destroy the temple and all the Philistines. This story prefigured the *Mocking of Jesus Christ, the *Road to Calvary, and the *Resurrection of Jesus Christ. With the exception of the story of Samson and *Delilah, none of the other episodes of his life merited either independent artistic topics or a prolonged iconographic interest in Christian art.

Sandals. A symbol for hermit and *pilgrim *saints. Discarded sandals signified humility and a recognition of holy ground.

Sarah. From the Hebrew for "princess." Wife of *Abraham, mother of *Isaac, a matriarch of Israel, and a foretype of *Mary. Having failed to conceive a child, Sarah followed the custom of her people by offering her servant, *Hagar, to her husband in hopes of an heir. Hagar bore a son, Ishmael, and grew haughty in her attitude towards her mistress. Past the age of childbearing, Sarah laughed when the three angels who visited Abraham announced that she would have a special son who would be heir to the covenant and father of a great nation. Some time later, Sarah gave birth to Isaac. No longer having to accept the mocking of Hagar and Ishmael, Sarah convinced Abraham to drive them into the desert. In Christian art, Sarah was represented within the context of the narrative episodes in the life of Abraham, especially the Philoxeny (or Hospitality) of Abra-

ham. Sarah prefigured both *Anne and Mary.

Sarcophagus. From the Latin for "flesh-eater." An above-ground stone or terra-cotta casket for the burial of the dead. The exterior of the sarcophagus was decorated, more or less elaborately depending upon the financial resources of the deceased, with symbols or iconographic motifs which identified the religious belief of the deceased.

Satan. From the Hebrew for "enemy" or "adversary" (originally Shaitan, a desert deity). The fallen angel who rebelled against God according to the apocryphal Book of Enoch. Satan was interpreted as the perpetual adversary of God and the active promoter of evil in the world. In *byzantine and *medieval art, he was a composite zoomorphic creature with a human body, claw *hands and *feet, a tail, *wings, and serpentine limbs. To signify that he was the "fallen angel" who presided over Hell, he was depicted as *black in color, symbolic of his distance from the *white light of God and his proximity to the *fires of *Hell. In late medieval and early *renaissance art, *Giotto painted Satan as a grotesque, ice-blue creature who was frozen in a pond of ice in the pit of Hell (paralleling *Dante's description in the *Divine Comedy*). In renaissance art, Satan was modeled after a classical Greco-Roman satyr.

Saul. The first *king of Israel, whose relationship with *David was interpreted as a foretype of the relationship between *Christ and the *Jews.

The two episodes regularly depicted in Christian art were the scene in which the young *shepherd David played his *harp to soothe Saul's melancholy (1 Sm 16:14, 15, 23), and the prophecy of the *Witch (or *Medium) of Endor (1 Sm 28:7). In Christian art, Saul was depicted as a physically mature bearded man dressed in royal *robes and wearing a *crown.

Savior. The Old Testament name for the "deliverer of God's people." Title applied to *Jesus Christ in the *New Testament. Identifying Christ as Savior signified that his voluntary sacrifice earned human salvation.

Saw. A carpenter's tool which became an *attribute of *Joseph (of Nazareth), *Simon the Zealot, *Euphemia, and Isaiah.

Scales. A symbol for judgment, along with a *sword of equality and justice. Scales were an *attribute of *Michael the *Archangel and the *Last Judgment.

Scallop Shell. A symbol of *pilgrimage and thereby an *attribute of *James Major and Edward the Confessor. In southern European art, *John the Baptist was depicted using a scallop shell at the *Baptism of Jesus Christ.

Scapegoat. A symbol for the crucified Jesus, who took on all the sins and sufferings of the world. The scapegoat was one of two *goats selected on Yom Kippur (Day of Atonement) to bear the sins of the community into the wilderness. While the other goat was ritually sacrificed, the scapegoat was released into the *desert. It was identified by the red woolen ribbon tied around its *horns and the *titulus* (placard) on which was inscribed the sins of the community.

Scapular. From the Latin for "cloak worn around the shoulders." A part of most monastic *habits, the scapular denoted the yoke of *Jesus Christ. A narrow length of cloth, originally a work apron, it was placed over the shoulders and extended to the length of the tunic.

Scepter. A symbol of royal power and authority. The scepter was an *attribute of *Gabriel the *Archangel, monarch *saints, Christ as King of Heaven, and God the Father.

Scholastica, Saint (c. 480–c. 543). Twin sister of *Benedict of Nursia and founder of an order of Benedictine *nuns. Dedicated to God at an early age, Scholastica was a devout and pious woman who met with her brother once a year at Monte Cassino. According to tradition, she and her brother spoke of the joys of *heaven into the morning of their last meeting. When she died three days later, Benedict reportedly had a vision of a *dove ascending into heaven. Scholastica was the leading female *saint of the *Benedictine Order. In Christian art, she was depicted as a mature woman dressed in a Benedictine *habit with a dove either issuing from her mouth or hovering over her *head and/or *book. Her *attributes included the *crucifix and the *lily.

Scorpion. A symbol of treachery, evil, the *Devil, and *Judas Iscariot (Rev 9:5).

Scourge (or **Whip**). An *Instrument of the Passion and with a *pillar a sign of the *Flagellation. In the *hands of a *saint, the scourge represented self-flagellation. It was an *attribute of *Ambrose and *Vincent of Saragossa.

Scroll. A symbol of authorship. The scroll denoted either classical philosophy or the *Old Testament in Christian art. An inscribed scroll identified individual *saints, fathers of the church, or the *Evangelists as authors. A scroll of music was an *attribute of *Cecilia, *Ambrose, and *Gregory the Great. A scroll inscribed with scriptural text was commonplace in northern *medieval and *renaissance art.

Scythe. An agricultural instrument symbolic of the harvest, death, and the fullness of time. The scythe was an *attribute of *Time (Father Time) and of *Christ at the *Apocalypse.

Sea of Reeds. *See* Moses, Red Sea, and Reed.

Sea of Tiberias (Jn 21:1–23). The Resurrected *Christ appeared on the shore to seven of the disciples, including *Peter and John, on the Sea of Tiberias. As they fished, an unrecognized stranger urged the *fishermen to cast their *nets to the right side of the *boat. John realized who the stranger was when the nets became so filled with fish that the disciples could not pull them in. The disciples then gathered over a meal of *bread and *fish on the shore as the Resurrected Christ spoke to them. Although rarely depicted in Christian art, this scene was confused with the *Stilling of the Water (*Navicella*).

Seal. A symbol of the mark or signature of God (Rv 7:2, 3).

Seamless Robe. A symbol of the *Passion of Jesus Christ and of unity, and thereby the wholeness of the Tradition.

Sebastian, Saint (third century). A legendary officer in Diocletian's Praetorian Guard who identified himself as a Christian when he refused to worship idols. On the order of the emperor, Sebastian was executed with *arrows. According to tradition, no vital organs were touched in order to prolong Sebastian's death agony. Left for dead by the Roman soldiers, the wounded Sebastian was nursed by Irene and the holy women back to health. Following his recovery, Sebastian sought to illustrate the power of *Jesus Christ by confronting the emperor. Enraged, Diocletian had Sebastian clubbed to death and his dead body thrown into the main sewer of Rome. One of the *Fourteen Holy Helpers, Sebastian was the patron of pin-makers, archers, soldiers, and potters, and was invoked against the plague. In Christian art, he was depicted as a handsome, young man in a state of almost total undress, who was tied to a *pillar, and shot with arrows. Sebastian was a particularly popular topic in *renaissance and *baroque art.

Seraphim. The six-winged, fiery-red celestial beings that guard the *throne of God the Father. Described as burning with love for God, the sera-

144. Amico Aspterini, *Saint Sebastian*.

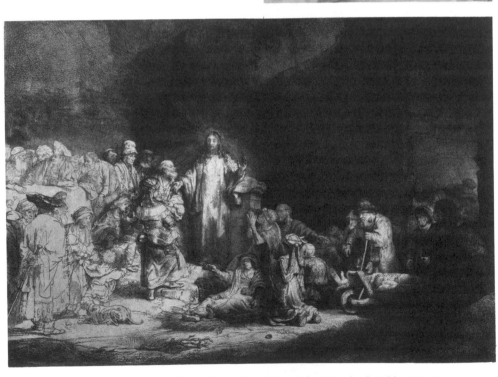

145. Rembrandt van Rijn, *Christ Preaching (The Hundred Gilder Print)*.

phim were led by *Uriel the Archangel (Is 6:2).

Sermon on the Mount (Mt 5:1–7:29; Lk 6:20–26). Paradigmatic image of the *Ministry of Jesus Christ. In his sermon, or lesson, Jesus defined the meaning of discipleship, the Beatitudes, and the Golden Rule, and taught the multitudes how to pray to God as Father. One of the most popular topics in Christian art, the Sermon on the Mount served as the model for all images of Christian preachers.

Serpent. A classical Mediterranean symbol for the fertility and curative powers of mother goddesses, and the *wisdom associated with virgin goddesses such as *Athena. According to the *Old Testament, the serpent tempted (or tricked) *Eve into eating the forbidden *fruit, and thereby was cursed by God to crawl on the ground (Gn 3). The *staff of *Moses was transformed into a serpent which swallowed the *snakes of Pharaoh's priests (Ex 4:2–4). The Brazen Serpent fashioned by Moses was a foretype of the *Crucifixion of Jesus Christ (Nm 21:8). In Christian art, the serpent signified the evil tempter of the Garden of Eden who was depicted as a reptile until the mid-twelfth century, when it became a composite figure of a serpentine body and tail with a female head, and in later *medieval and *renaissance art, a female head and torso. The serpent was an *attribute of *George of Cappadocia, *Margaret, *Benedict of Nursia, *John the Evangelist, and *Patrick. A serpent entwined around a *cross denoted the Crucified *Christ, while a serpent with an *apple in its mouth encircling the *globe represented human sinfulness overcome by the *Immaculate Conception.

Seven. A mystical number of completion and perfection, and a symbol for the *Holy Spirit, grace, and *charity.

Seven Deadly Sins (or **Vices**). A popular didactic topic in *medieval and *renaissance art which identified the greatest offenses against God, and paralleled the *Seven Virtues. The Seven Deadly Sins were pride (*superbia*), envy (*invidia*), anger (*ira*), lust (*luxuria*), sloth (*accidia*), avarice (*avaritia*), and gluttony (*gula*). Although there was not a common and regular set of anthropomorphic symbols or personifications for the Seven Deadly Sins, they were most often identified symbolically as female figures engaged in dramatic actions.

Seven Joys and **Sorrows of the Virgin Mary.** These medieval didactic and spiritual topics were represented either as a narrative cycle on medieval *churches or as a unified composition in *renaissance and southern *baroque art. The Seven Joys of the Virgin *Mary were the Annunciation, *Visitation, Nativity, *Epiphany (or *Baptism), *Christ among the Doctors, Resurrection, and Assumption. The Seven Sorrows of Mary were Simeon's Prophecy, *Flight into Egypt, Jesus lost in *Jerusalem, Meeting Jesus on the Road to Calvary, Crucifixion, *Descent from the Cross, and Entombment.

Seven Liberal Arts. This popular medieval and renaissance didactic topic

paralleled the *Seven Virtues and the *Seven Deadly Sins in *medieval art, and the classical Mediterranean gods and goddesses in *renaissance art. Normally personified as women, the Seven Liberal Arts were grammar, dialectic, rhetoric, arithmetic, music, geometry, and astronomy. Grammar was distinguished by her toga and her *attributes of inkpots, *pens, *candlesticks, and scalpel. Rhetoric was depicted as a beautiful female warrior who wore a *helmet and carried a *shield. Dialectic was a delicate woman with an elaborate hairstyle who held a *serpent, a wax *tablet, and a fishhook. Geometry wore a *robe inscribed with *stars and the signs of the *Zodiac, and held a *globe and a pair of compasses. Arithmetic had elegant, long fingers for her computations. Astronomy had great golden *wings and held a book and astronomical instruments. Music led the procession of musicians, poets, goddesses, and graces.

Seven Virtues. This popular medieval and renaissance didactic topic paralleled the *Seven Deadly Sins. The Seven Virtues were prudence (*prudenza*), *justice (*justicia*), *faith (*fides*), *charity (*caritas*), *hope (*spes*), fortitude (*fortitudo*), and temperance (*temperanza*). Normally personified as female figures, the Seven Virtues had a prescribed *iconography. The Theological Virtues were Faith, who held a *chalice or a *cross with *Peter seated at her *feet; *Hope, who elevated her *hands to *heaven with *James Major at her feet; and *Charity, who held *flames and a *heart, and was surrounded by *children, with *John the Evangelist at her feet.

The Cardinal Virtues were Prudence, often depicted as two-headed, who held a *snake or *mirror with Solon seated at her feet; Fortitude, who held either a *shield, *globe, *column, *sword, or lion's skin, with *Samson seated at her feet; Justice, who held *scales, sword, and cross with Trajan seated at her feet; and Temperance, who held two *vases or a sword with Scipio Africanus seated at her feet.

Shamrock Leaf (or **Clover**). A symbol of the *Trinity and an *attribute of *Patrick.

Shears. *See* Pincers.

Sheep. A single sheep signified a Christian *soul, while twelve sheep represented the twelve *apostles.

Shell. A symbol for *pilgrimage and *baptism. The cockleshell or *scallop shell was an *attribute of the *pilgrim, and of pilgrim *saints such as *James Major and *Roch. In southern art, *John the Baptist used a shell with a few drops of water in it to baptize *Jesus Christ. In northern art, he used a flask or *ewer.

Shepherd. A symbol for *Jesus Christ or a bishop.

Shepherd with Sheep. The symbol for *Jesus Christ as the *Good Shepherd.

Shield. An attribute of *George of Cappadocia, *Joan of Arc, and Anskar.

Ship. A symbol for the *church. The biblical foundation of the association

between a ship and the church was Noah's Ark (Gn 6:11–8:19), and the *Stilling of the Water (Mt 14:22–33; Mk 6:45–52; Lk 6:15–21). Among other early church fathers, Tertullian and *Ambrose employed the metaphor of the ship to describe or characterize the church. A ship was an *attribute of *Vincent, *Francis Xavier, Elmo, *Mary Magdalene, Brendan, *Nicholas (of Myra or Bari), *Julian the Hospitaler, *Peter, *Ursula, *Jonah, *Noah, and *Mary.

Shoe. An ambivalent symbol for authority and humility, and an *attribute of Crispin. The wearing of shoes denoted freedom as slaves went barefoot. In the *Old Testament, God ordered *Moses to remove his shoes as a sign of being on holy ground (Ex 3:5).

Sibyls. Oracular priestesses of antiquity each of whom made a pronouncement about *Jesus Christ or *Mary. Famed for their powers to see the future, the Sibyls were paralleled to the male *prophets of the *Old Testament in *medieval and *renaissance art. Each Sibyl was reported to have made at least one recorded prophecy which related to Jesus Christ; thus, the Sibyls represented the fact that the classical, or, pagan, world had a vision of the *Messiah. The Delphic Sibyl was identified by her *attribute of the *crown of thorns as she forecast the *Mocking of Jesus Christ. The European Sibyl held a *sword signifying her prophecy of the *Massacre of the Innocents, the *Flight into Egypt, and Christian missions to the Gentiles. The Agrippine Sibyl's *whip foretold the *Flagellation, while the Hellespontic

Sibyl's *nails and a *cross anticipated the *Crucifixion of Jesus Christ. The Phrygian Sibyl's *banner and cross prophesied the *Resurrection of Jesus Christ, and the Samian Sibyl's cradle and *rose predicted that the Messiah would be born among the lowly. The Cumean Sibyl held a bowl and a *sponge for her omens of the Crucifixion while the Libyan Sibyl's lighted taper suggested that the Messiah would be the light of the world. The Persian Sibyl's *lantern foretold the birth of Jesus while the Erythrean Sibyl's *lily predicted the *Annunciation to Mary. The Cumean Sibyl was distinguished by her *cornucopia, which predicted that a human mother would nurse her divine son, and the Tiburtine Sibyl's severed *hand signified the *Betrayal by Judas. Perhaps the two most famous sibyls were the Erythraean Sibyl whose prophecies prefigured the Annunciation, and the Tiburtine Sibyl who foretold at the moment of the *Nativity of Jesus Christ the virgin birth of a king who would be greater than Augustus.

Silver (as a color). Symbolic of glory, innocence, purity, joy, and virginity.

Silver (as an element). Tested by fire, this precious metal signified chastity and purity.

Simon the Canaanite, Saint. See Simon the Zealot, Apostle and Saint.

Simon the Zealot, Apostle and Saint (first century). Believed to have been among the shepherds to whom the birth of Jesus was announced on Christmas Eve. Following the *Ascension of Jesus Christ, Simon the

Zealot reportedly preached the *gospel with Jude in Egypt, Syria, and Persia, and was martyred either by the *saw or *crucifixion. In Christian art, he was identified among the disciples by his *attributes of a *cross, a large saw, a *fish, and a fish on a *book.

Siren. A mythical female creature who was either half *bird or half *fish and half human. The siren was capable of charming a man to sleep with her music in order to destroy him. According to medieval legends, *Eve was charmed by a siren in the *Garden of Eden to eat of the forbidden *fruit.

Six. A mystical number of creation (the six days) and perfection. Six signified mercy, justice, love, divine power, majesty, and *wisdom. It was the sum of three and three, the number of the *Trinity.

Skeleton. A symbol for death. A skeleton with a *scythe or *hourglass denoted the transitory nature of human life. In Christian art, the skeleton was found in depictions of the *Last Judgment, *Dance of Death, *Danse Macabre, and the penitential *saints (*David, *Mary Magdalene, *Peter, and *Jerome).

Skull. A symbol of the transitory nature of human life and material wealth. A skull was an *attribute of hermit and penitential *saints including *Paul, *Jerome, *Mary Magdalene, *Peter, and *Francis of Assisi. As a sign of vanity and death, a skull was an integral element to pictorial compositions of the memento mori

and *vanitas, and was an attribute of Melancholia. Placed below (or beneath) a *cross, a skull and crossbones denoted the medieval legend that the *cross of Jesus was placed on the grave of *Adam.

Skullcap. A rimless, close-fitting cap covering the crown of the *head, the color of which identified the ecclesiastical rank of the wearer: *black for priests and *monks, *purple for bishops, *red for cardinals, and *white for popes.

Sky. A symbol for the heavenly realm, the home of God the Father and the heavenly hosts of *angels and *saints.

Smoke. An ambiguous symbol for all things transitory and ephemeral, vanity, the anger and wrath of God, and prayers and petitions to God the Father.

Snail. An ambiguous symbol, used either to represent laziness and sinfulness or the *Resurrection of Jesus Christ.

Snake. A contradictory but universal symbol. The snake swallowing its own tail (*ouroboros*) signified eternity. Since the snake characteristically shed its own skin each year, its signified renewal or resurrection. One of the plagues set upon Egypt was of snakes (Ex 7:8–13). *See also* Serpent.

Snowdrop. A floral symbol of purity and hope. One of the earliest of spring flowers, the little *white snowdrop was a medieval *attribute of *Mary.

Solomon. From the Hebrew for "peaceful." An *Old Testament foretype for *Jesus Christ. This third King of Israel, the son of *David and *Bathsheba, Solomon was famed for his wisdom and for building the temple in *Jerusalem. *Judgment of Solomon* (1 Kgs 3:16–28): Two prostitutes were brought to Solomon to settle a dispute over the possession of a male infant. Both women had given births to sons at approximately the same time and date. The one boy had died, and now both women claimed the living child as her own. Solomon ordered the child to be divided between them. The true mother suddenly surrendered her claim upon the child in order to preserve his life. Solomon recognized her as the real mother, awarded her the child, and punished the other woman for false witness. *Solomon and the Queen of Sheba* (1 Kgs 10:1–13): The gifts brought by the *Queen of Sheba to King Solomon prefigured the *Adoration of the Magi, while Solomon's acceptance of Sheba as his royal equal was a foretype of the *Coronation of the Virgin Mary. A variant of this topic was its conflation with *Solomon's Idolatry* (1 Kgs 11:1–8): His infatuation with Sheba caused Solomon to burn incense to pagan gods. This theme was popular among Protestant artists who sought to undermine the use of religious (devotional) imagery in Roman Catholic worship. *Solomon and Bathsheba* (1 Kgs 2:19–20): Although he denied his mother's request, Solomon's action of placing her on a *throne next to his and putting a *crown upon her *head was a foretype of the Coronation of the Virgin Mary. In Christian art, Solomon was depicted as a large, bearded man dressed in royal robes and wearing a crown.

Sophia. From the Greek for "wisdom." A symbol for the wisdom of the virgin goddesses such as *Athena, and for the allegorization of wisdom in the *Holy Spirit and *Mary. Mistakenly identified as a female *saint, the Greek theological title *Hagia Sophia* should correctly be translated as the "Holy Wisdom of God," not as "Saint Sophia." *See also* Sophia, Saint.

Sophia, Saint (second century). The legendary mother of three daughters—*Faith, *Hope, and *Charity—who were personifications of the three theological *virtues. All four women were reportedly martyred in Rome in the second century.

Soul. This immaterial principle proper to each human separated from the physical body at death. In Christian art, the soul was signified by either a small winged figure (usually female) or a *dove.

South. One of the four cardinal points and a symbol both for light and warmth, as well as the *New Testament, in particular the Epistles.

Sower, The. *See* Parables.

Sparrow. An avian symbol for the lowly (that is, the multitudes), who were nurtured and protected by God the Father (Mt 10:29; Lk 12:6). The sparrow was an *attribute of *Dominic and *Francis of Assisi.

Spear. An *Instrument of the Passion and a symbol of the *Crucifixion of

Jesus Christ. The spear was an *attribute of *Longinus, *Michael the Archangel, *Thomas, and *George of Cappadocia.

Spider. A symbol of the *Devil and evil.

Spindle, spinning. A symbol of the gestation of an idea or new life. The spindle (or distaff) was an *attribute of the virgin goddess *Athena, the three Fates of classical Greco-Roman mythology, and *Mary. In byzantine *iconography, the Virgin Annunciate was depicted with a spindle in her *hands to signify both her task of weaving a sacred cloth for the Temple and the gestation of new life inside her womb.

Sponge. An *Instrument of the Passion.

Square. A symbol of the *earth and earthly things.

Square halo. An earth-connected symbol which signified that the person being depicted was alive at the time the painting (or sculpture) was made.

Squirrel. A symbol of avarice and greed. The red squirrel was a sign of the *Devil.

Staff. A symbol for power, magic, authority, identity, hermits, and *pilgrims. The staff was an *attribute of *James Major, *Ursula, *Raphael the Archangel, *Philip, *John the Baptist, *Roch, *Christopher, and *Jerome. A flowering staff signified either *Aaron or *Joseph (of Nazareth). A bishop's staff or *crosier signified his role as the shepherd of his flock. A staff in the *hand of *Jesus Christ represented his role as the *Good Shepherd.

Staff, Budding or **Flowering.** A symbol of prayer and God's favor, and an *attribute of *Aaron and *Joseph (of Nazareth).

Stag. A male animal symbol for piety, religious devotion, and spiritual aspiration (Ps 42:1) as well as the quest for the solitary and pure religious life. According to the *Physiologus*, the stag was a slayer of *serpents and thereby a symbol of *Christ, who tread on *Satan. The stag was an *attribute of *Eustace, *Hubert, and *Julian the Hospitaler.

Stake. An instrument of torture or martyrdom. The stake was an *attribute of *Dorothea, *Agnes, *Sebastian, *Thecla, and *Joan of Arc.

Star. An astronomical symbol for divine guidance or an epiphany. The starry sky signified *Abraham's progeny (Gn 22:17). In Christian art, there was the Star of *David, Star of Bethlehem, Star of the Sea, and a series of twelve stars which represented the twelve tribes of Israel, the twelve *apostles, the *crown of the Queen of Heaven, and the *Immaculate Conception. The star was an *attribute of *Dominic, *Thomas Aquinas, and *Nicholas of Tolentino.

Starfish. An aquatic symbol for the *Holy Spirit and *charity. An *attribute of *Mary, who as the *star of the *sea *(Stella Maris)* guided Christians

through the rough waves and storms of faith.

Stations of the Cross. A late medieval devotional practice fostered by the *Franciscans as an act of spiritual piety and contrition, and as a substitute for the *pilgrimage to *Jerusalem. The Stations of the Cross were a fourteen-stop procession which paralleled the *Via Dolorosa* ("Way of the Cross"). At each stop, whether inside an ecclesial building or out-of-doors, there was an image relating to the appropriate scriptural reference. This image allowed for meditation and contemplation on the sufferings of Jesus (and his mother). Among the fourteen Stations of the Cross were the three falls of Christ; the meetings with *Mary, Simon of Cyrene, and *Veronica; Jesus stripped of his garments; the Crucifixion; Jesus laid in the arms of his mother; and the Entombment. This devotional practice gave rise to both an *iconography of the Stations of the Cross, and to the fourteen images required for the performance of this spiritual pilgrimage. *See also* Passion of Jesus Christ.

Stephaton. The name given to the Roman soldier or anonymous bystander who offered the crucified Jesus a *sponge soaked in vinegar to quench his thirst on the *cross (Mt 27:48; Mk 15:36). In the byzantine tradition and *iconography, this individual was identified as Aesop from the Greek for *"hyssop" (Jn 19:29).

Stephen, Saint (d. c. 35). "The first deacon and martyr" noted in the Acts of the Apostles for his sermon accusing the Sanhedrin of the death of *Jesus Christ. Accused of blasphemy, he was stoned to death, thus becoming the *church's first *martyr. Saul of Tarsus was present at this execution. According to later pious tradition, the hidden burial place of Stephen was revealed by Rabbi Gamaliel, the teacher of Saul (Paul) of Tarsus, in a dream to the Palestinian priest, Lucian, in the year 415. Stephen's relics were then transferred to Rome and interred with those of *Laurence, who courteously moved to one side of the grave and offered his hand to assist Stephen in entering the grave. In Christian art, Stephen was depicted as a beardless young man dressed in a *deacon's *dalmatic, and held either a *palm, *censer, or *stone.

Stigmata. Plural of stigma meaning "mark." These marks signified the five wounds of the Crucified Christ. The stigmata appeared miraculously upon the bodies of certain extraordinary persons associated with devotion to the *Passion of Jesus Christ, such as *Francis of Assisi, *Catherine of Siena, and Catherine of Genoa.

Still Life. This replacement motif for traditional Christian art developed in the seventeenth-century Dutch and Flemish art. Ostensibly, the still life concentrated upon the representation of a grouping of natural objects such as *flowers, *fruits, *vegetables, or foods. Early still lives were either symbolic or allegorical in theme. Those which were symbolic emphasized the transient quality of material objects and the inevitability of death. The most common symbolic still lives were the *vanitas and the *memento

mori. Allegorical still lives developed from what had previously been details of flowers, fruits, vegetables, or other natural objects in fifteenth-and sixteenth-century Christian art, such as the *vase of flowers in Annunciation or Nativity scenes.

Stilling of the Water (or *Navicella*) (Mt 8:23–27; Mk 4:35–41; Lk 8:22–25). Jesus fell asleep as he and his disciples crossed the *sea in a *ship. A terrible storm flooded the ship, and the disciples were frightened. They woke him from a deep sleep and begged to be saved. After Jesus rebuked both nature and his disciples of "little faith," a great calm settled over the sea. This event was rarely depicted as a separate topic in Christian art, but was included within the byzantine and medieval cycles of the life of Christ. This event was confused with or collapsed into the *Walking on the Water.

Stole. From the Latin for "long garment." A narrow, embroidered liturgical vestment worn around the neck and extending to the ankles. The color of the stole was related to both the liturgical season, religious service, and the *chasuble. Signifying priestly authority and the yoke of Christ, a *stole was often embroidered with three *crosses—one at each end and one in the middle. The actual style of presentation of the stole signified the ecclesiastical rank of the wearer (crossed over the chest for a priest, hanging straight down for a bishop).

Stones. Geological symbols for resolution and strength. Stone(s) held by penitential *saints, such as *Jerome,

*Mary Magdalene, and *Barnabas, denoted mortification of the flesh. As a sign of martyrdom, stones are an *attribute of *Stephen.

Stork. A migratory bird symbolic of piety, prudence, chastity, and vigilance. As a harbinger of spring, the stork was associated with the *Annunciation to Mary (and hence with the universal delivery of babies). According to classical legend and the medieval *bestiaries, the stork protected and cared for its aged parents, and became a symbol of filial piety and devotion. According to the *Physiologus*, the stork as a slayer of *serpents signified *Jesus Christ.

Strawberry. A botanical symbol for *Mary in her sweetness, purity, and righteousness. The blood-red fruit signified *Jesus Christ and the Christian *martyrs. The trefoil leaves of the strawberry plant represented the *Trinity, while the five-petaled blossom the wounds of Christ. A combination of strawberries and *violets denoted the true humility of the spiritual and righteous believers.

Suffer the Little Children. *See* Blessing the Little Children.

Sun. A symbol for *Jesus Christ (Mal 4:2) and for *Mary (Rv 12:1). The source of light, heat, and energy, the sun represented spiritual illumination and glorification. In Christian art, the sun and the moon signified the passage from night into day at the Nativity and from day into night at the Crucifixion. The sun was an *attribute of *Thomas Aquinas.

Sunflower. A floral symbol for the Christian *soul in search of *Jesus Christ (as the *sun).

Surgical Instruments. *Attributes of *Cosmas and Damian.

Surplice. Vestment worn over a cassock during the liturgical service of the *sacraments. A symbol of holy truth, this knee-length *white linen tunic had an ornamented or lace-trimmed hem and flowing sleeves.

Susanna. From the Hebrew for "lily." According to the Roman canon of the *Old Testament, Susanna was the beautiful wife of Joachim, a prominent member of the Diaspora Jewish community in Babylon. One afternoon as she walked through her husband's garden, Susanna decided to bathe and sent her handmaidens for her bathing oils. After they returned, Susanna entered the *water as the servants departed to leave her in solitude. She was then accosted by two elders who were infatuated with her beauty. They threatened to bring false witness against her and accuse her of adultery with an unnamed youth. Despite the imminent danger of death by stoning (the penalty for adultery), Susanna refused the elders' demands that she have sexual relations with them, and called out for her servants. The elders then unjustly accused her of adultery and brought false witness against her in the courts. Found guilty of adultery, Susanna was sentenced to death by stoning. As Susanna approached the place of judgment, the young boy *Daniel cried out in her defense. All present returned to court where Daniel interro-gated each elder separately and proved they had lied against Susanna. Her innocence was glorified and the elders were punished. Prefiguring *Mary, the chaste Susanna became a paradigm of wifely virtues and an example of God's divine intervention on behalf of the innocent and the just. In earliest Christian art, Susanna signi-fied the triumph of innocence and was symbolized by a *lamb between two *wolves (the elders). Narrative figural compositions emphasized the trial in which the young prophet Daniel de-fended Susanna from unjust accusa-tion. Since she had placed her trust in God, *Augustine characterized Su-sanna as the epitome of wifely virtue and Christian womanhood as op-posed to *Lucretia, who committed suicide to protect her honor and the honor of her family. In *medieval art, the trial sequence was emphasized, as Susanna was interpreted both as a foretype of Mary and an example of legal justice. In *renaissance and *ba-roque art, the emphasis in depictions of the Susanna story shifted to repre-sentations of the *bathing scene. Dur-ing the seventeenth century, Susanna was described as more virtuous than Lucretia, and as the appropriate model for Christian women as honor-able wives and mothers in the moral-izing prints and engravings popular in Protestant countries.

Swallow. An avian symbol for the *Incarnation and the *Resurrection of Jesus Christ.

Swan. An ambivalent symbol for de-ceit, death, *Jesus Christ, and *Mary. The trumpeter swan only sang imme-diately before its death (the famed

146. *The Good Shepherd.*

147. Jacopo Tintoretto, *Susanna.*

148. *Synagoga.*

"swan song"), and thereby signified both the crucified Jesus and his last words on the *cross. A white swan was an *attribute of Mary.

Swine. An animal symbol for gluttony, sensuality, and *Satan, and an *attribute of *Anthony the Abbot.

Sword. A symbol of military and spiritual warfare and Christian martyrdom. As an *attribute of *Ares, *Athena, and the *virtues of fortitude and justice, the sword was assimilated into Christian art as an attribute of *James Major, *Michael the Archangel, *George of Cappadocia, *Louis of France, *Cecilia, *Paul, *Euphemia, *Agnes, *Alban, Cyprian, *Peter Martyr, *Lucia, *Catherine of Alexandria, *Julian the Hospitaler, *Thomas à Becket, Pancras, *Martin, Boniface, and *Justina of Padua.

Sword and scales. A symbol of virtue and *Justice, and an *attribute of *Michael the *Archangel.

Sylvester, Saint (d. c. 335). Bishop of Rome during the reign of Emperor *Constantine the Great. Sylvester was credited with the emperor's conversion to Christianity. Afflicted with leprosy, Constantine had a vision of *Peter and *Paul, who directed him to Sylvester for a cure. The pagan treatment for leprosy was to bathe in the *blood of innocent children. According to tradition, Sylvester bathed Constantine in the waters of Christian *baptism and cleansed him of this disease. In a variant of this legendary episode, Constantine was suffering from leprosy as he lay on his deathbed, but was relieved of his pain when Sylvester baptized him. In Christian art, Sylvester was depicted as dressed in pontifical *robes and *tiara, and holding a *crosier, a *book, and a picture of Peter and Paul. His *attributes included the *ox and the *dragon.

Synagoga. This blindfolded or veiled allegorical female figure represented the unbelief of *Judaism in *medieval art. She was contrasted to *Ecclesia, who was wide-eyed.

Synagogue. The place of assembly for the Jewish community, a House of Prayer, for religious, educational, and social functions. Following the destruction of the Temple of Jerusalem (70), the synagogue became the primary meeting place for Jewish community throughout the Diaspora.

T

T. From the Greek word for "God." Initial symbol for either God the Father or *Anthony the Abbot. The letter T denoted the Greek letter *tau*, which represented a *cross without an upper arm. According to one tradition, the *tau* cross was the protective sign used by the Israelites at the first *Passover. It also signified the *Brazen Serpent. In Christian art, the *tau* cross symbolized both eternal life in *Jesus Christ and the liturgical season of *Advent.

Tabernacle. From the Latin for "tent." A portable sanctuary or "temporary dwelling" for God used by the Israelites for their worship services in the wilderness or in exile. The *Ark of the Covenant was preserved within the curtained tent of the Tabernacle, but was later placed within the most sacred area of the Temple of *Solomon in *Jerusalem. In Christianity, the Tabernacle was the shrine on the *altar reserved for the *ciborium or *pyx, which contained previously consecrated eucharistic elements to be used as Viaticum for the sick or dying.

Tablets. A symbol of a teacher or an author. The four *evangelists and any of the major Christian authors had a tablet (with a *pen) as an *attribute. Two tablets represented the Ten Commandments given to Moses on Mount Sinai. Tablets falling from a blindfolded or veiled female figure signified *Judaism.

Talents. *See* Parables.

Tansy. An aster whose spicy fragrant oil had medicinal and magical powers, and thereby became an *attribute of *Mary in *medieval art. According to pious legend, the tansy was consecrated at the *Assumption of the Virgin Mary, and henceforth was used as a protection against magicians, *witches, and the *Devil.

Tecla, Saint. *See* Thecla, Saint.

Teeth. An *attribute of *Apollonia.

Temptation in the Wilderness (Mt 4:1–11; Mk 1:12–13; Lk 4:1–13). Following his *baptism, Jesus went into the wilderness for a forty day period of fasting and prayer in accordance with the *Old Testament prophecies and foretypes. This time was thought to have been a preparation for his public ministry. As he reflected on what his new role would be, Jesus was tested by God. At the end of this period, the *Devil's three temptations (as testings for Jesus's faithfulness) took place at three different sites—the wilderness, the pinnacle of the Temple, and on a *mountain. This event in Christ's life was prefigured in the Old Testament by the forty-year trial of the Israelites in the wilderness, the forty days that *Moses spent on Mount Sinai in order to receive the law, and the forty days that *Elijah traveled from the wilderness to Mount Horeb. In early Christian art, these temptations were rarely if ever depicted. Representations began in the ninth century with images of the Devil and Jesus on either the Temple pinnacle or the mountain. The Temptation in the Wilderness never attained a prominent pictorial theme or independent status, but was occasionally included within the narrative cycle of the life of Jesus Christ. The medieval model made the first temptation the main topic of interest, and thereby warranted more depictions, complex *iconography, and larger size, while the other two temptations would be represented on a smaller scale as side panel paintings. By the High Renaissance, the three temptations were conflated into one scene.

Ten. A mystical number of fulfillment and perfection as in the Ten Commandments and *Ten Bridesmaids. The number ten was a combination of three (signifying the *Trinity or God the Father) and seven (representing Humanity).

Ten Bridesmaids. See Parables.

Teresa of Avila, Saint (1515–1582). One of only two women named a *Doctor of the Church. This young Spanish woman entered a Carmelite convent against the wishes of her aristocratic but pious parents. An extraordinary devout woman, Teresa began having spiritual visions and conversations during her practice of spiritual exercises. In 1555, she reportedly experienced a "second conversion" which led to her fame as a mystic. As an ascetic reformer she initiated the austere order of the Discalced (barefooted) Carmelites, and was responsible for a resurgence of lay piety and spirituality in Counter-Reformation Spain. She worked with her confessor, *John of the Cross, to effect a reformed order of Carmelite Monks. An intense and brilliant woman, Teresa recorded her mystical and spiritual experiences with great clarity. Her books, including the *Interior Castle*, became a foundation for post-medieval mysticism. In Christian art, Teresa was depicted as a tall, physically large woman dressed in the white and brown *habit of the Discalced Carmelites. A popular topic in seventeenth-century southern *baroque art, Teresa was depicted within the context of three major spiritual episodes in her life: her ecstasy, the receipt of the Holy Nail from the Resurrected Christ, and the receipt of

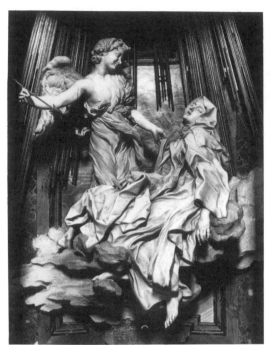

149. Gian Lorenzo Bernini, *The Ecstasy of Saint Teresa (of Avila)*.
150. *Theotokos Enthroned with Two Saints*.

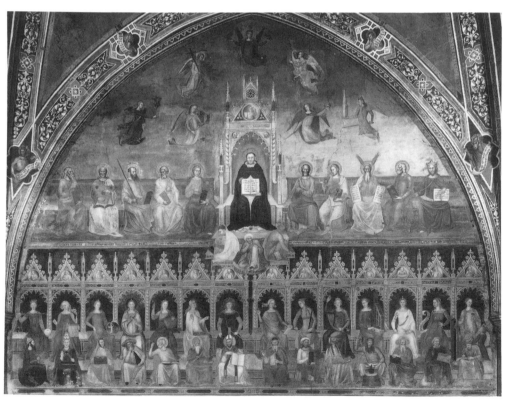

151. Andrea da Firenze, *The Triumph of Saint Thomas Aquinas*.

the *white *cloak from *Mary and *Joseph (of Nazareth).

Tetragrammaton. Four *Hebrew consonants that were transliterated as YHWH (or YHVH) to signify the most sacred name of God.

Tetramorphs. Symbolic creatures that represented either the four cherubim or, more commonly, the four *Evangelists: the winged young man (or *winged man's face) of *Matthew, the winged *lion of *Mark, the winged *ox of *Luke, and the *eagle of *John.

Thaddeus, Saint. *See* Jude Thaddeus, Saint.

Thecla, Saint (first century). This first female *martyr converted to Christianity by hearing the *gospel at the *feet of *Paul. The story of her conversion and her martyrdom were reported in the apocryphal *Acts of Paul and Thecla*. Having rejected her fiancé, Thecla gained permission to accompany Paul on a dangerous mission after she cut her *hair short and dressed in men's clothing. Although she suffered many tortures, including *flames and wild *beasts, Thecla survived to become a famed healer. Local physicians believed her curative powers were generated by her chastity. They sought to defile Thecla in their jealousy but were defeated when a *rock opened up to receive her as she fled from them. According to tradition, she died from old age inside the rock. In Christian art, Thecla was depicted as either a beautiful young woman, usually in a state of partial undress, who was tied to a *stake with *serpents or *lions at her feet signifying an attempted execution, or as an old woman dressed in a flowing *mantle holding either a *palm or a *pillar.

Theotokos. From the Greek for "God" and "to give birth to." This title was ascribed to *Mary by the Council of Ephesus (431) to distinguish her, her role, and her veneration. As a result of this decree identifying her as the Mother of God or the God-bearer, Mary began to be depicted only with the Child (either as an infant or an adult). The byzantine iconographic types of the Virgin and Child were identified as the Theotokos, and distinguished as to their spiritual or devotional intent by the gestures and postures of Mary and the Child.

Thirteen. Numerical symbol for faithlessness and betrayal. Thirteen was interpreted as an unlucky or evil omen.

Thistle. A botanical symbol for sin or sorrow as in God's curse on *Adam (Gn 3:17–18). A thorny plant, the thistle was also a sign of the *Passion of Jesus Christ and the sufferings of the Christian *martyrs. In the *hands of the Christ Child, the *goldfinch denoted the Passion as the *bird fed on thistles and *thorns.

Thomas, Apostle and Saint (first century). One of the original twelve disciples about whom much legendary material has been created. Best known as the "*Doubting Thomas," he failed to believe in the Resurrection until he was invited to touch the

320 · THOMAS AQUINAS, SAINT

*wounds of the Risen Christ (Jn 20:24–29). According to tradition, Thomas also failed to believe in the *Assumption of the Virgin Mary until she dropped her *girdle upon his *head. He reportedly evangelized India and was martyred there after a dispute with King Gundaphorous. Thomas was the patron of Christian India, architects, carpenters, masons, and geometricians. In Christian art, he was depicted as a youthful, beardless man holding either a *ruler or *carpenter's square, a *spear, or Mary's girdle.

Thomas Aquinas, Saint (c. 1225–1274). The "Angelic Doctor" of the *Church and the great systematizer of scholastic theology. A *Dominican, Aquinas studied with the great Dominican scholar Albertus Magnus (or Albert the Great) at the University of Paris. Aquinas is identified as the "Prince of the Scholastics" because of his masterful efforts to combine Aristotlean philosophy with Christian theology. The author of many significant theological books, Aquinas's most noted writing was the *Summa Theologica*. He was the patron of universities, centers of learning, and Roman Catholic schools. In Christian art, Thomas Aquinas was depicted as a short, portly man dressed in a Dominican *habit with the *sun embroidered on his chest. His *attributes included a *book, a *lily, a *dove, a *chalice, and an *ox.

Thomas à Becket, Saint (1118–1170). Distinguished by his intellectual and knightly accomplishments as Chancellor of England, he became archbishop of Canterbury on order of King Henry II in a royal attempt to control ecclesiastical power. Becket defended the integrity and honor of the *church against Henry, and was finally murdered at the instigation of the *king as he began the recitation of vespers at the altar of Canterbury Cathedral. This cathedral became an important *pilgrimage site from the time of Becket's canonization in 1172 until the reign of Henry VIII, when the tomb was destroyed and Thomas posthumously condemned for treason. In Christian art, Thomas à Becket was depicted as garbed in either a *black Benedictine *habit or episcopal *robes with *miter and *crosier. He was represented with a *sword in his *skull and/or *chest.

Thomas of Canterbury, Saint. *See* Thomas à Becket, Saint.

Thorn. Symbol for sin, tribulation, and grief. According to early Christian tradition, the thorn was interpreted as a result of the *Fall of Adam and Eve so that *Mary was described as a "rose without thorns," thus denoting her place in the paradise garden. An *Instrument of the Passion, the crown of thorns was a parody upon the Roman Emperor's *crown of *roses. The *tonsure of a priest or monastic was an allusion to the crown of thorns. *Saints were depicted wearing or holding a crown of thorns as a sign of their martyrdoms, while *Catherine of Siena and *Francis of Assisi wore (or held) the crown of thorns as a sign of their receipt of the *stigmata.

Three. A mystical number of completion (a beginning, a middle, and an

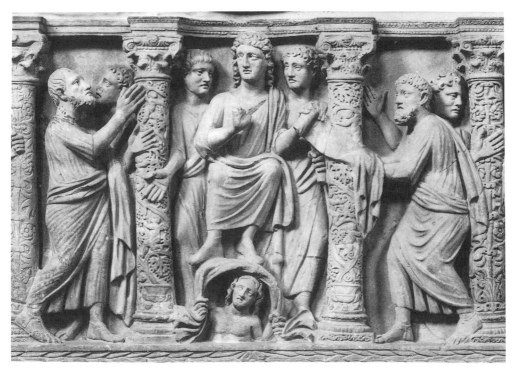

152. *Traditio Legis* detail from *Christian Sarcophagus.*

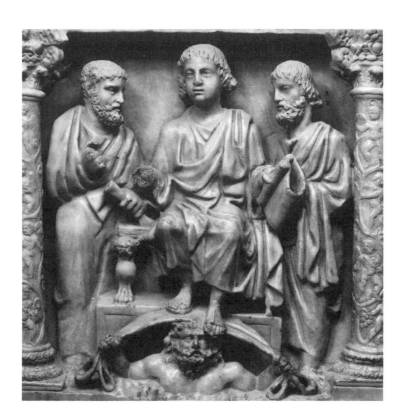

153. *Traditio Legis*
detail from
*Sarcophagus of
Junius Bassus.*

end), and supreme power. An indivisible number, three signified the *Trinity (God the Father, God the Son, and God the Holy Spirit), the three days that *Jonah lay in the belly of the *whale (or *sea monster), and the three days Jesus lay in the *tomb.

Three Marys at the Tomb. *See* Marys, Three, and Marys at the Tomb.

Throne (or **Cathedra**). From the Latin for "chair of authority." Official chair of the bishop, and the identifying characteristic of a *cathedral. A sign of episcopal dignity, the *throne was placed on the left (or *gospel) side of the sanctuary. In earlier Christian practice, the throne was located in the *apse behind the high *altar. In byzantine *iconography, the representation of the empty or vacant throne (*Etimacia*) denoted either God the Father or the Second Coming of *Jesus Christ.

Tiara. Reserved for use by the pope, this headpiece of three *crowns placed one on top of the other and surmounted by a *cross signified the *Trinity and the three estates of the *church (Rome, Christendom, and Spiritual Sovereignty). In northern *medieval and *renaissance art, the tiara identified either *Aaron as the foretype of Christian priesthood or God the Father. It was an *attribute of *Gregory the Great and *Sylvester.

Time (or **Father Time**). Anthropomorphic symbol for the cycle and transitory nature of human life. In Christian art, Time (or Father Time) was depicted as a winged, haggard, partially dressed old man with long *white *hair and *beard who carried an *hourglass. Other *attributes included a sickle, *scythe, *Zodiac, *snake or *dragon biting its own tail, or crutches.

Toad. Amphibian symbol for death, vices of lust, and greed. Related to the *frog, the toad was also a creature of dark and moist places. The toad was an attribute of the *Devil.

Tobias. A foretype of *Jesus Christ and a sign of filial piety and devotion. Son of the aged and blind Tobit, Tobias was dispatched on a long business trip. Tobias and his faithful little *dog were joined by a disguised *Raphael the *Archangel. He instructed Tobias in the art of fishing, and of cleaning (reserving the offal) of a powerful *fish which they ate. They rested one evening in the home of his cousin Sarah—a seven-time widow on her successive wedding nights. Raphael advised Tobias how to exorcise the *demon Asmodeus from Sarah so that the young hero could marry her. Upon their return to his father's home, Raphael counseled Tobias on the use of the fish offal to restore his father's vision. A paradigm for the theology of the guardian angel, the story of Tobias was recounted in the apocryphal Book of Tobit. In Christian art, Tobias was depicted as a handsome young man accompanied by his faithful little dog and the Archangel Raphael.

Tomb. A symbol for death and/or burial of the dead. In Christian art, the tomb (or *sarcophagus) was integral to the *iconography of the *Res-

154. *Transfiguration.*

155. *Transfiguration.*

urrection of Lazarus, the *Entombment, and the *Resurrection of Jesus Christ.

Tongs. Instruments of torture and *attributes of Dunstan and Eloi.

Tonsure. A symbol for the crown of thorns, the rejection of material things, and the possibility of the perfect life by a cleric or monastic. This sacrifice of *hair involved shaving hair from the top of the *head during the ceremony of induction into the clerical or monastic state.

Torch, Burning. Fire symbol for *Jesus Christ as the Light of the World in scenes of the Nativity or the Passion, especially the *Betrayal by Judas. The burning torch was an *attribute of *Dorothea, *Dominic, *Thomas Aquinas, and those saints who were martyred by burning.

Tortoise. A symbol for chastity and reticence, especially in the *hands of either *Mary or the Christ Child.

Towel. A symbol for rituals of cleansing, and spiritual purity. A spotless white towel was a symbol of the Virgin Annunciate. A towel and a *basin signified either *Mary or *Pontius Pilate.

Tower. Architectural symbol of virginity, vigilance, and inaccessibility. In Christian art, the tower was an *attribute of *Barbara, the Virgin Annunciate, and the *Immaculate Conception.

Traditio Legis. Latin for "giving of the law." An iconographic motif which merged with the Charge to Peter (Mt 16:19). The *Traditio Legis* denoted the giving of the new law by *Jesus Christ to *Peter. This new covenant subsumed and superseded the Mosaic Law. The earliest representations of this motif in fifth-and sixth-century *byzantine art depicted Christ seated (or standing) between Peter and *Paul. On Christ's right, Paul received the Law and Peter acclaimed this act. In later presentations, especially those after the eighth and ninth centuries, Peter and Paul reversed positions. This motif, like the Charge to Peter, was used as an iconographic and scriptural affirmation of the Primacy of Peter. Popular in southern *baroque art, the *Traditio Legis* came to symbolize the *sacrament of ordination.

Transfiguration of Jesus Christ (Mt 17:1–13; Mk 9:2–13; Lk 9:28–36; 2 Pt 1:16–17). Scriptural event signifying the glorification of *Jesus Christ on Mount Tabor. Accompanied by *Peter, John, and *James, Jesus went to Mount Tabor to pray. The disciples feel asleep, and when they awoke they saw Jesus glorified and in conversation with *Moses and *Elijah. The presence of these *Old Testament figures denoted Law and Prophecy, and the vision of the Cloud and Voice of God. This theophany was central to the Eastern Christian affirmation of Jesus as the Christ during the fourth-century Christological controversies, and was declared a liturgical feast by the sixth century (although it was not formally celebrated as such in Western Christianity until the fifteenth century). The presentations of this event in the sixth-century

images at Saint Catherine's Monastery, Sinai, and San Apollinare in Classe, Ravenna, defined the two iconographies for the Transfiguration into the sixteenth century. At Saint Catherine's Monastery, the figural and narrative depiction represented the glorified Jesus floating above Mount Tabor with Elijah and Moses to his left and right and with the sleeping disciples below. San Apollinare in Classe's symbolic and devotional presentation offered a glorified *cross with a bust medallion of Jesus floating in the sky with medallions of Elijah and Moses to the right and left, while the sleeping disciples were signified by three *sheep on the *paradise gardenscape below. In his last painting, the renaissance master *Raphael Sanzio conflated the Transfiguration with the Resurrection and the Ascension, thus establishing a new iconographic type for this event which continued into the nineteenth century.

Treasure. Financial symbol, usually a chest with coins or pieces of silver; an *attribute of *Laurence.

Tree of Jesse. A decorative motif created to display the genealogy of *Jesus Christ according to Matthew and Isaiah. In these depictions, Jesse, the father of *David, sat or reclined on the ground as a tree grew from his genitals. The *flowers or *fruits of this tree represented the Christ's ancestors, and at the top of the tree was a depiction of *Mary and the Christ Child. This *iconography was introduced into Christian art in a stained-glass window designed by the Abbot Suger for the Cathedral of Saint Denis, Paris. According to medieval tradition, the Tree of Jesse was a dead *Tree of Life which was resurrected by Christ's blood. In northern *medieval and *renaissance art, the Tree of Jesse had a representation of *Anne, the Virgin, and Child at the top. In southern renaissance art, the tree took on the physical characteristics of a *vine, suggesting eucharistic symbolism.

Tree of Life (or **Arbor Vitae**). A decorative motif from Middle Eastern art which signified immortality. The Tree of Life was depicted as filled with green leaves and flowers; in contrast the Tree of Good and Evil (or Tree of Knowledge) was represented as being on the edge of death like humanity after the *Fall of Adam and Eve. According to popular tradition, the Tree of Life was believed to be used for the *cross of *Jesus Christ. In Christian art, the Tree of Life symbolized *paradise and eternal life.

Trees, symbolism of. Symbols for the cycle of life, death, and resurrection in the fullness of the four seasons. As the one of the "fruits of the earth," trees—like *flowers and *plants—contained the seeds for each new and successive generation. As a generic symbol, a tree indicated growth, creative power, and immortality as its vertical thrust signified a link between *heaven and *earth. In Christian art, trees were purely decorative while a specific tree was an integral element of the theological intent of the image; for example, the *oak tree signified God the Father while the evergreen tree symbolized the Resurrected Christ. Trees played a central role in

many biblical, apocryphal, and legendary stories including the Temptation and Fall, the trial of *Susanna, the *Annunciation to Mary, and the *Entry into Jerusalem. Created on the third day, trees denoted meaning by their physical conditions, so that flourishing and flowering trees represented the positive values of life, hope, holiness, and health while a withering or dead tree suggested the negative values of diminishing powers and death. See also Acacia, Almond Tree, Aspen, Cedar, Cherry, Cypress, Elm, Fig Tree, Fir Tree, Ilex, Laurel Tree, Oak, Olive, Palm Tree, Pine, Plane Tree, Willow, and Yew Tree.

Trefoil. A symbol for the *Trinity and an *attribute of *Patrick.

Trent, Council of. See Council of Trent.

Trial of Bitter Waters (Nm 5:11–31). A test devised to gauge the guilt or innocence of a woman accused of adultery. According to the apocryphal *Protoevangelium of James* (15:1–4, 16:1–3), the High Priests demanded that *Mary and *Joseph (of Nazareth) take the Trial of Bitter Waters to prove their innocence as she was pregnant and had been a temple maid (and thereby in the care of the High Priests). Although rare, depictions of the Trial of Bitter Waters existed in early Christian and *byzantine art. Mary was represented drinking the bitter herbs; to the amazement of the High Priests, she survived her ordeal without sickness or death. This event became conflated with Joseph's first dream in *medieval

art but was rarely depicted after the early medieval period.

Trial of Jesus Christ Before the High Priests Annas and Caiaphas (Mt 26:57–68; Mk 14:53–65; Lk 22:66–71; Jn 18:12–14, 19–24). Immediately following his arrest by the Roman soldiers, *Jesus Christ was brought to the High Priests Annas and Caiaphas for judgment on the charge of blasphemy. Caiaphas rent his priestly garments in horror over the blasphemy he had heard. Annas and Caiaphas found Jesus guilty and condemned him to death. This event was rarely depicted as an independent topic in Christian art. Jesus was represented standing before the two priests, identified by their garments, as Annas's gestures indicated the questioning of the accused and Caiaphas ripped his priestly *robe with his two *hands. As a part of the Passion, the Trial before the High Priests Annas and Caiaphas never offered the drama or garnered the interest of the *Trial of Jesus Christ before Pontius Pilate.

Trial of Jesus Christ Before Pontius Pilate (Mt 27:11–16; Mk 15:2–14; Lk 23:2–24; Jn 18:29–40). Following the condemnation by the High Priests, *Jesus Christ was taken to the Roman governor, *Pontius Pilate, for an affirmation of this condemnation. According to Roman law, Jesus had to be found guilty of a civil charge such as treason. Without a treasonous response to his query if he were King of the Jews, Pilate found no fault in Christ. Hoping to release him and still retain peaceful relations with the High Priests, Pilate offered him for release to the crowd according to the

Roman custom at *Passover. Primed by the High Priests and Pharisees, the crowd asked not for Jesus but for Barabbas. As the crowd cried out for the blasphemer to be punished (crucified), Pilate publicly washed his *hands and declared himself free from the *blood of this innocent man.

Trials of Jesus Christ. *See* Trial of Jesus Christ before the High Priests Annas and Caiaphas, and Trial of Jesus Christ before Pontius Pilate.

Triangle. A geometric symbol for God the Father or the *Trinity. A triangular *halo was reserved for God the Father.

Tribute Money (or **Half-Shekel** or **Temple Tax**) (Mt 17:24–27). When the tax collectors asked *Jesus Christ for a tribute at Capernaum, he instructed *Peter to catch a *fish in whose mouth he would find the necessary tax money. This event was rarely depicted in Christian art, except within the context of the life cycle of Jesus Christ.

Trinity. The Christian doctrine that God—the one, unique and invisible—exists as three identities or hypostases: God the Father, God the Son, and God the Holy Spirit. As metaphysical paradox the reality of this sacred mystery surpassed all human understanding. In Christian art, representations of the Trinity were initially symbolic—the *triangle, three intertwined *rings, a *trefoil, or the grouping of the *hand of God, the *lamb, and the *dove. Following the iconographic pattern of the three *angels of the Philoxeny of *Abraham

as a foretype for the Trinity, Christian artists depicted three identical male figures of varied ages on separate thrones to signify the Trinity. The initial biblical event used for the representation of the Trinity was the *Baptism of Jesus Christ, in which the voice (the Father) affirmed Jesus (the Son) with the sign of the dove (the Holy Spirit). In northern *medieval and *renaissance art, the motif of the *Gnudenstuhl* or Throne of Mercy reflected the Trinity while God the Father held the crucified body of *Jesus Christ while the dove of the Holy Spirit hovered between them.

Triptych. An altarpiece composed of a large central panel and two attached side panels or wings. These side panels were hinged onto the central panel, and could be opened or closed depending upon the liturgical season or feast. The closed wings of the triptych were decorated with motifs which prefigured the *iconography of the central panel. The interior wings and central panel worked in an iconographic unison to create an overall narrative or scriptural theme.

Tunicle. This short *dalmatic worn by a subdeacon signified joy and contentment.

Turtledove. An avian symbol for purity. Two turtledoves in a basket were offered by *Joseph (of Nazareth) at the *Purification of the Virgin Mary.

Twelve. A mystical number of maturation or natural fulfillment, as in the twelve months of the year, the twelve disciples, the twelve signs of the *Zodiac, the twelve tribes of Israel, the

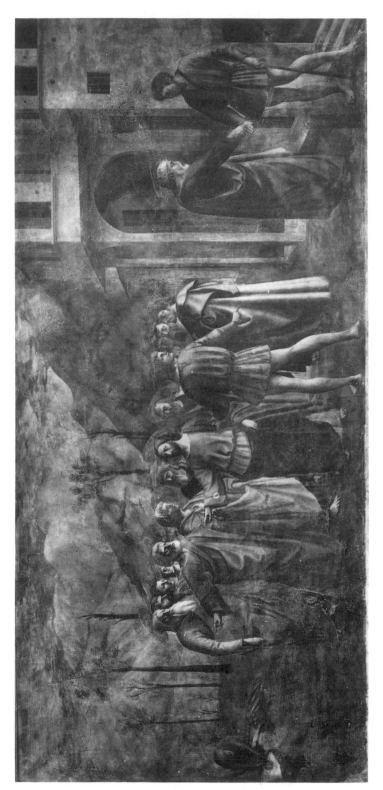

156. Masaccio, *The Tribute Money.*

twelve *prophets, the twelve *sibyls, and the twelve *stars in the *crown of the *Woman Clothed with the Sun.

Two. A numerical symbol for the humanity and the divinity of *Jesus Christ, and the male and the female species of human and animal life.

Two Debtors. *See* Parables.

Two Foundations. *See* Parables.

Two Sons. *See* Parables.

Tympanum. This semicircular or pointed space atop the lintel and enclosed by an arch was positioned over a *church or *cathedral *door. Carvings or sculptured reliefs in a tympanum presented the narrative or symbolic cycles of the *Old and *New Testaments. In medieval cathedrals, the *Last Judgment or *Majestas Domini* was represented on the tympanum over the Royal Portal.

U

Unicorn. A *mythical beast composed of *head and body of a *horse, the *beard of a *goat, the legs of a buck, and the tail of a *lion, with a single *horn in the middle of its forehead. Described in a variety of literature including the *Old Testament, the *Physiologus, and The *Golden Legend, the unicorn was believed to have had magical, medicinal, and curative powers which were accentuated by the fact that a unicorn would only appear to (and allow itself to be captured by) a young virgin. In Christian art, the unicorn signified purity and chastity, and was a symbol of *Jesus Christ, the Virgin Annunciate, the Perpetual Virginity of Mary, and all virgin *saints. It was an *attribute of *Justina of Padua and *Justina of Antioch.

Uriel, Archangel and Saint. From the Hebrew for "the light of God." One of the four *archangels identified by name in the *Bible. Uriel was present with the disciples at *Emmaus, and was the angel guardian of

the Holy Sepulcher. In Christian art, he was depicted as a tall, muscular young man with long archangel *wings who carried a *book or *scroll.

Urn. A container for oils, ointments, perfumes or *water, and a feminine symbol for cleanliness, fertility, and death. An elegantly decorated urn signified *Mary Magdalene and *Susanna.

Ursula, Saint (fifth century). A medieval princess whose legendary life and martyrdom were reported in the chronicles of Geoffrey of Monmouth and The *Golden Legend. A beautiful young princess, Ursula consented to marry Prince Conon on three conditions: that he and his court converted to Christianity, that she be granted ten noble virgin companions, each of whom had one-thousand virgin handmaidens, and that she and her companions be allowed a three-year *pilgrimage to the shrines of all the Christian *saints of Europe. Follow-

157. Benozzo Gozzoli, *Saint Ursula with Angels and Donor.*

ing her final pilgrimage to Rome, Ursula and her eleven-thousand virgin companions were slain by the Huns in Cologne. According to tradition, Ursula was spared by the leader of the Huns, but after she rejected him, he killed her with three *arrows. She was the patron of chastity, marriage, drapers, and teachers, and was invoked against the plague. In Christian art, Ursula was depicted as a beautiful young woman dressed in regal *robes with a jeweled *crown. She held an arrow or pilgrimage *staff with a *white *banner inscribed with a red cross. She was accompanied by her eleven-thousand virgin companions, who were represented either kneeling at Ursula's *feet, enclosed in the protection of her royal robes, or laying dead around her.

Vanitas. From the Latin for "emptiness." A *still-life painting which had religious overtones and which flourished in northern European art after the Reformation. A collection of objects were chosen and arranged to remind the viewer of the transitory and uncertain nature of human existence. From Ecclesiastes 1:2 ("*vanitas vanitatum . . .*" or "vanity of vanities"), a vanitas was identified by its hourglass with sand running out, *skulls, *mirrors, *butterflies, *flowers, and guttering *candles. The vanitas was derived from the northern European fascination with the *memento mori* depictions of *Jerome, which led to the variant known as *Melancholia.*

Vase. A generic feminine symbol of containment having multiple meanings in Christian art. An empty vase signified the body separated from the *soul. A vase rimmed with *birds quenching their thirst symbolized eternal bliss. A vase with a *lily (or lilies) was an emblem of the *Annunciation to Mary. A clear glass vase, in Annunciation or Nativity scenes, implied the perfect purity and perpetual virginity of Mary. A vase of ointment or perfumes was an *attribute of *Mary Magdalene and *Susanna.

Vegetables, symbolism of. Botanical symbols for the cycle of life, death, and resurrection in the fullness of the four seasons. As the produce of the earth, vegetables like *fruits and *flowers contained the seeds for each new and successive generation. As a generic symbol, vegetables indicated the abundance of harvest, fertility, and earthly desires (as associated with fecundity and creation of new life). In Christian art, vegetables could be purely decorative, but a specific vegetable had an integral meaning with regard to the theological intent of the image; for example, the combination of cucumbers, *peaches, and *pears signified good works. *See also* Gourds, Leek, Olive, and Thistle.

Veil. A piece of cloth, often translucent, which concealed the wearer's

hair or face, denoting modesty, chastity, and renunciation of the world. As a religious garment, the veil was the outer covering of a *nun's headdress. A veil with the *head of *Jesus Christ, technically a vernicle, was an *attribute of *Veronica. It was also an attribute of *Agatha, whose veil on a spear stemmed the flow of lava from Mount Etna, thereby saving Catania.

Veil of Veronica. Representation of the *head of *Jesus Christ depicted on a veil and one of the best-known *acheiropaeic images in Christian art. The veil was an *attribute of *Veronica, who was reputed to have dried Jesus's face with her handkerchief as he carried his *cross to *Calvary. The imprint of his face remained miraculously on this sweat cloth (*sudarium*) or vernicle, creating an *acheiropoitos. The narrative source for the Veil of Veronica was the apocryphal *Gospel of *Nicodemus.*

Venus. The Roman goddess of love, grace, fertility, and beauty. Several classical Greco-Roman myths were the basis of Venus as the foretype of both *Eve and *Mary. She won the golden *apple thrown into the wedding feast of Thetis by offering Paris the most beautiful woman in the world, thereby initiating the Trojan War. From the blood of her beloved Adonis sprang the *anemone. His death was interpreted in Ovid's *Metamorphoses* as a prime example of a metamorphosis—the death and rebirth of flowering nature. As the mythical mother of Aeneas, Venus became the "Mother of All Romans." A popular image in art, Venus was depicted as a beautiful young nude woman. Her special *attributes were the *rose and the pearl. The two artistic styles of representing the nude Venus as either the "crystalline" Venus or the "vegetable" Venus denoted the classical concepts of Sacred and Profane Love. The gestures, postures, and attributes of the "crystalline" Venus were assimilated into images of Mary, while those of the "vegetable" Venus became associated with Eve.

Veronica, Saint. A legendary woman whose story of her encounter with Jesus on the *Road to Calvary had no canonical scriptural authority, but could be found in the apocryphal *Gospel of Nicodemus.* An unnamed pious woman offered her linen handkerchief to Jesus on his way to *Calvary to wipe the sweat from his brow. When the cloth was returned to her, she found the imprint of his visage. Her name thereby became Veronica, from the Latin *vera icon* for "true likeness." By the *medieval period, she was conflated with the unnamed *Woman with the Issue of Blood (or *hemorrisha*). Also identified as the vernicle or *sudarium* ("sweat cloth"), Veronica's Veil has been preserved at Saint Peter's Basilica Church since the eighth century. This miraculous portrait was an *acheiropaeic image, that is, "one not made by hands." The patroness of linen drapers and washerwomen, Veronica's *attribute was the cloth bearing Jesus's portrait.

Vestments, liturgical. Garments worn by priests and other ecclesiastics at specific liturgical and church ceremonies. Worn over the cassock or habit, liturgical vestments developed

158. Hans Memling, *Saint Veronica.*
159. Piero di Cosimo, *The Visitation with Saint Nicholas and Saint Anthony Abbot.*

160. Rogier van der Weyden, *The Vienna Crucifixion.*

from ancient priestly ceremonial robes and civil Roman costumes.

Vices. Abstract personifications of evil were depicted in *medieval and *renaissance art, especially in cathedral carvings, and prints and engravings. The Seven Vices were Pride, Covetousness, Lust, Anger, Gluttony, Envy, and Sloth. Unlike the Seven *Virtues, the *attributes of the Seven Vices were neither clearly defined or regularized. *See also* Seven Deadly Sins.

Vincent of Saragossa, Saint (fourth century). A *deacon in Saragossa during the Diocletian persecutions who was subjected to horrific tortures. Dacian, the Roman Proconsul, sought to destroy Vincent's Christian commitment through tempting luxuries, including a fine bed of down strewn with *flowers upon which the tortured Vincent was lain. Placed on the bed, Vincent commended his spirit to God and died. Dacian ordered the corpse abandoned to wild animals, but it was guarded against all attackers by a *raven. Weighted down with a *millstone, Vincent's body was thrown into the *sea, only to be miraculously washed ashore and buried in the sand until it was discovered and transferred to Valencia for sacred burial. In Christian art, Vincent was depicted as a beautiful young man who was dressed in the *habit of a deacon and carried the *palm of martyrdom. His special *attribute was two *crows, who accompanied his relics from Cape Saint Vincent for burial. His attributes were a *whip, *chain, *grill with iron hooks, and *millstone, which signified his tortures.

Vine and Vine Leaves. Ancient symbols of peace and plenty, widely used in the *Old and *New Testaments to denote the relationship between God and his people. The vineyard was the sheltered site where the Keeper of the Vineyard (God) tended his vines (the children of God) (Is 5:7). As an emblem of *Christ, it was the "true vine" (Jn 15:1, 5, 8). Vine and vine leaves referred to the Christian *church—God was the keeper of the vineyard—and were also a symbol of the *Eucharist.

Violet (as a color). The color alternately of love and truth, or of passion, penitence, sorrow, and suffering. It was worn by penitiential saints such as *Mary Magdalene, and by *Mary following the Crucifixion.

Violet (as a flower). Small and common flower denoting humility, modesty, and hidden virtue. Violets grew low to the ground with its blossoms dropping in shyness. It was a floral *attribute of *Mary, who was described by *Bernard of Clairvaux as the "violet of humility." This flower implied the humility associated with *Christ's humanity. White violets were the attribute of Fina.

Virgin Birth. The miraculous conception of *Jesus Christ. Following Roman Catholic and Eastern Orthodox Church teaching, *Mary was believed to have conceived by the *Holy Spirit, and therefore her virginity was not damaged. A series of miraculous conceptions and virgin births in classical Mediterranean mythology prefigured this event. The scriptural foundation for the miraculous con-

161. William Blake, *The Parable of the Wise and Foolish Virgins.*

ception derived from Isaiah 7:14, Matthew 1:18, and Luke 1:34–5, 3:23. The story of the testimony of *Salome the Midwife was found in the apocryphal *Protoevangelium of James*.

Virtues. Abstract personifications of good were popular in *medieval and *renaissance art, especially in *cathedral carvings, and in prints and engravings. Personified as female, the *Seven Virtues were *Faith, *Hope, *Charity, Temperance, Prudence, Fortitude, and Justice. Faith, Hope, and Charity were identified as the Theological (or Christian) Virtues, which were attained through faith, while the other four were known as the Cardinal Virtues, which were attained through training and discipline.

Visitation (Luke 1:39–56). Scriptural event denoting the visit of *Mary, immediately following the Annunciation, to her elder cousin *Elizabeth, then pregnant with her son, *John the Baptist. Elizabeth and her unborn child acknowledged through word and deed the special child in Mary's womb; the unborn John reportedly leapt with joy, while his mother proclaimed the greeting that has been incorporated into the Ave Maria. Mary responded with the poetic hymn that became identified as the *Magnificat. In early Christian and *byzantine art, the depiction of the Visitation was part of the narrative cycle of the *Nativity of Jesus Christ. The two women were depicted either in an embrace or in conversation. In the fourteenth century, due to the influence of *Bonaventure, the Visitation be-

came an independent and important Marian feast. The *iconography of the Visitation was distinguished from the Nativity cycle, and became an independent topic. In the High Middle Ages, a new motif developed in which the two infants were displayed in their respective mother's womb (later proscribed by the *Council of Trent). In fifteenth-century Flemish manuscript *illuminations, Elizabeth was depicted kneeling before Mary, who reached out to embrace her cousin.

Vitus, Saint (d. 303). A Sicilian nobleman who was converted to Christianity by his tutors. His pagan father attempted to have his son recant by having him scourged and imprisoned. The angels who came to visit him danced with Vitus. He cured Diocletian's son from possession, but refused to deny his faith and was tortured and thrown to the *lions. When the beasts refused to destroy Vitus, licking his feet instead, he was boiled in a cauldron of hot oil. One of the *Fourteen Holy Helpers, Vitus was the patron of dancers and mummers, and invoked against epilepsy, Saint Vitus's dance, insomnia, and difficulty in getting up in the morning. He was the protector against *snake bite and mad dogs. His *attributes included a *cock, *dog, and *wolf. He was depicted in Christian art as a naked young man standing in a cauldron.

Vocation of the Apostles. *See* Calling of the Apostles.

Vulgate. *Jerome's fourth-century translation of the *Bible into Latin, or the vulgar (common or vernacular)

language. His occasional poor translations, such as *Moses' *horns instead of rays of light, were important in the development of Christian *iconography. A revised version of the Vulgate was approved by the *Council of Trent.

W

Wafer. Symbol for the manna of the *Old Testament, or the *Eucharist. The wafer was an *attribute of *Barbara and *Bonaventure.

Walking on the Water (Mt 14:22–23; Mk 6:45–52; Jn 6:15–21). The disciples were dispatched by boat to Capernaum, when Jesus noted that they rowed with great difficulty because of a strong wind, he walked across the *water to assist them. *Peter tried to join Jesus on the water, but sank and cried out for help. Together they walked to the boat and the wind ceased. This event was rarely depicted as a separate topic in Christian art, but was included within the byzantine and medieval cycles of the life of Christ. This event was confused with or collapsed into the *Stilling of the Water (or *Navicella*).

Wallet. Symbol of travelers and *pilgrims, and an *attribute which signified the *Archangel *Raphael, and *Roch and *James the Evangelist.

Wand. A slender staff which possessed magical powers such as those used in classical Mediterranean art and mythology by the healers, like Aesklypios, and magicians. In the *Old Testament, Aaron's staff was transformed into a *serpent that swallowed the serpents of Pharaoh's sorcerers, and *Moses used his *staff to strike the *rock and bring forth *water. The many suitors for *Mary left their staffs overnight in the Temple, but only *Joseph (of Nazareth)'s flowered as a sign that God had chosen him to be Mary's husband.

Wandering Jew. The anonymous *Jew of medieval legend who refused to permit Jesus to rest at his door on the *Road to Calvary. This Jew was condemned, therefore, to wander over the face of the *earth until *Judgment Day. Many variations on the story were related in medieval and renaissance texts.

Washbasin. A symbol for cleanliness. This was a frequent *attribute of the

Virgin Annunciate in northern, especially Flemish, *medieval art.

Washing the Feet of the Apostles (Jn 13:1–20). Prior to the *Last Supper, Jesus washed the feet of each of the twelve disciples as a sign that God in Christ had come to serve humanity. This event was included within the Passion cycle in *byzantine, *medieval, and *renaissance art. It was rarely depicted as an independent topic in Christian art. Jesus was shown kneeling at the feet of the twelve seated disciples with a *washbasin, *pitcher, and *towel. The disciples had facial expressions and gestures of awe and reverence.

Water. Symbol for cleansing and purification, especially in relation to the *sacrament of *baptism. This particular Christian rite involved the washing away of sin and the birth into a new life as a preparation for the *Last Judgment. The act of washing, or the accessories of *water and washing, implied innocence, for example when *Pontius Pilate washed his hands (Mt 27:24–26) or the Christian catechumen was immersed into the baptismal waters. In the *Old Testament, water suggested struggle, trial, and tribulation like the Flood (Ps 69:1,2; Gn 21:7). The *ewer and basin, *pitcher, transparent *vase, *fountain, and *well were symbols related to water which also signified the virginity and purity of Mary. When mixed with wine during the Zéon rite of the sacrament of Eucharist in the Eastern Orthodox Church, water denoted the humanity of Jesus Christ as the wine was his divinity. This rite was represented in depictions of the *Last Supper and Communion of the Apostles by the liturgical vessels of a wine ewer and a water pitcher, and in representations of the Crucifixion by the *red and *white streams from the wounded side of Jesus.

Weasel. In the *Old Testament, this was an unclean animal which was reputed to conceive through its *ear and to give birth through its mouth (Lv 11:29). According to *medieval *bestiaries, the weasel was familiar with herbs and could cure its young of illnesses with rue. In Christian art, it signified *Christ's victory over *Satan as the weasel's traditional enemy, the *basilisk, was a symbol of evil.

Wedding Banquet. *See* Parables.

Weeds Among the Wheat. *See* Parables.

Well (or **Fountain**). A symbol of *baptism, salvation, and of life and rebirth (Rv 22:1). The *waters of eternal life were depicted as a flowing well, whereas a sealed well alluded to the perpetual virginity of *Mary. Three wells, or fountains, grouped together were an *attribute of *Paul, for according to pious legend his severed *head hit the ground in three places after his martyrdom. In those three places, three wells, or fountains, sprang up.

West. One of the four cardinal points which specified darkness and the home of *demons. The west *rose *window of the *gothic *cathedral made the light of the *gospel accessible to those seated in darkness.

Weyden, Rogier van der (1399/1400–1464). The leading Flemish painter in the middle of the fifteenth century. With minimal extant biographical evidence, Rogier was identified as a student of Robert Campin or the Master of Flemalle. His work was filled with a depth of religious feeling and expressed in linear and sculptural terms. His work was influential in Flanders and Germany into the late fifteenth century. Concerned with human emotion, Rogier had a personalized sense of color tending towards gold and pale, bright colors which combined with his stylizations of gestures and facial expressions. His masterpiece, the *Deposition*, was filled with iconographic innovations, including the depiction of tears and the swooning *Madonna whose bodily contortions signified her compassion for her son's passion. Technically proficient, Rogier was an iconographic innovator of the highest caliber.

Whale. This aquatic mammal signified containment and concealment. As a symbol of the *Devil, whose cunning enticed unbelievers into the depths of *Hell, the whale's huge body was interpreted as an island and the *ships which anchored there were destroyed when the whale dove into the *waters. His open mouth represented the gates of Hell. In the *Old Testament, *Jonah was swallowed by the whale and rested there for three days as a foretype of the *Entombment and *Resurrection of Jesus Christ. The whale denoted the *tomb of Jesus and symbolized the passion, death, and resurrection experience (Jon 1:17, 2:1–2, 10). In early Christian art, the whale was a popular symbol of the faithful who trusted in God and were saved.

Wheat. Symbol of the bounty of the *earth. As the source of the bread of life, sheaves of wheat signified both the *Eucharist and *Mary, metaphorically the container of the grains from which came the flour for the Eucharist.

Wheel. A never-ending, rotating circular force which symbolized supreme power. In *medieval and *renaissance art, it was used to expel *Adam and *Eve from the *Garden of Eden. The burning or flaming wheel with eyes and wings supported the Throne of God according to the vision of *Ezekiel (Ez 1:1–28). An *attribute of *Catherine of Alexandria, the Catherine Wheel was a sign of her martyrdom. The Wheel of Fortune was a medieval allegory for the transitoriness of human existence, wealth, and the futility of worldly goods.

Whip (or **Scourge**). An *Instrument of the Passion, and used as a symbol for punishment by whipping or flagellation. An *attribute of *Ambrose of Milan, it signified the expulsion of the heretics from Italy. The whip was also an attribute of Vincent, who was martyred by being beaten with a whip (or scourge).

White. A color symbolizing innocence, light, joy, purity, virginity, faith, glory, holiness of life, and the *soul (Ps 51:7; Mt 17:2; Mt 28:3). *Christ wore white after the Resurrection, while *Mary wore white in the *Immaculate Conception, Assumption, her *Presentation in the

Temple, and scenes prior to the Annunciation. The white garments of Roman vestal virgins signified their innocence and purity and led to the customs of white garments for brides, those receiving first communion, and for baptism. If worn by a judge, a white robe denoted integrity; by a wealthy man, humility; and by a woman, chastity. Early Christian clergy wore white, a practice which was continued as the liturgical color for *Christmas, *Easter, Ascension, and other joyous feast days (including the feasts of the Blessed Sacrament and the feasts of Mary and *angels, confessors, virgins, and women not martyred). This was also the liturgical color from Holy Saturday through *Pentecost. White vestments were worn for the burial of *children and the clergy, and since Vatican II for all funerals as liturgies of resurrection, and for marriage ceremonies. The color of light, white was also represented by silver.

Wicked Tenants. *See* Parables.

Widow and Unjust Judge. *See* Parables.

Wild Beast. A zoological symbol for the conversion of savage pagans or barbarians to Christianity.

Willow. A symbol for the *gospel of *Christ. Although widely distributed among the peoples of the world, the gospel remained intact like the willow tree, which survived no matter how many of its branches were cut off. In depictions of the Crucifixion or *Lamentation, the willow signified the tears shed in grief and over the dead.

Wimple. A linen covering wrapped around the head, neck, and cheeks of a medieval woman for warmth. Popular in fourteenth-and fifteenth-century Flanders, the wimple is found in late medieval northern art. As a sign of modesty, it was adapted as part of a *nun's *habit.

Window. An opening in a wall implying penetration without destruction or violation of the integrity of the wall. The clear glass used in windows symbolized the perpetual virginity of *Mary, and was popular in northern *medieval art, especially in depictions of the Annunciation.

Winepress. An *Old Testament symbol for the wrath of God (Is 63:3). A popular medieval image, the *Mystical Winepress signified the redemptive suffering of *Christ and the salvation promised through the *Eucharist. The mystical winepress was prefigured by the bunch of *grapes *Hebrew spies carried on a *pole from the Promised Land (Nm 13:17–33).

Wings. Symbolic of divine mission; hence the *angels, *archangels, seraphim, and cherubim have wings. The emblems of the four *Evangelists all have wings: the winged *lion of *Mark, the winged *ox of *Luke, the winged young man of *Matthew, and the winged *eagle of *John.

Wisdom. Intellectual capacity as personified by the allegorical figure, Sapientia, who was characterized as a

lady of nobility, or the Greek goddess *Athena (*Minerva). One of the Seven Gifts of the *Holy Spirit, Wisdom was personified in Christian art and theology as *Sophia (Greek for "wisdom") who was the mother of three female virgin *saints: *Faith (Fides), *Hope (Spes), and *Charity (Caritas).

Witch. A person, male or female, who made a pact with the *Devil by signing over body and *soul in return for power or wealth. The Devil granted them magical powers, including the gift of flight, and companions, usually *toads or *cats. Female witches were lascivious, uncontrollably lustful creatures who sought out unhappy husbands and unmarried young men, and were represented in the superior position in sexual copulation as a sign of their ability to "turn the world upside down." Witches were depicted as naked elderly women with sagging breasts and bellies and straggly *hair. They were popular in late medieval northern and *baroque art, especially after the publication of the *Malleus Malleficarum,* and the Reformed traditions's teachings on women's fundamentally evil nature.

Witch of Endor (1 Sm 28:3–25). This necromancer was visited by *Saul on the eve of a crucial battle against the Philistines. At his pleading, she conjured up the spirit of the dead *prophet Samuel who advised that neither the king nor any of his three sons would survive the battle. Learning that his sons had been killed, a seriously wounded Saul fell on his own *sword.

Wolf. The male wolf signified avarice, greed, and sexual lust, while the she-wolf denoted a prostitute. In Christian art, the wolf was a symbol for heretics and pagan barbarians (Mt 7:15). According to the *Fioretti,* *Francis of Assisi converted the wolf of Gubbio from a killer into a friend; the wolf thereby implied the ability to convert savage pagans.

Woman Clothed with the Sun (Rv 12:1–6). A revelatory vision of *Mary, particularly in relation to the teachings and *iconography of the *Immaculate Conception and Assumption, as recorded by *John the Evangelist on Patmos. When he consulted the Tiburtine *Sibyl, the emperor Augustus had a similar vision of a "woman clothed with the sun" which was interpreted as the classical Greco-Roman foretype of Mary. Many of her *attributes—including the *crown of *stars, crescent *moon, and the *dragon and *serpent under her feet—were described by the author of the Book of Revelation.

Woman with the Issue of Blood (Mt 9:20–22; Mk 5:25–34; Lk 8:43–48). For twelve years, a certain woman had been plagued by a continuous flow of blood. Any medical treatment she received only worsened her condition. Hearing of Jesus, she sought him out in hope of a cure. As he passed her in the crowd, she reached out and touched the hem of his garment. Immediately, the flow of blood stopped. Sensing the cure, Jesus turned to ask who had touched his garment. Frightened, the woman prostrated herself and confessed. Affirmed by her faith, Jesus told her to

go in peace. This event was rarely depicted in Christian art except in the narrative cycles of early Christian and *byzantine art. This miraculous cure can be distinguished from other encounters Jesus had with women as this woman (the *hemorrhissa*) was depicted kneeling behind him and touching the hem of his garment.

Woman of Samaria (Jn 4:1–30). As a sign of that his mission spread beyond the *Jews and of his transformation of the cultural subjugation of women, Jesus spoke to a Samaritan woman and asked her to give him a drink of *water from a *well. In response to her query—how a Jew could permit a Samaritan to give him water—Jesus replied that he would give her living water and she would never thirst again if she only asked. Recognizing that he was the *Messiah, the Samaritan woman brought together as many citizens as she could find. During his two day stay, he converted many of the Samaritans. This event was rarely depicted as a separate topic in Christian art; rather, it was included in the context of the narrative cycle of the life of Jesus Christ. The traditional presentation depicted Jesus and the woman standing (or sitting) by the well. She held a jug or a bucket, and offered him a drink.

Woman Taken in Adultery (Jn 8:1–11). In an effort to trick Jesus into blasphemy and thereby end his ministry, the Pharisees brought a "woman taken in adultery" to him for judgment according to the Mosaic Law (Lv 20:10; Dt 22:22–24). Recognizing the implicit danger of their query, Jesus said that the one among them without sin must cast the first stone. Jesus bent down and made marks in the ground (an indication of frivolousness on the part of the rabbi who was being asked to pass capital judgment) with his writing. When Jesus looked up, only the woman remained. Having no accusers, Jesus told her he would not condemn her and sent her home. According to tradition and Christian devotion, this anonymous woman became conflated with *Mary Magdalene. The theme of the Woman Taken in Adultery had a sporadic history in Christian art. The earliest images dated from the fifth century, and emphasized the final scene between Jesus and the accused woman. Rarely depicted in *byzantine and *medieval art, this theme was retrieved by Michael Packer in 1481 when the scene shifted to the accusation of the woman before the crowd. This was the only scriptural story in which Jesus wrote, but few artists depicted this action. The theme of the Woman Taken in Adultery became popular in *renaissance and *baroque art.

Woodpecker. This ambiguous aviary symbol represented the *Devil, heresy, and *Christ. The woodpecker's consistent search for worms was a symbol for incessant prayer. As a destroyer of worms, the woodpecker denotes Christ as the enemy of the Devil.

Worms. A symbol for the *serpent and the *Devil.

Wounds. A symbol of the *Crucifixion of Jesus Christ. On the body of a

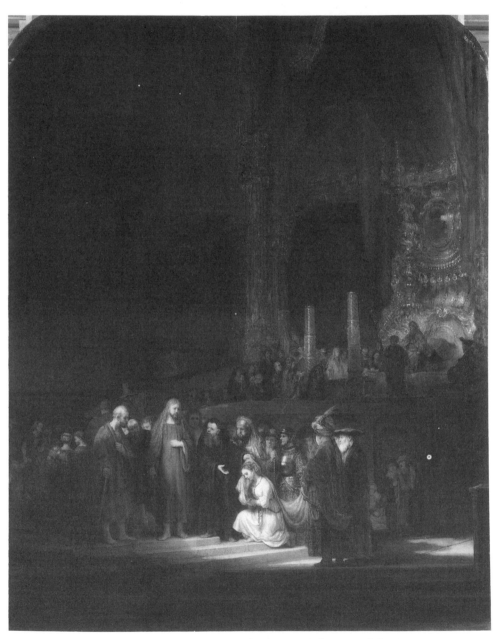

162. Rembrandt van Rijn, *The Woman Taken in Adultery.*

*saint, wounds symbolized martyrdom.

Wreath. A sign of spiritual glorification. This circle of leaves or *flowers held in the hands of *angels glorifies a *saint or a holy person. The exact meaning of a wreath was related to the identification of the leaves or flowers. A *laurel wreath signified either victory over death, or distinction in writing Christian poetry or literature. An oak wreath meant physical and spiritual strength, a yew wreath immortality, and a cypress wreath mourning.

XYZ

XP. The Greek letters chi and rho were the first two letters of *Christos*—Greek for "Christ." Combined to form a cross, the XP signified the Latin word *pax* ("peace").

Year. The annual cycle of the sun and the seasons was a symbol of fulfillment corresponding the twelve months with the twelve signs of the *Zodiac, the twelve tribes of Israel, the twelve disciples, the twelve apostles, and so on. The Church (or Liturgical) Year included the annual religious observances and holy days, beginning with *Advent, which narrated the Christian story through the liturgical services in conjunction with the life cycle of *Jesus Christ.

Yeast. *See* Parables.

Yellow. Color with two opposite symbolic meanings dependent upon the context. In its primary meaning, yellow was an emblem of the *sun and suggested divinity. Yellow signified illuminated truth; that is, the truth removed from the shadows. The golden yellow background of byzantine and renaissance paintings symbolized the sacredness of the space. *Joseph (of Nazareth) and *Peter both wore yellow as a symbol of revealed truth. However, yellow could also denoted infernal light, degradation, jealousy, treason, cowardice, instability, and deceit, such as when *Judas Iscariot wore yellow. Medieval heretics and nonbelievers wore yellow garments, while yellow *crosses denoted the contagious areas during the plagues. In the medieval ghetto, the *Jews were required to wear yellow badges.

Yew Tree. A botanical symbol for immortality.

Zaccheus (first century A.D.). This chief tax collector or publican of Jericho wanted to see Jesus during his *Entry into Jerusalem for the *Passover celebration. A physically small man, Zaccheus climbed a sycamore *tree so that he could see Jesus over

the crowd. Noticing Zaccheus in the tree, Jesus called to him to come down so that Jesus might stay at his home. His choice of Zaccheus, a sinner, as his host angered certain to whom Jesus responded that he had come to save sinners not the just (Lk 19:1–10). Medieval legends identified Zaccheus as Amadour, living in France with his wife *Veronica.

Zaccheus (first century). This Jewish teacher was astounded at the innate knowledge of the young Jesus, according to the apocryphal *Infancy Gospel of Thomas* and *Gospel of Pseudo-Matthew*.

Zacharias, Saint (first century). The father of *John the Baptist and the husband of *Elizabeth was a priest of the temple in *Jerusalem. Zacharias was stunned into silence by the *Archangel *Gabriel for his disbelief when told that his previously barren wife would bear a son. Following his son's circumcision, Zacharias wrote that the child would be named John, as the angel had declared, and his speech returned (Lk 1:5–25, 57–66). The apocryphal *Protoevangelium of James* identified Zacharias as the priest who presided over the selection of the suitors for *Mary, and later was stabbed to death at the temple altar during the *Massacre of the Innocents. In Christian art, Zacharias was depicted as an elderly man who held his finger to his lips, signifying his inability to speak. His *attributes were the *censer, a writing tablet, and a taper.

Zeno, Saint (d. 372). A patron of Verona, this zealous preacher was famed for his wisdom and kindness. As bishop of Verona (361–372), his sermons were the earliest homilies in Latin to give information about Christian worship and life in the fourth century. Legend recounted that he gave two men three fishes; they stole a fourth but could not cook it because, although in boiling water, it remained alive. He was reputed to have saved Pistoia from destruction by floods by creating the Gonfolina Pass. In Christian art, Zeno was depicted dressed in the *vestments of a bishop and with a *fish hanging from his *crosier.

Zenobius, Saint (d. 424). A Florentine nobleman who was converted to Christianity by one of his tutors. A friend of *Ambrose of Milan, Zenobius became bishop, and later patron, of Florence. There were many legends concerning his ability to restore the dead to life. In Christian art, Zenobius was depicted with a dead child or young man in his arms, or near a child under the wheels of a wagon. His other *attribute is the withered *elm which, according to legend, was on the wayside of the road to the *cathedral to which the saint's body was being carried for burial. Once his body touched the dead *tree it burst forth into leaf. Zenobius was a popular topic in medieval and early renaissance Florentine art.

Zero. This numerical symbol for nonbeing was also a symbol of potential force, like an *egg.

Zeus. The supreme god of Greek mythology and symbol for the essence of divine power. Described as the father

god, he protected the weak, rewarded the just, punished the wicked, and guarded the sanctity of the home and community. Thunder and lightning, sky omens, a *scepter, the *oak tree, and *birds, especially the *eagle, were among his *attributes. Zeus was depicted in Hellenistic and *renaissance art as a physically vigorous, mature nude or partially nude male with a full *beard and an olive wreath on his head. These images were the source for the anthropomorphic images of God the Father in Christian art.

Zodiac. From the Greek for "life" and for "wheel." The symbolic wheel of life, an *attribute in Christian representations of *Father Time. It was a circular diagram showing the Zodiac signs used in astrology. The Zodiac was an imaginary band of *stars in the *heavens, including the paths of the *sun and the *moon; it was divided into twelve parts, each named for a constellation. It described the annual cycle of the sun and the seasons. The signs of the Zodiac corresponded to the Labors of the Months and signified the omnipotence of God through time and space. The motif of the Zodiac was popular in *medieval art, especially in the *illuminations for *Books of Hours, decorative carvings in churches, and in Flemish paintings, especially on the themes of the *Annunciation to Mary and the *Nativity of Jesus Christ.

Zubarán, Francisco de (1598–1664). A master of devotional images, and one of the great painters of the Spanish baroque. He lived in Seville and in religious houses of Spanish colonies of the New World. Zubarán's early style favored bleak, austere piety. As a painter of elemental doctrinal works which were expressed in clear, sober colors and massive, solemn figures, Zubarán was influenced by the southern Spanish tradition of unidealizaed representation. His *Adoration of the Shepherds* typified his painterly quest to implement the union of realism with mysticism (following Tridentine teaching). The success of *Bartolomé Esteban Murillo in the 1640s caused Zubarán to create a series of works that were softer and more saccharine in expression. To obtain these painterly goals, Zubarán developed a smoother technique and an *iconography of romantic devotions, especially to *Mary.

Zucchetto. *See* skullcap.

Bibliography

Achtemeier, Paul J. *Harper's Bible Dictionary.* Harper and Row, 1985.

Attwater, Donald. *The Penguin Dictionary of Saints.* Revised by Catherine Rachel John. Penguin Books, 1983.

Bell, Robert E. *Dictionary of Classical Mythology: Symbols, Attributes and Associations.* ABC-CLIO, 1982.

———. *Women of Classical Mythology: A Biographical Dictionary.* Oxford University Press, 1991.

Bernen, Satia, and Bernen, Robert. *A Guide to Myth and Religion in European Painting, 1270–1700.* George Braziller, 1973.

Biedermann, Hans. *Dictionary of Symbolism: Cultural Icons and the Meanings Behind Them.* Translated by James Hulbert. Meridian Books, 1994.

Bowden, John. *Who's Who in Theology.* Crossroad Publishing, 1992.

Butler's Lives of the Saints. Edited by Michael Walsh. HarperCollins, 1991.

Chetwynd, Tom. *A Dictionary of Symbols.* Paladin/Grafton, 1982.

Cirlot, J.E. *A Dictionary of Symbols.* Philosophical Library, 1962.

Cooper, J.C. *An Illustrated Encyclopedia of Traditional Symbols.* Thames and Hudson, 1978.

Cotterell, Arthur. *A Dictionary of World Mythology.* Putnam, 1980.

———. *The Macmillan Illustrated Encyclopedia of Myths and Legends.* Macmillan, 1989.

Coulson, John, ed. *The Saints: A Concise Biographical Dictionary.* Hawthorn, 1958.

Daniel, Howard. *Encyclopedia of Themes and Subjects in Paintings.* Thames and Hudson, 1971.

Davidson, Gustav. *A Dictionary of Angels, Including the Fallen Angels.* Free Press, 1967.

De Bles, Arthur. *How to Distinguish the Saints in Art by Their Costumes, Symbols, and Attributes.* Gale Research, 1975.

Delaney, John J. *Dictionary of Saints.* Image Books, 1983.

Didron, Adolphe Napoléon. *Christian Iconography: The History of Christian Art in the Middle Ages.* 2 vols. Frederick Ungar Publishing, 1965.

Drake, Maurice and Wilfred. *Saints and their Emblems.* Burt Franklin, 1971.

Earls, Irene. *Renaissance Art: A Topical Dictionary.* Greenwood Press, 1967.

Encyclopaedia Judaica. 16 vols. Keter Publishing, 1971.

Encyclopedia of Religion. 16 vols. MacMillan, 1987.

Encyclopedia of World Art. 15 vols. McGraw Hill, 1959–1963.

Evans, Joan. *Monastic Iconography in France from the Renaissance to the Revolution.* Cambridge University Press, 1970.

Every, George. *Christian Legends.* Paul Hamlyn, 1987.

Farmer, David Hugh. *The Oxford Dictionary of Saints.* Clarendon Press, 1978.

Ferguson, George. *Signs and Symbols in Christian Art.* Oxford University Press, 1966.

Funk & Wagnall's Standard Dictionary of Folklore, Mythology and Legend. Funk & Wagnall's, 1949–1950.

Goldsmith, Elizabeth Edwards. *Ancient Pagan Symbols.* AMS Press, 1973.

Grabar, André. *Christian Iconography: A Study of its Origins.* Princeton University Press, 1968.

Graves, Robert. *The Greek Myths.* Penguin Book, 1955.

Grimal, Pierre. *The Dictionary of Classical Mythology.* Penguin Books, 1991.

Hale, J.R., ed. *A Concise Encyclopaedia of the Italian Renaissance.* Oxford University Press, 1981.

Hall, James. *Dictionary of Subjects and Symbols in Art.* Harper and Row, 1979.

———. *A History of Ideas and Images in Italian Art.* Harper and Row, 1983.

Hamilton, Edith. *Mythology.* Little, Brown and Company, 1963.

Herder Dictionary of Symbols. Translated by Boris Matthews. Chiron Publishing, 1993.

Hinks, Roger. *Myth and Allegory in Ancient Art.* Kraus, 1976.

Hulme, F. Edward. *The History, Principles, and Practice of Symbolism in Christian Art.* Gale Research, 1969.

Jacobus de Voragine. *The Golden Legend: Readings on the Saints.* 2 vols. Translated by William Granger Ryan. Princeton University Press, 1993.

Jameson, Anna Brownell (Murphy). *The History of Our Lord as Exemplified in Works of Art.* 2 vols. Longmans, Green, and Company, 1872.

———. *Legends of the Madonna as Represented in the Fine Arts.* Riverside Press, 1887.

———. *Legends of the Monastic Orders.* Longmans, Green, and Company, 1890.

———. *Sacred and Legendary Art.* 2 vols. Longmans, Green, and Company, 1890.

Jobes, Gertrude. *Dictionary of Mythology, Folklore, and Symbols.* 3 vols. Scarecrow Press, 1961.

Kaftal, George. *Iconography of the Saints in Italian Painting from Its Beginnings to the Early XIVth Century.* 5 vols. Sansoni, 1952–1985.

Kaster, Joseph. *Putnam's Concise Mythological Dictionary.* Perogee Books, 1990.

Katzenellenbogen, A.E.M. *Allegories of the Virtues and Vices in Medieval Art from the Early Christian Times to the Thirteenth Century.* 2 vols. University of Toronto Press, 1989.

Knipping, John Baptiste. *Iconography of the Counter-Reformation in the Netherlands: Heaven on Earth.* 2 vols. B. de Graar, 1974.

Kravitz, David. *Who's Who in Greek and Roman Mythology.* C.N. Potter, 1976.

Lurker, Manfred. *Dictionary of Gods and Goddesses, Devils and Demons.* Routledge and Kegan Paul, 1987.

Mathews, Thomas F. *The Clash of Gods: A Reinterpretation of Early Christian Art.* Princeton University Press, 1993.

Meracante, Anthony S. *The Facts on File Encyclopedia of World Mythology and Legend.* Facts on File, 1988.

Metford, J.C.J. *Dictionary of Christian Lore and Legend.* Thames and Hudson, 1983.

Murray, Peter, and Linda Murray. *The Penguin Dictionary of Art and Artists.* Penguin Books, 1988.

New Catholic Encyclopedia. 15 vols. McGraw Hill, 1967.

New Larousse Encyclopedia of Mythology. Putnam, 1968.

Physiologus. Translated by Michael J. Curley. University of Texas Press, 1979.

Réau, Louis. *Iconographie de l'art chrétien.* 6 vols. Presses Universitaire de France, 1955–1959.

Schiller, Gertrud. *Iconography of Christian Art, Volume I.* Translated by Janet Seligman. New York Graphic Society, 1971.

———. *Iconography of Christian Art, Volume II.* Translated by Janet Seligman. Lund Humphries, 1972.

Sill, Gertrude Grace. *A Handbook of Symbols in Christian Art.* Macmillan Publishing Company, 1975.

Steinberg, Leo. *The Sexuality of Christ in Renaissance Art and in Modern Oblivion.* Pantheon Books, 1983.

Waal, Henri van de. *Iconoclass: An Iconographic Classification System.* North-Holland, 1973–84.

Walker, Barbara G. *The Woman's Dictionary of Symbols and Sacred Objects.* Harper and Row, 1988.

———. *The Woman's Encyclopedia of Myths and Secrets.* Harper and Row, 1983.

West, Edward N. *Outward Signs: The Language of Christian Symbolism.* Walker and Company, 1989.

Whittlesey, E.N. *Symbols and Legends in Western Art.* Scribners, 1972.

Whone, Herbert. *Church, Monastery, Cathedral: A Guide to the Symbolism of the Christian Tradition.* Enslow Publishers, 1977.

Winternitz, Emanuel. *Musical Instruments and Their Symbolism in Western Art.* Yale University Press, 1979.

List of Illustrations

9. North Netherlandish, *The Adoration of the Magi* (fourth quarter 15th century: National Gallery of Art, Washington, D.C.). Oil on canvas, 1.830 × 1.645 (72 × 64¾); framed: 2.159 × 2.032 x.120 (85 × 80 × 4¾). Samuel H. Kress Collection. ©1994 National Gallery of Art, Washington, D.C. 1952.5.41 (1120)/PA.

10. Giorgione, *The Adoration of the Shepherds* (c. 1505/10: National Gallery of Art, Washington, D.C.). Oil on panel, .908 × .100 (35¾ × 43½). Samuel H. Kress Collection, ©National Gallery of Art, Washington, D.C. 1939.1.289 (400)/PA.

11. Adriaen Isenbrandt, *The Adoration of the Shepherds* (probably 1520/1540: National Gallery of Art, Washington, D.C.). Oil on panel, .746 × ˉ.570 (29⁷⁄₁₆ × 22⁷⁄₁₆); framed: .933 × .749 (36¾ × 29½). Ailsa Mellon Bruce Fund. ©1994 National Gallery of Art, Washington, D.C. 1978.46.1 (2724)/PA.

12. El Greco, *Madonna and Child with Saint Martina and Saint Agnes* (1597/99: National Gallery of Art, Washington, D.C.). Oil on canvas, wooden strip added at bottom: 1.935 × 1.030 (76⅛ × 40½), added wooden strip at bottom: .046 × 1.030 (1⅞ × 40½). Widener Collection. ©National Gallery of Art, Washington, D.C. 1942.9.26 (622)/PA.

13. Giovanni di Paolo di Grazia, *Saint Agatha* (15th century: The Metropolitan Museum of Art, New York). Tempera on wood; gold ground. 18⅛ × 5⅞. The Michael Friedman Collection, 1931. ©1994 The Metropolitan Museum of Art, New York. 32.100.83c.

14. Benvenuto di Giovanni, *The Agony in the Garden* (c. 1490: National Gallery of Art, Washington, D.C.). Tempera on panel, .432 × .483 (17 × 19). Samuel H. Kress Collection. ©1994 National Gallery of Art, Washington, D.C. 1939.1.318 (429)/PA.

15. Duccio di Buoninsegna, *The Calling of the Apostles Peter and Andrew* (1308/11: National Gallery of Art, Washington, D.C.). Tempera on panelwood, .435 × .460 (17⅛ × 18⅛). Samuel H. Kress Collection. ©1994 National Gallery of Art, Washington, D.C. 1939.1.141 (252)/PA.

16. Workshop of Fra Angelico, *The Madonna of Humility* (c. 1430/40: National Gallery of Art, Washington, D.C.). Tempera on panel, .610 × .455 (24 × 17⅞). Andrew W. Mellon Collection. ©1994 National Gallery of Art, Washington, D.C. 1937.1.5 (5)/PA.

17. Gerard David, *The Saint Anne Altarpiece* (c. 1500/20: National Gallery of Art, Washington, D.C.). Oil on cradled oak, painted surface: left panel, 2.340 (including addition at top) × .749; center panel, 2.325 (including addition at top) × .960; right panel, 2.340 (including top) × .738. Widener Collection. ©1994 National Gallery

of Art, Washington, D.C. 1942.9.17 (613)/PA.

18. Giovanni di Paolo di Grazia, *The Annunciation* (c. 1445: National Gallery of Art, Washington, D.C.). Tempera on panel, .400 × .464 (15¾ × 18¼). Samuel H. Kress Collection. ©1994 National Gallery of Art, Washington, D.C. 1939.1.223 (334)/PA.

19. Jan van Eyck, *The Annunciation* (c. 1434/36: National Gallery of Art, Washington, D.C.). Oil on canvas transferred from panel, painted surface: .902 × .341 (35⅝ × 13⅜); panel: .927 × .367 (36½ × 14⁷⁄₁₆). Andrew W. Mellon Collection. ©1994 National Gallery of Art, Washington, D.C. 1937.1.39 (39)/PA.

20. Simone Martini, *The Annunciation* (14th century: Galleria degli Uffizi, Firenze). Courtesy of Alinari/Art Resource, New York.

21. Juan de Flandes, *The Annunciation* from the *San Lazaro Altarpiece* (c. 1508/19: National Gallery of Art, Washington, D.C.). Oil on panel, painted surface: 1.102 × .784 (43⅜ × 30⅞); framed: 1.302 × .990 × .107 (51¼ × 39 × 4¼). Samuel H. Kress Collection. ©1994 National Gallery of Art, Washington, D.C. 1961.9.22 (1382)/PA.

22. Juan de Flandes, *The Nativity* (with *Annunciation to the Shepherds* in background) from the *San Lazaro Altarpiece* (1508/19: National Gallery of Art, Washington, D.C.). Oil on panel, painted surface: 1.105 × .793 (43½ × 31¼); framed: 1.298 × .987 × .107 (51⅛ × 38⅞ × 4¼). Samuel H. Kress Collection. ©1994 National Gallery of Art, Washington, D.C. 1961.9.23 (1383)/PA.

23. Jacopo Bassano, *The Annunciation to the Shepherds* (probably c. 1555/60: National Gallery of Art, Washington, D.C.). Oil on canvas, 1.061 × .826 (41¾ × 32½); framed: 1.311 × 1.063 × .10 (51⅝ × 41⅞ × 4). Samuel H. Kress Collection. ©1994 National Gallery of Art, Washington, D.C. 1939.1.126 (237)/PA.

24. Sassetta and Workshop of Sasseta, *The Meeting of Saint Anthony and Saint Paul* (c. 1440: National Gallery of Art, Washington, D.C.). Tempera on panel, .475 × .345 (18¾ × 13⅝); framed: .622 × .492 × .104 (24½ × 19⅜ × 4⅛). Samuel H. Kress Collection. ©National Gallery of Art, Washington, D.C. 1939.1.293 (404)/PA.

25. Sassetta and Workshop of Sassetta, *Saint Anthony Distributing His Wealth to the Poor* (c. 1440: National Gallery of Art, Washington, D.C.). Tempera on panel, .475 × .345 (18⅝ × 13⅝); framed: .628 × .466 (24¾ × 18⅜). Samuel H. Kress Collection. ©1994 National Gallery of Art, Washington, D.C. 1952.5.20 (817)/PA.

26. Mathias Grünewald, *The Temptation of Saint Anthony* detail from *Isenheim Altarpiece* (1515: Musée d'Unterlinden, Colmar). Courtesy of Giraudon/Art Resource, New York.

27. Vincenzo Foppa, *Saint Anthony*

of Padua (before 1500: National Gallery of Art, Washington, D.C.). Oil and tempera on panel, 1.490 × .565 (58⅝ × 22¼); framed: 1.721 × .800 × .095 (67¾ × 31½ × 3¾). Samuel H. Kress Collection. ©1994 National Gallery of Art, Washington, D.C. 1952.5.63 (1142)/PA.

28. Attributed to Sassetta, *Saint Apollonia* (c. 1435: National Gallery of Art, Washington, D.C.). Tempera on wood, .279 × .104 (11 × 4⅛). Samuel H. Kress Collection. ©1994 National Gallery of Art, Washington, D.C. 1943.4.5 (506)/PA.

29. Antonio Vivarini, *Saint Apollonia Destroys a Pagan Idol* (c. 1450: National Gallery of Art, Washington, D.C.). Tempera on panel, .597 × .343 (23½ × 13½). Samuel H. Kress Collection. ©1994 National Gallery of Art, Washington, D.C. 1939.1.7 (118)/PA.

30. Johann Koerbecke, *The Ascension* (1456/57: National Gallery of Art, Washington, D.C.). Tempera on panel, .927 × .648 (36½ × 25½); framed: 1.171 × .851 (46⅛ × 33½). Samuel H. Kress Collection. ©1994 National Gallery of Art, Washington, D.C. 1959.9.5 (1528)/PA.

31. Paolo di Giovanni Fei, *The Assumption of the Virgin* (probably c. 1385: National Gallery of Art, Washington, D.C.). Tempera on wood, .667 × .381 (26¼ × 15). Samuel H. Kress Collection. ©1994 National Gallery of Art, Washington, D.C. 1961.9.71 (1623)/PA.

32. Michel Sittow, *The Assumption of the Virgin* (c. 1500: National Gallery of Art, Washington, D.C.). Oil on panel, painted surface .211 × .162 (8⁵⁄₁₆ × 6⅜); panel: .213 × .167 (8⅜ × 6⁹⁄₁₆). Ailsa Mellon Bruce Fund. ©1994 National Gallery of Art, Washington, D.C. 1965.1.1 (1928)/PA.

33. Anthony van Dyck, *The Assumption of the Virgin* (1628/29: National Gallery of Art, Washington, D.C.). Oil on canvas, 1.181 × 1.022 (46½ × 40¼). Widener Collection, ©1994 National Gallery of Art, Washington, D.C. 1942.9.88 (684)/PA.

34. Nicolas Poussin, *The Assumption of the Virgin* (c. 1626: National Gallery of Art, Washington, D.C.). Oil on canvas, 1.344 × .981 (52⅞ × 38⅝); framed: 1.715 × 1.368 × .146 (67½ × 53⅞ × 5¾). Ailsa Mellon Bruce Fund. ©1994 National Gallery of Art, Washington, D.C. 1963.5.1 (1905)/PA.

35. Sandro Botticelli, *Saint Augustine in His Study* (15th century: Ognissanti, Firenze). Courtesy of Alinari/Art Resource, New York.

36. Gian Lorenzo Bernini, *Baldachino* (1624/33: Saint Peter's Basilica, Vatican City). Courtesy of Alinari/Art Resource, New York.

37. *The Baptism of Christ* (11th century: Monastery, Daphni). Byzantine Visual Resources, ©1994, Dumbarton Oaks, Trustees for Harvard University, Washington, D.C. A.76.121 (R).

38. Master of the Life of Saint John, *The Baptism of Christ* (probably

1330/40: National Gallery of Art, Washington, D.C.). Tempera on panel, .490 × .405 (19¼ × 16); framed: .546 × .473 (21½ × 18⅝). Samuel H. Kress Collection. ©1994 National Gallery of Art, Washington, D.C. 1939.1.131 (242)/PA.

39. Paris Bordone, *The Baptism of Christ* (c.1535/40: National Gallery of Art, Washington, D.C.). Oil on canvas, 1.295 × 1.320 (51 × 52); framed: 1.765 × 1.791 × .114 (69½ × 70½ × 4½). Widener Collection. ©1994 National Gallery of Art, Washington, D.C. 1942.9.5 (601)/PA.

40. Nicolas Poussin, *The Baptism of Christ* (1641/2: National Gallery of Art, Washington, D.C.). Oil on canvas, .955 × 1.210 (37⅝ × 47⅝). Samuel H. Kress Collection. ©1994 National Gallery of Art, Washington, D.C. 1946.7.14 (786)/PA.

41. Anonymous Portuguese, *Saint Barbara* (15th century: National Gallery of Art, Washington, D.C.). Oil on wood, 1.500 × .547. Timken Collection. ©National Gallery of Art, Washington, D.C. 1960.6.30 (1582)/PA.

42. Giovanni Bellini and Workshop of Giovanni Bellini, *Madonna and Child in a Landscape* (1490/1500: National Gallery of Art, Washington, D.C.). Oil on panel, .750 × .585 (29½ × 23); framed: 1.108 × .886 (43⅝ × 34⅞). Samuel H. Kress Collection. ©1994 National Gallery of Art, Washington, D.C. 1939.1.262 (373)/PA.

43. Filippo Lippi, *Saint Benedict Orders Saint Maurus to the Rescue of Saint Placidus* (c. 1445: National Gallery of Art, Washington, D.C.). Tempera on panel, .416 × .711 (16⅜ × 28); framed: 4.98 × .794 (19⅝ × 31¼). Samuel H. Kress Collection. ©1994 National Gallery of Art, Washington, D.C. 1952.5.10 (804)/PA.

44. Imitator of Flemish 15th Century, *Saint Bernard with Donor* (obverse) (probably early 15th century: National Gallery of Art, Washington, D.C.). Oil on panel, painted surface: .575 × .221 (22⅝ × 8¹¹⁄₁₆); panel: .588 × .233 (23⅛ × 9³⁄₁₆); framed: .651 × .295 (25⅝ × 11⅝). Chester Dale Collection. ©1994 National Gallery of Art, Washington, D.C. 1942.16.2 (699)/PA.

45. Sandro Botticelli, *Madonna of the Magnificat* (15th century: Galleria degli Uffizi, Firenze). Courtesy of Alinari/Art Resource, New York.

46. Sandro Botticelli, *The Mystic Nativity* (15th century: The National Gallery, London). Courtesy of The Trustees, The National Gallery, London. 1034.

47. Lodovico Carracci, *The Dream of Saint Catherine of Alexandria* (c. 1590: National Gallery of Art, Washington, D.C.). Oil on canvas, 1.388 × 1.105 (54⅝ × 43½); framed: 1.816 × 1.527 × .114 (71½ × 60⅛ × 4½). Samuel H. Kress Collection. ©1994 National Gallery of Art, Washington, D.C. 1952.5.59 (1138)/PA.

48. Giovanni di Paolo di Grazia, *The Miraculous Communion of Saint Catherine of Siena* (15th century: The Metropolitan Museum of Art, New York). Tempera and gold on wood, 11⅜ × 8¾ (28.9 × 22.2). Bequest of Michael Friesdam, 1931. The Friesdam Collection. ©1994 The Metropolitan Museum of Art, New York. 32.100.95.

49. Orazio Gentileschi and Giovanni Lanfranco, *Saint Cecilia and an Angel* (c. 1617/18 and c. 1621/27: National Gallery of Art, Washington, D.C.). Oil on canvas, .878 × 1.081 (34⅝ × 42½); framed: 1.098 × 1.298 × .073 (43¼ × 51⅛ × 2⅞). Samuel H. Kress Collection. ©1994 National Gallery of Art, Washington, D.C. 1961.9.73 (1625)/PA.

50. Master of Saint Heiligenkreuz, *The Death of Saint Clare* (c. 1410: National Gallery of Art, Washington, D.C.). Oil on panel, .675 × .553 (26⁹⁄₁₆ × 21¾); painted surface: .663 × .540 (26⅛ × 21¼); framed: .875 × .743 × .057 (33¾ × 29¼ × 2¼). Samuel H. Kress Collection. ©1994 National Gallery of Art, Washington, D.C. 1952.5.83 (1162)/PA.

51. El Greco, *Christ Cleansing the Temple* (probably before 1570: National Gallery of Art, Washington, D.C.). Oil on panel, .654 × .832 (25¾ × 32¾). Samuel H. Kress Collection. ©1994 National Gallery of Art, Washington, D.C. 1957.14.4 (1482)/PA.

52. Paolo Veneziano, *The Coronation of the Virgin* (1324: National Gallery of Art, Washington, D.C.). Tempera on panel, .991 × .775 (39 × 30½); framed 1.152 × .849 (45⅜ × 33⁷⁄₁₆). Samuel H. Kress Collection. ©1994 National Gallery of Art, Washington, D.C. 1952.5.87 (1166)/PA.

53. Fra Angelico, *The Healing of Palladia by Saint Cosmas and Saint Damian* (probably 1438/43: National Gallery of Art, Washington, D.C.). Tempera on panel, .365 × .467 (14⅜ × 18⅜). Samuel H. Kress Collection. ©1994 National Gallery of Art, Washington, D.C. 1952.5.3 (790)/PA.

54. Lucas Cranach, *The Torgau Altarpiece* (16th century: Staedel Institut, Frankfurt). Courtesy of Foto Marburg/Art Resource, New York.

55. *Crucifixion* (fourth century: The British Museum). Ivory casket. Courtesy of The Trustees of The British Museum, London. #56,6–23,5.

56. *Crucifixion* (eleventh century: Monastery, Daphni). Mosaic. Byzantine Visual Resources, ©1994, Dumbarton Oaks, Trustees for Harvard University, Washington, D.C. A.76.172 (R).

57. Master of Saint Veronica, *The Crucifixion* (c. 1400/10: National Gallery of Art, Washington, D.C.). Oil on wood, .460 × .314 (18⅛ × 12⅜). Samuel H. Kress Collection. ©1994 National Gallery of Art, Washington, D.C. 1961.9.29 (1390)/PA.

58. Mathias Grünewald, *Crucifixion* detail from *Isenheim Altarpiece*

(1515: Musée d'Unterlinden, Colmar). Courtesy of Foto Marburg/Art Resource, New York.

59. Giovanni di Paolo di Grazia, *Dance of the Blessed* detail from *Last Judgment* (14th century: Accademia, Siena). Courtesy of Alinari/Art Resource, New York.

60. Hans Holbein, *End of Mankind* from the series *Dance of Death* (16th century: National Gallery of Art, Washington, D.C.). Woodcut. Rosenwald Collection. ©1994 National Gallery of Art, Washington, D.C. 1943.3.4847 (B-7438)/PR.

61. Peter Paul Rubens, *Daniel in the Lions' Den* (c. 1613/15: National Gallery of Art, Washington, D.C.). Oil on linen, 2.243 × 3.304 (88¼ × 130⅛). Ailsa Mellon Bruce Fund. ©1994 National Gallery of Art, Washington, D.C. 1965.13.1 (1948)/PA.

62. Hubert and Jan van Eyck, detail of *Deesis* from *Last Judgment*, detail from *Ghent Altarpiece* (1432: Saint Bavo Cathedral, Ghent). Courtesy of Giraudon/ Art Resource, New York.

63. Rogier van der Weyden, *The Deposition* (16th century: Museo del Prado, Madrid). Courtesy of Alinari/Art Resource, New York.

64. Fra Angelico, *Calvary with Saint Dominic* (15th century: Museo di San Marco, Firenze). Courtesy of Alinari/Art Resource, New York).

65. *Dormition of the Virgin.* (11/ 12th century: Kariye Jaime, Istanbul). Mosaic. Byzantine Visual Resources, ©1994, Dumbarton Oaks, Trustees for Harvard University, Washington, D.C. K-183.56.121.

66. Michelangelo Merisi da Caravaggio, *Death of the Virgin* (17th century: Musée du Louvre, Paris). Courtesy of Giraudon/Art Resource, New York.

67. Duccio di Buoninsegna, *The Nativity with the Prophets Isaiah and Ezekiel* (1308/11: National Gallery of Art, Washington, D.C.). Tempera on panel, left panel: .438 × .165 (17¼ × 6½); center panel: .438 × .444 (17¼ × 17½); right panel: .438 × .165 (17¼ × 6½). Andrew W. Mellon Collection. ©1994 National Gallery of Art, Washington, D.C. 1937.1.8 (8)/PA.

68. Albrecht Dürer, *The Four Apostles* (16th century: Alte Pinakothek, München). Courtesy of Scala/Art Resource, New York.

69. Giuseppe Angeli, *Elijah Taken Up in a Chariot of Fire* (c. 1740/ 55: National Gallery of Art, Washington, D.C.). Oil on linen, 1.746 × 2.648 (68¾ × 104¼); framed: 2.070 × 3.023 × .101 (81½ × 119 × 4). Samuel H. Kress Collection. ©1994 National Gallery of Art, Washington, D.C. 1952.5.70 (1149)/ PA.

70. Michelangelo Merisi da Caravaggio, *Supper at Emmaus* (16th century: Pinacoteca Brera, Milano). Courtesy of Alinari/Art Resource, New York.

71. Rembrandt van Rijn, *Supper at Emmaus* (17th century: Musée

51½ × 4½). Samuel H. Kress Collection. ©1994 National Gallery of Art, Washington, D.C. 1952.5.76 (1155)/PA.

84. Giotto, *Lamentation* (1305: Scrovegni Chapel, Padua). Courtesy of Alinari/Art Resource, New York.

85. Francesco di Giorgio Martini, *The Nativity, with God the Father Surrounded by the Angels and Cherubim* (c. 1472: National Gallery of Art, Washington, D.C. and The Metropolitan Museum of Art, New York). Tempera on wood, oval: .365 × .518 (14⅜ × 20⅜). The Metropolitan Museum of Art, New York. Gift of George Blumenthal, 1941. [41.100.2]. National Gallery of Art, Washington, D.C. Samuel H. Kress Collection, 1952.5.8 (799)/PA. ©1994 National Gallery of Art, Washington, D.C. and The Metropolitan Museum of Art, New York.

86. El Greco, *The Holy Family with Saint Anne and the Infant John the Baptist* (c. 1595/1600: National Gallery of Art, Washington, D.C.). Oil on canvas, .532 × .344 (20⅞ × 13½); framed: .730 × .546 × .057 (28¾ × 21½ × 2¼). Samuel H. Kress Collection. ©1994 National Gallery of Art, Washington, D.C. 1959.9.4 (1527)/PA.

87. Mathias Grünewald, *The Mystic Nativity*, second opening of *Isenheim Altarpiece*, (1515: Musée d'Unterlinden, Colmar). Courtesy of Giraudon/Art Resource, New York.

88. Lucas Cranach, *The Holy Kin-* *dred* (16th century: Stadkirche, Wittenberg). Courtesy of Foto Marburg/Art Resource, New York.

89. William Holman Hunt, *The Light of the World* (19th century: Keble College, Oxford University). Courtesy of Foto Marburg/Art Resource, New York.

90. Bartolomé Esteban Murillo, *The Immaculate Conception* (17th century: Museo Provinciale, Siviglia). Courtesy of Alinari/Art Resource, New York.

91. Workshop of Simone Martini, *Saint James Major* (probably c. 1320: National Gallery of Art, Washington, D.C.). Tempera on panel, .308 × .232 (12⅛ × 9⅛); framed: .444 × .600 (17½ × 23⅝). Samuel H. Kress Collection. ©1994 National Gallery of Art, Washington, D.C. 1952.5.25 (822)/PA.

92. Master of Saint Francis, *Saint James Minor* (probably c. 1270/ 80: National Gallery of Art, Washington, D.C.). Tempera on wood, .495 × .241 (19⅝ × 9½); framed: .584 × .323 (23 × 12¾). Samuel H. Kress Collection. ©1994 National Gallery of Art, Washington, D.C. 1952.5.15 (PA) 810.

93. Paduan 15th Century, *Saint Jerome in the Wilderness* (c. 1450/ 1460: National Gallery of Art, Washington, D.C.). Tempera on wood, .805 × .550 (31¾ × 21⅝); framed: 1.025 × .762 (40⅜ × 30). Andrew W. Mellon Collection. ©1994 National Gallery of Art, Washington, D.C. 1937.1.32 (32)/PA.

108. Leonardo da Vinci, *The Last Supper* (1498: Santa Maria della Grazie, Milano). Fresco. Courtesy of Alinari/Art Resource, New York.

109. Salvador Dali, *The Sacrament of the Last Supper* (1955: National Gallery of Art, Washington, D.C.). Oil on canvas, 1.667 × 2.670 (65⅝ × 105⅛); framed: 2.026 × 3.020 (79¾ × 118⅞). Chester Dale Collection. © 1994 National Gallery of Art, Washington, D.C. 1963.10.115 (1779)/PA.

110. Leonardo da Vinci, *The Annunciation* (early 16th century: Galleria degli Uffizi, Firenze). Courtesy of Alinari/Art Resource, New York.

111. Veronese, *The Martyrdom and Last Communion of Saint Lucy* (c. 1582: National Gallery of Art, Washington, D.C.). Oil on canvas, 1.397 × 1.734 (55 × 68¼); framed: 1.899 × 2.242 × .088 (74¾ × 88¼ × 3½). Gift of The Morris and Gwendolyn Cafritz Foundation and Ailsa Mellon Bruce Fund. ©1994 National Gallery of Art, Washington, D.C. 1984.28.1/PA.

112. Anonymous Byzantine, *Enthroned Madonna and Child* (13th century: National Gallery of Art, Washington, D.C.). Tempera on panel, 1.311 × .768 (51⅝ × 30¼). Gift of Mrs. Otto H. Kahn. ©National Gallery of Art, Washington, D.C. 1949.7.1 (1048)/PA.

113. Andrea di Bartolo, *Madonna and Child* (obverse) (c. 1415: National Gallery of Art, Washington, D.C.). Tempera on wood, .286 × .178 (11¼ × 7). Samuel H. Kress Collection. ©1994 National Gallery of Art, Washington, D.C. 1939.1.20.a (131)/ PA.

114. Raphael, *The Alba Madonna* (c. 1510: National Gallery of Art, Washington, D.C.). Oil on panel transferred to canvas, diameter: .945 (37¼); framed: 1.372 × 1.359 (54 × 53½). Andrew W. Mellon Collection. ©1994 National Gallery of Art, Washington, D.C. 1937.1.24 (24)/PA.

115. Albrecht Dürer, *The Madonna and Child* (obverse) (c. 1496/99: National Gallery of Art, Washington, D.C.). Oil on panel, .524 × .422 (20⅝ × 16⅝); framed: .662 × .555 × .076 (26¹⁄₁₆ × 21⅞ × 4). Samuel H. Kress Collection. ©1994 National Gallery of Art, Washington, D.C. 1952.2.16 (1099)/PA.

116. *Majestas Domini* (11/12th century: Cathedral of the Magdalene, Vézélay). Courtesy of Giraudon/Art Resource, New York.

117. Master of the Catholic Kings, *The Marriage at Cana* (c. 1495/97: National Gallery of Art, Washington, D.C.). Oil on panel, original painted surface: 1.371 × .927 (54 × 36½); with addition at bottom: 1.531 × .927 (60½ × 36½); framed: 1.848 × 1.305 × .127. Samuel H. Kress Collection. ©1994 National Gallery of Art, Washington, D.C. 1952.5.42 (PA) 1121.

118. El Greco, *Saint Martin and the Beggar* (1597/99: National Gallery of Art, Washington, D.C.).

Oil on canvas, wooden strip added at bottom, 1.935 × 1.030 (76⅛ × 40½); added wooden strip at bottom: .046 × 1.030 (1⅞ × 40½); framed: 2.2576 × 1.362 × .127. Widener Collection. ©1994 National Gallery of Art, Washington, D.C. 1942.9.25 (621)/PA.

119. Master of the Saint Lucy Legend, *Mary, Queen of Heaven* (c. 1485/1500: National Gallery of Art, Washington, D.C.). Oil on oak(?), painted surface: 1.992 × 1.618 (78⁷⁄₁₆ × 63¾); panel: 2.015 × 1.638 (79⅜ × 64½). Samuel H. Kress Collection. ©1994 National Gallery of Art, Washington, D.C. 1952.2.13 (1096)/PA.

120. School of Amiens, *The Priesthood of Mary* (13th century: Musée du Louvre, Paris). Courtesy of Giraudon/Art Resource, New York.

121. Vittore Carpaccio, *The Virgin Mary Reading* (c. 1505: National Gallery of Art, Washington, D.C.). Oil on panel, transferred from wood to canvas, .781 × .506 (30¾ × 20). Samuel H. Kress Collection. ©1994 National Gallery of Art, Washington, D.C. 1939.1.354 (447)/PA.

122. Filippino Lippi, *Adoration of the Child* (15th century: Galleria degli Uffizi, Firenze). Courtesy of Alinari/Art Resource, New York.

123. Rogier van der Weyden, *The Magdalen Reading* (15th century: The National Gallery, London). By courtesy of The Trustees of The National Gallery, London. 654.

124. Michelangelo Merisi da Caravaggio, *The Repentant Magdalene* (17th century: Galleria Doria-Pamphili, Roma). Courtesy of Alinari/Art Resource, New York.

125. Master of the Magdalene Legend, *Mary Magdalene Preaching* (15th century: Philadelphia Museum of Art, Philadelphia). Oil. The John G. Johnson Collection. Courtesy of the Philadelphia Museum of Art. J#402.

126. Donatello, *The Magdalene* (15th century: Opera de Duomo, Firenze). Courtesy of Alinari/Art Resource, New York.

127. Michelangelo Buonarroti, *The Doni Tondo* (1504: Galleria degli Uffizi, Firenze). Courtesy of Giraudon/Art Resource.

128. Lorenzo Lotto, *The Nativity* (1523: National Gallery of Art, Washington, D.C.). Oil on panel, .460 × .359 (18⅛ × 14⅛); framed: .635 × .533 x.101 (25 × 21 × 4). Samuel H. Kress Collection. ©1994 National Gallery of Art, Washington, D.C. 1939.1.288 (399)/PA.

129. Petrus Christus, *The Nativity* (c. 1450: National Gallery of Art, Washington, D.C.). Oil on oak, painted surface: 1.276 × .949 (50¼ × 37⅜. Andrew W. Mellon Collection. ©1994 National Gallery of Art, Washington, D.C. 1937.1.40 (40)/PA.

130. Correggio, *Noli Me Tangere* (15th century: Museo del Prado, Madrid). Courtesy of Alinari/Art Resource, New York.

131. *Pantocrator* (11/12th century: Monastery, Daphni). Mosaic.

Byzantine Visual Resources, ©1994, Dumbarton Oaks, Trustees for Harvard University, Washington, D.C. A.76.44 (R).

132. Bernardo Daddi, *Saint Paul* (1333: National Gallery of Art, Washington, D.C.). Tempera on panel, 2.337 × .892 (92 × 35⅛). Andrew W. Mellon Collection. ©1994 National Gallery of Art, Washington, D.C. 1937.1.3 (3)/PA.

133. Rembrandt van Rijn, *The Apostle Paul* (probably 1657: National Gallery of Art, Washington, D.C.). Oil on canvas, 1.289 × 1.019 (50¾ × 40⅛). Widener Collection. ©1994 National Gallery of Art, Washington, D.C. 1942.9.59 (655)/PA.

134. Domenico di Bartolo, *Madonna and Child Enthroned with Saint Peter and Saint Paul* (c. 1430: National Gallery of Art, Washington, D.C.). Tempera on panel, .527 × .311 (20¾ × 12¼); framed: .565 × .336 (22¼ × 13¼). Samuel H. Kress Collection. ©1994 National Gallery of Art, Washington, D.C. 1961.9.3 (796)/PA.

135. Michelangelo Buonarroti, *Vatican Pietà* (1499/1500: Saint Peter's Basilica, Vatican City). Marble. Courtesy of Alinari/Art Resource, New York.

136. Bartolomé Esteban Murillo, *The Return of the Prodigal Son* (1667/70: National Gallery of Art, Washington, D.C.). Oil on canvas, 2.363 × 2.610 (93 × 102¾). Gift of the Avalon Foundation. ©1994 National Gallery of Art, Washington, D.C. 1948.12.1 (1027)/PA.

137. Raphael Sanzio, *The Disputation of the Sacrament* (early 16th century: Stanze, Papal Palace, Vatican City). Courtesy of Alinari/Art Resource.

138. Rembrandt van Rijn, *Jacob's Blessing* (17th century: Gemaldegalerie, Kassel). Courtesy of Foto Marburg/Art Resource, New York.

139. Piero della Francesca, *The Resurrection* (15th century: Galleria Communale, Sansepolcro). Courtesy of Alinari/Art Resource, New York.

140. Mathias Grünewald, *The Resurrection* detail from second opening of *Isenheim Altarpiece* (1515: Musée d'Unterlinden, Colmar). Courtesy of Giraudon/Art Resource, New York.

141. Sebastiano del Piombo, *The Resurrection of Lazarus* (16th century: The National Gallery, London). Courtesy of The Trustees of The National Gallery, London. 1.

142. Stefan Lochner, *Madonna of the Rose Garden* (15th century: Wallraf-Richartz-Museun, Koln). Courtesy of Art Resource, New York.

143. Benozzo Gozzoli, *The Dance of Salome* (1461/62: National Gallery of Art, Washington, D.C.). Tempera on panel, .238 × .343 (9⅜ × 13½); framed: .401 × .504 × .057 (15¹³⁄₁₆ × 19⅞ × 2¼). Samuel H. Kress Collection. ©1994 National Gallery of Art, Washington, D.C. 1952.2.3 (1086)/PA.

144. Amico Aspterini, *Saint Sebastian* (c. 1505: National Gallery

of Art, Washington, D.C.). Oil on panel, 1.149 × .660 (45¼ × 26); framed: 1.394 × .895 × .101 (54⅞ × 35¼ × 4). Samuel H. Kress Collection. ©1994 National Gallery of Art, Washington, D.C. 1961.9.1 (414)/PA.

145. Rembrandt van Rijn, *Christ Preaching (The Hundred Gilder Print)* (c. 1643/49: National Gallery of Art, Washington, D.C.). Etching, drypoint and burin on European (white) paper, (White/Boon 74 ii/ii). Gift of R. Horace Gallatin. ©1994 National Gallery of Art, Washington, D.C. 1949.1.48 (B-15254)/GR.

146. *The Good Shepherd*, Eastern Mediterranean, probably Asia Minor (c. 260/275: The Cleveland Musem of Art, Cleveland). Marble, 19¾ × 10⅛ × 6¼. The Cleveland Museum of Art, John L. Severance Fund, 65.241.

147. Jacopo Tintoretto, *Susanna* (c. 1575: National Gallery of Art, Washington, D.C.). Oil on canvas, 1.502 × 1.026 (59⅛ × 40⅜). Samuel H. Kress Collection. ©1994 National Gallery of Art, Washington, D.C. 1939.1.231 (342)/PA.

148. *Synagoga* (c. 1230: Cathedral of Our Lady, Strasbourg). Courtesy of Giraudon/Art Resource, New York.

149. Gian Lorenzo Bernini, *The Ecstasy of Saint Teresa (of Avila)* (17th century: Santa Maria della Vittoria. Roma). Courtesy of Alinari/Art Resource, New York.

150. *Theotokos Enthroned with Two Saints* (6th century: Monastery of Saint Catherine, Sinai). Encaustic on panel. Reproduced through the courtesy of the Michigan-Princeton-Alexandri Expedition to Mount Sinai.

151. Andrea da Firenze, *The Triumph of Saint Thomas Aquinas* (15th century: Cappella degli Spagnoli, Santa Maria Novella, Firenze). Courtesy of Alinari/Art Resource, New York.

152. *Traditio Legis* detail from *Christian Sarcophagus* (early Christian: Lateran Museum, Vatican City). Courtesy of Alinari/Art Resource, New York.

153. *Traditio Legis* detail from *Sarcophagus of Junius Bassus* (359: Vatican Museum, Vatican City). Courtesy of Alinari/Art Resource, New York.

154. *Transfiguration* (6th century: San Apollinaris in Classe, Ravenna). Mosaic. Courtesy of Alinari/Art Resource, New York.

155. *Transfiguration* (6th century: Monastery of Saint Catherine, Sinai). Apse mosaic. Reproduced by permission of the Michigan-Princeton-Alexandria Expedition to Mount Sinai.

156. Masaccio, *The Tribute Money* (15th century: Brancacci Chapel, Church of the Carmines, Florence). Courtesy of Alinari/Art Resource, New York.

157. Benozzo Gozzoli, *Saint Ursula with Angels and Donor* (c. 1455: National Gallery of Art, Washington, D.C.). Tempera on wood, .470 × .286 (18½ × 11¼). Samuel H. Kress Collection. ©1994 National Gal-

lery of Art, Washington, D.C. 1939.1.265 (376)/PA.

158. Hans Memling, *Saint Veronica* (obverse) (c. 1470/75: National Gallery of Art, Washington, D.C.). Oil on oak, painted surface: .303 × .228 (11¹⁵⁄₁₆ × 9); panel: .312 × .244 (12¼ × 9¾). Samuel H. Kress Collection. ©1994 National Gallery of Art, Washington, D.C. 1952.5.46 (1125)/PA.

159. Piero di Cosimo, *The Visitation with Saint Nicholas and Saint Anthony Abbot* (c. 1490: National Gallery of Art, Washington, D.C.). Oil on wood, 1.842 × 1.886 (72½ × 74¼). Samuel H. Kress Collection. ©1994 Na-

tional Gallery of Art, Washington, D.C. 1939.1.361 (PA) 454.

160. Rogier van der Weyden, *The Vienna Crucifixion* (15th century: Kunsthistoriches, Vienna). Courtesy of Art Resource, New York.

161. William Blake, *The Parable of the Wise and Foolish Virgins* (19th century: Tate Gallery, London). Courtesy of Tate Gallery, London/Art Resource, New York.

162. Rembrandt van Rijn, *The Woman Taken in Adultery* (17th century: The National Gallery, London). Courtesy of The Trustees of The National Gallery, London. 45.

Index